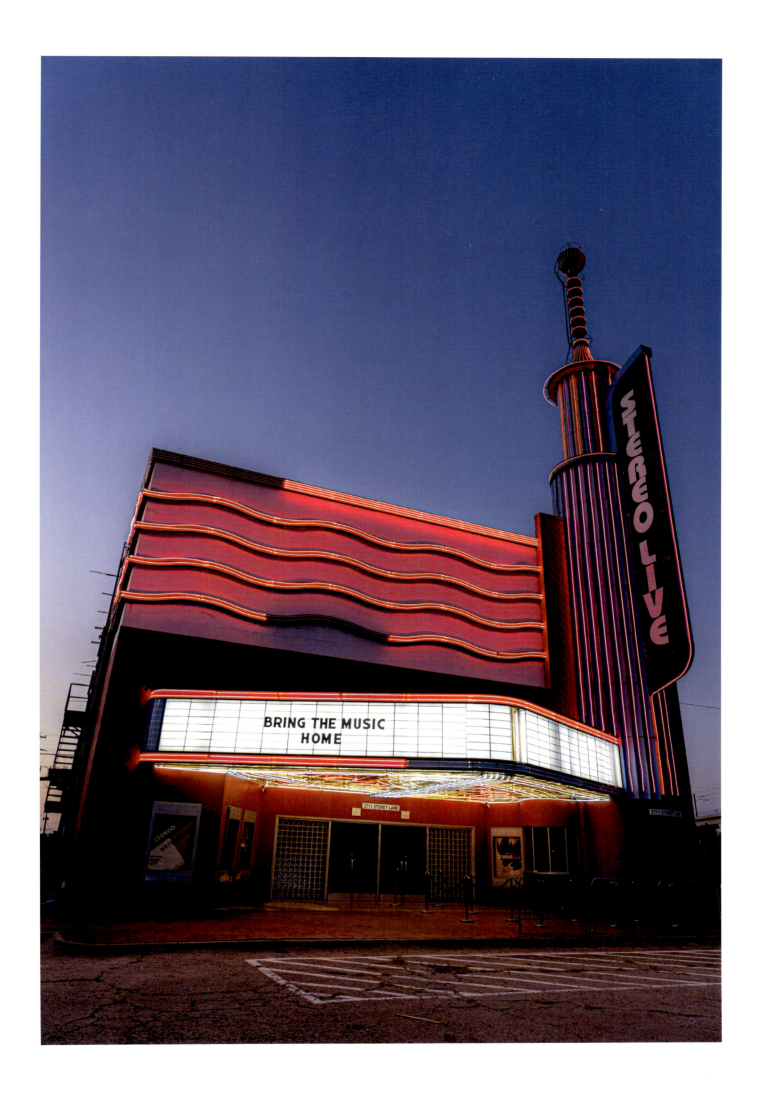

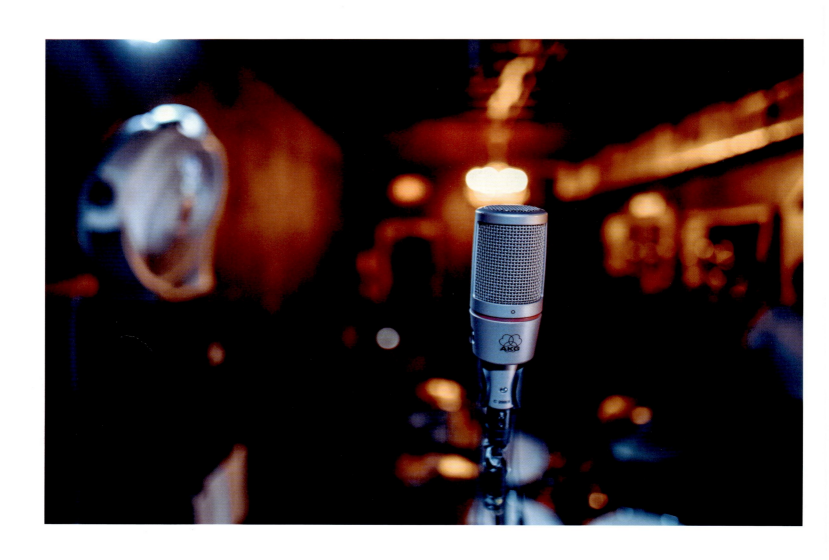

Previous page: Marquee at
Stereo Live, Dallas, TX
Photograph by Cory Cameron
Above: Microphone at Ventura,
San Antonio, TX
Photograph by Oscar Moreno

BRING MUSIC HOME

WRITTEN BY

Amber Mundinger + Tamara Deike

ART DIRECTION

Kevin W. Condon

Contents

Bring Music Home
Amber Mundinger,
Kevin W. Condon,
and Tamara Deike

Photographs and text © 2021
the attributed authors

ISBN: 978-1-7363569-0-6

Designed by Bonnie Briant Design
Printed by EBS, Verona, Italy
First edition, 2021

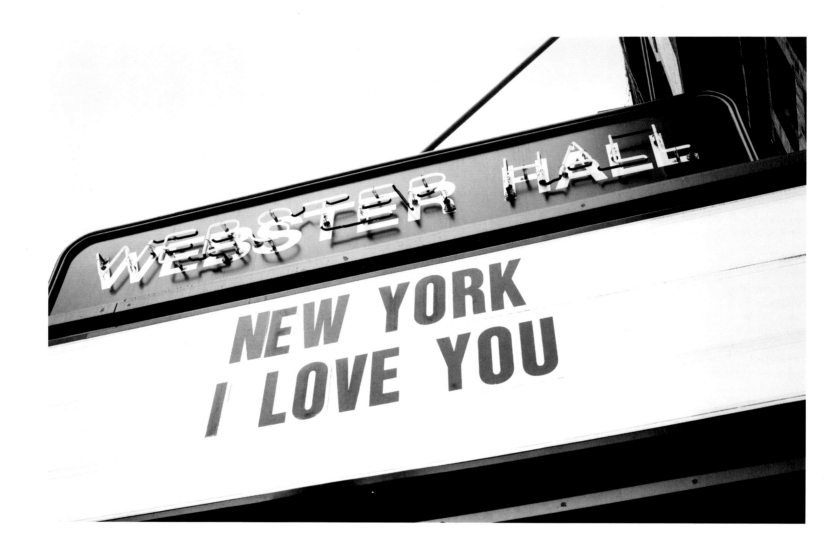

Marquee at Webster Hall, New York, NY
Photograph by Kevin W. Condon

Acknowledgments

Bring Music Home...Thanks YOU.

This book is dedicated to you, the unsung heroes of live music culture. You're the creative characters who work behind the curtain to make it all happen.

The spotlight is on. Walk into the light. We applaud you.

Thank you for keeping the passion ignited.

May the music never die and these important places and people continue to shape our communities and culture for years to come.

And, this book is dedicated to all of the venues we've lost recently—especially those featured in this very book.

The Bring Music Home Team Would Like to Thank:

Ken Jones	Cody Cowan
Rohit Singh	Alex Maas
Edward Oates	Jesse Malin
Joseph Baldassare	Fine Southern Gentleman
Dana Glaeser	Michelle Fox
Corey Stewart	Kyle Henry
Misha Vladimirskiy	Dave Gallagher
Susan Antone	Rob Jensen
Stephen Sternschein	J.C. Gabel
Reverend Moose	Roger McNamee

And a Special Thanks to Our Incredible "Dream Team"—Without You, None of This Would be Possible:

Julie Potash Slavin	Rachel Goodman
Crystal Kalish	Megan Cook
Brooke Uris	Sydney Van Ness
Lucas Bleeg	Nikki Craig
Pam Ricklin	Emma Maliborski
Laura Youngkin	Nicole Andrews
Ben Sargent	Pat McGuire
Bonnie Briant	Eric Gang
Jose Berrio	April Milek
Matt Lief Anderson	Nick Kova
Joyce Lee	Meghana Goli
Katherine Barna Glover	Elizabeth Barna
Caitlin Burla	Stephen K. Peeples
Crisene Casper	Rory Aronsky
Isaac "IZ" Burns	

Thank you to our Creative Collaborators who partnered with us across cities to bring this project to life. You made Bring Music Home possible:
Every single photographer, producer, poster artist, and videographer who participated in this project with us across the country.

The Bring Music Home Founders Would Like to Personally Thank:
Amber—The amazing friends, colleagues, and collaborators who came together to make this happen with Kevin, Tamara, and me. Kevin and Tamara for coming together to create this with me. My husband, Dana, who is my biggest champion and advocate. Thank you for supporting me and the Bring Music Home team in so many ways. Sheffield for the constant cuddles and video chat cameos. Every single person and place who participated in this project. It was an honor and a privilege to meet each of you and hear your stories. Thank you for entrusting us to do so.

Kevin—My mom, dad, brother, and sister for the lifelong encouragement to follow my instincts. Amber and Tamara: two of the most incredible people I know—forever fortunate to work alongside them. The many, many, many people who collaborated on this book. The people who own, operate and play in these venues we scrambled to capture—you have all held responsibility for many of the best years of my life thus far, as well as countless others. You are missed and we want you back. The musicians who have trusted in me to photograph their many moments which, as a result, has led me to this one. There have been so many of you and I cannot wait for more, but there are three specifically featured in this book: Danny Gomez (of Native Sun), Elliot Moss and Conor Curley (of Fontaines D.C.). You, and the bands you play with, made the year leading up to COVID one of the best I could have possibly hoped for, and I am forever grateful.

Tamara—Amber & Kevin for inviting me to the party...and your endless dedication to making this happen! Every single collaborator + teammate who put their blood, sweat & tears into this project. Corey for the bottomless cups of coffee and 24/7 belief in me—Thank you, babe. Mom, Dad + family for the love + support. Tom + Kathy for the true gift of creative space, to bring this to life! My friends for all the support (you know who you are)! Austin venues + their teams for allowing me to step inside your spaces, and for sharing your stories with me. And of course, thank you to the music community, for joining us on this journey...

The Story Behind
Bring Music Home

"Bring Music Home" is exactly that. A way for *you* to bring music home. A concept dreamt up in the middle of a global pandemic, a way to showcase the important and passionate stories of live music's unsung heroes—the venue owners and staff who keep the lights on, the volume loud, and make the magic happen seven nights a week.

Dive bars, nightclubs, dancehalls, and stadiums dot the country from coast to coast—from small towns to major cities. Bring Music Home focused in on hundreds of locations all over the U.S., producing the hefty book you're holding right now, working remotely to help prevent the risk of COVID spread, with zero upfront budget. Please know that we think all music venues matter, and if your city or favorite space was left out, it ain't personal, we promise.

Somehow, we were able to convince an INCREDIBLE group of extremely talented creatives—photographers, artists, journalists, producers, videographers, and dozens of other indispensable volunteers and collaborators—to say "yes," and join us on this storytelling adventure. This book would not be possible without their unrelenting faith in the process, their respect for their local communities, and most importantly, their love for live music culture.

Over the past several months, we have watched our music community suffer, yes, but we've also seen people come together in creative ways. We've witnessed new solutions to the challenges facing the music economy, and recognize that this, too, is just the beginning. There is plenty more work that needs to be done to grow the music economy, increase diversity, and continue to create ways for up & coming musicians and creatives to be seen and heard.

Our "why" is simple.

Music is culture. And without culture, our communities are empty, void of connection.

A portion of the proceeds from your purchase of this book will directly benefit the National Independent Venue Association (NIVA). And, by purchasing this important time-capsule piece, you are also supporting more than 60 individual creatives who helped make this book a reality.

So thank *you*.

And hopefully, we'll be seeing you soon…in the crowd at a show.

xo,
The Bring Music Home Team

Amber Mundinger

"Bring Music Home" was created at the height of the COVID-19 pandemic in early March 2020. The idea started with a conversation between Kevin and me. We were in the midst of NYC being the No. 1 one hotspot for coronavirus, both of us dealing with shifts in our work and life due to the impact, and hopped on a FaceTime chat to catch up. I clearly remember sitting on the couch in my husband's shop in the West Village and talking to Kevin who was at home in Brooklyn. Things were stressful and scary and NYC was shutting down right in front of our eyes.

I shared with him that I thought we should document what was happening—the people and places we care about so much—that were all closing for the foreseeable future. He agreed and I began to write a treatment for the project.

As I was writing the treatment, I had been catching up with Tamara a few times on the phone. We had met via Kevin the year before, hit it off, and were swapping stories of the state of the pandemic in each of our cities and the shifts in the music industry. On a walk in Central Park, while catching up with her on a call, I mentioned the project idea and asked if she might be interested. We had wanted to collaborate since we had first met and she was dealing with a similar situation in Austin that we were experiencing in NYC. She was all in.

From there the three of us discussed five or six cities that might make sense to focus on. We created potential venue lists, thought of potential friends we could collaborate with in those cities, laid out protocols for safety, and adjusted the treatment of the project to something that we felt fully explained and did it justice. Kevin and I would tackle NYC together—he as photographer and I as producer. Tamara and Matt Lief Anderson, another friend, would handle Austin and we mapped it out from there.

In terms of logistics, it was quite the journey. For example, for our first shoot in NYC, I had to bicycle six miles to the West Village from my apartment in the Upper West Side. I then dropped my bike and changed into moto gear. Walked to my motorcycle in the Perry Street garage and rode 20+ minutes to Brooklyn for the shoot with my backpack of masks, hand sanitizer, iPad Pro, and all the other necessities. I then reversed all of that to get home. We adapted each shoot to ensure it was safe based on the circumstances and comfort levels of those we were working with along with current health guidelines.

In regard to relief, as part of the project, we wanted to have both short-term and long-term relief. When we started BMH we were mapping out local charities in each city that could be potential partners. A few weeks into the project through mutual friends and colleagues, we heard that the National Independent Venue Association (NIVA) was forming, and through Tamara's work in Austin with a few of the founders, we were able to partner with them.

It truly was amazing to see the chain of events that unfolded in the midst of this crazy, historical time in our lives. That we were able to bring this idea to life is a testament to the passion, grit, and genuine love and generosity of our friends and colleagues in music and beyond.

Six cities ended up totaling more than 30, a handful of collaborators culminated into 60-plus and people worked tirelessly to get this done over the course of seven months. In those seven months in the midst of a pandemic, dealing with their own personal situations due to COVID and its impact on people's lives, this team captured 200+ venues, interviewed 375+ individuals, and took their portraits. Everyone worked in the communities they love so much to make sure that no matter the outcome of what we were/are all living through, these stories would be captured.

Poster artists created original art for our Bring Music Home short-term relief effort with NIVA. Friends in publicity, legal, accounting, social media, logistics, graphic design, and more donated their time. Photographers and producers across the country became solo adventurers or dynamic duos to capture this content in each city across multiple venues. Husbands, wives, partners, girlfriends, boyfriends, friends, and fiancees lent their support. Brands that care about music, and our work, supported the ultimate publishing of this book.

And here we are. This book is the culmination of thousands of hours of people's time and efforts. It is the most comprehensive documentation of independent music venues and the people behind them—the unsung heroes of music—during the first seven months of this pandemic.

But the story of "Bring Music Home" does not end with this book. We will continue to document and share these stories in other media and tell new stories as they unfold. It is also a story we hold close. It's the story of our communities, industry, and colleagues.

I look forward to being behind the scenes again at that first big show. When the lights go down, the energy is palpable and the crowd roars.

Kevin W. Condon

I suppose the context needed to explain the origin of this project starts early in 2019. I had met Amber and her husband, Dana, the year prior and we had become friends quickly. Amber was the first person at *Rolling Stone* to take a chance on me as a music photographer and got me on board to shoot SXSW in 2019. It was my first time there (and I am desperately hoping not my last) and my first time published in the magazine I have held iconic for so long. Many bands I met and photographed at the festival went on to become big parts of my life afterward. The rest of the following year was a gorgeous blur of music, travel, and friends. I had never begun to consider that live music would stop.

When it did, I'm sure that much like many of you, I went into a bit of a shock as the ripples began to spread. This was obviously going to carry deep into the year. Longer. I really did not have a lot of fight or hope in me. It was less what I was losing personally and more so that the industry, the art, that I love was in a dire way. It felt like all I could do was watch and wait for the death rattle. Granted, I might have been a little hyperbolic; time will tell. But it was how I felt and Amber realized this.

Amber is a saint for so often taking time to talk positively even when everything suggests it is nearly impossible to be so. She made a point to reach out early into our lockdown and within a call or two, we both realized that death rattle or not, we did not have to sit around. We both have been lucky to have made a lot of friends in music over the years—so we started reaching out. If only to give these shuttered, hurting venues a chance to tell their stories and document this ugly but historical moment when it all went on pause. It did seem a little sad to me, but the more we thought about it the more we realized it had to be done—but on a much bigger scale than just our city.

This is when we reached out to Tamara, whom I had met in the summer of 2019 when I was fortunate enough to be a guest at an event she was producing—one of my favorites of the year, really. We had gotten in touch over photos I had taken and very naturally became friends from there. I had introduced Amber and Tamara that following winter and they became fast friends as well. Tamara lives in Austin and our idea was that we wanted to cover multiple cities in the U.S. and we would start with these two.

As we began to set up photographer/producer duos in a couple of other cities, we quickly realized it wasn't a couple of cities. There were dozens. But what I love about these two incredible partners of mine is that, to them, it didn't seem daunting in the slightest—they both took it to a whole other level without breaking a sweat. They are truly incredible at what they do and this book would not exist without the delightful vivaciousness they both displayed going after this project.

Now here we are. Dozens of cities. Hundreds of venues. Hundreds of participants, both in front of and behind the camera. Millions and millions who miss live music.

If I could speak directly to Live Music and all the people involved in making it one of the most spectacular reasons to be alive: I don't know what a world is without you and I will do whatever I can to never find out. I love you and I miss you and I hope to see you soon.

Tamara Deike

There's something to be said for uncertainty…when things are unfamiliar, you sort of have to pick sides, you know? One path is fear-based. The other is pure roll-the-dice, take a chance on the unknown.

When Amber and Kevin reached out about the concept for the project, I was personally still licking my wounds from the devastating cancellation of SXSW here in Austin. Months of pre-production, creative strategy, time, and money dissolved in one fell swoop. Not just for me, but for so many friends in the music industry community.

Venues were shuttered, with no signs of reopening. Our friends—talent bookers, musicians, tour managers, bar staff, and more—were out of work. The loans and benefit programs being offered were murky, while our federal government rattled off mixed messages, distorted by constant bipartisan dueling. Our country was at its breaking point as blow by blow, it buckled under the weight of racial injustices and economic strain. All of which paralleled an unseen outbreak of a deadly disease that was quickly gaining force with each passing day.

It's also no small thing to recognize the energy that brings you together with other creatives. When I met Kevin, it was because of his work…his photography was absolutely stunning. I was mesmerized by shots he'd captured at an event I'd produced and I felt compelled to reach out to him. We became fast friends. He connected me with Amber shortly after, and we also had an immediate bond. I remember being blown away by her positivity and work ethic.

I'd been looking for something to sink my teeth into, a way to express some kind of hope in the midst of so much turmoil. The respect I have for Amber and Kevin is massive, and it took a certain level of trust to lock arms with one another and venture out into what was a seriously unsettling moment in time, and agree to do something fully, no matter what, and see it through to completion as a team. When Kevin and Amber asked me to join, I'm pretty sure my response was something like, "I'm all in."

Working over these past months on the "Bring Music Home" project has been so incredibly rewarding, in ways I never would have imagined. I've grown, I've cried, I've learned, and most importantly, I've connected to other passionate humans, and created friendships in the middle of a pandemic.

The unrelenting creativeness from the dozens of photographers, producers, and videographers who have trusted us and helped bring this story to life, has been one of the most incredible aspects of this project. This book would not exist, without their dedication to sticking it out, getting the shots, the stories, and pure dedication to getting it *done*. I feel so honored to know you all…

And one thing I know for certain, after hearing face-to-face the unique stories of so many incredible people from all over the country, is that music is indispensable. No matter age, race, or political views, music is the life force that moves us and connects us to one another at our most human level.

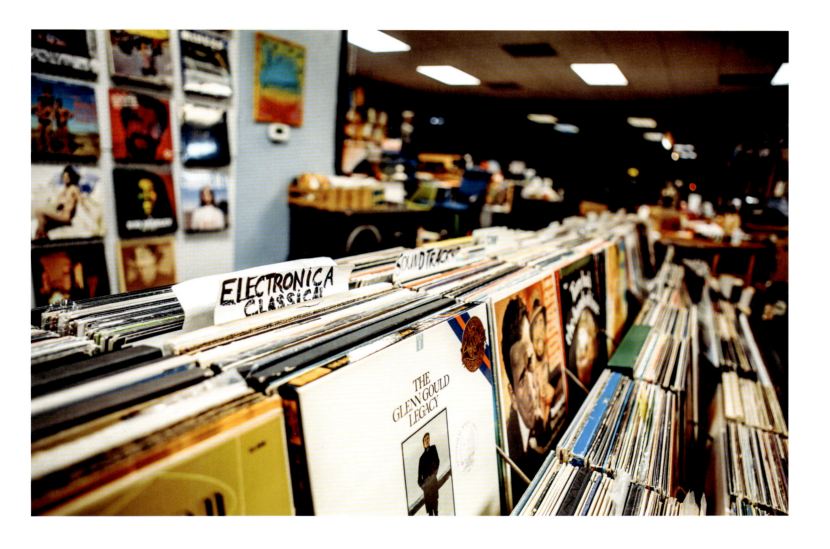

Above: Record section at Imagine
Books and Records, San Antonio, TX
Photograph by Oscar Moreno
Following page: Guitar hanging at The
Saint, Asbury Park, NJ
Photograph by Danny Clinch

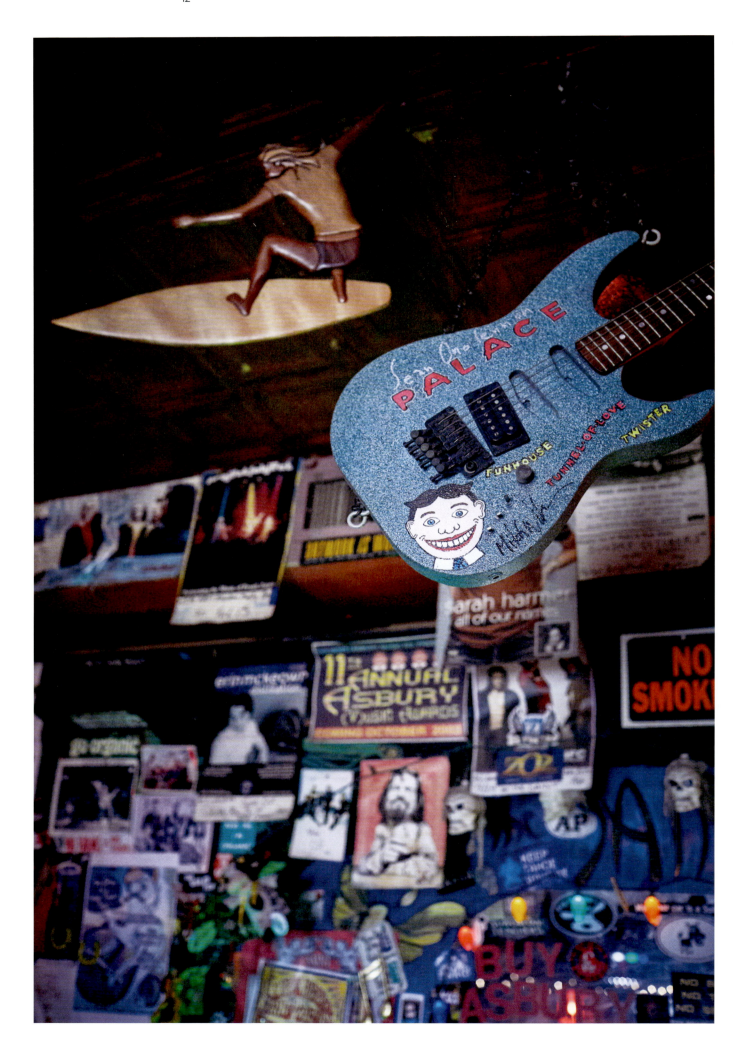

As this time comes together, the very existence of independent venues is in jeopardy. The sudden closure, immediate lack of revenue, and continued overhead has only been exacerbated with the reality that no one can predict when venues will be able to fully reopen. A daunting 90% of independent venues across the country might never see that day. Perhaps it is too late, or perhaps *Bring Music Home* captured the moment in time where the world metaphorically waited in line for the doors to open and the show to start.

We are surrounded by locked venues and empty rooms. The anticipation of stage lights to come is accompanied by as much hope as it is uncertainty. This moment of in-between-ness—depicted in photographs and stories, of the places we've been and those we might never get to see ourselves—is as historical as it is sentimental, for every event that was ever held in one of these venues was a moment in time where something special happened.

Maybe it was someone's first show, or possibly their last. Maybe the evening ended with a celebration or just a chance for old friends to spend time being old friends. Those memories are personal to everyone in the room: a band's first show where they swear there were only 20 people in the room, yet somehow there are hundreds with the same memory; or the T-shirt bought to commemorate the evening that is more missed than the former relationship that claimed it.

Most people don't have the benefit of seeing the rooms themselves. It's the events that happen within them that justifiably overshadow all the hard work that goes into making each evening unique. There's something special about being alone in a venue. That feeling when the door opens and the house lights flicker on, looking upon the worn floors or empty seats, with the anticipation of what's to come: a room full of life and the people that will fill it out.

Then, one by one, staff starts to show up for their shift, the artists load in, fans queue up, and, never soon enough, the room goes silent right before everything simultaneously disappears and comes together, all in one room.

And just as quickly, the process reverses: the stage goes silent, fans go home, gear gets packed, staff punches out, and the last person to leave locks the door.

Now, thanks to this collection, everyone has the opportunity to see the rooms in their most raw sense. This is an all-access pass to the country's most special rooms. See what it looks like when the door is unlocked for the first time each day, the potential of what is to come, or the memories of what once was. Access is given not just to the buildings, but those who make them so adored.

Most people who make their living in these venues, whether taking your ticket or your drink order, keeping you safe or quieting you down, performing on stage, or sweeping it—don't think of these venues as just a place to work. It's where they get to work. There's an entire world of people who live to bring joy to total strangers. Those in the audience come not just for the entertainment but also for the community, to sing or laugh or cry among a room of familial no-longer-strangers. These are our sanctuaries that, at this writing, have gone quiet.

No matter what present day might bring for the reader or these venues, this book is a solemn reminder of how we lost the opportunity to gather, which, up until now, we've taken for granted. These venues are to be celebrated as the places that gave us life, that brought us together, that created memories, and that we revere as the cultural incubators they are. It is in these rooms where we are with our people—those we know and those we have not yet met—where we are no longer alone.

To those that have the luxury of hindsight, who are holding this book in a world where live events happen with abandon, and locally owned and operated rooms are hosting a new generation of emerging talent, take a moment to look around.

Look at the marquee. Look at the people. Look at the floors, the signage, the fixtures, the stage décor. Just look around and take it all in. For none of us knows when a book might be all we have left by which to remember it.

Until we're together again,

Rev. Moose
Executive Director/Co-Founder
NIVA (National Independent Venue Association)

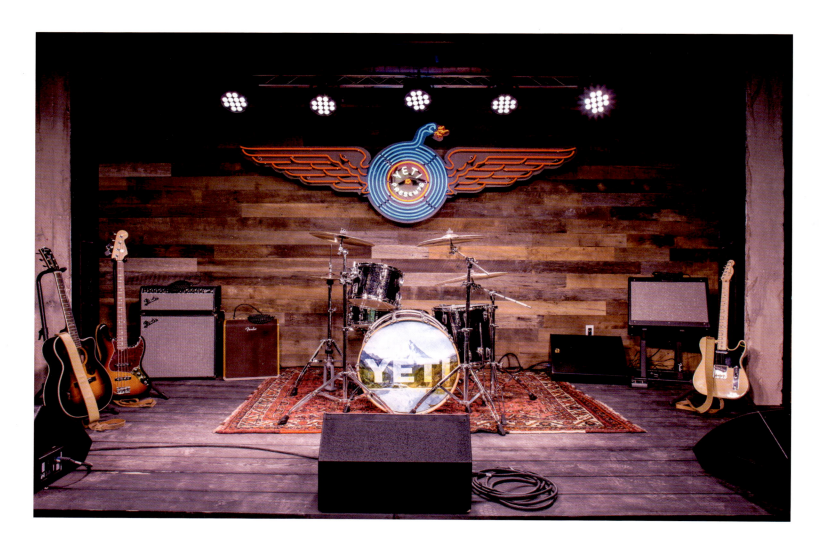

YETI®

Passion, restlessness, storytelling…that's where musicians and YETI really line up.

Music brings people together. We know it well because music is woven throughout our communities and pursuits. A professional bull rider and an alpinist may not have anything obvious in common, but there's a soundtrack behind each of their pursuits.

And the YETI community as a whole—from our fans to our pros—is passionate about music. Whether it's our Spotify Weekly Playlist, various festival activations, artist collaborations, or licensing a great song for a YETI Presents film, YETI has been active in the music community for more than 5 years and has no plans of slowing down. It's an important part of our ethos.

In 2017, we opened our first retail store in Austin which includes a fully equipped stage. There, we've hosted shows by local and national acts like the Black Pumas, Tyler Childers, Ryan Bingham, Liz Cooper & The Stampede, and many others. Since then, we've opened retail stores in Charleston, Chicago, and Denver, all of which include stages where we will continue supporting local music.

YETI is proud to support Bring Music Home and the National Independent Venue Association (NIVA) in their efforts to raise awareness of the importance of live music venues.

Walk into an empty venue, before doors, before sound check, or after it's all over at the end of the night, and you can sense it—a breathing, a resonance, the unique scent resulting in the combination of the building itself, production equipment, and years of spilled drinks. Even in the quiet, there's a pulse, and every show adds a tangible variation to the beat and tone of the physical space.

Or maybe not. But that's what it feels like. There's plenty of waxing poetic when it comes to live music experiences, but that makes sense. Each show is a marker of time and place; a "remember when we saw…" and a few hours of some kind of heightened, shared experience, whether you sat in the last row of the highest balcony or pressed up against the stage.

Through my life, the years have been punctuated and remembered through shows and bands and venues. I can see the stage from the spot where I leaned on the balcony at Mississippi Studios for that Hayes Carll show better than I can remember my college graduation, and the evening I saw M. Ward and Calexico play at the Great American Music Hall in San Francisco is clearer in my memory than the apartment I lived in that whole year.

I can track the cities where I've lived and worked through War on Drugs shows—Doug Fir, Tractor Tavern, Johnny Brenda's, Stubb's, Paradise Rock Club—and distinguish summers through festival lineups and mid-day discoveries, like that unforgettable year when Lizzo, Tank and the Bangas, and Billie Eilish all played early shows on the Tito's Handmade Vodka stage at Lollapalooza.

Holidays that stand out from the collage in the general memory bank are always the ones with live music—New Year's Eve with a local punk band at a bar in Germantown, New York. Or Willie Nelson at Austin's Moody Theater. Waiting out a torrential downpour to see LCD Soundsystem play on Halloween, and the Dropkick Murphys reliable appearances on the most memorable (if slightly hazy) St. Patrick's Days in Boston.

As soon as I remember the band and the venue, the entire evening shifts into focus around it—what we ate, what I wore, who I unexpectedly ran into, what the air felt like that night. Even the mundane, in-between moments of waiting in line at the bar or for the bathroom blink through my mind. And with those visceral cues, the rest of my life, outside of music, becomes a little clearer, too.

Since I started my role at Tito's Handmade Vodka in 2015, music-related activities quickly started to fill my work calendar. The opportunities

to not only enjoy live music as a fan, but also to peek behind the curtain of the industry, have flashed through the past years at a remarkable frequency.

The love of live music is at the heart of the Tito's spirit, and flows from our founder. Tito has always loved a party, and if there's live music, well, even better. His vast vinyl collection skews heavy toward "classic rock legends," but he's a serious fan of the Austin music scene and will jump at the chance to support singer-songwriters and cover bands alike.

Tito's passion lit the way for the brand's involvement in the music industry for the past 20-odd years. We've sponsored music festivals for decades, supported independent music stores through our partnership with Record Store Day, raised money and awareness for Austin's own revolutionary HAAM (Health Alliance for Austin Musicians) and other crucial music-centric nonprofit organizations, and been a steady presence to keep booze flowing and the show going at unofficial backyard shindigs, dive bar stages, and iconic music venues across the country.

In 2020, the breakneck pace of the Tito's Handmade Vodka events schedule came to a screeching halt, along with the entire music industry. As people stayed home to stay safe, calendars across the world replaced dates with "cancelled" notifications into the foreseeable future, and venues stayed empty of musicians, fans, and the crucial caretakers who keep the lights on and floors swept, the sound engineered, drinks full, and the box office open.

Nobody is pausing to hear the pre-show echoes or adding new layers of sound to the histories recorded in the walls, and the year is a blur of the same news, same scenery, same clothes, and not a lot of serendipitous run-ins. Without the experiential punctuation of live music, many of us who track time passing through stages and sets have been left with a year-long run-on sentence. And we crave a return to these hallowed spaces.

In this global pause, as we're missing live music and filling in the gaps with livestreams to our living rooms, backyards, and makeshift offices, some beloved, historic venues have had no choice but to close permanently, and we cannot suffer more casualties. Live music is the heart and the soul of the music industry. It's the source, the engine, where it all begins. We need music venues to keep the music industry alive. So we work toward a future of open box offices, packed houses, and stages for our favorite bands to play.

—Josie
Team Tito's Since '15

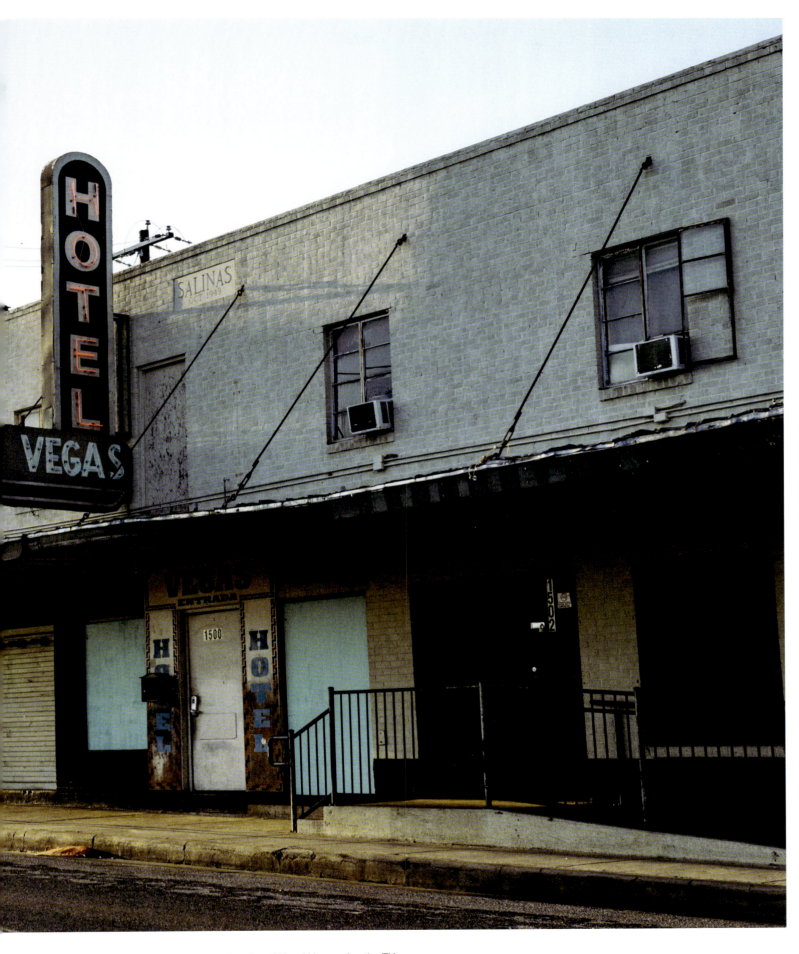

Exterior of Hotel Vegas, Austin, TX
Photograph by Matt Lief Anderson

Atlanta

POSTER DESIGN
Vanya Padmanabhan

PHOTOGRAPHER
Kai Tsehay

PRODUCER
Joy Martins

Always Moving — *Always Forward*

We make the culture. It's blasting out of amped car stereos down Edgewood and riding top down on Ponce. It's trap and rap and really everything but. It's mixtapes and it's vinyl and it's an mp3. If we're lucky. it's an mp4. It's a dive show and a stadium tour. It's garage bands and it's the big guys. It's unapologetic and honest and flashy and fake. It's mid-traffic. Always traffic and always there. It's a real wholesome boundless "I feel full" kind of love. Do you feel it? Five Points. Little Five Points. West End. East Atlanta. It's in the corners. It's in the middle. Think 'The Fox'. It's twang and blues and beats on a laptop. Are you listening? It's really good. Does the job ever end? Always in progress and always forward. The team is strong. The drinks are cold. On the roof. At the 'Attic'. In the Basement (RIP). At the lounge. In the lot. On that one friend's porch. It's too good to let go! There is not a goodbye in sight. Instead a big see you soon.

TILL WE CAN SING AND TOUCH AND LAUGH IN PERSON. DANCE ON. CHILDREN OF THE DIRTY SOUTH.

Atlanta

Piera Moore

1. Don't sleep on someone just because it feels like "everyone makes music." You may look back in your high school yearbook and realize that you had a class with the next big thing coming out of Atlanta.

2. Atlanta is home to more than just rap. You can find very talented neo-soul, electronic/house, and rock musicians here, too.

3. Any space can be a music venue here—clubs, warehouses, restaurants, cafes, parks, street corners, etc.

4. Atlanta breeds authenticity. Our contributions to Black popular culture (and, thus, popular culture in general) are fueled by themes, struggles, and customs that are ancestral. Black people's roots in the South have greatly influenced our art forms.

5. There's a lot of overlap between the music industry and other art forms and genres here. Musicians, photographers, tattoo artists, event coordinators, fashion designers, and more often work together to bring their visions to life.

6. We in the South always have something to say and have always used our voices to speak up, from the Civil Rights Movement and the young activists of the Atlanta University Center to Outkast and Lil Baby.

7. Any space can be a studio here—a garage, a closet, your cousin's house, etc.

8. Followers do not always equal influence. Some of the best artists coming out of Atlanta have 5,000 followers or fewer on social media but their music reaches listeners around the world.

9. Atlanta's DJ's are also very influential. They make sure artists in the city get heard in the clubs, on the radio, and on their online mixes. Many Atlanta artists get their start by having their music played in local clubs—especially strip clubs.

10. It's a city of networks— someone you meet in passing (at a party or bar, or while shopping at a pop-up) could become your next business partner, collaborator, or manager.

Luv2/VODS

We all have to stand up for one another. We need to help one another at this point in time because it's all we have. We're in the business where getting together is very important, socializing is very important.
Terrence OJ

Terrence OJ, Owner

Murphy Park

During this time, I've learned I'm pretty resilient to anything that comes my way... this is something I enjoy doing. And in dealing with COVID, I've learned how much I care about my family and friends around me. Danielle Latreece

I started all this back in 2015, just with a crazy idea to take this giant space of abandoned land, a parking lot, and turn it into something cool...something that was going to bring life and vitality to Southwest Atlanta. It was just an open canvas. We're just more creative, so we're just compelled to do these kinds of things. Asa Fain

Top: Interior of Murphy Park
Bottom: Danielle Latreece, Booker/
Operations and Asa Fain, Owner

The Northside Tavern

My dad bought this property in 1972 and ran it as a redneck pool hall. This area of town was rough [then]; there were mills all around here. My sister took over and decided to make it a live entertainment venue. That was in 1993 and it was a long, hard process for her to get it to where it is today. It's been devastating. We've gone from a full scale seven-days-and-nights venue operating and supporting the Atlanta market, and from a nice volume, to zero. Tommy Webb

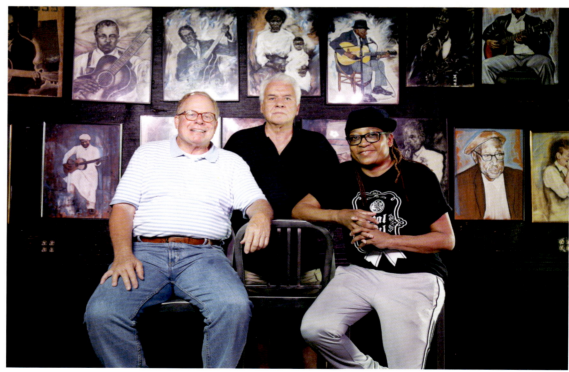

Top: Stage at The Northside Tavern
Bottom: Tommy Webb, Owner; Ron DiNunzio, General Manager; Lola Gulley, Entertainment Coordinator/ Main Performer

30 Ivan Allen Jr Blvd. NW, Atlanta, GA 30308

25

Atlanta

Oak Atlanta

We just make sure everyone's comfortable, and the environment is still lit at the same time. We're just here to bring great music and joy to everyone who comes.
Ola Amokomowo

I think the club scene is major for Atlanta...it's no secret. Most of the songs that are cut and broken are at the club. Luckily for me, my venue is also known for the biggest brunch in the city...in the state, probably. But we actually break a lot of those records and music. I've had [at Oak] DaBaby, Lil Baby, T.I. Teyana Taylor, Cardi B....so many. Anthony Adighibe

Top: Interior of Oak Atlanta
Middle: Anthony Adighibe, Co-Owner
Bottom: Ola Amokomowo,
Director of Marketing

Austin

POSTER DESIGN
Justin Prince

PHOTOGRAPHER
Matt Lief Anderson

PRODUCER
Tamara Deike

Playlist

This Select EP Playlist Curated by DJ Hesta Prynn

1. **Scholz Garten** *The oldest in the game* As the oldest operating business, live music venue, restaurant, and bar in Texas—not to mention the longest-running Biergarten in America—Scholz wears a lot of hats. In an increasingly changing Austin, the Garten holds it down as a familiar and beloved mainstay for locals. Its outdoor patio offers ample space for enjoying free live music throughout the week, delicious German-Texan comfort food, and a great selection of drinks. UT students congregate for the largest tailgate party in the city, SXSW-ers pour in to hear great bands, friends gather for celebrations, and through the years it has remained the home of the Austin Saengerrunde singing society, officially the oldest ethnic organization in Austin. Giddyup, little Liebling.

2. **Stubb's** *World-class BBQ and even better concerts* Ask Austin locals what the city is best known for and there's a good chance the answers will be split between live music and barbecue. At Stubb's, you get both under the same (open-air) roof. Located in the historic Red River district a few blocks north of Sixth Street, this institution first came to be in Lubbock, the brainchild of one Christopher B. Stubblefield. A cook who refined his meat skills while serving in the Korean War, "Stubb" opened his first BBQ joint in 1968 and it quickly grew into a musical hotspot in the '70s, hosting Texan up-and-comer regulars like Joe Ely and Stevie Ray Vaughan, and legends like Muddy Waters, Linda Ronstadt, John Lee Hooker, and Johnny Cash. The Lubbock location closed in 1985, but at the encouragement of Stubb's friend Willie Nelson, he reopened in Austin the next year and re-settled into the venue's current location in 1996. Along the way, the Stubb's brand exploded in the early '90s when Ely showed off a bottle of the chef's BBQ sauce during a Letterman show appearance; soon it could be found in stores nationwide. Today, music and meat fans come by the truckload to enjoy a meal and show at Stubb's, which hosts a Sunday gospel brunch in addition to giants of every musical genre. As Stubb himself said, the secret to his sauce was simply "love and happiness." You'll leave stuffed with your fill of it all.

3. **Mohawk** *A contemporary indie music haven* In a city where bars and venues often elect to wear their TEXAS-NESS on their sleeves, a cool, cutting-edge, contemporary spot like the venerable Mohawk offers a refreshing change of pace. And while it could be the hippest venue in just about any city, the Mohawk still somehow maintains a certain degree of Texas-ness without having to smack you in the face with a longhorn-shaped belt buckle about it. Since 2006, this 900-cap indie music haven located just across from Stubb's on Red River has been the place to see the world's hottest touring acts. The club has stages both outdoors and indoors, three bars, and its rooftop bleachers offer an impressive view of the downtown skyline. If your favorite artist is playing a huge venue on their second or third (or tenth) time in Austin, chances are their first show in town was at Mohawk.

4. **The Continental Club** *Authentic Texas roadhouse style on South Congress* From its perch just across the Colorado River from downtown, The Continental Club has ridden several waves since opening in 1955—supper club, burlesque revue, blue-collar watering hole, '80s punk den—before arriving at its current and most iconic status as one of the darkest, dive-iest, honkytonk-in'-est music venues in the land. As bougie South Congress has evolved around it, The Continental has stayed largely the same since its 1987 renovation, and a night out here typically includes plenty of dancing, drinking, and damn good tunes. From roots rock and blues to rockabilly, country, and beyond, this hallowed joint can rip with the best of 'em. No hootin', no hollerin', no service.

5. **The Moody Theater** *The state-of-the-art home of* Austin City Limits Known as ACL Live at The Moody Theater, this is the new downtown home of *Austin City Limits*, the longest-running music television program in American history. Anchoring the fancy-pants Block 21 development on Second Street (aka "Willie Nelson Boulevard"), the 2,750-seat Moody also hosts myriad non-ACL shows throughout the year as well as galleries of work by music photographers Jim Marshall and Scott Newton. Everyone sounds better through the Moody's next-level sound system, as recent ACL stars like Leon Bridges, Gary Clark Jr., Billie Eilish, and H.E.R. can attest.

AUSTIN

A SIDE

Scholz Garten:
Grupo Fantasma
Cumbia De Los Pajaritos

Stubb's:
Spoon
I Turn My Camera On

Mohawk:
White Denim
Just Dropped In (To See What Condition
My Condition Was In)

The Continental Club:
Gary Clark Jr.
This Land

Moody Theater:
Stevie Ray Vaughan
The Sky Is Crying (Live)

SCAN TO PLAY

Austin

Cody Cowan

1. Musicians, venue workers, and the scene have scoffed since Day One at Austin's characterization as the "Live Music Capital of the World" as an arrogant appropriation of our rough culture, insider-scene, and creative contributions.

2. "Keeping it weird" is also a squares' idea, one that takes the art/music/outsider culture of Austin (and especially South Austin) as well as our once locally famous-and-weird hard-scrabble influencers to make bumper stickers and sell cheap merch at the airport.

3. Folks love to hate SXSW for bringing strangers by the bulk into town each March, even though SXSW is largely the reason for the growth of live music in Austin from a niche obsession to a global brand.

4. The areas north of the UT campus and south of Ladybird Lake were once considered suburbs or not-IN-Austin well into the '80s. The true boundaries of Central Austin are still hotly debated by locals, though real estate has decided they exist somewhere between Round Rock and Buda.

5. Cosmic Cowboy was the term used back in the Armadillo World Headquarters days to describe the intermingling of counterculture with redneck in Texas. The sometimes-outlaw (and at times, traditional) influence of rural Texas still echoes in the hard attitudes and cavalier etiquette of our city's fair venues.

6. The geese are not friendly, should you happen upon them while visiting Lady Bird Lake and decide to share your sandwich and snap a selfie unawares.

7. The tourist-friendly South Congress (now called SoCo by outlanders) was for decades an open drug market and prostitution destination for ne'er-do-wells and congressmen alike.

8. A section of Guadalupe Street on UT campus, also known as "the Drag," was once the destination for generations of youth culture to explore record stores, arcades, headshops, poetry-salons, live music, and cultural ephemera, before being monetized into the never-ending strip mall you see today.

9. Congress Avenue was largely an abandoned, distressed, and unkempt no-man's-land in the '80s and '90s that music-goers of the time would have to traverse quickly in order to see shows between 6th St. and the Warehouse District.

10. Austinites have complained of the city "selling out," "being cooler in Old Austin," and becoming gentrified since at least the early '80s, even if rapid growth only began about 10 years ago. We have a long history of nay-saying and haterism, and young and old seem to offer complaints like a badge of honor—the recognition of entry into truly being "from Austin."

Antone's

There's just people who are like, hell or high water, 'I'm not living in no town that doesn't have Antone's.' It's the flickering flame of hope...in some situations. And so there's a pressure that comes with that, but the pressure is, ironically, almost relieved by just knowing that we don't have a choice. Antone's will continue.
Will Bridges

People would ask Clifford [Antone's founder], 'Well, what is your motivation for happiness?' And this has been the question for so many years. And he'd say, 'To have fun.' And it truly is about that. Susan Antone

Opposite top left: Susan Antone,
Co-Owner
Opposite bottom left:
Will Bridges, Co-Owner
Right: Susan Antone and Will Bridges
Bottom: Interior of Antone's

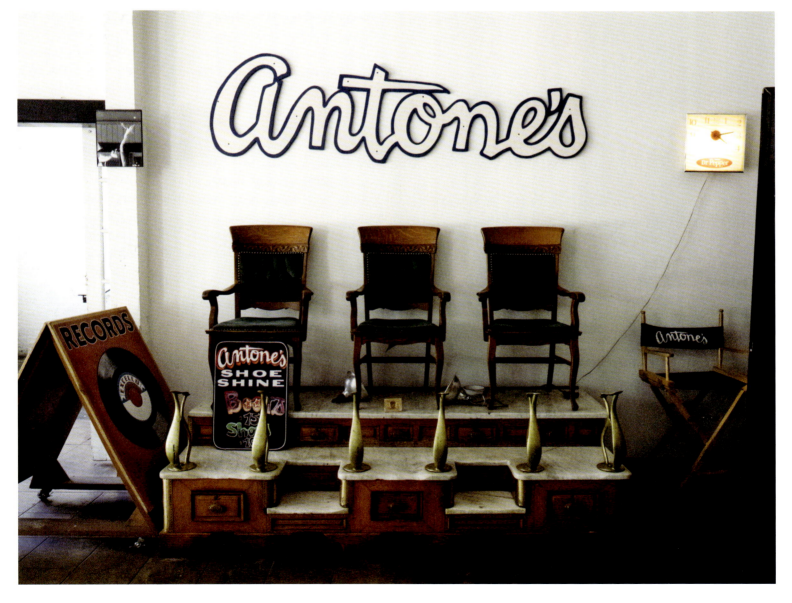

Barracuda

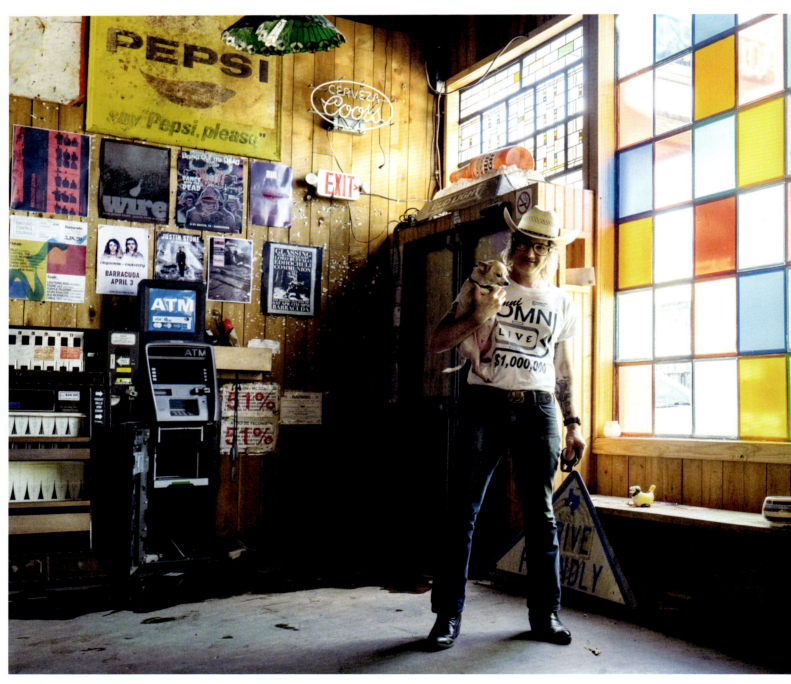

There's not a profitable strategy for music venues in downtown Austin and Red River. The rents are very, very high. There's no multi-use opportunity here. There's really nothing that can be done with this space to bring in revenue in the meantime.
Jason McNeely

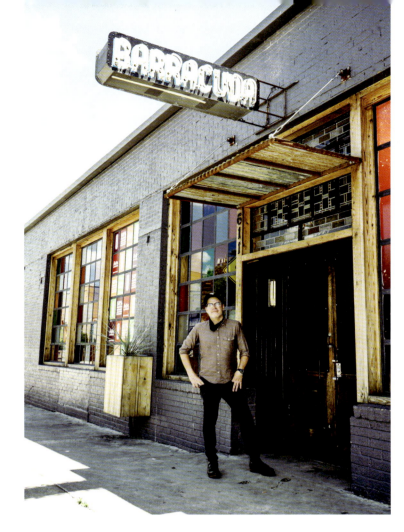

One would hope and imagine, that as an artist, having all this time off for creativity, I'd want to just barrel into the work and be inspired by how depressing this is. But depression is also kind of the absence of a feeling. Depression is stagnation. So feeling physically and emotionally drained by the jarring shock of the shutdown, I've been very uninspired, sometimes hard on myself for not using the spare time.
Sabrina Ellis

Top left: Roky Moon, Musician (Texas Sharks)
Bottom left: Jason McNeely, Owner
Top right: Dan Holloway, Talent Buyer
Bottom right: Sabrina Ellis, Musician (A Giant Dog)

Cactus Cafe

The magic of the place is that it's small enough that the energy between the stage performer and the audience is very palpable. This close, the audience knows when the performer is actually the real deal.
Chris Lueck

Below: Matthew Muñoz, Owner/Operator and Chris Lueck, Bar Manager
Right: Chris Lueck and Matthew Muñoz

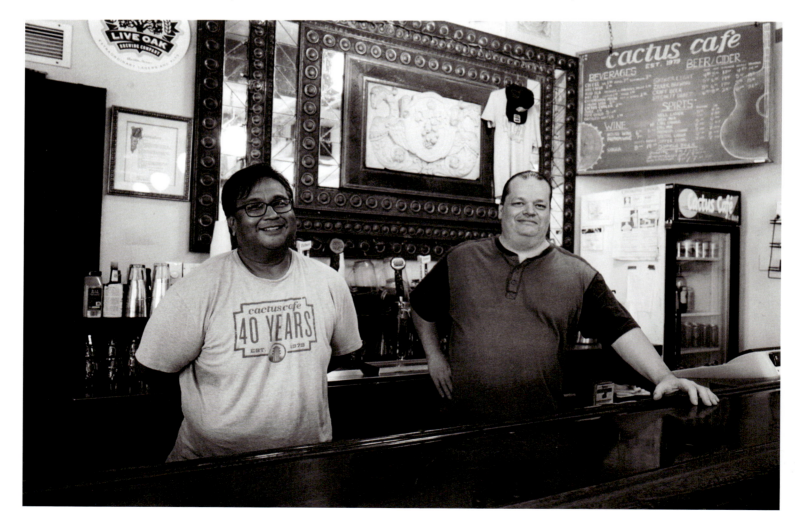

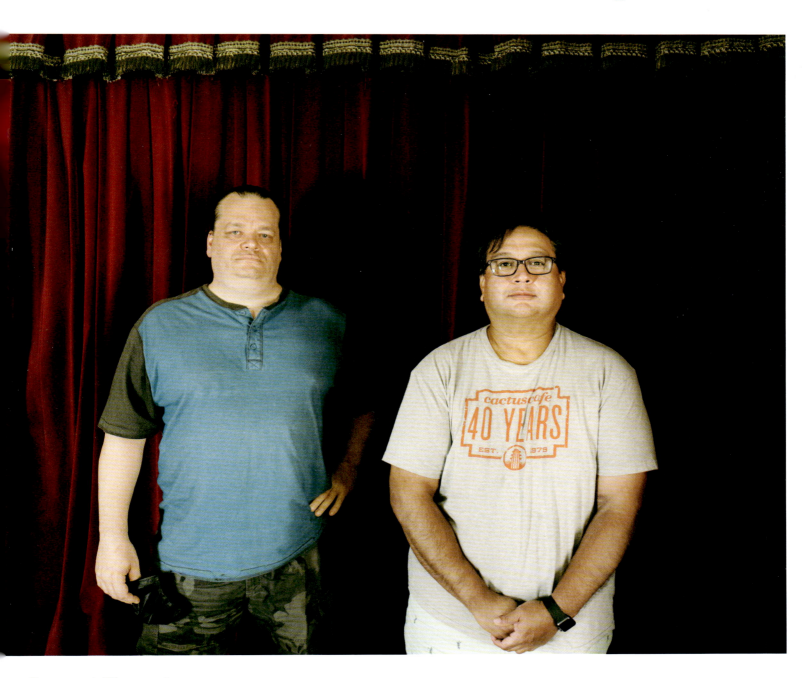

I've spent 37 years here
and met some of the
most important people
in my life in this room.
It makes me sad and
it would be horrible, if
for some reason, things
went on too long and I
had to move on.
Matthew Muñoz

The Continental Club

This is our life [as musicians]. This is all we know. We don't know how to live another way. So, it's not just that we play and we get paid and we go home. It's a big love affair, whether you think of it that way, consciously or not, every day, that's our life. There is no alternative for us.
Mike Flanigin

This club we're sitting in right now has been here since 1955, and I've been in charge since 1987. Up until [COVID], this is what I did every day. It's tough for me to open this door. People see me unlock the door and walk in here. I was in the office the other day and the phone rang and I answered it, 'Continental Club…' 'Oh, hey, are you open?' 'Well, no…' 'Why you answering the phone then?' 'Well, 'cuz that's what I've been doing every day for 35 years.' Steve Wertheimer

It [the Austin music scene] feeds everybody. It's bigger than us. What we do involves person-to-person contact and it's just not the same. It's not just experience on your instrument. It's also experience with the people, a simpatico thing going on. Sue Foley

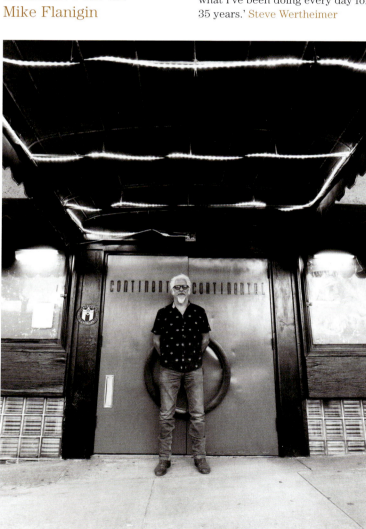

Above left: Steve Wertheimer, Owner
Above right: Sue Foley, Musician
Right: Mike Flanigin, Musician
Opposite: Mike Flanigin; Sue Foley; Steve Wertheimer under the marquee

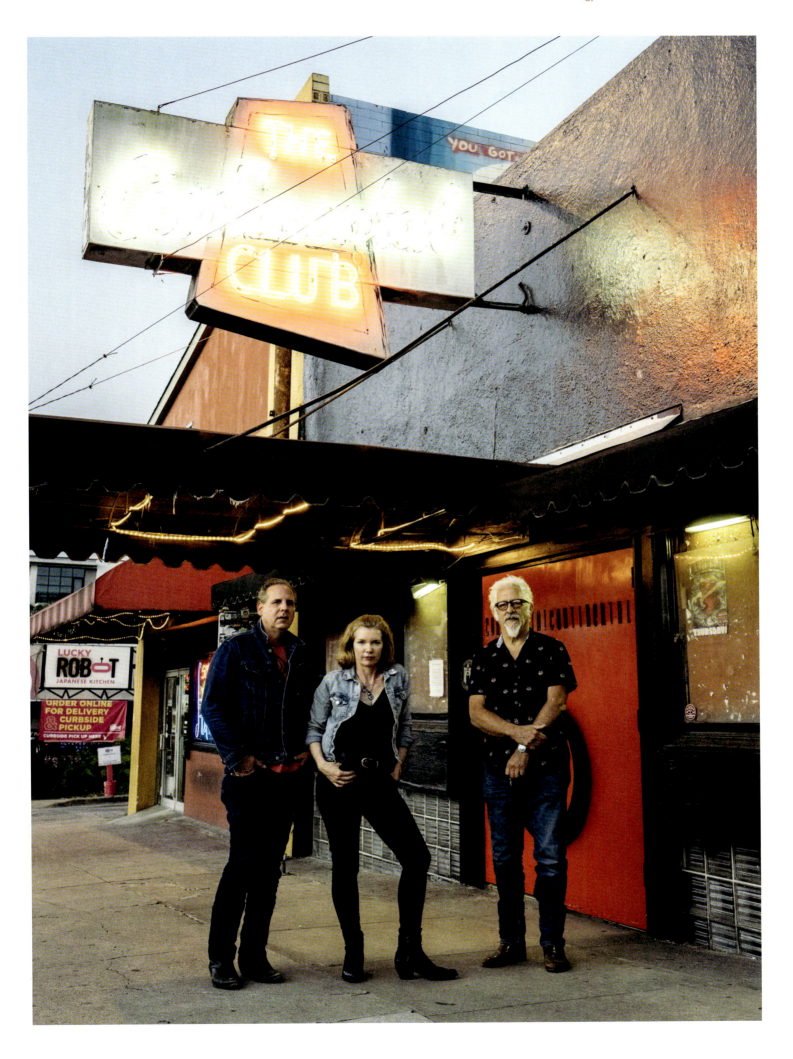

Emo's

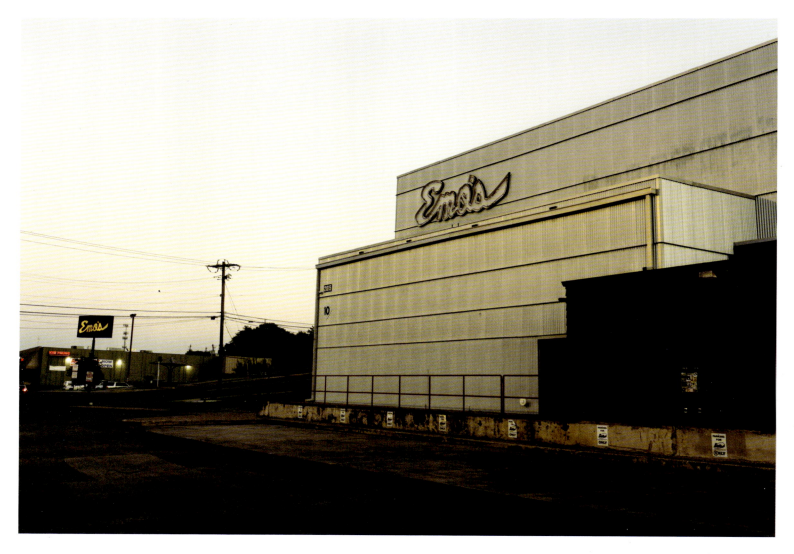

We're a very caring community. The guys and gals have called me on regular basis while I've been furloughed. And because we're friends, and we're workmates, really, we're resilient and bounce back, and we're just gonna charge back. We're a spirited bunch.
Brent Juve

Above: Exterior of Emo's
Right: Kristyn Ciani, Talent Buyer; Kelly Green, Assistant Production Manager/Stage Manager; Brent Juve, Venue Manager; Mobley
Opposite: Mobley, Musician

We're not some big city. Just the way we treat venues and people—it's just a good Austin spirit in general, of treating each other correctly and having good vibes.
Kelly Green

I think it has to be looked at as an entire ecosystem. The venues are important, but the venues are nothing without artists. I took for granted the value and impact that gathering together with other people has on a person. People coming together and connecting with each other…I hope that continues after all this is over and that we don't go back to taking each other collectively for granted.
Mobley

Empire Control Room

There's no reason why people who work in this industry should be one check away, one situation away, from just being homeless. But there are communities in this country that have been there for a long time. For generations, that's been our reality. Jonathan "Chaka" Mahone

I think that's the way this whole thing has gone. It's just been, like, darker and darker. But then there's always somebody with f**king light, you know —or a match.
Stephen Sternschein

Opposite top: Interior of Empire Control Room
Opposite bottom: Stephen Sternschein, Owner/NIVA Board Treasurer
Above: Jonathan "Chaka" Mahone, Musician (Riders Against the Storm)
Right: Jonathan "Chaka" Mahone and Stephen Sternschein in front of Empire Control Room

The Far Out Lounge & Stage

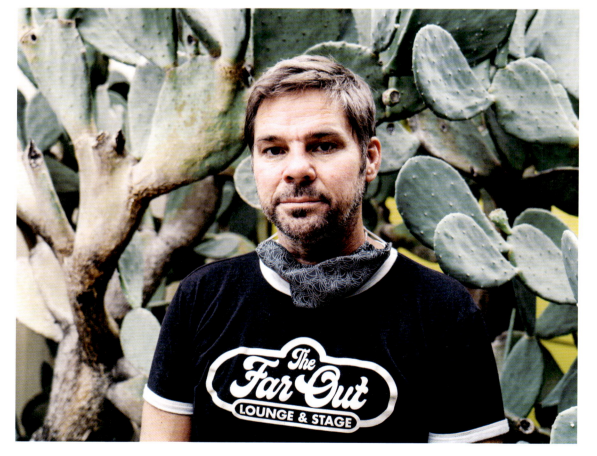

We had more than 150 bands booked with a dozen events. And then they canceled SXSW. We weren't an 'official' venue, so for another seven days we worked on filling in the blanks and then that next Friday everything shut. So it was like getting punched twice. That's not just our story. That happened to everyone [in Austin].
Lawrence Boone

Just watching that first show—the first time hearing live music again—and watching people's response to that was almost spiritual.
Clayton England

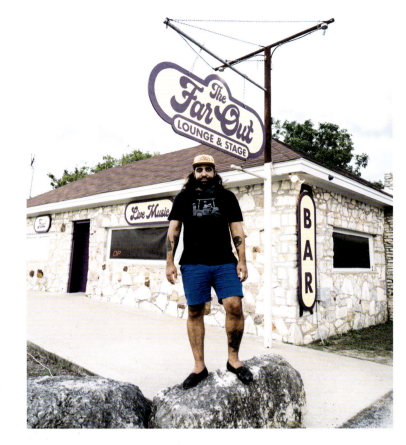

We are an amplification of our neighborhood, quite literally. If you want a stage here and you're a neighbor and you're in need, you're a person who has something meaningful and thoughtful to say. That's what this place is for. COVID can't kill this. Your voice will be amplified here, and we're not gonna let people die and be unheard.
Pedro Carvalho

Opposite top left: Clayton England, Bartender/Musician
Opposite top right: Lawrence Boone, Talent Buyer
Opposite bottom: Bay Anthon, Founder/Owner
Right: Pedro Carvalho, Owner/Operator
Below: Lawrence Boone; Pedro Carvalho; Clayton England; Bay Anthon outside The Far Out Lounge & Stage

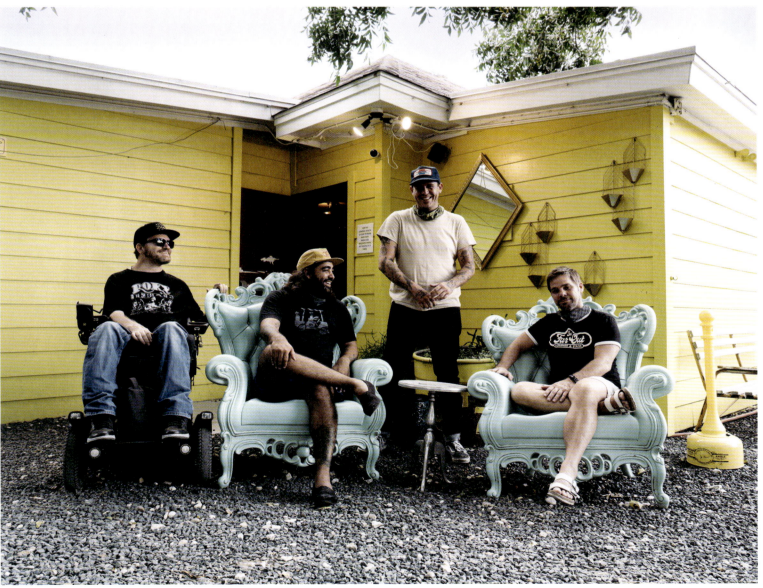

Hotel Vegas

We are the local talent feeder room. And the talent hangs out here, too. There's definitely an energy here people want to be a part of, that sometimes attracts talent too big for the room. Brian Tweedy

I didn't realize until deep into COVID that I was working myself to death, and that COVID in some ways may have saved my life. Jason McNeely

Above top: Jason McNeely, Managing Partner
Above below: Brian Tweedy, Managing Partner
Right: Christian Moses, Managing Partner
Opposite page: Brian Tweedy; Charles Ferraro, Managing Partner; Christian Moses; Jason McNeely outside Hotel Vegas

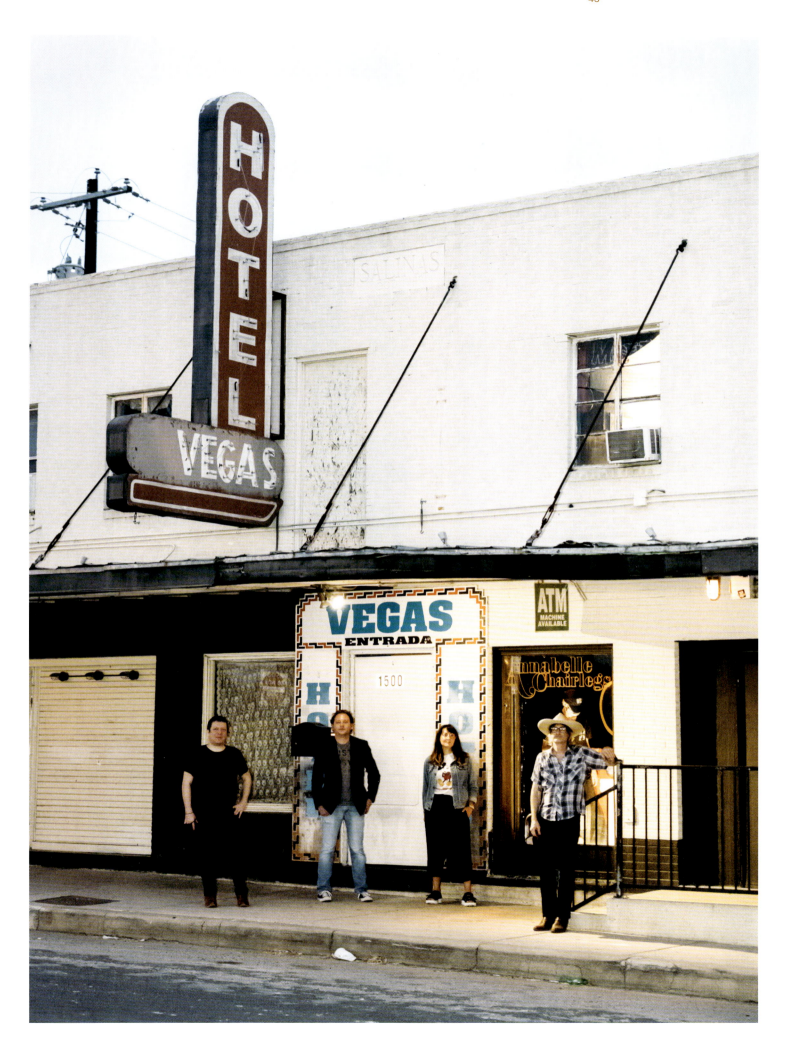

Mohawk

I know how resilient Mohawk is and the music scene in Austin is in general. And so, I know at some point we're going to be able to come up with some amazing shows. And we're gonna have all our friends back here. So that's what I'm hopeful for: that we'll be able to do what we know how to do. Mikey Wheeler

The touring ecosystem has been completely thrown off. Fortunately, we have a lot of good local and regional artists in Texas. And if cities want to hold on to both the cultural and economic engines that are independent, live music venues, they're gonna have to step up in a major way. And I mean, money.
Austen Bailey

Opposite page left: Tyson Swindell, General Manager
Opposite page right: Austen Bailey, Talent Buyer
Above: Mikey Wheeler, Assistant General Manager
Right: Exterior of Mohawk

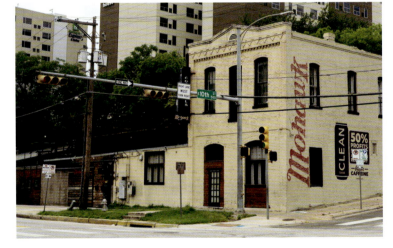

I think the most exciting thing is the ability to learn how to make this a more successful business by learning how to make new revenue streams out of nothing, taking a microscope to every single part of this business. The reality is that we're open so often you don't get the opportunity to take a hard look at things as much as we have now, and we'll probably never get this opportunity again. Tyson Swindell

Moody Theater

There's nothing more exciting than the energy in a room of a crowd of people. The band feeds off that energy of the room. And this room had one of the most beautiful energies in any venue that I've ever seen.
John Wheatley

Below: John Wheatley,
Director/Production
Right top: Interior of Moody Theater
Right bottom: Statue of Willie Nelson

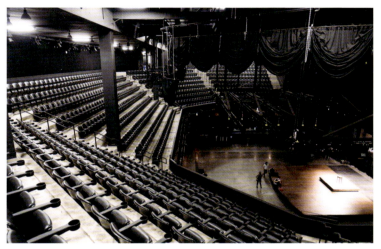

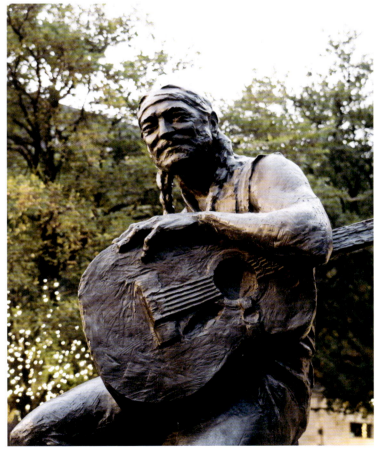

I think when we get on the other end of this, we're gonna find a whole new chapter in the history of the music industry in this town.
John Wheatley

Saxon Pub

The people trying to get started now are going to be pushed back because we have to go with the already established act that's going to bring people to the door and put butts in the seat. And I know that's going to affect our bookings, because we can't afford to take a chance on somebody who's going to draw five people to hone their act. That's the sad part. It's gonna set music back for who knows how many years. Joe Ables

Below: Joe Ables, Owner
Opposite: Joe Ables; Jodie Ables-Witherspoon, Talent Booker; Jolene Stietz, Bartender

You know, somebody named Willie Nelson said, 'You just can't start at Carnegie Hall. If you don't have the little places, it's over.' And we're real proud to help people do that.
Joe Ables

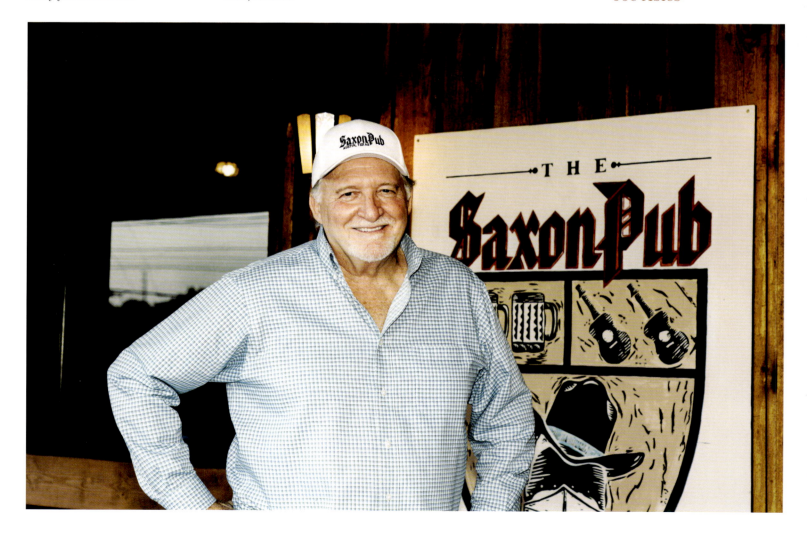

Scholz Garten

I think, ultimately, guys like us who are DIY have hustled the streets for decades, and are creative types [who will] flex and shine and potentially come out stronger on the other side. Daniel Northcutt

The people in the Gold Rush who made the most money weren't actual miners. The people selling the shovels were the ones who made the money. So, it's like that kind of thinking. Although it's small, it's how I'm looking at this whole situation: I'm gonna start selling shovels.
Alex Maas

Opposite bottom left: Alex Maas,
Musician (The Black Angels)
Opposite bottom right:
Daniel Northcutt, General Manager
Right: Sam Douglas,
Spaceflight Records
Below: Daniel Northcutt; Alex Maas;
Sam Douglas outside Scholz Garten

Scoot Inn

It feels like such a direct loss to lose a building, in the midst of all this with people dying. And then you're like, 'Oh, right, spaces are dying.' Spaces hold energy and memory, especially dusty old buildings like this thing.
Alejandro Rose-Garcia

It's surreal. I had hopes this was only gonna last a couple of months and we'll get through this. And I still hold on to that every few months. I come by two or three times a week and walk in and say, 'Hi,' but the whole boarding up of my girl is heartbreaking.
Crisene "Casper"

Above: Crisene "Casper," Venue Operations Manager; Alessandra Cotton, Front of House Coordinator; Alejandro Rose-Garcia, Musician (Shakey Graves); Stephanie Hunt, Musician (Buffalo Hunt)
Opposite: Alejandro Rose-Garcia and Stephanie Hunt

Now I feel like my job has been deciding how I want to show up in the world completely. And really taking stock of what creativity means outside of just me singing a song for somebody. But on a deeper level, what I can nurture and foster within myself. Like an observation of the importance of positivity and optimism, because they are so rare. And we're made to feel guilty for it. So we have to somehow create that amidst a climate where it feels like that's almost illegal. Stephanie Hunt

Stubb's

It's tough to see years
or months of work
unravel that quickly
[due to cancellations].
So you're just thinking
on your feet and
going with the flow.
A couple of weeks in,
I really realized the
the gravity of what had
just happened, and
it's tough, unsettling
sometimes. But
hopefully, this time
will allow us to get
creative and find ways
to bring music back
down the road at a
smaller capacity or new
and different events,
and different ways
to engage live music.
Margaret Galton

Below left: Ryan Garrett,
General Manager
Below right: Margaret Galton,
Talent Buyer
Opposite top: Margaret Galton
and Ryan Garrett
Opposite bottom: Exterior of Stubb's

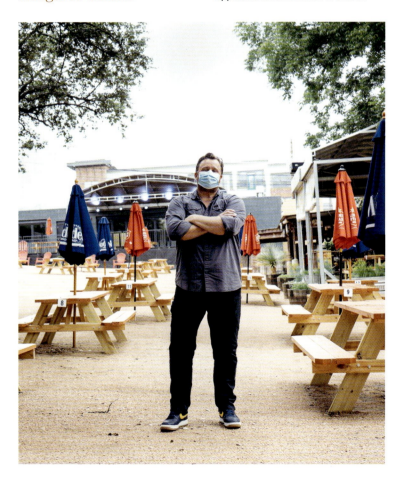

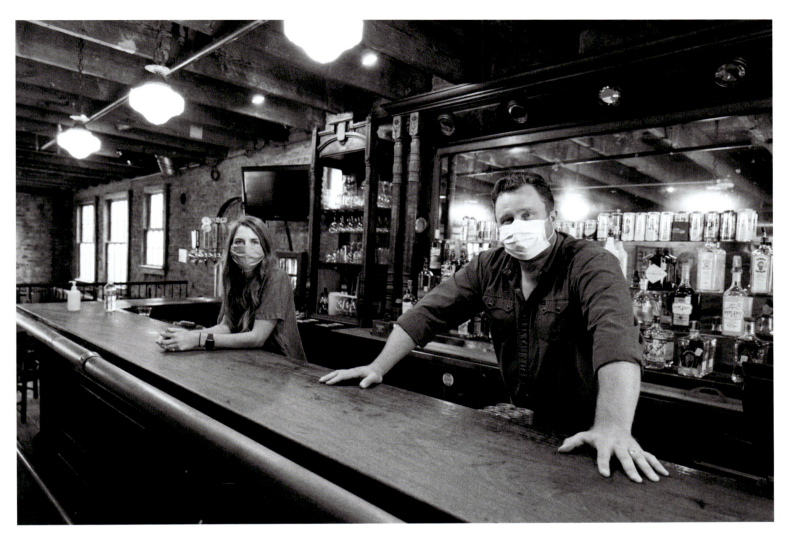

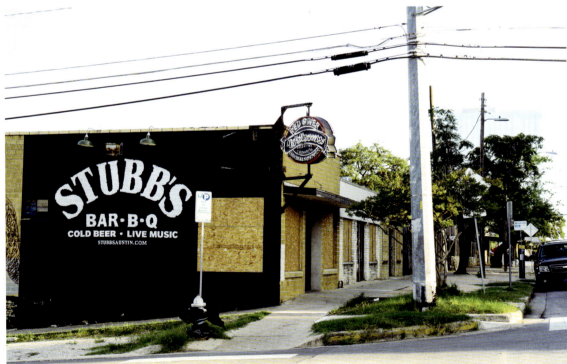

In this market, you can't fake it. The artists who show up here, they know where they're playing. They know the venue. This community also knows when someone's phoning it in and when they're not. [Artists] don't want to be on the wrong side of that, so they bring their A-game. And what you get is a concert spirit experience that's unmatched. This is hallowed ground. And make no mistake, [letting staff go] is the toughest thing I've had to do in 20 years of being here. It's a close-knit family we hope to get back. You have to have faith and belief that we're all going to be together again. Ryan Garrett

Threadgill's

Janis [Joplin] and I had no chemistry at all, I was scared to death of her. I would have a couple of beers and get brave and ask her to sing me a song and she would ignore me. Then, before too long, Kenneth [Threadgill] would ask her to sing, and she'd sing the exact same song I'd just asked her to. Eddie Wilson

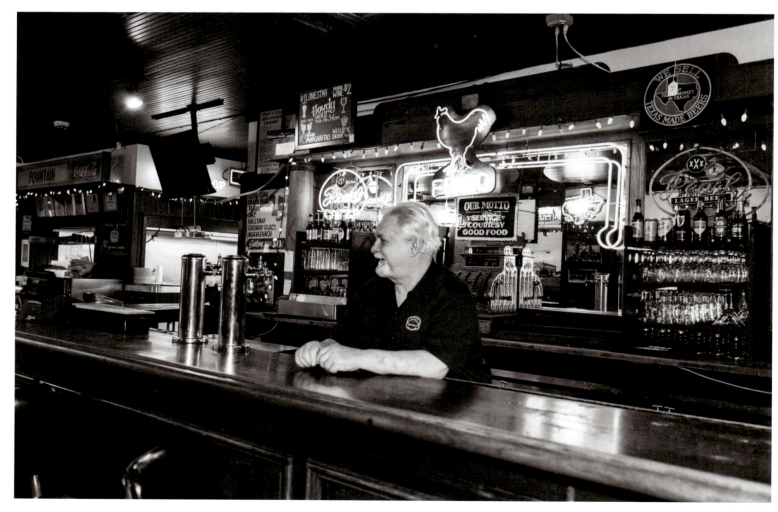

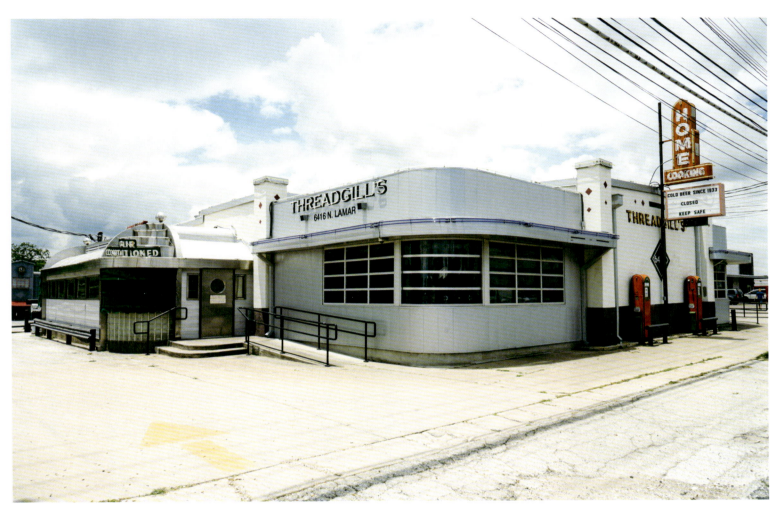

Opposite top: Interior of Threadgill's
Opposite bottom: Eddie Wilson, Owner
Above: Exterior of Threadgill's
Bottom: Bar at Threadgill's

Waylon Jennings came here because Willie [Nelson] called him from the office, after he got off stage the first time he played the Armadillo [Wilson's first club], and said, 'Waylon, you got to get your ass down here. You're not gonna believe what I found.'
Eddie Wilson

The White Horse

Will Tanner [Antone's/ Hole In The Wall] said it best: 'The White Horse brought Texas back to Austin.'
Eric "Busty" Morris

I actually played a couple weeks ago. I loved it, but felt super uneasy. I've never really taken three months off playing before, so I was more nervous than I've ever been in my entire life. But it was great. Tate Mayeux

It felt so good to be in front of people and have them be listening. I was like, 'Thank God...I can still be entertaining.' I was worried, because when you're trying to be entertaining to your phone screen, it's really hard. You can't really tell what's happening. Devin Jake

I actually learned how much The White Horse does for Austin that we all took for granted, including the musicians. I really miss how much it was. A lot. I'll never take it for granted again, that's for *damn* sure. Vanessa Danby

Opposite page left: Eric "Busty" Morris, Talent Booker
Opposite page right:
Tate Mayeux, Musician
Top: Vanessa Danby, General Manager/Bartender (front); Devin Jake, Musician; Tate Mayeux; Eric "Busty" Morris
Above: Vanessa Danby
Right: Devin Jake

Baltimore

POSTER DESIGN
Julia Fletcher

PHOTOGRAPHER + PRODUCER
Josh Sisk

Baltimore

Josh Sisk

1. Baltimore is the birthplace of Baltimore Club, a regional style of dance music with a devoted following. Sometimes referred to as simply "Club Music," it has been innovated by artists like Miss Tony, Frank Ski, Rod Lee, Scottie B, DJ Technics, and DJ Class.

2. Local radio station 92Q—the soundtrack to the city—is one of the most popular stations in Baltimore and still manages to support local music with blocks of Baltimore Club and a rotation for homegrown and often up-and-coming rappers. Towson University's college station, WTMD, also puts a focus on playing and promoting local artists.

3. This city values diversity and inclusivity. The Crown might host a punk show, a drag show, and a rap show all in the same night, with crowds bouncing around from room to room. That "anything goes" spirit pulses through Baltimore's vibrant music scene.

4. Music happens in unorthodox places here. In addition to so many of our amazing venues, Baltimore is home to dozens of long-lived and storied warehouses, group houses, old factories, and even a converted church or two that all regularly host music events.

5. Baltimore is the land of pleasant record shops. Despite its more humble size, it's home to many record shops, from the more mainstream to niche. Particularly fun shops to visit include punk/funk mecca Celebrated Summer, avant haunts like the True Vine or Normal's, and many more. We even have a turntable shop, Just Audio.

6. Artscape, the country's largest outdoor arts festival, makes its home in Baltimore. Artscape is a showcase of visual and multimedia artwork, a street bazaar, and a dance party, with a wide variety of musical performances and stages to boot. Over the years, local musicians have hosted unofficial companion music festivals playfully riffing on the festival's name: Whartscape (organized by Dan Deacon and the Wham City collective), Ratscape (for the punks), and even Scapescape.

7. The music venues in town all have a family vibe, and employees often work at several clubs. You might see the door guy at Sidebar bartending at the Ottobar or doing sound at Soundstage…it all contributes to a cozy, tight-knit, familial scene.

8. The clubs and venues themselves have intertwining histories, too. Chambers became the Ottobar became the Talking Head, then Club Midnite became the Ottobar. The 8x10 Club became Funk Box, which then became the 8x10 again, owned by fans who went to the original club. The current owner of the "new" (moved in 2001) Ottobar was one of the very first bartenders hired at the original Ottobar.

9. It's the home of High Zero, a festival of completely improvised music that has attracted musicians and music fans from around the world for 20-plus years. The fest is put on by the Red Room Collective, who also regularly schedule experimental and improvisational music events both in their own venue and throughout the city (and online via livestreams).

10. Baltimore is the home of our very own Rock Opera Society. BROS puts on multiple original performances each year around the city, including a full-length original production. These aren't just jam sessions; they're musicals, complete with custom sets, original costumes and choreography, a live band accompaniment, and lots of attitude. They've even done collaborations with the Baltimore Symphony.

8x10

The club is a facilitator for up-and-coming musicians and for fans. It's a place for people to find themselves in the music scene.
Robert Hewitt

Below: Jeremy Schon, Artist (Pigeons Playing Ping Pong); Robert Hewitt, Bartender; Abigail Janssens, Co-Owner/General Manager/Booking; Brian Shupe, Co-Owner
Opposite top: Stage at 8x10
Opposite bottom: Ticket booth at 8x10

My favorite part of [the 8x10] is taking care of the bands and making sure they're happy, and taking care of the audience. I love greeting people, I love seeing friends here. I miss that terribly. When we do reopen, we'll come back just as strong.
Abigail Janssens

Live music has been happening at this location for more than 30 years. My wife Abigail and I have been doing music here for 15 years, and we were coming here when we were kids. That's why we bought it. We're fans, first. [Abigail] and I traveled with the Allman Brothers and the Grateful Dead, and we decided to come off the road and bring what we learned to the 8x10.

Brian Shupe

The Crown

It feels like you're having an out-of-body experience. I realize how important it is for people to have venues, to have music. I want this [time] to remind the world how important art is because when they start cutting budgets, the first thing to go is art. We literally cannot exist without art. Judges, politicians, what did you do when you were locked in the house? I turned on a movie, listened to music, read a book. I believe art heals a lot, and with the pandemic, it's getting a lot of people through. Kotic Couture

I know that when I'm here, everyone is expressing themselves exactly the way they want to be. It's really special and so easy to take for granted. Ayaka Takao

Top: Kotic Couture, Artist
Above left: Ayaka Takao, Bartender
Above right: Michael Young, Manager

I think physical space is very important. A space like The Crown is a place where you can come and learn things, no matter what your background. Physical space is your time to interact and find out things about yourself and other people. It's really interesting to feel all the energy [here] throughout a whole day and how people interact. Michael Young

Metro Gallery

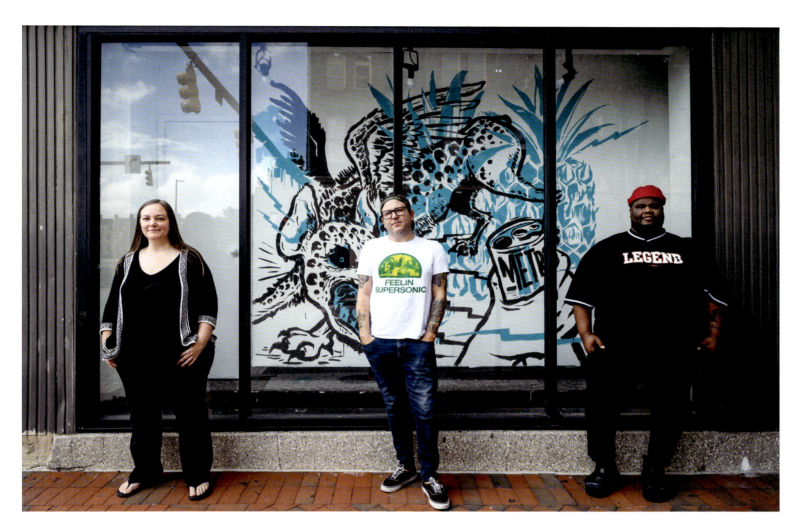

I think it's going to take a while for people to feel comfortable being around each other. It breaks my heart to think that people are considering, 'Is it safe to go see my favorite band?' Sarah Werner

I've been thinking about [the first post-COVID show] a lot. Gotta be a full band. I want a brass section, definitely three background singers. The theme is 'celebration,' with lots of glitter, champagne and sunshine, gold mics, killer outfits, and just really good music. It's gotta be like Earth, Wind & Fire 3020. You take venues for granted because they've always been there. It takes some anomaly like this to realize how much these places have shaped your life. DDm

My favorite memory at Metro was my first day here a decade ago. When I came in, I had a cast up to my shoulder. We still joke about it, because it was the only time I have ever made a Singapore Sling in my 15 years of bartending, and I swear to God, I made like 40 of them with one arm that night. Patrick Martin

Top: Sarah Werner, Owner; Patrick Martin, Bar Manager/Artist; DDm, Artist
Above: Interior of Metro

Ottobar

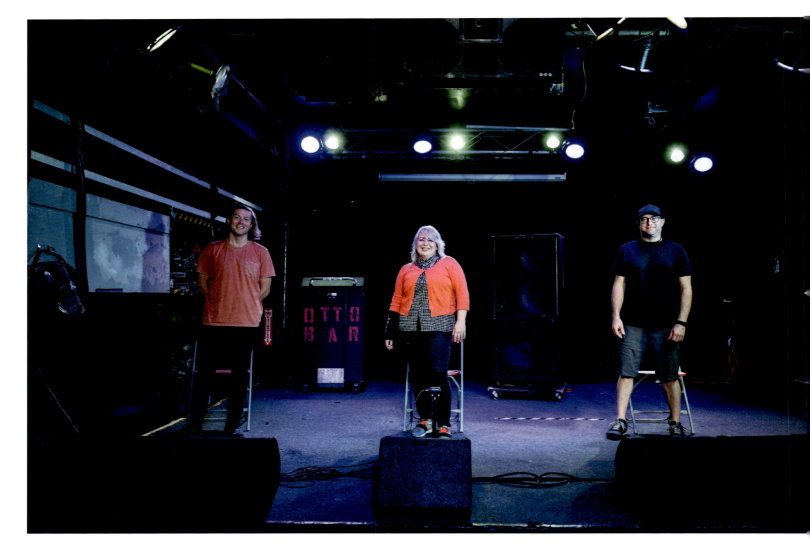

My favorite memory at the Ottobar was Double Dagger's final show here: Dan Deacon played first, Future Islands was second, and Double Dagger was last. We were touring a lot with them at that time. There are signs here that say 'No Stage Diving' and Ottobar decided to ignore that rule for the night. As soon as Double Dagger started playing, it was just a sea of people crowd surfing. I really hope that band reforms. It'd be sick if they were the first show when things reopen. William Cashion

Above: William Cashion, Artist (Future Islands); Tecla Tesnau, Owner; Todd Lesser, Talent Buyer

I've been the in-house talent buyer since the venue opened in 1997. One of my shows had gotten canceled back when Ottobar had first opened, so I moved my show here which ended up being the second night it had ever been open. Todd Lesser

I own the glorious Ottobar. Infamous, maybe. My first show at the Ottobar was bartending on the first night we ever opened in 1997. Baltimore at the time was passed over a lot for quality shows, so when we opened it became a destination for touring acts to make Baltimore a stop in their tours, which was really unusual at the time. Tecla Tesnau

The Red Room

A friend of mine from Texas happened to post on our Instagram page, 'Hey, I Paypal'd you some money. I want a [merch] mystery box… just fill it up with things you think I'd like.' And due to that [social] post it just really blew up, and I'm still processing orders…people will PayPal me any amount, give me some clues about what they're into and I fill it up for them. And I throw in some weird extras. Rupert Wondolowski

The Red Room is inside Normal's Books and Records. The partners in the bookstore were always interested in having live stuff. The music part of things became more and more independent [over the years]. The venue holds 22 people. I feel like experimental improv stuff has become a highly regarded genre in Baltimore, and I do really feel like that's because of The Red Room. Martin Schmidt

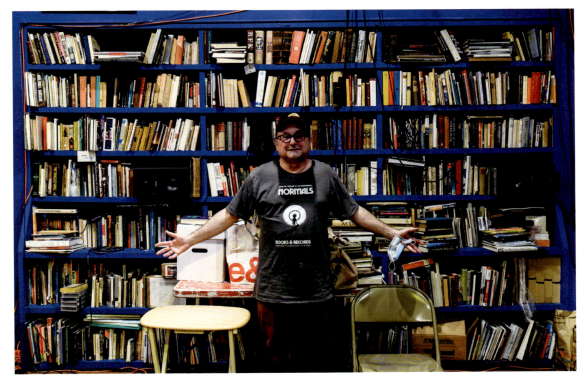

Top: Martin Schmidt, Artist (Matmos)
Above: Rupert Wondolowski, Co-Owner, Normal's Books and Records

The Sidebar

This place just brings people together whether they want it or not. You're here, you're a friend. Travis Hunt

To call [Sidebar] 'integral' is an understatement. This is where a lot of bands get their first shows... or figure out if they even want to be in a band. It's a basement, a small spot. That's where you get that sense of community. When you come into a show [here], you're going to recognize most people, and if you don't, that's who you buy a drink for: 'Hey, what's up? I haven't seen you before...' Megan McShart

Above: Stickers on wall of The Sidebar
Below: Megan McShart, Bartender/ Musician and Travis Hunt, Owner

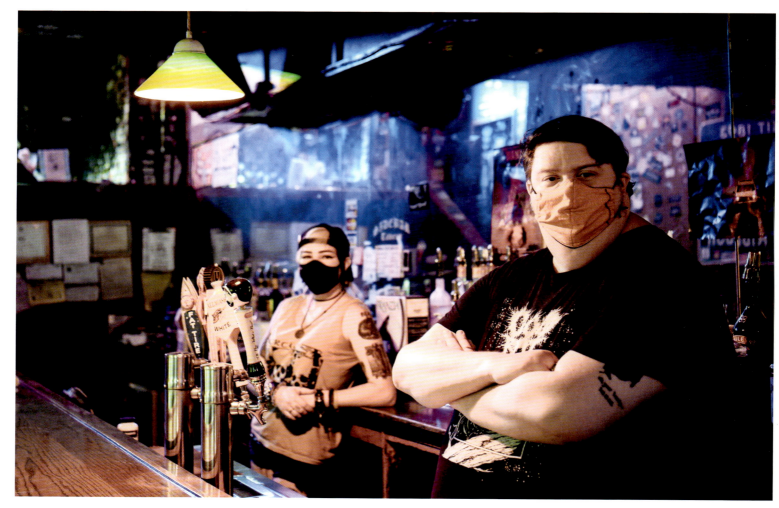

Soundstage

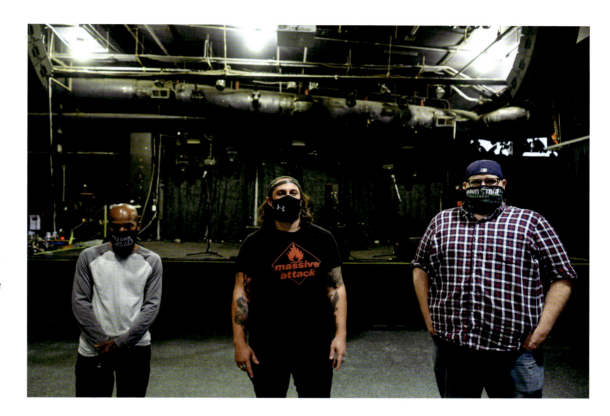

The Soundstage is like the heart of the music community in Baltimore city. For hip hop, rock, and EDM, it's the place where every artist strives to be on that stage and to be a part of it. Billy Lyve

Bands love playing here. They always want to come back. It hurts a lot to have to stop the momentum when I feel like so many people were looking at us as being a good thing in the city. We were the first to close and we'll be the last to open, but we haven't been given any guidance by city or state. Adam Savage

Our venue bridges the gap between the smaller and indie DIY venues to the mainstream clubs and theaters. We get a lot of artists who are on their way up to stadiums and amphitheaters and sometimes it's the last chance for fans to see them in such an intimate setting. A lot of regional and local artists cut their teeth here. Dave Adams Jr.

Above: Billy Lyve, Promoter/Artist;
Adam Savage, Talent Buyer;
Dave Adams, Jr., General Manager
Below: Interior of Soundstage

Boston

POSTER DESIGN
Joey Mars

PHOTOGRAPHER + PRODUCER
Omari Spears

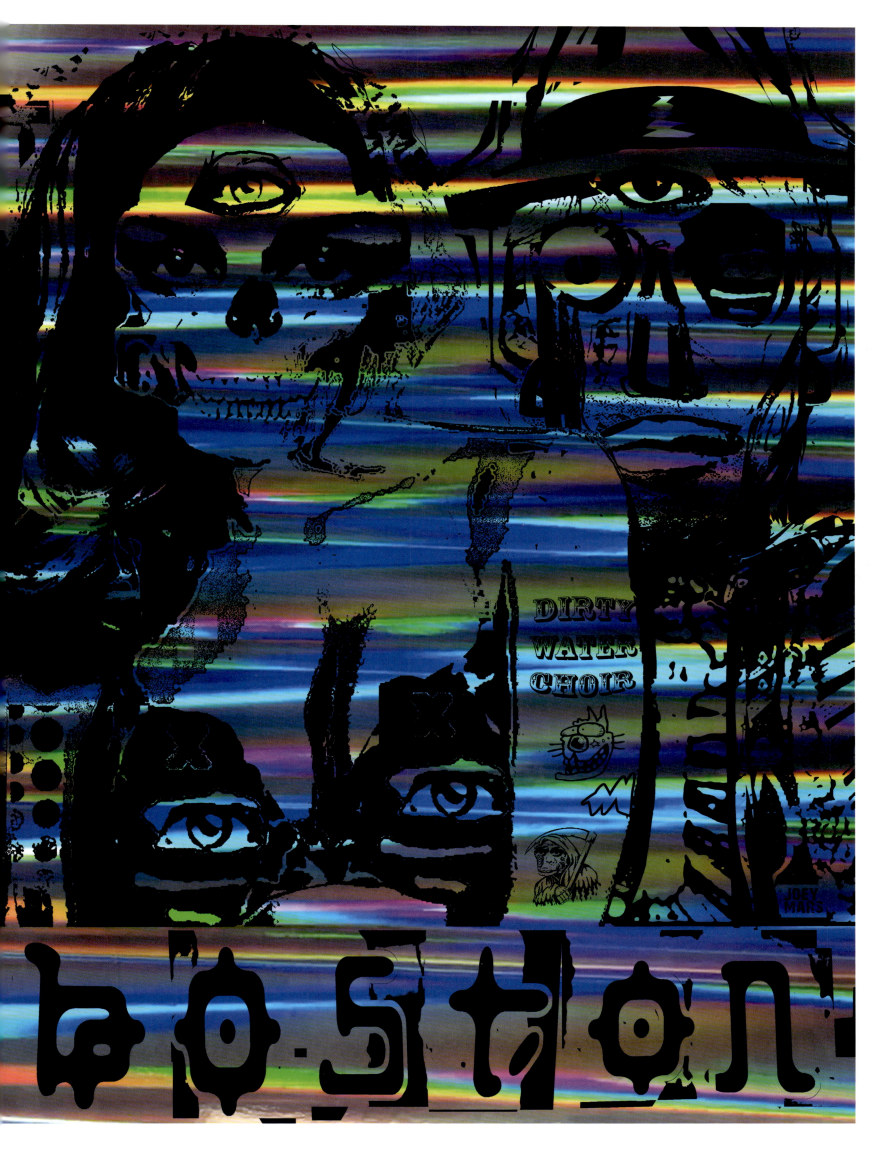

Boston

Omari Spears

1. Boston has so many bands! The number of new acts popping up here is massive. It's not hard to find a stacked bill on a weeknight made up of all or mostly local bands.

2. The best shows aren't necessarily in the biggest venues. While enjoying a concert at one of Boston's large venues is always a good time, make sure to check out what's going on at smaller venues and DIY spots.

3. There are some really good people in Boston invested in the arts community. From music writers and sites, bookers, photographers, videographers, there are lots of folks who offer up their time and spaces to help the DIY scene stay afloat, and, of course, musicians. So many community members care about the music scene and want to see it thrive.

4. Boston Calling is Boston's "big" festival. But there's a bunch of other festivals worth checking out. We've also got Fuzzstival, BAMS Fest, Hassle Fest, and more.

5. Allston is a great place for live shows. So much so that it can be tough to choose between multiple gigs on a given night. Sometimes it's possible to start at one venue and catch the end of a different show at another before the night is over.

6. Boston has a rap scene! While Boston's many rock bands get a lot of attention, it's important not to overlook its rap scene. There are some refreshingly creative and innovative rappers coming out of Boston who deserve just as much praise and attention.

7. Check out Porchfest. Different parts of Boston host this outdoor music buffet of sorts, where bands perform on volunteers' porches.

8. Boston has some neat active record labels. Be it Run For Cover or Disposable America, there are great things coming out of some of our local record/tape labels.

9. There are some cool record stores worth checking out in Boston. All sorts of different stores are scattered around the area, like Cambridge's Armageddon Shop and Brookline's Village Vinyl & Hi-Fi.

10. Boston has a rich music history. There's a bunch of up-and-coming bands in Boston that are fantastic, but some iconic bands have also come from the area. Boston's music history is worth checking out.

Boch Center

Below: Interior of the Boch Center
Opposite top: Brian Gale, Vice President/Managing Director/Booking/Marketing
Opposite middle: Chuck McDermott, Musician/Singer/Songwriter
Opposite bottom: Joe Spaulding, President/CEO

There are a lot of artists who'll be writing a lot of material. With this downtime you have a renewed interest in new music. There will be a lot of new material and new interest from people to go out and experience live music, maybe like you've never had before. That's going to be great for the artists. Brian Gale

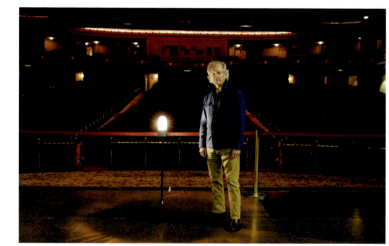

You could say this could lead to a deeper appreciation for where music and the arts fit into our lives, and that would be a wonderful thing. Chuck McDermott

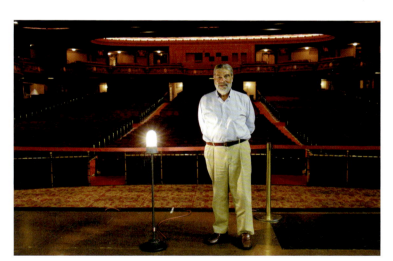

A ghost light is in every theater. For centuries, these lights have protected this theater. It shows that when no one is here and all these lights are off, the ghost light is plugged in and it stays on. It shows that theaters never go dark. Joe Spaulding

Brighton Music Hall

When we come back, the demand will be so high I don't think there will be any days off. When we come back, we'll come back strong. Tim McKenna, Senior Production Manager

Interior of Brighton Music Hall

I miss doing shows. I miss the people, my crew. And I can't wait for live music to come back. Billy Budd, Production Manager

Colonial

I kind of grew up here. My mother worked backstage. I was here running across the stage pretending I was in 'Hello, Dolly.' I feel such a connection to this place and to my mother [she passed away in January 2017]. So, being here is like being with my mother. Molly McCormack Lebel

For me as the manager and programmer, finding and connecting the audience with the show is the greatest gift. Erica Lynn Schwartz

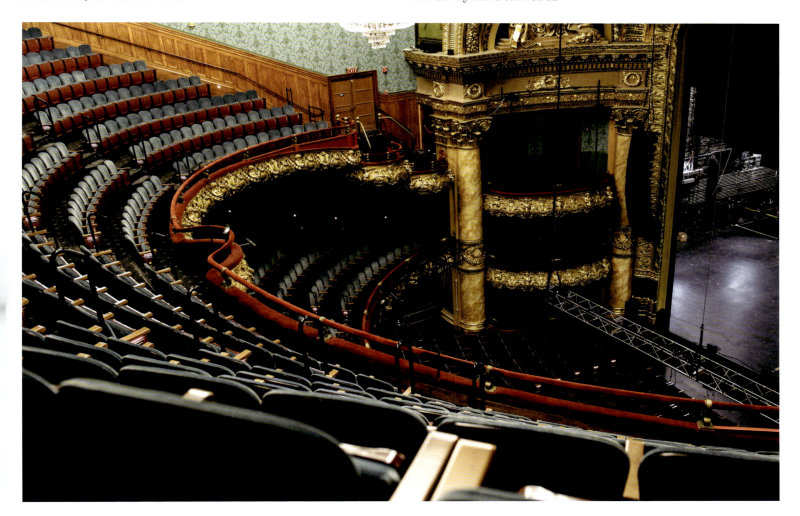

Above: Interior of the Colonial
Left: Erica Lynn Schwartz, General Manager
Right: Molly McCormack Lebel, Box Office Manager

House of Blues

At this very minute, there are 12 million people sitting at home, waiting to get back to work. It's going to be worth waiting for. When we come back, we'll be back strong.
Tim McKenna

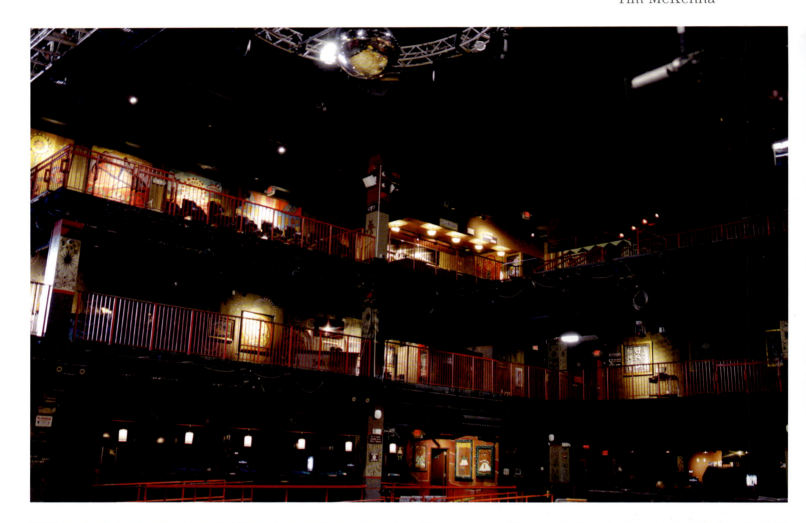

Top: Interior of House of Blues
Above left: Billy Budd,
Production Manager
Above right: Tim McKenna, Senior
Production Manager

ONCE Somerville

Something I miss is, as you first enter the venue there are tile stairs out in the foyer, with the great chandelier. The staff has a tendency to gather on those stairs, especially once the show is up and running and everything is cool. I didn't realize how much I enjoyed just hanging out with them. The thing everybody needs to remember: There will be live music and there will be venues. But if people want them to be these venues, there needs to be a lot of support.
JJ Gonson

Above: JJ Gonson, Owner/Operator
Below: Interior of ONCE Somerville

Paradise Rock Club

I first started working at the Paradise in the 1980s and was there for 30 years. When we first opened, the whole venue was seated. We built it as a showcase because we needed a place for up-and-coming bands to play. In the late '70s and '80s those up-and-coming bands were AC/DC, Van Halen, U2...a few 'small' bands like those. Tim McKenna, Senior Production Manager

Above: Entrance of Paradise Rock Club
Below: Bar in Paradise Rock Club

The Sinclair

We're just trying to keep our heads up and know when the shows do come back that we'll all be here every day because we'll be so excited. Josh Bhatti

It's almost like I took this job for granted, took live music for granted. I'm ready to get back to normal. Josh Smith

Above: Exterior of The Sinclair
Below: Josh Smith, Talent Buyer and Josh Bhatti, Head of Booking

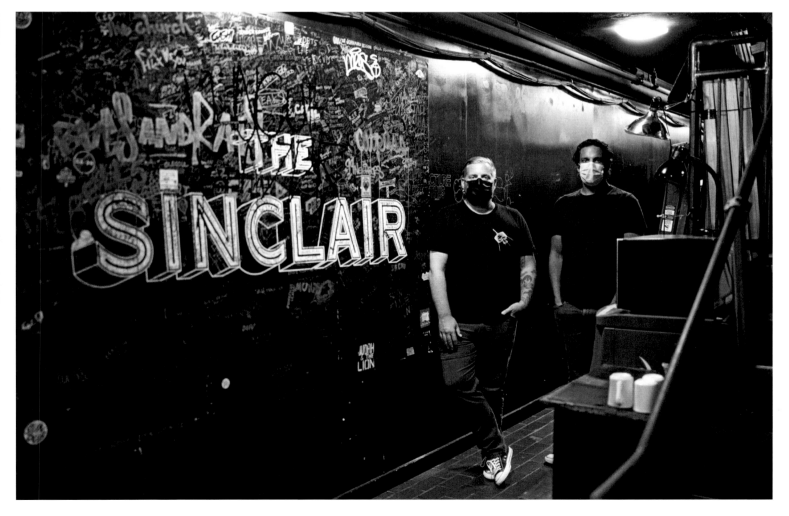

Charlotte

POSTER DESIGN
David Haire

PHOTOGRAPHER + PRODUCER
Justin Smith

Charlotte

Scott Weaver

1. The Milestone Club Established in 1969, this no-frills, legitimately punk rock club stands alone. Everyone from R.E.M. to Nirvana has played it, and the room sounds about as good as any I've ever heard or had the pleasure of playing in. Locals fondly refer to it as the CBGB of the South and for good reason.

2. Studio East This studio was founded in 1964 by Arthur Smith (who released the influential track "Guitar Boogie" in 1945) and is where James Brown recorded "Papa's Got a Brand New Bag" a year later. This historic Charlotte landmark still serves as a first-rate recording facility in the Queen City.

3. Local Hip Hop Atlanta is rightfully known as the Hip Hop Capital of the South, but Charlotte has a thriving scene as well. Local venues like Snug Harbor have hosted regular events like Knocturnal (cypher, guest DJs) and Player Made (focus on Southern hip hop) and there are several artists—Elevator Jay with his distinctly Southern delivery, iRa evRywhR's dreamy vibes— making waves in the underground scene. The music, art, and fashion surrounding hip hop culture are becoming more symbiotic and prevalent by the day.

4. Impact on Early Alternative Music Charlotte was home to Fetchin Bones, probably the only band in the '80s from this town to get a ton of college radio play. They eventually signed to Capitol Records and were featured on MTV. After that band broke up, married bandleaders Hope Nicholls and Aaron Pitkin went on to form Sugarsmack and signed to Sire. Hope appeared on the first Marilyn Manson record and recorded and toured with industrial music supergroup Pigface. They continue to innovate and inspire with their follow-up projects, Snagglepuss and It's Snakes.

5. Excelsior Club Established in 1944, this venue was considered the social club and music venue for the African-American community in the Southeast and hosted acts like Sam Cooke, Louis Armstrong, and Nat "King" Cole. It holds a significant place in both the musical and political history of Charlotte and is one of the only free-standing social clubs, complete with a downstairs ballroom, left in the city. It's a treasure.

6. DJ and Electronic Music Culture Charlotte has hosted countless world-class DJ's in the bigger dance clubs, but smaller venues like Petra's Bar are home to regular events that showcase talented local DJ's. We also have a growing roster of electronic artists like Dirty Art Club and Astrea Corp blurring the lines between DJ culture and the indie rock scene. Andy Kastanas is one of the key figures in the history of the DJ culture in Charlotte and beyond, from founding one of the best dance clubs this city has ever known, Mythos, to reporting to the *Billboard* dance charts for 20 years.

7. Local Festivals There is a handful of large, nationally recognized festivals in North Carolina, but the importance of local indie festivals cannot be understated. From tribute nights for charity like God Save the Queen City to citywide happenings like Reverb Fest and Recess Fest to Permanent Vacation's daytime Squirt parties, the local fests do a great job of highlighting local talent and bringing artists together.

8. Rock en Español There is a solid Latin music community in Charlotte. In the last decade, the Rock en Español scene has gained a lot of momentum thanks to bands like Ultima Nota and Patabamba. Currently, bands like Chocala have great crossover appeal and have played packed shows to diverse crowds in venues around the city that have an influence on the indie scene as well.

9. SHIPROCKED! I hesitated to include this event since I produced it, but it brought so much variety to the musical offerings of the city that I think it warrants mentioning. This decade-long weekly event held at Snug Harbor was not only a dance party and home to many alternative drag and burlesque performances, but also served as host to many diverse musical guests that might not have otherwise gigged in our city. My goal was to book multi-genre acts from the avant-garde, queer, female, electronic, and punk scenes that often fly under the radar in more mainstream venues in our city, and we succeeded in doing so. Over the years, SHIPROCKED! hosted acts like Cakes da Killa, The Coathangers, Calvin Love, Soft Metals, Cazwell, and countless more. The party still exists as a seasonal event, and I plan to continue providing this platform for unique artists for years to come.

10. Diversity and a Strong Community In the last few years, our city has enjoyed an explosion of new musical acts from all genres, and the support shown between artists is notable. Adventurous booking and cross-pollination through diversely stacked bills have been key in creating a strong music community. At this moment, Charlotte has great representation in neo-soul, jazz, punk, metal, country, hip hop, electronic music, singer-songwriter, and more. These artists attend each other's shows and show support and appreciation for other acts that are outside of what they do musically. As long as we have our independent venues to allow for this, I think it will continue to grow. Our city's offerings to the world are something to be excited about!

The Milestone

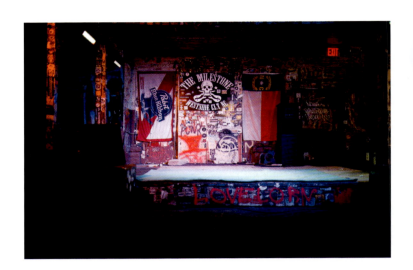

Even if the basic level of society dissipates, The Milestone will still be here, because people will still sing, still dance, still rejoice. No matter what's happening, no matter how dark it gets, even in the darkest [times] of humanity, of any period, there were singers and dancers.
Neal Harper

Below: DJ Price; Wyley Buck, Owner/Booker; Neal Harper, Former Owner (kneeling)
Right: Stage at The Milestone

I DJ here. I was hoping for things to start curving down with the numbers. I want to keep all my people safe. This is a local place, so the people who come and spend money to hear you DJ and play music—they're not just faceless people in the crowd. You basically know the people coming in and they're friends. So you cancel that show. DJ Price

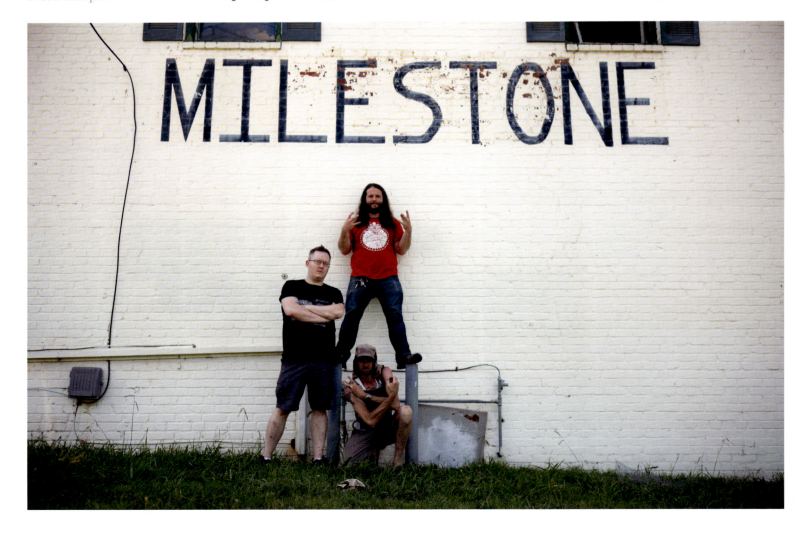

Neighborhood Theatre

Above: Seats at the
Neighborhood Theatre
Below left: Gregg McGraw,
MaxxMusic Owner/Talent Buyer
Below right: Logan High,
General Manager and John Brady,
Production Manager

Nobody wants to admit they need help. We did a GoFundMe, and the response we got tells me that we're going to fight like hell to keep this place open, because the community said, 'We need you to do that.' This was *literally* the Neighborhood Theatre. It was the Astra Theatre, then Mill Village. Then it became a porn theatre, a gay porn theatre, then an alternative turnstile, an African American Baptist Church, and *then* it became the Neighborhood Theatre. So it has a storied past.

Gregg McCraw

Snug Harbor

It was a shock to realize I didn't have anything to do or going on at first. I got real stir-crazy. It's definitely hard to go from working in a live music venue to legitimately not having anything to do. It's very hard to adapt to.
Chris Burns

Above: Chris Burns, General Manager
Above right: Scott Weaver, DJ
Right: Scott McConnell, Original Owner

People need a sense of community. And they need to feel like they fit in no matter where they're coming from, I guess. [Snug Harbor] definitely took on a family vibe. The people who did SHIPROCKED! with me, the dancers, the performers, and a lot of the artists that tour through here stay in touch with me...I call it my SHIPROCKED! family. This place was a gift to our neighborhood that allowed someone like me to do whatever I wanted. Scott Weaver

Thirsty Beaver

Below: Brian Wilson, Co-Owner;
Bruce Hazel, Bartender/Musician;
Mark Wilson, Co-Owner

We were just going to try to make it all-inclusive. It's one of the things I think we're most proud about—to have a place where people can be themselves, enjoy it and not feel like they're being judged or anything along those lines. Just a community neighborhood bar. [The community] has really supported us over the years, and we've been fortunate to be here.
Mark Wilson

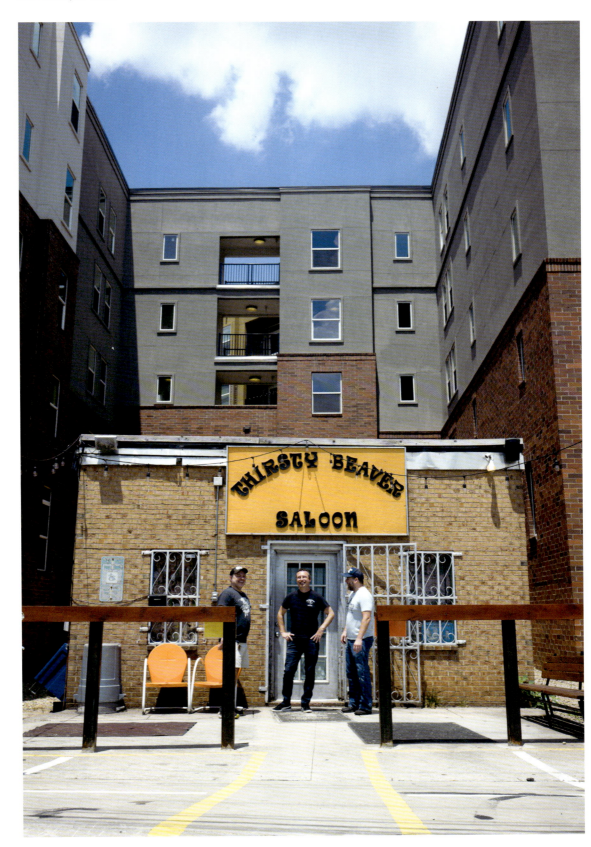

Chicago

POSTER DESIGN
Eliza Weber

PHOTOGRAPHER
Matt Allen

PRODUCER
Ryan Filchak

VIDEOGRAPHER
Ezekiel Ornelas

Playlist

This Select EP Playlist Curated by DJ Hesta Prynn

1. Bric-a-Brac Records & Collectibles *'Punk, Junk, and Rock N Roll!'* Co-owners and spouses Nick and Jen have put a lot of effort into the aesthetics, starting with the huge mural on the side of the building of their beloved "shop dog" Corgi, Dandelo. It's part record store, part venue, and part '80s and '90s oddball toys and pop culture ephemera. You come to Bric-A-Brac for the experience. The store is chock-full of obscure music and memorabilia, and friendly staff to help guide you in the right direction. The items are unusual but the prices are accessible, and the shows are always free and all-ages. As they note on the shop's Facebook page, Bric-A-Brac is all about 'Punk, Junk, and Rock N Roll!'

2. The Empty Bottle *Alt dive haven* The Bottle, as most call it, is a hole-in-the-wall rock venue in the truest sense. Its 400-capacity no-frills interior, graffiti'd bathroom, and cheap drinks have been the backdrop for nearly three decades of legendary booking (thankfully the plumbing's improved). This is where the Yeah Yeah Yeahs played their first Chicago show to a crowd of 10 people. This is where The Flaming Lips played a show back in '94 that they still look back on as one of their favorites. It's a historic music venue, but it's also just a place to hang. And aside from the Elliott Smiths, Wilcos, Sea and Cakes, Tortoises, Guided By Voices, Veruca Salts, Yo La Tengos, and countless other '90s and '00s indie and alt legends to have played the Bottle, owner Bruce Finkelman gets credit for booking a wide variety of acts, ranging from freeform jazz to avant-pop, post-punk, alt-country, drum'n'bass, and beyond.

3. Sleeping Village *You could practically live here* Co-Owners Rob Brenner and Billy Helmkamp earned their stripes with the Whistler, a well-respected music venue turned award-winning cocktail bar, art gallery, and record label. But they had their sights on something bigger, so they teamed up with Eric Henry to create Sleeping Village: A model of sleek, interior design and state-of-the-art sound engineering (no joke, they hired a team of University of Chicago physics graduates to help them engineer the optimal acoustics for the space). The performance booking is diverse, and the space feels intimate without being too tight. You can come here at night for a show or a drink from one of their 56 taps, or you can order a coffee and a bite to eat, connect to the Wi-Fi, and make it your remote working office during the day. Plus the outdoor patio is dog-friendly!

4. Metro *If these walls could talk...* Metro's role in grunge and alternative rock history is the stuff of legends. R.E.M. played its inaugural concert in '82. Kurt and Courtney started dating the night Nirvana played a now-fabled show on their *Nevermind* tour, capped off by Grohl tearing apart his drum set and throwing the pieces into the audience. Prince once played till four in the morning. It helped launch the careers of Liz Phair, Veruca Salt, and Smashing Pumpkins (who also played their farewell concert there in 2000). With all its amazing history, it's still where you go to see up-and-coming acts. Founder and owner Joe Shanahan is Metro's heart and soul, whose ear for the next big thing has proven itself time and again. He'll be the first to tell you the venue still stands for what it's always stood for: A place for new and emerging artists to be treated with respect, get some great exposure, and join the ranks of those that came before.

5. smartbar *Heartbeat of the city* What Metro is to rock, smartbar is to house music. For starters, it had "The Godfather of House Music" Frankie Knuckles play its opening weekend in 1982 (and many appearances thereafter), and has had countless legendary residencies since: Derrick Carter, Joe Smooth, Jeff Derringer, and The Blessed Madonna (formerly The Black Madonna), to name a few. Also run by Shanahan and located in the basement of the Metro building, the 400-capacity room is perfect in terms of size, sound, and ambiance.

CHICAGO

A SIDE

Bric-a-Brac:
Jamila Woods
VRY BLK
(featuring Noname)

Empty Bottle:
The Sea and Cake
Parasol

Sleeping Village:
Ohmme
Icon

The Metro:
Smashing Pumpkins
Bullet with Butterfly Wings

smartbar:
The Blessed Madonna
Levitating
(featuring Dua Lipa, Madonna, Missy Elliot)

SCAN TO PLAY

Chicago

Roy Kinsey

1. **Classick Studios** First things first is the music—always has been, always will be. This recording studio in West Humboldt Park started in the basement of a house on Kilpatrick and is a space where many of the city's most talented producers, engineers, and artists have worked. Grammys were made here. In fact, my own album, *Kinsey: A Memoir*, was mixed and mastered here. This studio in the heart of the city feels different from any other place I've recorded, and having dropped six albums, I've recorded in a few spots.

2. **Taco El Jalisciense** Across the street from Classick Studios, this Mexican food is the most fire of all the Mexican spots I've visited in the city, and I've eaten a lot of tacos. I usually get a chicken or veggie burrito, or tostadas—but that's definitely dinner when we have a session.
Honorable Mention: Soulé Chicago Restaurant—Black-owned Soul Food on Damen and Chicago.

3. **Blind Barber** I've always loved a small spot with good drinks, good people, and good music. This spot reminds me of all the fun I had on my old stomping grounds at a bar like Tonic Room. No pretense, just vibes.
Honorable Mention: The Delta —Good music, drinks, and tamales!

4. **Fernwood Barbers** You'd think I'd get a cut at Blind Barber, but if you've had a barber for a while then you know you don't just switch up. My homie here used to cut hair in his basement and now has opened his own boutique shop, cutting the heads of the best of them. If you know you'll be in town a couple of days, try to book in advance. We all deserve nice things.

5. **Gramaphone Records** You don't need me to tell you about this place. This legendary record store, or music library as I like to call it, located on Chicago's North Side is a place any self-respecting music lover must visit. Big supporters of my music when the *Blackie* and *Kinsey* LPs dropped, they—like so many other record stores in Chicago—supported and keep my records in stock. One love to them.

6. **Chicago Public Library** What kind of librarian would I be if I didn't put the Harold Washington Library Center on this list? No matter where you are in the city you're bound to be close to one of the 81 branches to pop into, but HWLC downtown on State is the most beautiful library space I've seen. Libraries, and books especially, are the worlds that gave me the courage to create worlds of my own through music. I dare you to go into one and not be transformed.

7. **Semicolon Bookstore & Gallery** This Black woman-owned bookstore and gallery space at 515 Halsted is another space to find Black stories, fund Black futures, and support Black businesses. Every month they invite Chicago Public Schools students to come and #ClearTheShelves, giving away books free of charge to CPS students.
Honorable Mention: Women & Children First Bookstore

8. **Brave Space Alliance** The Brave Space Alliance is a vehicle to empower and elevate queer and trans voices, particularly those belonging to people of color, to allow our communities a seat at the table on key decision-making processes that impact the community of Chicago. Send them money!

9. **Chicago Freedom School** Chicago has revolutionary roots. We've always needed places to uplift and empower students, to understand our history, and to prepare people, organizations, and institutions to build equitable and safe spaces for emerging ideas and identities.

10. **Asrai Garden** If you know me, you know I'm a Libra, that I like beautiful things, and that I will buy flowers because they look beautiful in the window. Asrai Garden in Wicker Park sells the most unique flowers and the most beautiful gold. This is definitely the spot to visit for an arrangement.

Bric-a-Brac Records & Collectibles

Bric-a-Brac Records is a bridge between DIY spaces and independent venues. We do have a safety net of being a brick-and-mortar store as opposed to DIY spaces that are always at risk of being shut down for various reasons. The venues can only provide so much, especially in Chicago, where there aren't as many all-ages spaces. Jen Lemasters

Opposite: Daniel B. Lynch and Rachael
Brianna, Musicians (The Lipschitz)
Above: Jen Lemasters and
Nick Mayor, Co-Owners
Below: Interior and games at
Bric-a-Brac Records & Collectibles

I know [the musicians] really miss
playing, too. I think everyone's
really feeling the emptiness of not
being able to play their music for
people. Nick Mayor

Empty Bottle

The people who work here and come here are also the people working toward a better world together, and I feel like it's all connected somehow. This matters because this little shack saves lives. We need to hold onto it.
Emily Kempf

It's not just about going to see a band play. It's about potential friendships and connections, everything else that happens in a public space where you can hang out, maybe get a little too drunk or not, and make some memories. Jason Balla

Opposite top and bottom:
Jason Balla; Emily Kempf; Eric
McGrady, Musicians (Dehd)
Above: Emily Kempf;
Eric McGrady; Jason Balla

The Hideout

I'd describe The Hideout as a place that welcomes people of every walk of life, genre, music, and type. We've always been very inclusive of different levels of art, music, and politics here.
Hawk Colman

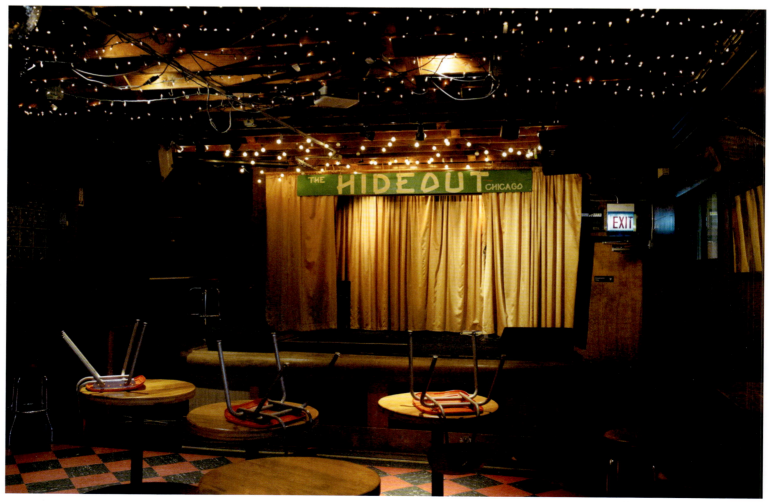

There's an intent behind this bar to reach out to the community and be a place where musicians feel comfortable, and a safe space where you can do weird things. I don't think it's gonna go away. I think there's enough people who want this place to continue because it offers creative people a venue and a space. Community is hugely important and that's where culture comes from. That's where change comes from. That's where intelligent thought comes from—people coming together. Jon Langford, Musician

By uniting all the Chicago music venues, CIVL [Chicago Independent Venue League] brought everybody together. And I think it really raised awareness among music fans and cultural appreciators in the city that, yeah, this city is like no other. Lawrence Peters, Musician/Bartender

Opposite top: Tim Tuten, Co-Owner
Opposite bottom: Interior of The Hideout
Right: Michelle Debois, Bartender/Longtime Employee and Hawk Colman, Musician/Door Staff
Below: Sully Davis, Program Director

Metro

One positive thing that's come out of [the pandemic] among the music community is the National Independent Venue Association (NIVA). It's an organization that has brought together close to 2,000 venues that are independently run around the country. It's unheard of in our industry to have this kind of cohesion and understanding and be able to communicate across all these lines. Sometimes we're competitors, so we sometimes don't always talk that way with each other. But this whole situation has brought us together a lot. And just talking to other promoters, their venue staff, and other people, we understand that we're all in this together, and that our collective voice is a pretty strong thing. Joe Carsello

Above: Joe Carsello,
Senior Talent Buyer
Opposite top: Exterior of Metro
Opposite bottom: Stage at Metro

The biggest thing we've noticed is that the community wants to support us. A lot of venues in Chicago have experienced that outpouring of support, and we couldn't be more appreciative of the music family that's developed in Chicago.
Joe Carsello

Sleeping Village

That's the thing I have felt most deprived of during quarantine—my sense of community. Getting out my anger and just dancing it away. I haven't had that. But at the end of the day, it's about the people in the audience with me, and less about who I'm worshipping on stage. Rita Lukea

What I love about Chicago is you can start a band with your friends and then the next week, you can go play one of these DIY places in the city, try things out to see what works. There are so many of them, and so many people who are running them really well.
Jonathon Freund

Saving our stages is first and foremost, because without our stages, so many things we like in the community go away. For every dollar spent here, $12 is put back out into the local economy, and that's a real statistic from research run in Chicago. It's not just us looking out for ourselves, it's really looking out for the cultural longevity of this amazing music city and something we hope to reanimate. Kyle LaValley

Left: Jonathon Freund, Rita Lukea, Tyler Ommen, Musicians (Pixel Grip)
Above: Kyle LaValley, Talent Buyer/ Head Programmer

smartbar

How do we use ourselves as a megaphone for different cultural things around the city? It's a place where we encourage people to find ways to stay healthy, safe, and creative. When Black Lives Matter moved forward, we used that same platform to promote all these things that are very close to us. Joe Carsello

smartbar has been through a lot of waves in the music scene. Chicago's known for house music. House DJ's including Frankie Knuckles were residents here, and Derrick Carter is still a resident here. We've grown a lot of music scenes from this building. Joe Carsello

Above and Opposite: Joe Carsello,
Senior Talent Buyer

Dallas

POSTER DESIGN
Hunter Moehring

PHOTOGRAPHER
Cory Cameron

PRODUCER
Mallory Miller

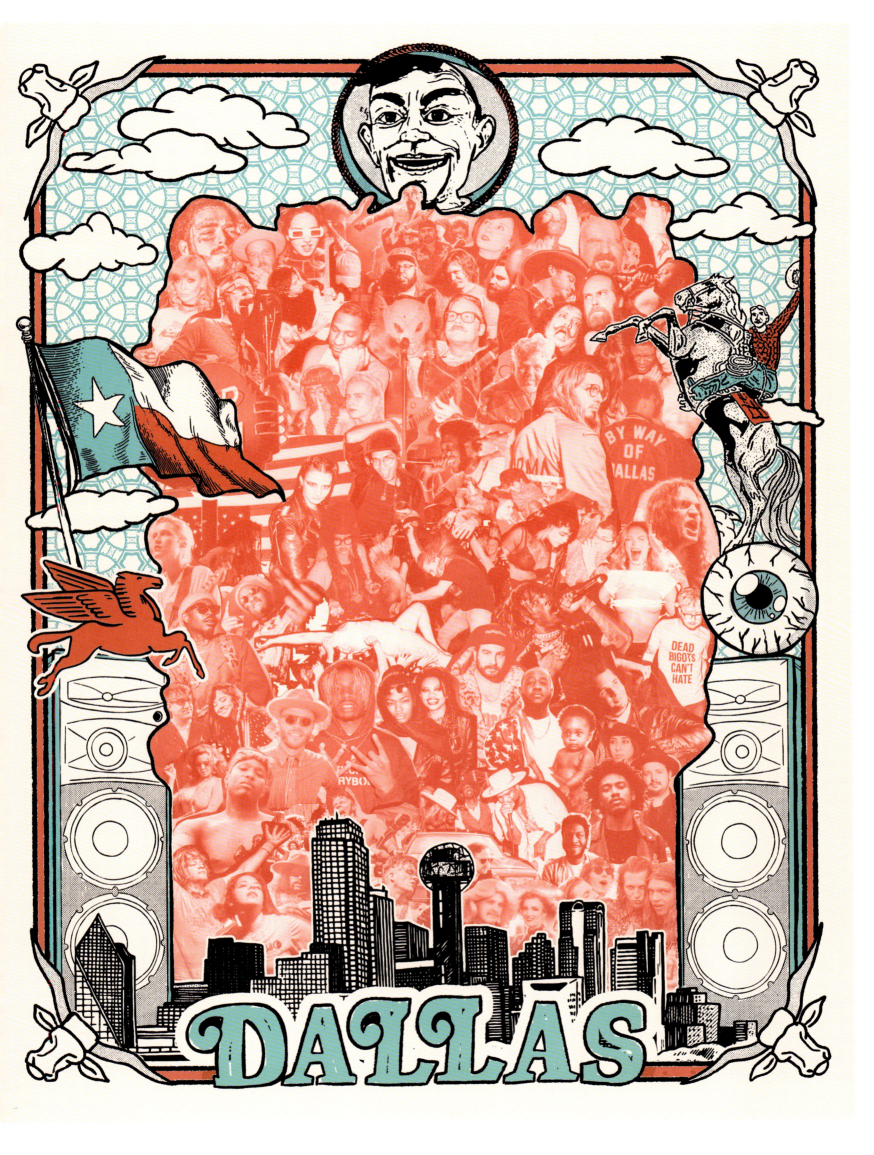

Dallas

Cory Cameron

1. Country music legend Merle Haggard made the Guinness Book of World Records for buying the world's largest round of drinks when he bought 5,095 shots of Canadian Club for the entire club at Billy Bob's Texas in the Fort Worth Stockyards. The bill totaled $12,737.50 and equaled 40 gallons of whiskey.

2. Gilley's in Dallas still houses the original mechanical bull "El Toro" that was featured in the 1980 John Travolta movie *Urban Cowboy*, filmed at singer Mickey Gilley's original megabar in Pasadena.

3. Trees Dallas was the site of an infamous onstage fight between Nirvana frontman Kurt Cobain and a club security guard during a performance in 1991.

4. The Deep Ellum neighborhood just east of downtown Dallas became a hotbed for early jazz and blues in the 1920s. Blues musician Huddie "Lead Belly" Ledbetter's "Take a Whiff on Me" was one of the earliest songs to use the word "Ellum" to refer to Elm Street.

5. Looking to attend a show at The Kessler? Be prepared to listen closely, as the venue is touted to have the best acoustics in the state of Texas.

6. The Bomb Factory, once a bomb- and jeep-manufacturing plant during World War II, surfaced as a music venue in the mid-'90s, closed a few years later, and reopened in 2015 with a headlining performance by Dallas native Erykah Badu.

7. If you were looking for the party in the 1980s, you would have found it at the Starck Club. Designed by then-unknown Paris-based fashion designer Philippe Starck, the discotheque was the city's center for music and dancing, and also introduced the drug MDMA.

8. The Majestic Theatre is the last remnant of Theater Row, the city's historic entertainment center on Elm Street. A Dallas landmark, it is listed on the National Register of Historic Places.

9. Jeff Liles, now the Artistic Director at The Kessler, is a vital part of the Dallas music scene. He helped create the scene in Deep Ellum as a DJ and talent booker in the '80s and '90s and is now doing the same to bring the arts to the Oak Cliff and Bishop Arts areas.

10. Though Austin's SXSW is the biggest music festival in Texas, Dallas-Fort Worth has no shortage of festivals that happen each year, including JMBLYA, Lights All Night, and 35 Denton.

The Bomb Factory

We're sort of the forgotten industry. The fortunate thing and the positive thing is we have so many people who love and support the arts and music. And we're going to support each other.
Whitney Barlow

Below: View from stage at
The Bomb Factory
Opposite top: Damany Daniel, Creative
Director and Whitney Barlow, Owner
Opposite bottom: Stage at
The Bomb Factory

To constantly reframe what the problems are that we're solving, I think is what's the most staggering. Damany Daniel

Gas Monkey Bar N' Grill

Below: Exterior of Gas Monkey
Bottom: Alex Mendosa,
General Managing Partner

We just do what we want to do, the old-school way, with heart and soul and feeling. We're not driven by stockholders or corporate BS. We're very *live*. We just do it our way, the cool rock 'n' roll way, and bands feel that. Peter Ore, Lead Talent Booking

Gilley's

We're serving up the Texas experience. People come here from all over the country, and we're here to put on a Texas sideshow for them. Dean Pearson

When people play here, they're either on their way up, or on their way down. I say that respectfully. Jay Stewart

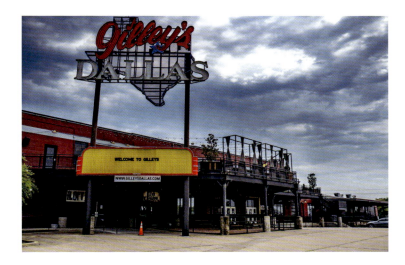

Top left: Exterior of Gilley's
Top right: Stage at Gilley's
Above: Dean Pearson, Private Event
Manager; Mallory Miller, Producer
(*Bring Music Home*); Jay Stewart,
General Manager

The Kessler

It fills a niche. There really isn't anything else like it in town, a sit-down listening venue. Most venues like this, in most metropolitan areas, there's an eco structure around them the neighborhood depends on as the central attraction that keeps the neighborhood afloat. If this place goes away, a lot of other places go away.
Jeffrey Liles

Below: Jeffrey Liles, Artistic Director and Diana Cox, Director of Operations

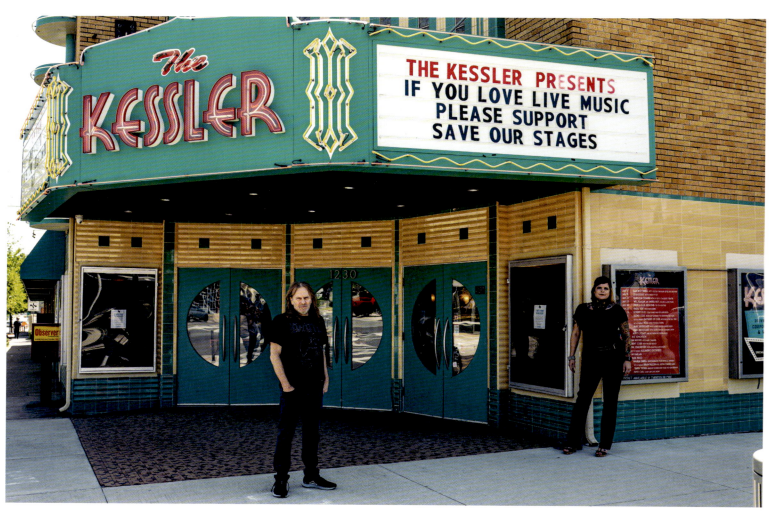

Stereo Live

Above: Entrance of Stereo Live
Below: Stage at Stereo Live

Stereo Live Dallas is an incredibly special place. When we were developing the venue, one of our key priorities was preserving the incredible Art Deco theater elements while capturing the underground feel that is a hallmark of Dallas' rich electronic dance music community. We've had the biggest artists play sold-out shows including Tiësto, Martin Garrix, Fisher, and John Digweed. Our goal is to create life-changing experiences where the audience gets goosebumps every time an artist walks on stage. We cannot wait to return after the pandemic is over to create many more years of memories. Surain Adyanthaya, Owner/Resident DJ

Denver

POSTER DESIGN
Mike Graves

PHOTOGRAPHER + PRODUCER
Lisa Siciliano

Denver

Lisa Siciliano

1. Red Rocks In its spectacular setting, the concert venue, park, and amphitheater known as Red Rocks is Colorado's iconic entertainment venue. Everyone from The Beatles to Tool has played here and many famous concert videos were filmed here as well, most notably U2's *Under a Blood Red Sky*.

2. Caribou Ranch Located just 40 minutes west of Denver, Caribou Ranch was a recording studio built in 1972 by producer James William Guercio in a converted barn on ranch property in the Rocky Mountains near Nederland, Colorado. Many major albums were recorded here in the '70s and '80s, including masterpieces by Elton John, Chicago, Joe Walsh, Stephen Stills, John Lennon, Billy Joel, Waylon Jennings, Amy Grant, and Michael Jackson.

3. The Brown Palace This historic hotel in downtown Denver is best known as the preferred stop for The Beatles while the band was in town—there is even a Beatles Suite where the band is said to have stayed. The hotel has been frequented by other famous musicians, including Taylor Swift, Bruce Springsteen, the Rolling Stones, Cyndi Lauper, Metallica, Jon Bon Jovi, and Pearl Jam, as well as by many United States presidents.

4. The Underground Music Showcase Also known as UMS, this 20-year-old festival is like a mini-SXSW and serves as the largest annual indie music festival in the Rocky Mountain region. Occurring in late July, the UMS highlights four days of music and art and features more than 400 performances in 20 venues along a one-half mile section of South Broadway.

5. Colorado Music Hall of Fame The Colorado Music Hall of Fame was started by music promoter and artist manager Chuck Morris in 2011. To date, more than 40 musicians have been inducted into the Hall. You can find the Hall's induction exhibits at the Trading Post at Red Rocks.

6. FMQB/Triple-A Radio Conference at the Fox Theatre Just up the road from Denver, The Fox Theatre in Boulder is a world-class, 500-seat venue that hosts the FMQB Radio Conference every August. Bringing in music giants such as Bonnie Raitt, Dave Matthews, John Mayer, and Willie Nelson, the four-day radio industry event is a must for artists, radio DJ's, record label executives, and music industry professionals.

7. Led Zeppelin Denver was Led Zeppelin's first stop on their first-ever North American tour. The British band played the Auditorium Arena on December 26, 1968.

8. Pearl Street Mall/16th Street Mall Boulder's Pearl Street Mall and Denver's 16th Street Mall are two of the few places in the country where you can see world-class street performers in an open-air pedestrian mall on any day of the week.

9. Musical Governor Former Colorado Governor John Hickenlooper is a huge supporter of his state's music scene. Having enlisted famous Colorado bands like OneRepublic, The Lumineers, and Big Head Todd and the Monsters to play his inaugurations, the recently elected U.S. senator is also a musician in his own right and once played banjo at Red Rocks with Old Crow Medicine Show.

10. John Denver You can't talk about Denver music without bringing up John Denver, who liked the area so much that he changed his own last name in tribute. On March 12, 2007, Colorado's Senate passed a resolution to make Denver's trademark 1972 hit "Rocky Mountain High" one of the state's two official state songs.

7th Circle

On paper, I'm the owner of the place, but really it's a collective of about 100 of us who actually run this venue. Music is not just a weekend entertainment thing for us, it's our lives. Aaron Saye

The group of young people we have in this space right now is absolutely incredible. They manage to shock and surprise and inspire me absolutely every single day. Cameron Cronick

Above: Shanea
Right: Aaron Saye, Owner
and Cameron Cronick
Opposite top: Nick Farrow
and Shy Moon
Opposite bottom: Shanea
and Aaron Saye

Local 46

It's fight or flight right now. While there is obviously unspoken support in the industry, everyone is trying to survive and save themselves. I think small business owners have to be willing to adapt. We have adapted and we've got an incredible community, which is really great.
Niya Gingerich

Above: Interior of Local 46
Right: Niya Gingerich, Owner

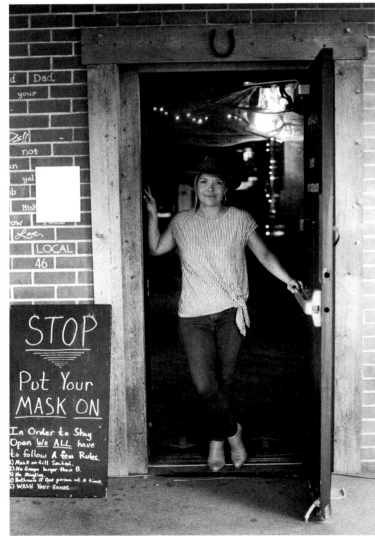

Oriental Theater

The Oriental Theater was built in 1926 and opened New Year's Day 1927. It was built as a silent cinema. Andrew Bercaw

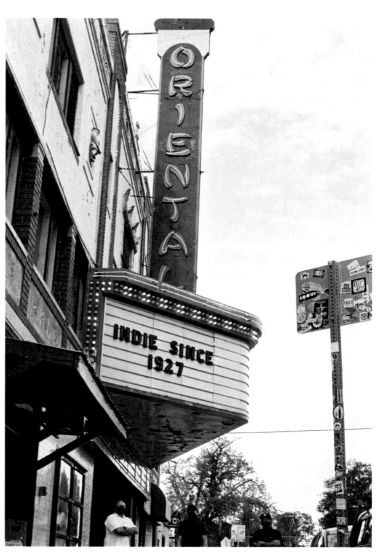

Above: Andrew Bercaw, Owner; Peter Ore, Talent Buyer; Scott Happel, General Manager
Right: Exterior of the Oriental Theater
Below: Otone Brass Band live-streaming from the stage of the Oriental Theater

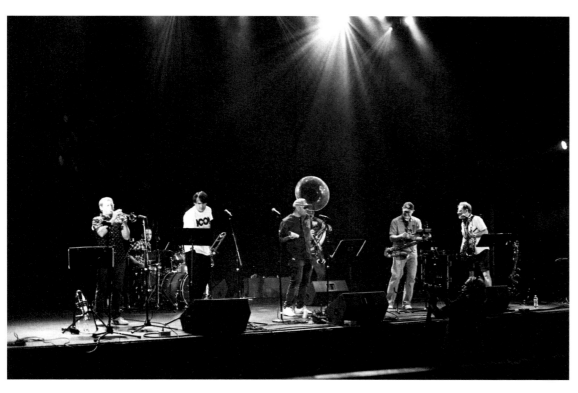

I've learned that we're all very determined to keep this place open. It means a lot to us, not just professionally, but also emotionally. Scott Happel

Detroit

POSTER DESIGN
Rebecca Goldberg

PHOTOGRAPHER
Cydni Elledge

PRODUCER
Maggie Derthick

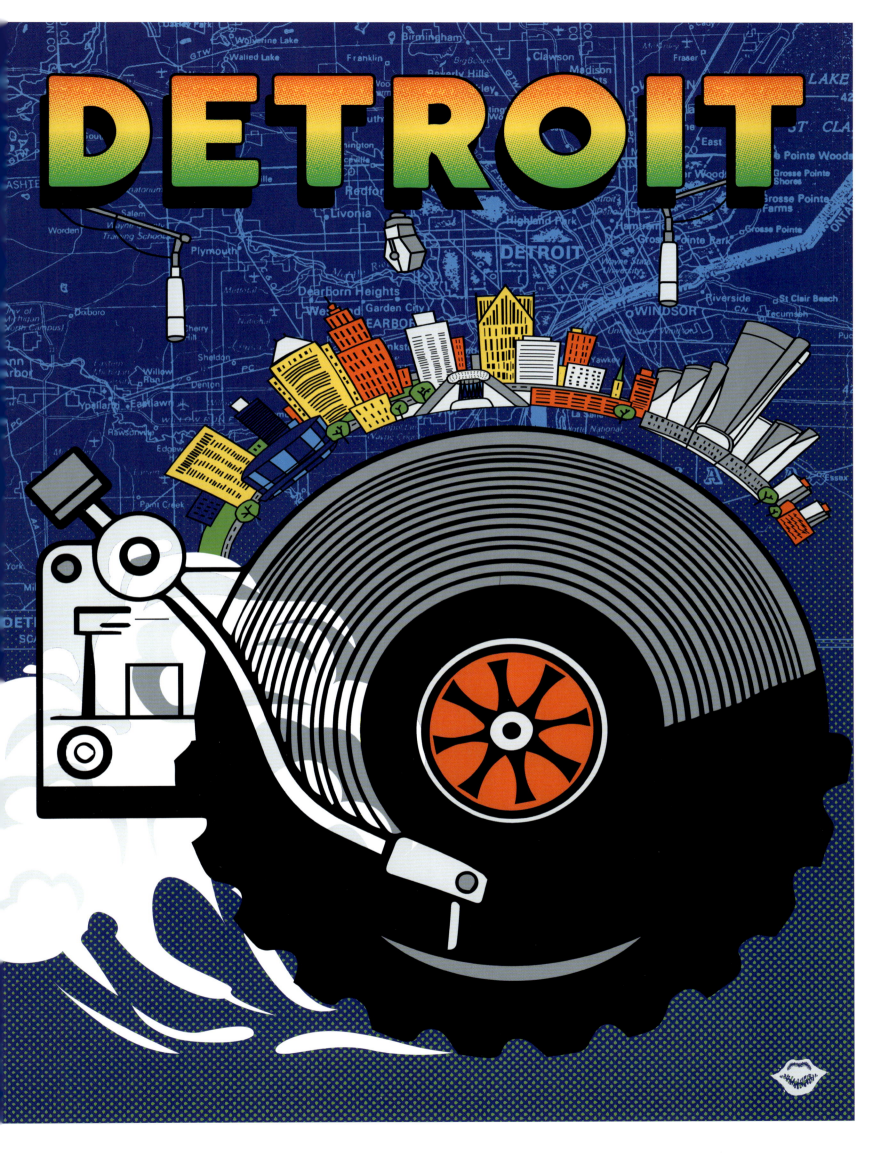

Detroit

Maggie Derthick & Kiara Jackson

1. Detroit is home to the legendary Motown Records, founded by Berry Gordy in 1959. Motown produced some of the biggest artists of the era, including The Supremes, The Jackson Five, Marvin Gaye, Stevie Wonder, The Miracles, and so many more.

2. Detroit has birthed some of the most influential rappers in the game including Eminem, Big Sean, Dej Loaf, J Dilla, and Royce Da 5'9".

3. Detroit has also been called the Gospel Capital and is home to many legendary gospel performers. From singers like Aretha Franklin, The Clark Sisters, and The Winans Family to Fred Hammond, Marvin Sapp, and Vanessa Bell Armstrong, the list goes on and on.

4. Techno music was originated in Detroit by Juan Atkins, Derrick May, and Kevin Saunderson— also known as "The Holy Trinity" —in 1981.

5. Paradise Valley is a historic area in Detroit that was home to Black-owned nightclubs and restaurants from the 1920s to the 1950s. Many jazz icons such as Ella Fitzgerald, Duke Ellington, Billie Holiday, and Louis Armstrong performed in Paradise Valley.

6. Sada Baby, Kash Doll, Icewear Vezzo, Babyface Ray, Tee Grizzley, and 42 Dugg (among many others) are taking the current Detroit rap scene to the next level with their authentic sound and flows.

7. Detroit hosts some of the biggest music festivals in the country, including Ribs and R&B Music Festival, Movement Electronic Music Festival, Detroit Jazz Festival, and Mo Pop Festival.

8. You can catch some amazing jazz at Baker's Keyboard Lounge, one of the oldest operating clubs in the world.

9. Fittingly, Detroit is home to both the Motown Museum and the Techno Museum.

10. Basically, you can't throw a stick without hitting a music venue in Detroit. Our historic spots continue to host the biggest names in music while serving as home base for some of the world's biggest talents. From The Majestic to Marble Bar, Cliff Bell's to Café D'Mongo's, The Fillmore to The Fox Theatre, Magic Stick to Music Hall, there is something for everyone. Detroit's live music scene will blow you away!

Majestic Theatre

There's been a unification of the industry. Everyone gets a chance to see what it looks like without music and it's not good for anyone. It's not like the venues are doing better than the artists. We're all suffering to the same extent and I think it's just brought a little bit of unity to the industry.
Zach Tocco

Above: Part of the historic Majestic is intimate venue The Magic Stick
Below: Zach Tocco, Marketing Director and David Zainea, Owner/ General Manager

In 1984 it was my dad and his brothers at the time. They used to manufacture trophies in here and build bowling alley lanes. In 1987 it became a venue and we started doing dance music, and then it moved into live music in 1989. I think our second show was Buddy Guy. David Zainea

Marble Bar

This is actual magic, like real magic, in seeing a show at an intimate music venue. You're channeling a timeless spirit where the rest of reality is paused and you're being encapsulated in this exchange between the artist and the audience, and it really becomes one living thing for a short amount of time. Ted Krisko

Above: Installation at Marble Bar
Below: Ted Krisko, Talent Buyer/Music Director; DJ Dez Andres, DJ/Musician; Kory Trinks, Manager

Being a world traveler and not being able to travel, I've personally been investing more in creating that space at home. I'm surprised by the love people have been showing. At the same time, I'm disappointed by some people in the city not taking the proper precautions. It makes the future so questionable. DJ Dez Andres

There is a transfer of energy between performer and the crowd, and it's something that cannot be duplicated. It transcends race, religion, history, and it is what really has impacted me. Finding myself on the dance floor was the first time I figured out who I actually was. That kind of spiritual revelation cannot be duplicated in your living room at home. Kory Trinks

The Old Miami

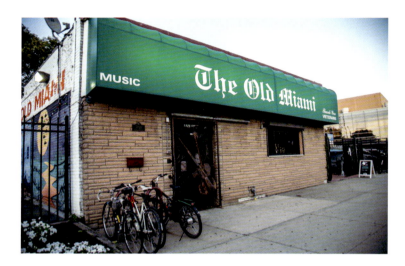

Above: Exterior of The Old Miami,
established in 1980 by owners Dan
Overstreet and Julie Flynn
Above right: Daniel Ross,
General Manager
Below: Interior of The Old Miami

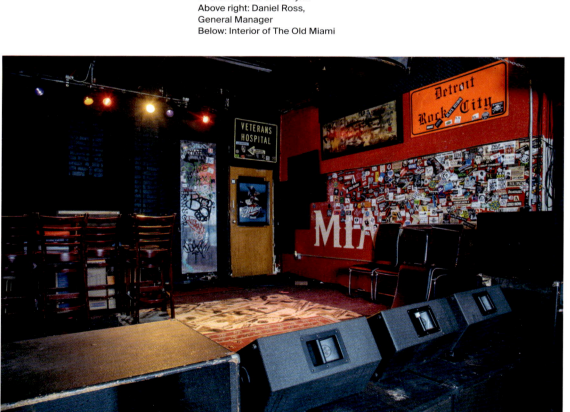

That's the reason we're different
from most other animals: We need
to be together, we need to share
experiences with each other, we
need to share our consciousness
with one another. It's important
to have these spaces to come out
and celebrate, feel good together,
and to be social. These things are
just important to the fabric of
humanity. Daniel Ross

TV Lounge

We go back and forth about [reopening]. One day, [it's], 'We can do this...' The next day, 'Mmm, I don't think so. It's not worth it.'
Joshua Guerin

It's been an emotional roller-coaster. What's shocking for me is to have months to sit down and think. I couldn't have even imagined this. Now, my mind is all over the place. I have a million ideas, tons of ideas, bar-wise. It's like I'm 21 [again]. I just can't release them all now.
Ivory "Tree" Graves

Above: Interior of TV Lounge
Right: Ivory "Tree" Graves, Owner and Joshua Guerin, Manager

Houston

POSTER DESIGN
Carlos Hernandez

PHOTOGRAPHER
Julian Bajsel

PRODUCER
Craig Hlavaty

Poster: Carlos Hernandez / Burning Bones Press 2020

Houston

Craig Hlavaty

1. Numbers has hosted hundreds of important new wave, alternative, and punk bands throughout its history, including Nine Inch Nails opening for The Jesus and Mary Chain in 1990. Sadly, Numbers was also where Blind Melon's Shannon Hoon played his final gig with the band in 1995 prior to his death from a drug overdose.

2. Prior to being one of the premier listening rooms in Houston, The Heights Theater served as a wedding venue, art house, and movie theater. The building survived a fire in 1969, which many believe was actually arson perpetrated by an angry mob unhappy that the owners had shown *I Am Curious (Yellow)*, one of the first mainstream XXX films.

3. Decades before it became the Montrose district's coolest dive, Grand Prize Bar was a funeral home. These days the most gothic thing about it might be the regular darkwave DJ sets happening upstairs, or the creepy picture of a grandma next to the downstairs bar.

4. Opened in 2006, Warehouse Live has hosted acts as diverse as Prince (with protégé act 3rdeyegirl), Drake (who's even name-checked the club in a song), Hayes Carll, Kings of Leon, and grunge icons like Chris Cornell and Scott Weiland. The venue is also well-known for being brave enough to host both GWAR and Insane Clown Posse at least once a year.

5. Located in the historic Near Northside neighborhood, White Oak Music Hall also has a separate venue, the Raven Tower, right next door. Named for the swinging bachelor pad that once overlooked nearby I-45 North, the apartment has been converted into an eye-popping event space with an epic view of downtown Houston.

6. These days, Stereo Live is a noted EDM haven, but in its past life it was briefly known as "Club 6400." Open for less than two years, it was one of the most popular industrial and new wave venues in the city before a mysterious fire ended the party. To this day there are Club 6400 tribute nights around Houston celebrating the late '80s scene fixture.

7. Nearing 50 years of existence, Cactus Music is perennially named Houston's favorite record store. Customers can shop for new and used vinyl, find Houston-centric gifts, and even sip a complimentary Saint Arnold beer during in-store performances. You might even be able to offer a belly scratch or two to a pup on a busy day in the dog-friendly shop.

8. Hundreds of couples have celebrated their nuptials at Rockefeller's, which operates as a wedding venue when it's not hosting live bands. If you show up to the gig early enough, you can hit up Star Pizza next door for a few craft beers and a slice of its signature Cowbell pizza, topped with real beef brisket and homemade "MoreCowbell" sauce.

9. The Flat, run by the world-renowned DJ Sun, is nestled on the north end of the historic Montrose neighborhood, the city's famous LGBTQ gathering place. A sprawling patio out back is perfect for those all-too-rare cool Bayou City evenings, and you can usually find DJ Sun holding court with musicians and patrons alike.

10. The Smart Financial Centre is located just southwest of Houston proper inside Fort Bend County, one of the most diverse counties in the United States. It's possible to see a Bollywood music revue, a classic heavy metal act, a Latin dance show, and a stand-up gig in the span of a week at the venue.

Cactus Music

Cactus goes back many decades, to the days of the Record Ranch in the '40s that regularly hosted live performers. We are a record store that routinely stages in-store performances with touring artists. That's been our touchstone, since artists like Patti Smith and The Ramones. We're a launchpad for many local, national, and regional artists that have new projects out. Certainly for all Texas artists, Cactus is a big piece of the puzzle as far as launching a new record.
Quinn Bishop

Opposite: Quinn Bishop, Co-Owner

We really help artists find their audiences. People anticipate our schedule of live music events. We've many times been voted 'Best Live Music Venue' in Houston for small venues, but with your traditional 'gig' venues, we really sit side by side with them. Our business complements their business, building traction for ticket sales leading up to the shows we're both marketing.
Quinn Bishop

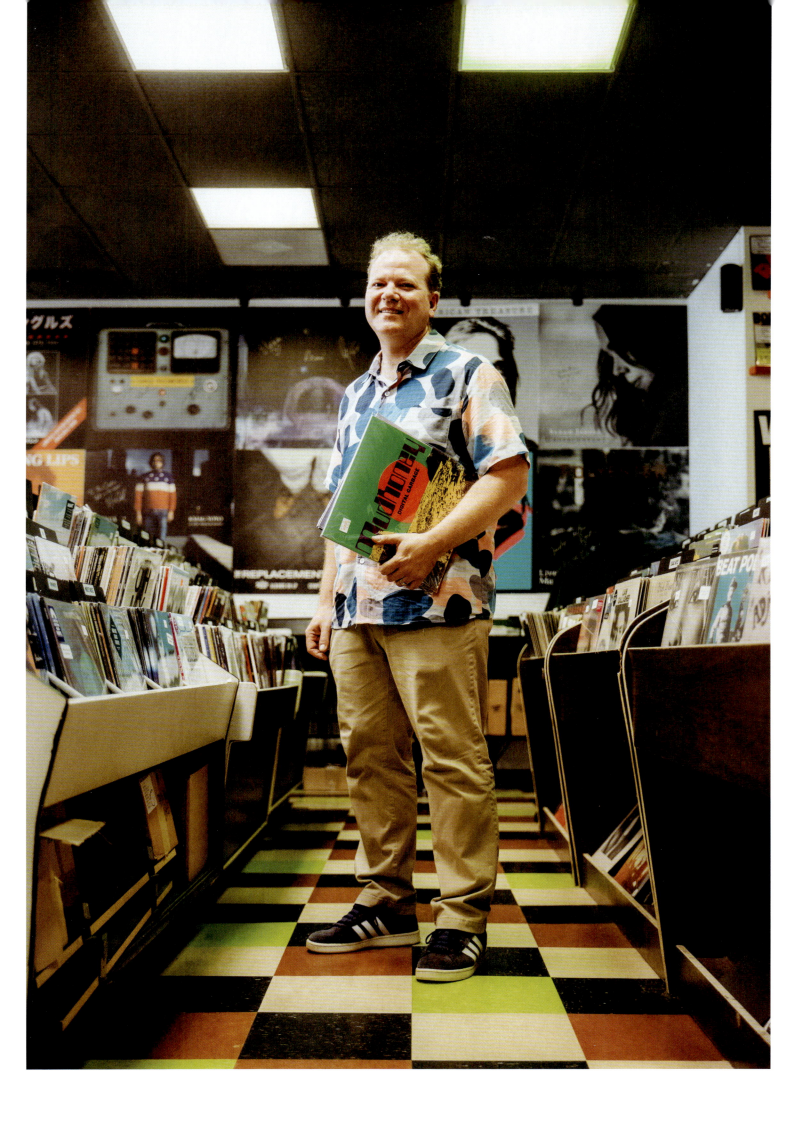

The Flat

I acquired The Flat in 2014. I started as a DJ, then was able to purchase the place. For the time being, we're just open on the patio. Not that I welcome stress, but it keeps me on my toes. My daughter asked me how to navigate these times, and the word that came up was 'opportunity.' If I'm advising that, then I feel like I should take my own advice. I've thought of ways we could take advantage of the 'reset' button. I'd like to expand hours and make money across the timeline. In the future, we'll open at 7 a.m., we'll have a coffee shop, we're turning it into a workspace.
Andre J.E. Sam-Sin

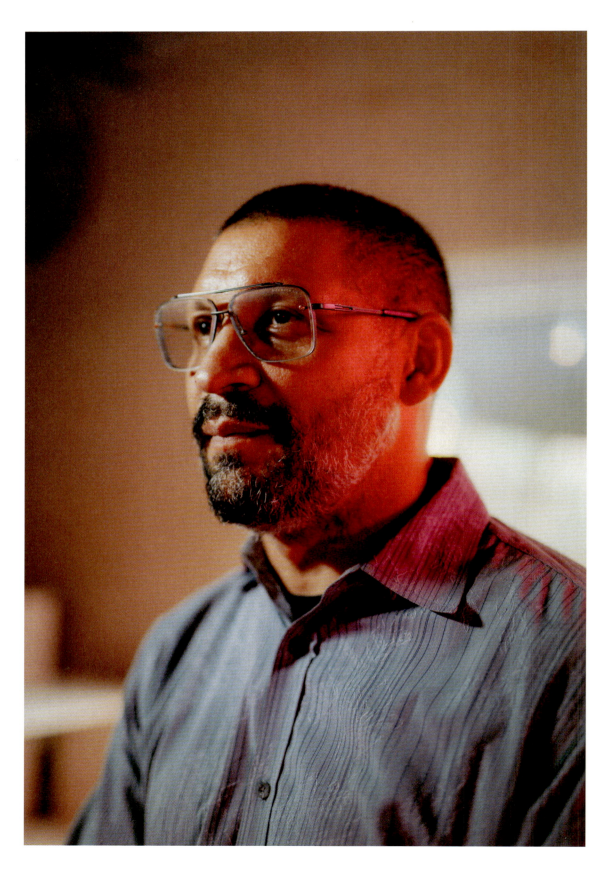

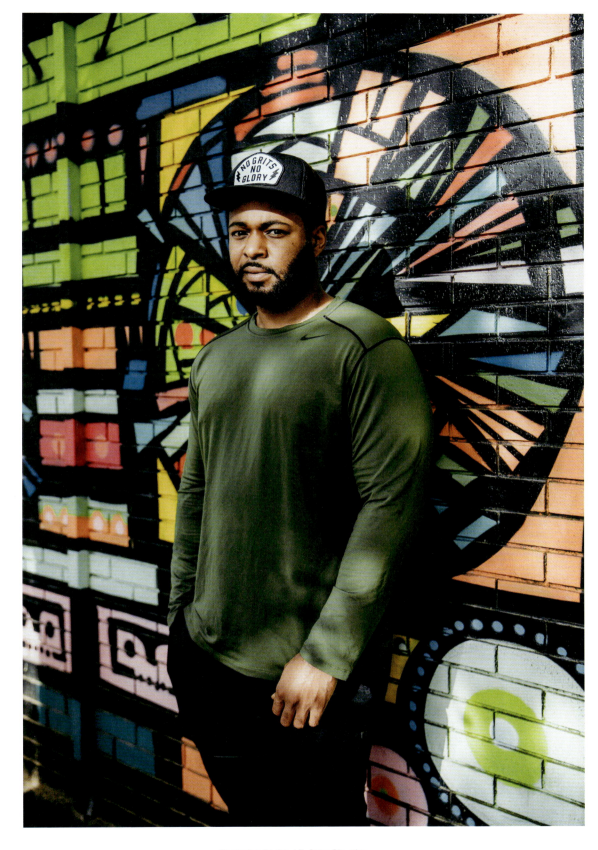

Just seeing what [COVID] has done to the live music scene, and all the musicians at home—people are recording from their home studios, streaming live performances. I've seen everything from rock bands doing live concerts to huge jazz big bands on just 24 squares on a Zoom screen. That's the new normal for this time.
Chase Jordan

Opposite: Andre J.E. Sam-Sin, aka DJ Sun, Musician/Owner
Above: Chase Jordan, Musician

Grand Prize Bar

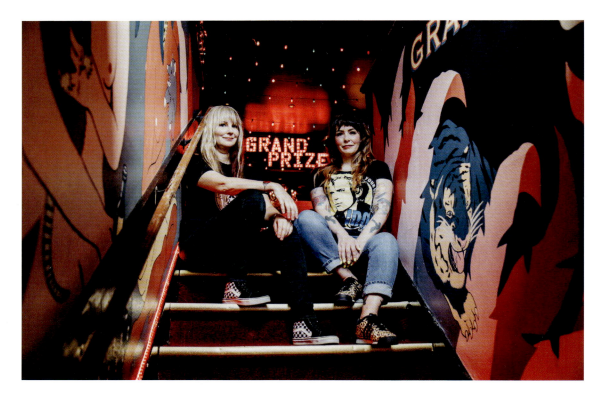

We're an industry bar, and a lot of 'industry people' don't just work at one bar, they work at two or three other bars. Who has insurance? Most people in the entertainment industry don't have insurance. We want to keep our staff as safe as possible. Lindsay Beale

There's no rule book on any of this stuff. We've actually ended up making a lot of really great decisions without realizing they were really great decisions until later, and we did that as a team. Our staff and our customers are a lot happier for it. Carrie Oliver

Above: Carrie Oliver, Owner/Music Maintenance and Lindsay Beale, General Manager/Booker
Below: Lindsay Beale
Opposite: Carrie Oliver

The Heights Theater

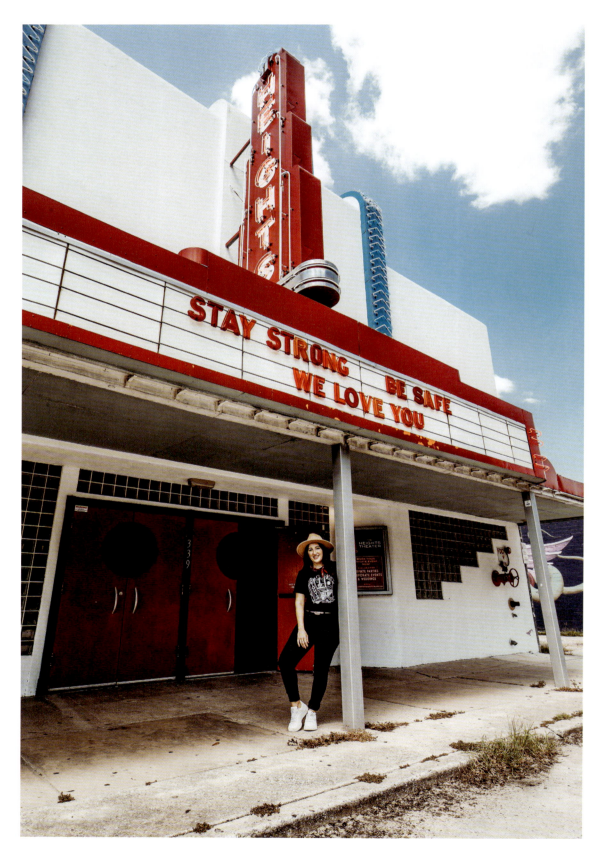

We've been very active in our efforts across America. We've always been involved in Texas, but now we're also working with Save Our Stages—and doing more than just being a venue and talent buyers and concert promoters. We are working to save our entire industry, to be honest. Mark C. Austin, Senior Talent Buyer

We opened in 1929 and we've been a movie theater, an art gallery, and an event space. The first show we had to cancel was March 13, 2020. We started an online merch program which was completely new for us. We had a special commemorative T-shirt made and all proceeds went to the staff who were out of work. People were really receptive, so now we're working on a new merch plan to keep money coming in the doors. Adrienne Joseph

Opposite: Adrienne Joseph,
Marketing/Special Events Manager
in front of The Heights Theater
Below: Adrienne Joseph

Numbers

Right: Rudi Bunch, Owner/
General Manager
Below: Wes Wallace,
Event Coordinator/DJ
Opposite top: Marquee at Numbers
Opposite bottom: Interior of Numbers

[Numbers] is a landmark, for sure. A lot of people in the city have seen a show here or at least been here. We used to be the only game in town for medium-sized shows. [As DJ Robot, the former owner, used to say:] 'No cocktail waitresses, no valet services, no attitude.'
Wes Wallace

We're a dance club and dancing was deemed illegal activity under the governor's guidelines. People have to be seated so there would be no dancing, and people weren't allowed to walk to the bars and get drinks. So a 25% capacity wouldn't have been a viable business model for us. At 50% we thought if dancing was allowed, we'd give that a shot. But it wasn't, so we didn't. And we're still closed. Rudi Bunch

Rockefeller's

Every show that was
postponed—we only
got three requests for
refunds. Everyone has
the hope that things are
coming back. It's like,
they bought their ticket
and are like, 'I'll wait.'
Mike Pittman

Below: Mike Pittman, Partner/
Janitorial/Accounting
Opposite top: Exterior of Rockefeller's
Opposite bottom: Mike Sims,
Booking/Bar Manager

'General admission' has sort of
become a dirty word—I don't
know if people are gonna want
to do that for awhile. Even the
general admission tickets we do
have for sale aren't moving. It's
the seats that sell. Do we need
to just transition into being a
livestream venue? Is that gonna
be how you watch a concert
now? It's all pay-per-view anyway.
It kinda feels like we're going
backward a little. [There's] all this
technology but it's like we'll be
going back to a field to watch a
show again. Mike Sims

Smart Financial Centre

One of my favorite things is when I'm in my office and they start sound-checking, and my walls start vibrating. There's an energy that happens when music's being made. I miss seeing the crowd, and happy faces. I miss our staff as well. We work a lot of hours, so our fellow co-workers become like a second family. Andrew Huang

Everybody always says, 'If you find a job you love, you'll never work a day in your life.' I'm fortunate I have a job like that. The thing I've always treasured most about being in this industry—I love standing in the lobby when a crowd is coming into a show. That is the most enjoyable thing you can experience. I really miss that noise of the public coming in. I don't know if people understand: We offer four hours of relief from whatever it is they have in their daily lives. Whatever problems people have, they're gone. There's really no price tag you can put on that. David Skinner

Opposite: Andrew Huang,
Marketing Director
Below: David Skinner,
General Manager

Stereo Live

We're a very much come-as-you-are venue, very inclusive. You'll see all ages, all races, and they come together at Stereo Live.
Surain Adyanthaya

Opposite top: Albert Fix, DJ/Production
Opposite bottom: Albert Fix;
Surain Adyanthaya, Co-Owner; Zach Gunselman, Manager
Below: Zach Gunselman

People in Houston are just so busy day to day. Dancing is probably one of the most healthy things you can do for your brain and I think people miss that. When I came to shows here, to be able to dance, it just felt like I could wash the week away. It's very good for your mental health to come out and socialize with people. Zach Gunselman

Warehouse Live

Drake, Bruno Mars, Adele—we catch 'em on the way up, and we catch 'em on the way down. I don't know if [normalcy] will ever happen again. Do the bands even want to travel? Do they even want to come? We wanna do it, of course.
Chris Schroeder

My favorite show we've ever had here was Duran Duran. Kim, our accounting assistant, was dancing on a bar. Oh! And the NIN show was amazing, that 'Day for Night' thing. It was a rehearsal, but man! You don't have any real concept of reality when you're running shows like this. Days are running together. You know, we're independent. Maybe this [COVID] will have a silver lining. Maybe it will shake people up: 'If I want my bands to play here, maybe I can't be a greedy bastard anymore.' Maybe we can reach out and snag some of those acts that haven't played here in a really long time.
Ashly Montgomery

Above: Ashly Montgomery, Marketing Director
Right: Chris Schroeder, Head of Security
Opposite page: Ashly Montgomery and Chris Schroeder out front of Warehouse Live

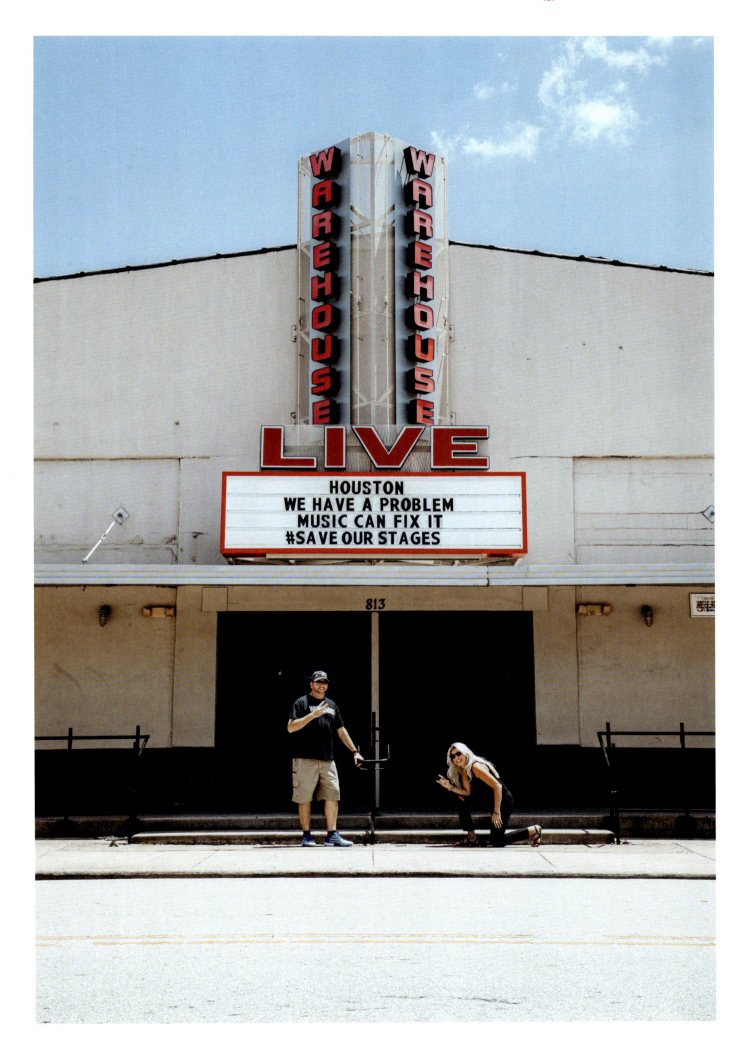

White Oak Music Hall

The world is changing, so music will change around it. Musical themes—what everybody is going through—will be expressed in different ways. Will people want something that's just surface-based fun, or more political things?
Christian Larson

I think [COVID] has forced people to be more introspective and I'm curious to see what happens to the content, from there, as opposed to just creating content for the sake of content. I think it's forced a reset and added value. It's made people appreciate concerts more. People are a lot more stir-crazy than they anticipated, but I think it's also changed how people see music, and entertainment in general. That will help drive where music goes. Luis Rivera

Opposite top: Christian Larson, Talent Buyer and Luis Rivera, General Manager
Opposite bottom: Interior of White Oak Music Hall
Above: Luis Rivera
Below: Christian Larson

Los Angeles

POSTER DESIGN
Young & Sick

PHOTOGRAPHER
Pooneh Ghana

PRODUCER
Daniel Oakley

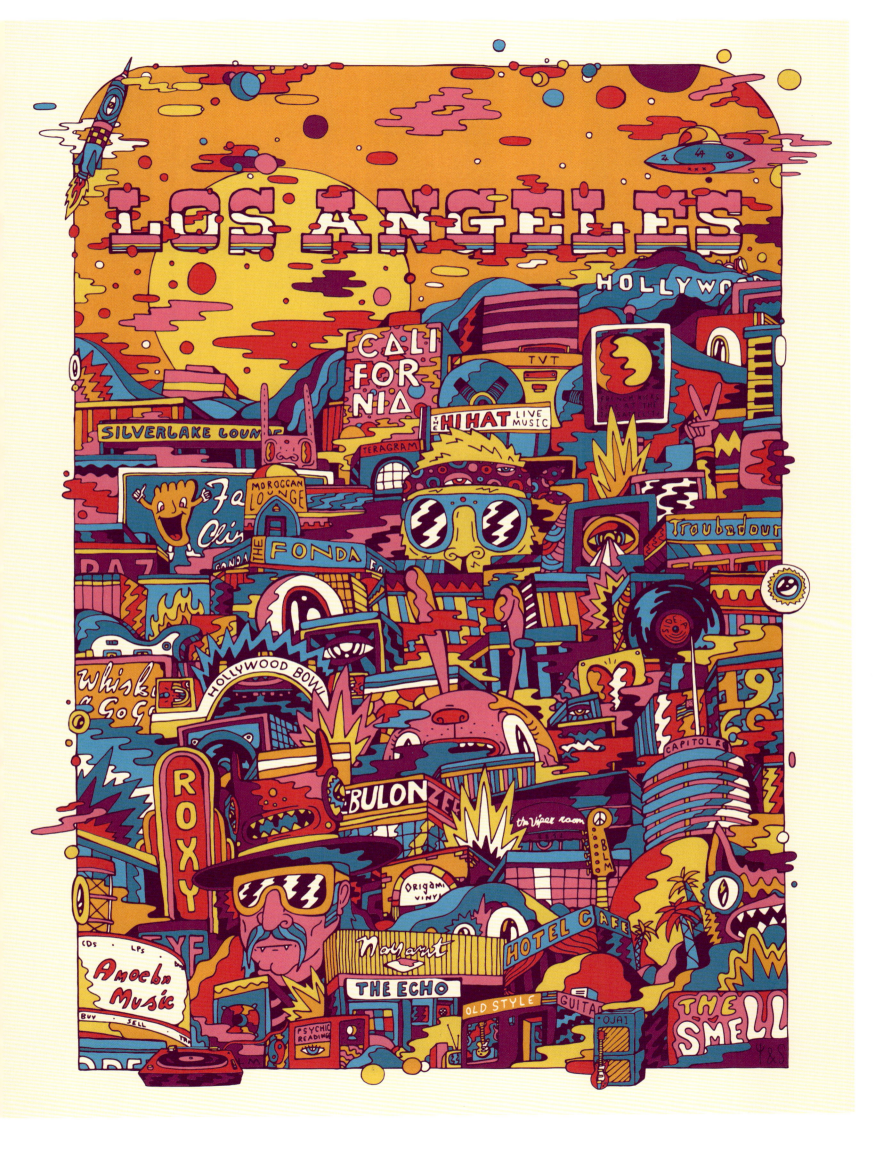

Playlist

This Select EP Playlist Curated by DJ Hesta Prynn

1. Troubadour *See the stars from Laurel Canyon to Paradise City* Venues don't get more legendary than the Troub. Since 1957, this West Hollywood staple just downhill from the Sunset Strip has hosted some of the world's biggest and soon-to-be-biggest acts on its small thrust stage. The room is intimate, dark, and perfect—there's not a bad view in the joint. This is where transplanted L.A. legends like Joni Mitchell, Neil Young, Tom Waits, and James Taylor got their starts; stand-ups like Lenny Bruce and Richard Pryor waxed obscenely; a bunch of bar habitues backed Linda Ronstadt then founded Eagles; Carly Simon, Elton John, The Byrds, Randy Newman, Billy Joel, Tim Buckley, and Neil Diamond played famous early sets…and it's where John Lennon punched a photographer after he and Harry Nilsson, drunk on Brandy Alexanders, got 86'd during a Smothers Brothers set. Through the years, it has remained the place for a legend to play a special show (a record release, surprise underplay, filmed or recorded set,

etc.) while also hosting amateur nights and multi-act local shows. From Radiohead to Coldplay to Dave Chappelle to Prince to Cypress Hill to Joe Strummer to Tom Petty to Guns N' Freaking Roses (then and now!), the Troubadour looms largest over the L.A. scene.

2. Hotel Cafe *A singer-songwriter's best friend* Since opening in 2000 as a coffeehouse performance space for singer-songwriters, the Hotel Cafe has expanded to become a larger-scale venue while maintaining its intimate heritage. Known around this big-industry town as an artist-friendly stage with an expectation for audiences to listen rather than chat (what a concept!), this cozy nook on Cahuenga Boulevard has helped launch the careers of Damien Rice, Sara Bareilles, Ingrid Michaelson, and Rachael Yamagata, while providing early exposure for giants like John Mayer, Adele, and Katy Perry. Hotel Cafe has also launched a record label, live albums, and its own tour—we're still waiting on that Hotel Coffee™ drip, though.

3. Bootleg Theater *Pretense-free music, theater, dance, and art* The Bootleg is one of the city's best and least-stuffy places to catch a multitude of live art all in the same building. It's not fancy—think plywood and brick meet house red and PBR—but that just keeps the spotlight on the artists. From world-class touring musicians (Arcade Fire, Angel Olsen, Jim James) and LA's own now-risen stars (Phoebe Bridgers, Cold War Kids, Father John Misty, Devendra Banhart) to engaging drama and comedy theater, art shows, dance performances, and special events, the Bootleg captures the multi-disciplinary spirit of a true Angeleno artistic multi-hyphenate.

4. The Mint *Blues, roots, and more for more than 80 years* This mid-city landmark has changed hands a couple of times but has never lost its place in the L.A. blues and roots scene. For more than 80 years, The Mint has hosted top-notch blues acts (Taj Mahal, William Clarke), legendary guitarists (John Mayall, Alejandro Escovedo), upstarts on

their path to fame (Ben Harper, Susan Tedeschi, Jeff Buckley, Macy Gray), and even Hollywood actors exercising their songcraft (Harry Dean Stanton had a regular gig here for years). It's a modern, comfortable take on the classic nightclub experience—private tables, quality food and drinks, and a relaxed yet intimate vibe. In true L.A. fashion, you never know who might stop by for a quick cameo.

5. The Smell *DIY or die* In a city where "don't you know who I am" and "I'm on the list" are given and taken as currency, The Smell stands alone as a bastion of open-armed DIY spirit. Since opening in 1998, this Skid Row-adjacent downtown mecca for the city's young (and young-at-heart) punk rock and art communities has operated as an anomaly: It's all-ages, not-for-profit, volunteer-operated, drug- and alcohol-free, and usually just five bucks to get in. Sure, it's called The Smell for a reason, but when you're crammed in to see epic acts like Moving Units, No Age, Mika Miko, The Mae Shi, Abe Vigoda, Lucky Dragons, and more, it's totally worth it.

LOS ANGELES

A SIDE

Troubadour:
Buffalo Springfield
For What It's Worth

Hotel Cafe:
John Mayer
Waiting on the World to Change

Bootleg Theater:
Grouplove
Tongue Tied

The Mint:
Jeff Buckley
Grace

The Smell:
Warpaint
New Song

SCAN TO PLAY

Los Angeles

Aaron Saltzman & Nick van Hofwegen aka Young & Sick

1. There are musical gems hidden all over L.A., not just the well known venues. Explore! Hotel Cafe, No Name Bar, The Masonic Lodge, The Hi Hat, The Smell, Hyperion Tavern.

2. The Dresden is a favorite haunt. Marty and Elayne have performed nightly for over three decades. A proper martini piano bar, and a must-visit.

3. Collaboration is the key in L.A. for artists. The city is packed with songwriters, producers, managers, label people, etc. Collaborating not only helps stretch the creative muscle, but can be a driving force in meeting all sorts of interesting folks.

4. Respect the 300-cap venues! Venues like the Moroccan Lounge, The Echo, The Mint, Hotel Cafe and No Name Bar (to name a few), are often pivotal in the early stages of an artist's career. Artists take these venues very seriously, and will often prepare for ages before playing the room. These may be some of the most authentic performances you'll see, and the artist may be the next massive act.

5. Les Paul designed the echo chamber for Capitol Studios on the ground floor of the Capitol Tower in Hollywood. The natural reverb is said to last for up to five seconds. This gave The Beach Boys' "Good Vibrations" that iconic sound. Nat "King" Cole, Frank Sinatra, and Dean Martin all recorded there. Capitol's archive of original recordings is top-notch.

6. The Troubadour's history is easily its own coffee table book. Elton John made his U.S. debut here. Guns N' Roses got signed to David Geffen after their performance here. Joni Mitchell, Eagles, Van Morrison, Tom Waits, and a plethora of other household names played the venue in the early pivotal time of their careers.

7. The Roxy was opened by David Geffen alongside a few other partners. The story is told that Geffen was fed up with the Troubadour's deal structures for new bands playing the space. The venue would book the band for at least two shows at the same fee. While the fee made sense for a first show, after the acts got popular, the entry-level fees felt unfair. Hence, The Roxy opened on Sunset to provide a new venue for young talent. The grand opening was a three-night performance by Neil Young.

8. If the recording studios in L.A. could talk.... This city has shaped popular music culture. While there are too many studios to mention in a ten tips list, two stand out immediately. Sunset Sound had acts like Led Zeppelin, Van Halen, and The Rolling Stones record there with modern acts like The Black Keys and M83. Over in the Valley, Sound City Studios is the home to Nirvana's *Nevermind*, along with a plethora of legends such as Johnny Cash, Neil Young, Fleetwood Mac, Elton John, Tom Petty and the Heartbreakers, Guns N' Roses, Nirvana, Red Hot Chili Peppers, Metallica, Death Cab for Cutie, and Fall Out Boy.

9. Check out Rockaway Records, a lovely vintage record store with an insane selection of collectible items, special editions, and rare stuff. Especially good for '60s and '70s psych and soul.

10. Old Style Guitar, a tiny guitar shop frequented by big names. They make their guitars and sell a ton of beautiful vintage instruments. The National even came and did an acoustic show for free.

11. In the back of a pizza shop in DTLA lies a hidden speakeasy and "listening bar" called 'In Sheep's Clothing.' It's modeled after a Japanese listening room popularized in Tokyo. The bar boasts a stunning sound system, beautiful wood decor, and plays incredible records all night. Pair it with a delicious Japanese whiskey. You can't go wrong.

Bootleg Theater

All the stuff we have taken for granted our whole lives has disappeared from that day. When it comes back, it's gonna be like, 'Oh, *thank* you! I *love* you!' Alicia Adams

Below: Stage at Bootleg Theater
Right: Alicia Adams, Co-Owner and
Kyle Wilkerson, Talent Buyer

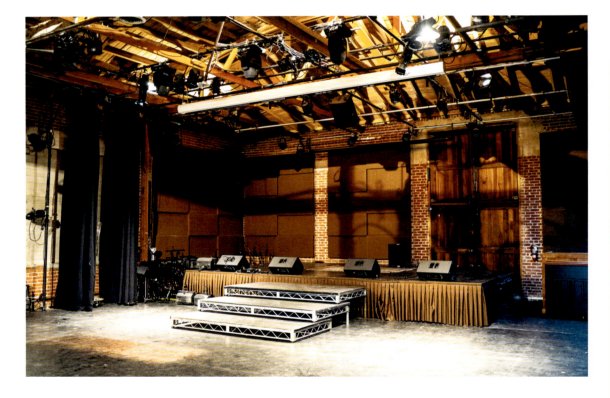

Everybody is talking about the community we've created here in L.A., specifically here at Bootleg. I feel like it's part of the fabric of the L.A. music scene...the art scene, the theater scene, too.
Kyle Wilkerson

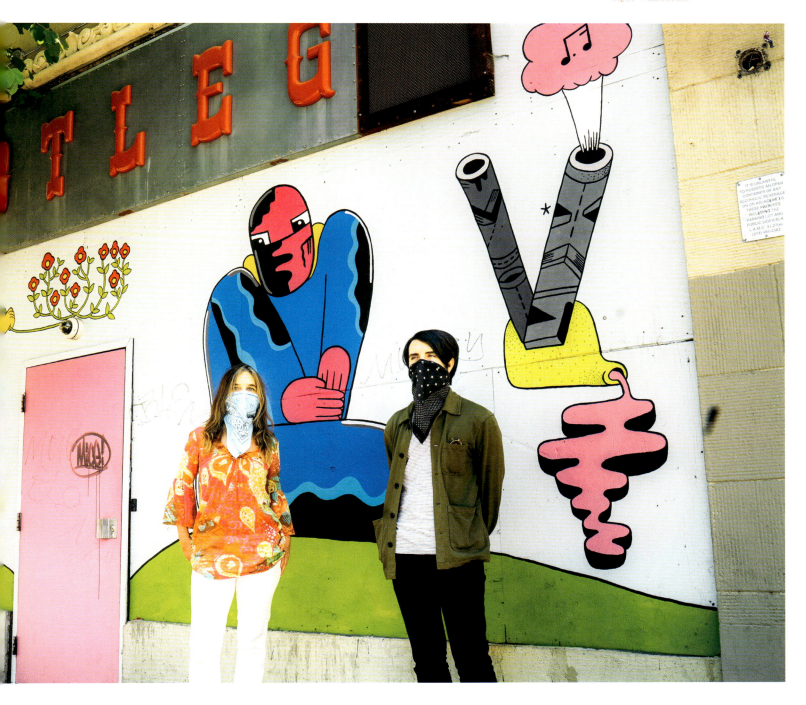

The Hotel Cafe

Above: Gia Hughes,
Production Manager
Opposite top: Gia Hughes
outside The Hotel Cafe
Opposite bottom: Stage of
The Hotel Cafe

If enough artists get comfortable with live-streaming, it could make a decent dent in what we go negative every month. It's not going to cover it, but it helps. We're going into debt, every day, every month. When we pop out on the other side, it's going to be substantial. But I think it's worth sticking around. We'll all figure it out on the other side. Money is just money.
Marko Shafer, Co-Owner

I do think it's important for us to persevere as an institution. We are a community hub here in Los Angeles. It's an important place, too, for artists to be who they are, and make art work. We're making sure they are in a safe and inclusive environment, where people can come and enjoy art in a safe space and just have a place to gather. I look forward to reopening our doors and discovering more up-and-coming artists and hoping that through this time, we've all been able to create more challenging art. Gia Hughes

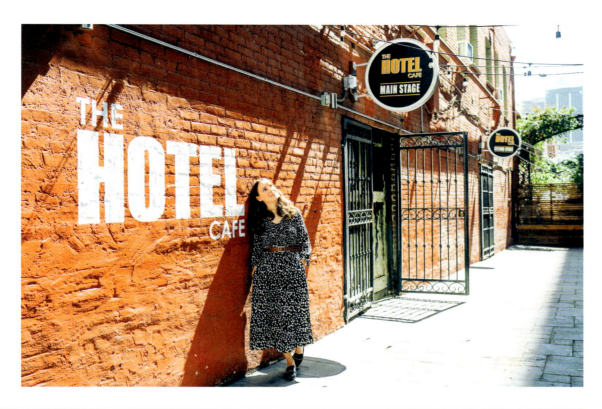

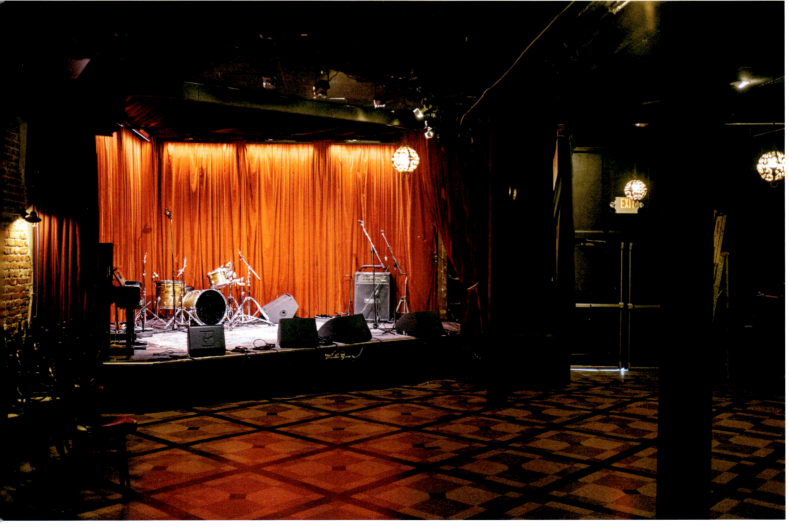

The Mint

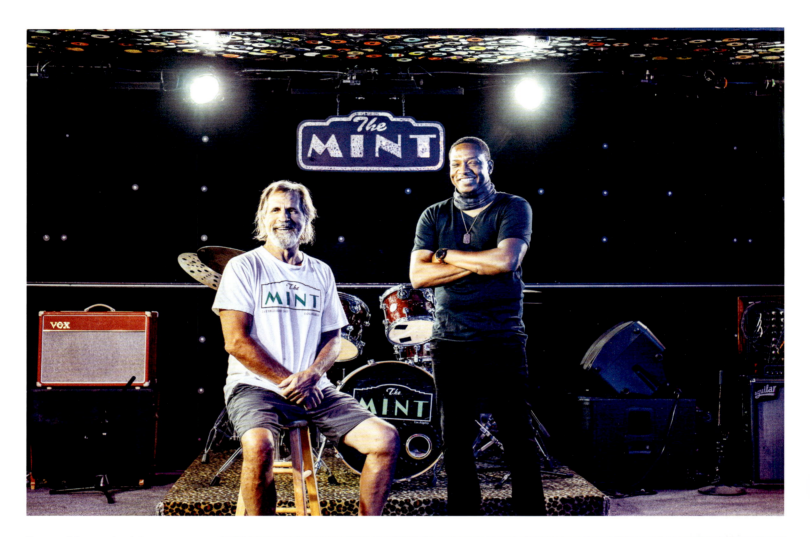

For me, [the pandemic] was a good time to write more songs. It was a good time to practice my craft more, learn more things about the guitar, about songwriting in general. It was also just a good time to really reconnect with family and build relationships more.

Caleb Henry, Musician (Caleb Henry and the Customs)

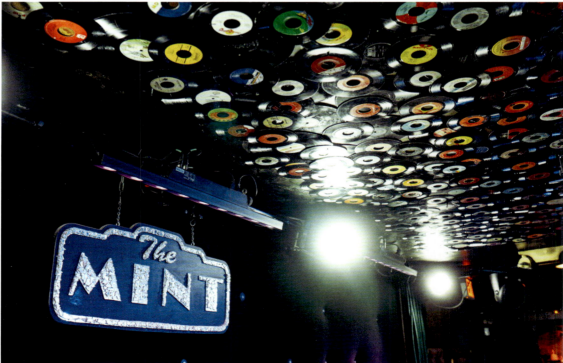

We've had a lot of characters in here. For me, the best part [about The Mint] is when the stars just come hang out. We've had Laurence Fishburne, you know…just rubbin' elbows. That's the best. Christopher Conway

A lot of people got their start here. Macy Gray, the Wallflowers, Ben Harper got signed out of here. We've had Jackson Browne, Bonnie Raitt. In addition, there's been a ton of great local artists who are.really amazing in their own right. Billy Bob Thornton has played here a few times, Dennis Quaid. So we get all kinds! Todd Christiansen

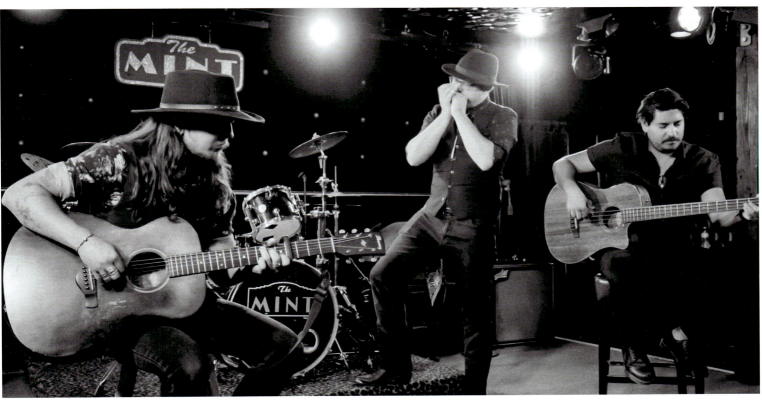

Opposite top: Todd Christiansen, Owner and Christopher Conway, Security
Opposite bottom: Ceiling of The Mint
Above: DJ booth at The Mint
Below: Caleb Henry & the Customs (Caleb Henry, Jake Strommen and Joseph De La O)

The Smell

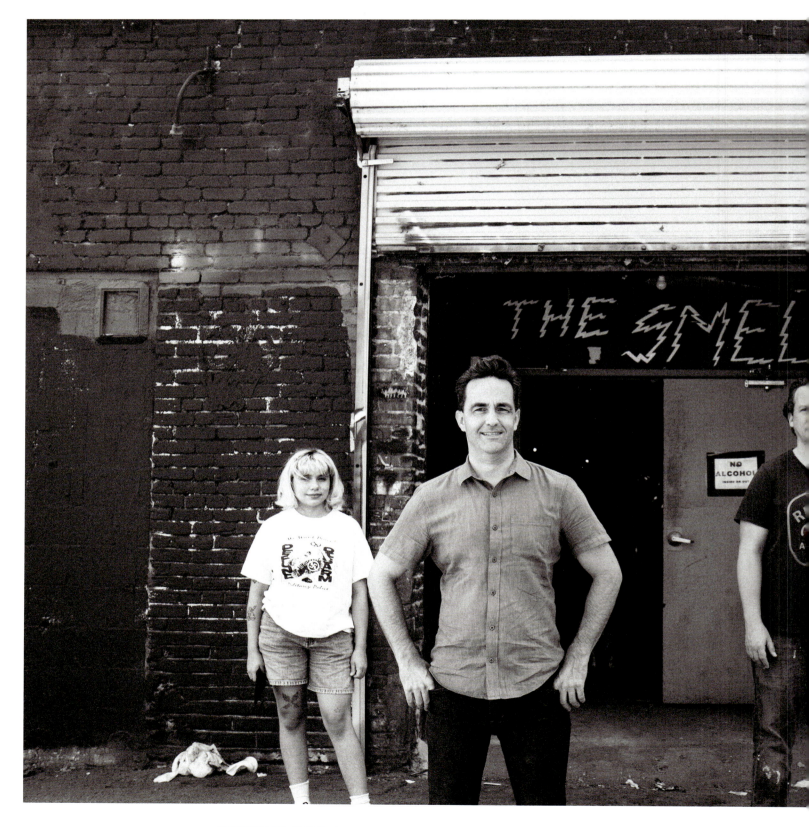

Stephanie Loza, Audio Engineer;
Jim Smith, Owner;
Randy Randall, Musician

I think what we learned from getting started, and from performing at The Smell in the beginning, was that the number of people doesn't matter as much as the community that you're a part of. We were able to recognize that within our home, and as we traveled and saw different parts of the world, we could recognize that in other places as well. There's a sense, an understanding, that it's not just about playing music. It's really about supporting bands and musicians, a community that exists all over the country and all over the world. Randy Randall

It doesn't surprise me that the [music] community is out there and their people are sticking together. The people care about each other. It's definitely inspired me. And it's given me hope we will get back to normal, and that when we do, the community will have survived this and still be there. That's inspiring. Jim Smith

Troubadour

Once we get to the other side, we plan to book the hell out of this place. Every single night. We have to make up for a lot of loss and just do what we do best. The thing about the Troubadour is it's 'what you see is what you get.' It might not be the most glamorous place, but it's a place where you walk in and you have that magic moment. I think that's what's special about this venue. We don't try to be glitzy, we don't try to be glam. And it's not about the Troubadour, it's about the artist sitting on that stage. We want the artists to be able to come back, we want new artists to come to play their new songs, and for people to come back and enjoy that community, that sense of heaven, for this one hour. I can just let it all go because I'm in a space where I feel safe, with other people like me. We are lost in that moment. Christine Karayan

I've been a bartender here for 17 years and I've loved every minute of it. I've had a front-row seat to music history, every genre of music. I couldn't see myself doing anything else. Our last show was the best show to go 'out' on—a sold-out Glass Animals show. The crowd was super into it, it was amazing! If we had to close, we closed with a good one. Alysia Behun-DuBrall

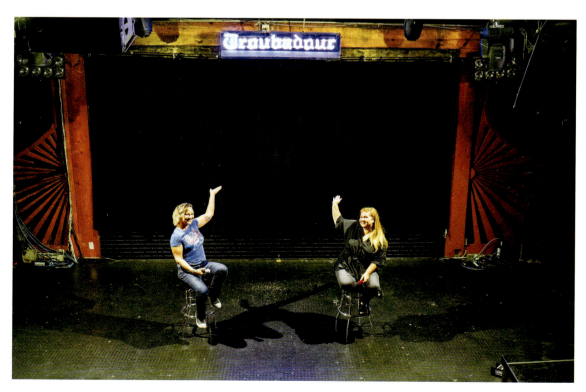

Below and right: Alysia Behun-DuBrall, Head Bartender and Christine Karayan, General Manager/Owner

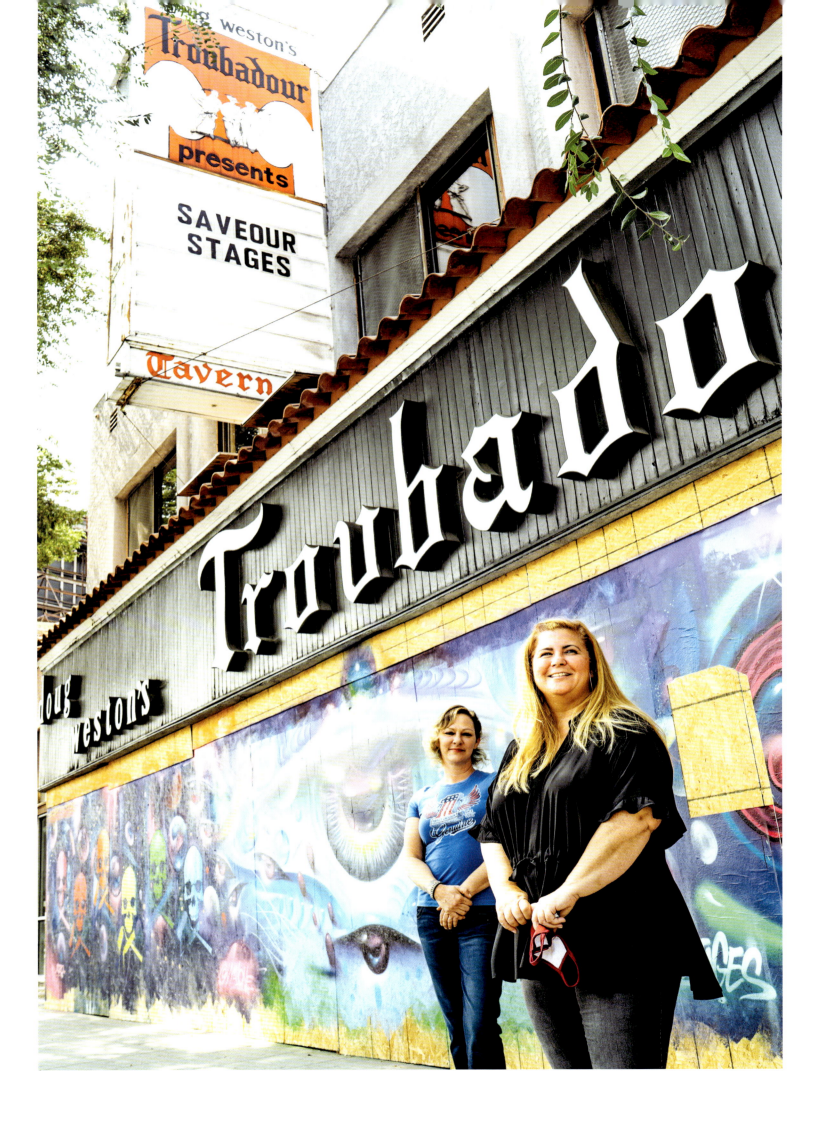

Memphis

POSTER DESIGN
Mia Saine

PHOTOGRAPHER + PRODUCER
Lawrence Matthews

VIDEOGRAPHER
Justin Thompson

MEMPHIS

Playlist

This Select EP Playlist Curated by DJ Hesta Prynn

1. Levitt Shell *Site of Elvis Presley's first show* A WPA bandshell built in 1936 in Memphis's famous Overton Park, Levitt Shell is a city institution that presents 50 free concerts every year and is perhaps best known as the site of Elvis's first paid performance, on July 30, 1954, opening for Slim Whitman. Having undergone several renovations and survived various attempts to bring it down, Levitt Shell soldiers on into yet another decade as one of the country's best and most beloved outdoor amphitheaters. Countless legends have played this hallowed site, from Chet Atkins, Carl Perkins, Wanda Jackson, Marty Robbins, Black Sabbath, and ZZ Top, to more recent acts like Seun Kuti & Egypt 80, Lukas Nelson & Promise of the Real, and Jenny Owen Youngs.

2. Stax Museum of American Soul Music *Catch a show in Soulsville USA* Formed by the sibling partnership of Jim Stewart and Estelle Axton in 1960, Stax Records is to soul music what Kleenex is to facial tissues. This one-of-a-kind museum and event space is located at the site of the label's original headquarters and offers guests the opportunity to peruse priceless relics and memorabilia from soul icons like Otis, Booker T., Mavis, Sam, Dave, and plenty more. Stax's famous Studio A also hosts live music events, and the entire place is available to be rented for private gatherings, weddings, and concerts. Or you could just lean back against Isaac Hayes's fur-lined Cadillac and pretend like you're one bad mother—*shut your mouth!*

3. Hi Tone Cafe *Catch a vibe from the live music, cold beer, and great food* Now in its third incarnation and nestled happily in Midtown Memphis, the Hi Tone Cafe is an intimate and much-loved club specializing in all types of contemporary music, amazing grub, and stiff drinks. It's open until 3 a.m. and mostly standing-room-only, so things tend to get sweaty—but in the best way possible. When headlining acts like Jason Isbell, The Hold Steady, Valerie June, or Curren$y come through, a night at the Hi Tone can feel like one of those "I was there when..." moments.

4. Crosstown Arts *Vertically cultivating Memphis's creative community* In 2010, the Crosstown Arts collective was created to both transform and inhabit the city's new Crosstown Concourse space—the rescued and converted 1.5 million-square-foot Sears Crosstown building that had been built in 1927, but remained empty for some time. Also, the collective's stated purpose is to help cultivate Memphis's creative community, and today thousands of Memphians "live and work, learn and teach, heal and grow, create and recreate, and shop and eat" in their new "vertical urban village." In a special nook within the Concourse, you will find The Green Room, an intimate venue highlighted by its exceptional acoustics and top-line sound gear. A truly flexible space that hosts a broad spectrum of performers from acoustic- and piano-led singer-songwriters to hip hop, jazz, and even orchestral groups, The Green Room is but one of many Crosstown spaces helping to put the city's creative community to work.

5. The CMPLX *Art gallery and venue space for The Collective, Memphis's own Black arts organization* The CMPLX is the multipurpose venue space operated by The Collective, Memphis's own arts organization dedicated to Black artists and communities. The Collective's threefold purpose—to elevate Black artists, empower Black communities, and shift the culture of Memphis—is helped infinitely by this inspiring creative space and stage, which had been active yet transient for several years before settling into this permanent location in early 2019. Located in the historic West Orange Mound neighborhood (the country's oldest, and first, neighborhood created by and for Black people), The CMPLX has its fingers on the pulse of the city's booming arts and music scenes and hosts multi-genre music performances, art shows, and dance events in addition to arts-based programming, workshops, and community-building efforts. As the slogan on the venue's facade reads: "Welcome Home."

MEMPHIS

A SIDE

Levitt Shell:
Elvis Presley
That's All Right

Stax Museum of American Soul Music:
Booker T & the M.G.'s
Soul Limbo

Hi Tone Cafe:
Valerie June
Shakedown

Crosstown Arts:
Talibah Safiya
Ten Toes Down

The CMPLX:
Beneviolence
Know

SCAN TO PLAY

Memphis

Tim Sampson

1. Royal Studios The home of Willie Mitchell's Hi Records since the 1950s, Royal Studios is now operated by his son, Memphis music kingpin Lawrence "Boo" Mitchell (named the 2019 Memphian of the Year by *Memphis* magazine). Hi was home to stars like Al Green, Ann "I Can't Stand the Rain" Peebles, Otis Clay, Syl Johnson, and even the Silver Fox himself, Charlie Rich. The studios' more recent projects include Bruno Mars' "Uptown Funk," Drake music videos, and a Memphis soul covers album by Melissa Etheridge. Physically, nothing has changed in 50 years: burlap and insulation are falling out of the ceilings, master tapes from Hi's golden years are stacked on shelves, the green room has fake green grass, and Al Green's famed microphone is still in place in the sound booth. Royal isn't technically open to the public but all visitors have to do is knock on the door and a Mitchell family member will happily let you in and show you around.

2. Talibah Safiya Tall, lanky, and beautiful, Talibah Safiya has quickly become one of Memphis's most prized soul artists. Using limited instrumentation, her songs are fine examples of powerful storytelling that connect intimately with the audience.

3. Scott Bomar and The Bo-Keys Not a household name in Memphis at-large but a standard-bearer within the Memphis music scene, Scott Bomar has filled a niche in the city for decades now. By adding longtime Memphis session musicians from Stax Records and Hi Records—in the studio, at gigs around the city, and touring extensively throughout Europe— he offers a modern twist on R&B. His Electraphonic Recording Studio is a maze of vintage recording equipment and is sought after by the likes of Cyndi Lauper and other stars who want that Memphis funk stamp on their sound.

4. B.B. King's Blues Club Yes, it is the anchor of touristy Beale Street, but fear not: The music is always top-notch. From the house band to visiting artists and special guests on special nights, you can't go wrong with this venue. The elegant supper club above it, Itta Bena, has no signage and a secret entrance, and you can catch some great jazz singers up there while you sip one of their knockout martinis and taste the she-crab soup.

5. Levitt Shell Levitt Shell is certainly no well-kept secret in Memphis. It sits outside in the city's famed Overton Park, a beautiful urban oasis designed by the same firm that designed New York's Central Park. It was where Elvis Presley delivered a breakthrough performance on Aug. 5, 1955, and has since been renovated into one of the best outdoor music venues in the country. Locals have traditionally brought lawn chairs, coolers, blankets, and the kids to one of the many free concerts offered during spring and fall.

6. Wild Bill's Tucked into a strip shopping center next to a discount grocery store in, well, not the best part of town (but certainly not the worst…don't worry, it's safe), Wild Bill's is the last of the real neighborhood juke joints in Memphis. With red walls, a tiny dance floor, chicken wings, white bread, and people from every walk of life imaginable, Wild Bill's bounces with thundering R&B music by some of the best singers and musicians in the world.

7. Stax Museum of American Soul Music Hallowed ground. Located at the original site of the famed Stax recording studios, this is the world's only museum dedicated to Stax Records and all other genres of classic American soul music. Filled with memorabilia related to stars like Otis Redding, Booker T. & the M.G.'s, the Staple Singers, Sam & Dave, and dozens of others, the museum tells a uniquely American story that could have only happened in Memphis. From the early-1900s African-American country church that was brought from the Mississippi Delta to celebrate the gospel roots of modern music, to Isaac Hayes's peacock-blue, gold-trimmed, fur-lined 1972 Cadillac Eldorado (complete with a TV and refrigerator), there's just no reason not to visit this gem on any trip to the city.

8. Yo Gotti & Friends Birthday Bash Every June, for one night only, Memphis becomes the hip hop epicenter of the universe as Memphis-born rapper Yo Gotti throws one of the biggest parties of the year at Downtown's FedEx Forum. It's glitz; it's glamour; it's a parade of hip hop royalty with guest artists like Nicki Minaj, Young Jeezy, Lil Wayne, and more.

9. Memphis Slim House Located across the street from the Stax Museum in the neighborhood known as Soulsville, USA, the Memphis Slim House is a configuration of the original home of jump blues singer, piano player, and composer Memphis "John Len Chatman" Slim, who lived at the site until moving to Paris in the 1960s. The original structure couldn't be "saved" but was carefully preserved in pieces, and much of the wood, bricks, and other elements were repurposed for the contemporary new building. This is where Memphis musicians and out-of-town guests gather to record and rehearse music, exchange ideas, see films and art exhibits, and collaborate on sounds from the past and the present.

10. Big Ass Lounge While technically the Big S Grill, the few people in Memphis who know about this bar lovingly refer to it as the Big Ass. A tiny white shack that's so hard to find, your Uber driver might have a tough time picking you up, this smoke-filled watering hole might have the country's only jukebox worthy of making a Top 10 city music list. On any Saturday night, with 40-ounce beers flowing and the jukebox blasting Shirley Brown, Bobby "Blue" Bland, Bobby Rush, and Johnnie Taylor, you wouldn't be surprised to hear the middle-aged women yell to the owners to turn it up even louder while asking you to dance around the tables with them.

The CMPLX

When the city opens back up, I see us taking it to the next level, because we're using this time to prepare for multiple outcomes. And I feel pretty confident that whatever the situation is, we will work our way through it. We always have. We'll find a way to make it work.
Damion "Dame" Smith

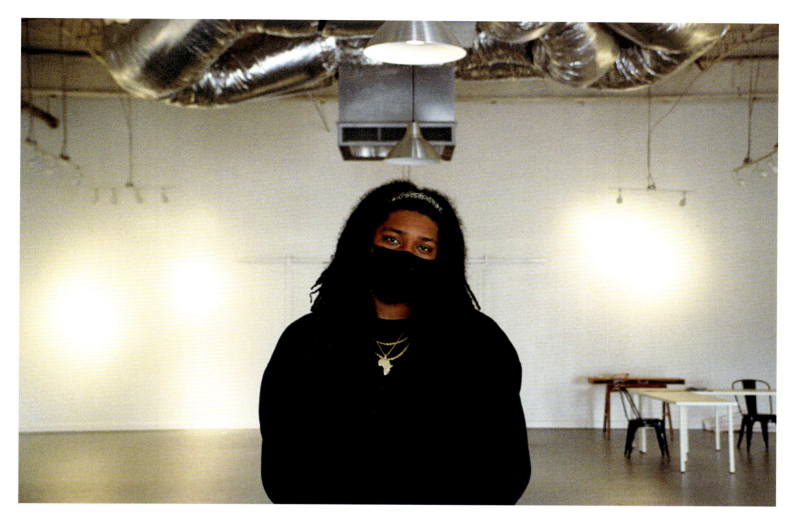

What the space means to me, especially as a director and a Black musician—I hoped in the beginning it would mean an opportunity for people to showcase themselves, a place where they could be taken seriously, and be supported [when they tried] to do something, not taken advantage of. A lot of times when you try to be a musician and you're in the development stage, it's really challenging if no one really tries to support you or if they have no interest in you outside of financial gain. So this was the space where that could just not be the case. Dame Smith

Opposite and above: Dame Smith, Musician/Operator

Crosstown Arts 430

Above: Ceiling lights at
Crosstown Arts 430
Opposite: Tori Nute,
Event Coordinator

As much as you think you understand the way the art culture works, you're probably wrong because it changes all the time. Seeing the way different artists and venues have endured through this insanity, where people's entire lifelines and financial ties are being cut entirely and it's out of their hands—the creativity and the strength of just trying to work through it has been incredible and really impressive. That's the whole idea of art, to surprise you, and to evolve. Tori Nute

[Crosstown Arts 430] began in the fall of 2013, as a local community space to offer an area for artists of all disciplines to come together and have the opportunity to share their art, and at the same time give an opportunity for people of all levels to do so. There's something about art that can be intimidating sometimes and that can feel like a really exclusive club. So, there is just a chance to provide something in the community to break down those walls and make this a space for everyone. Tori Nute

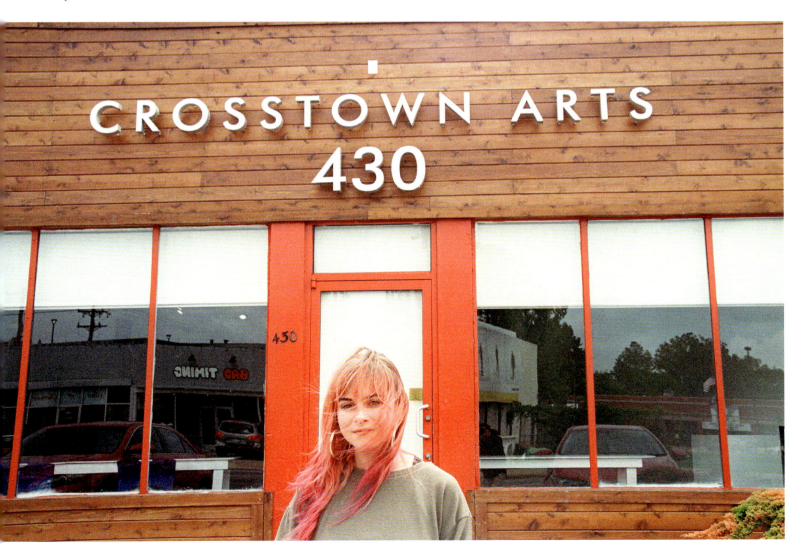

The Green Room

We can't have live performances right now but we still want to provide opportunities for Memphis musicians in whatever way we can. We started 'Against the Grain,' an online platform where Memphis musicians just record at home, and we put it on this website. People can also donate any amount, and 100% of those donations go to the artists. Jenny Davis

Opposite: Inlay on a table at
The Green Room
Above: Jenny Davis, Musical
Department Manager

There's a lot of great
venues in Memphis.
We are just trying to
add to what Memphis
has instead of
competing with what
else is happening.
So The Green Room
is more like a listening
room. Audience
members are
encouraged to come
in and out. We try
to program a lot of
different varieties of
artists as well.
Jenny Davis

Growlers

We do shows almost every night of the week, from country, hip hop, drag shows...it's a plethora. The people in Midtown Memphis are diverse, and we're a pretty diverse music venue. We've always put a big emphasis on local music here, too, even trying to put local musicians with the bigger acts coming through to show support, make connections, to network. I think touring music is going to be a little more difficult to get back to because people are going to have to route their tours. When everything opens up, [musicians] won't know which way to go. Tony Westmoreland, Owner

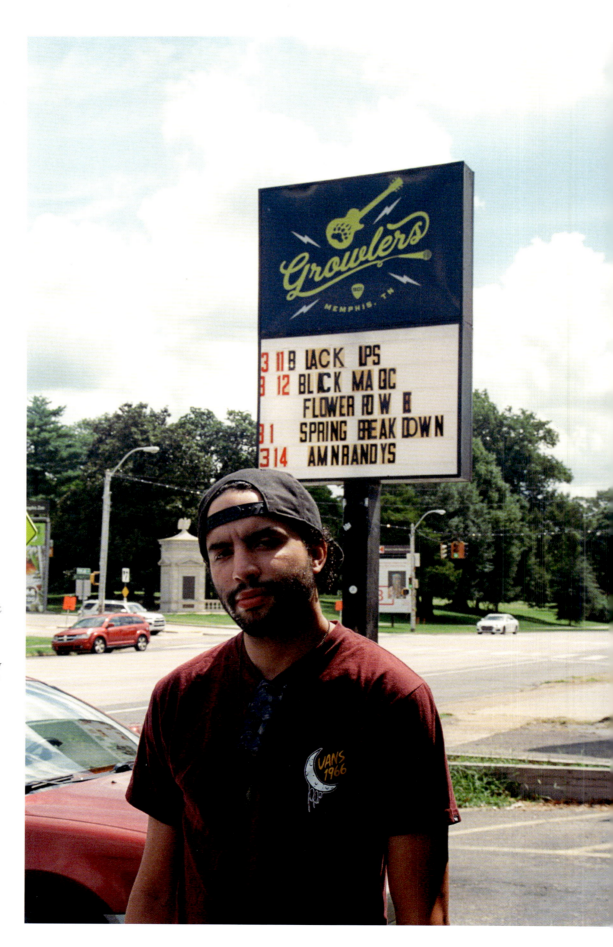

Every band that potentially can go on tour, that has the money to go on tour, is gonna get back on the road because that's where their income was coming from. It wasn't even really record sales or anything else. So there's gonna be a lot more bands touring, and we're gonna see a lot of bands that have never come to Memphis at all, or it's been 10-plus years since they've been here. Mark Schreck

Opposite: Mark Schreck, Operator
Below: Pool table at Growlers
Right: Mark Schreck

Hi Tone

We've gotten a lot closer as a staff [due to COVID]…just kind of being there for each other with everything that's going on. I think one of the biggest things is, we got each other's back. Corderoa Smith, Staff Member

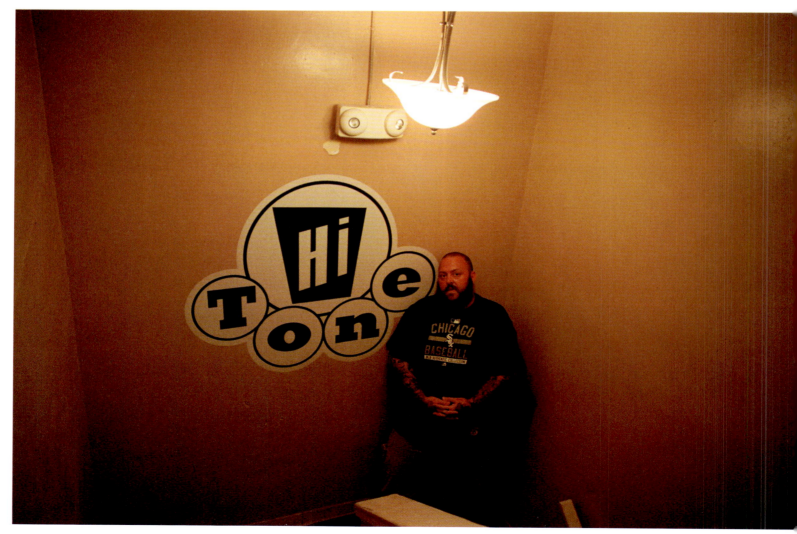

You know how it goes. A lot of times in the bar world you see an owner lose his business because he has a drinking problem, or a drug problem, or a gambling problem, or just burned completely out. But for someone like myself and everyone around me who have just enjoyed working in the community and presenting badass music on a nightly basis, to have that completely just ripped away, through no fault of your own—it's depressing. Brian "Skinny" McCabe

Opposite, top and bottom:
Brian "Skinny" McCabe, Owner
Above: Neon lights at Hi Tone

Levitt Shell

One of the really fun things about Memphis—we are tight. We fight for each other. There is a reason the city is the grit and the grind. We're open to anything we can do that makes Memphis stronger, whether it's for artists, or for teachers. It's a sweet city to be in, because we really do champion each other. Cindy Cogbill

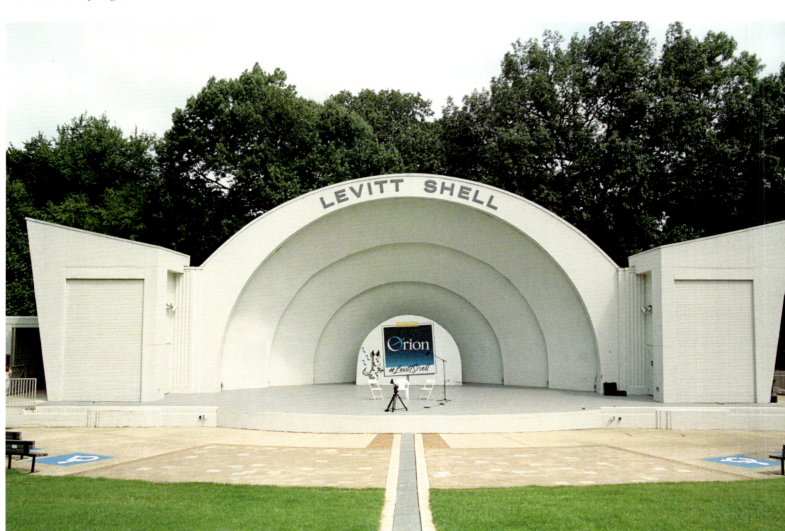

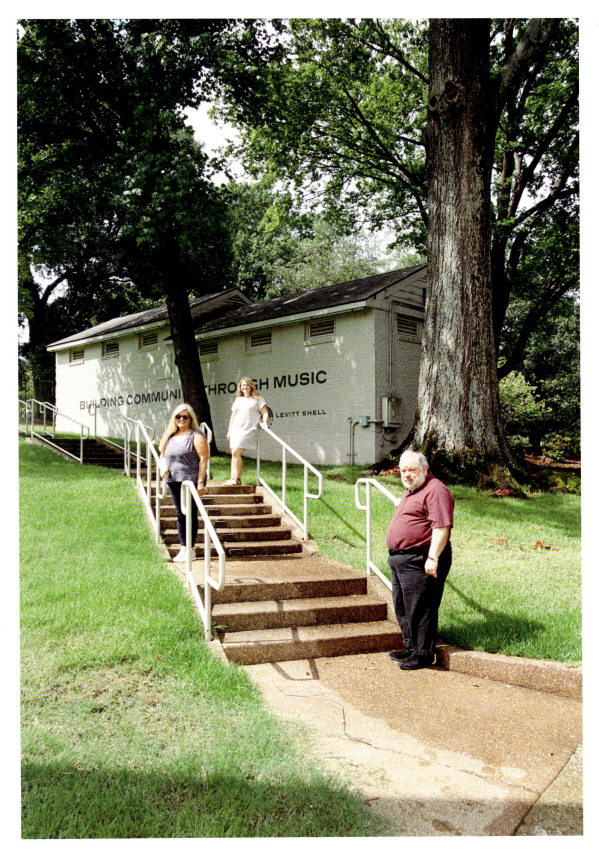

Levitt Shell was created during the Great Depression, to build morale, bring people together in the community and make people feel like there was hope again. As much as music is essential to us now, we feel like our people are the most essential. In the care of our community, health is No. 1. The music will come back, but right now it's just about taking care of each other. Natalie Wilson

Opposite: Stage at the Levitt Shell
Above: Natalie Wilson, Executive Director; Cindy Cogbill, Director of Programming/Marketing; David Less, Memphis-based Author

Stax Museum

We are on the grounds of the former Stax Record Co., which moved here in 1968. It got started up in North Memphis in 1957. They turned an old movie theater into one of the premier recording studios in the country, making some of the greatest American popular music ever, from Otis Redding and Sam & Dave to Staple Singers and Isaac Hayes. One of the things we do that sets us apart from other music museums here in Memphis is our regular slate of free public programming that really tries to appeal to the locals [The programming] allows us to showcase some of the great Memphis musicians playing today, and at times showcase some of the former Stax legends who used to record at 'Soulsville USA.' Jeff Kollath

Above: Vintage car at Stax
Below: Display at Stax
Opposite top: Interior at Stax
Opposite below: Brandon Dickerson, Musician/Staff Member and
Jeff Kollath, Executive Director

Just being in love with the music, in love with the history, and then graduating from the program [Stax Music Academy] and seeing other young people come up—I just wanted to help them. My love for this place, for the music, the story, the history, the community—I just kept going.
Brandon Dickerson

Miami

POSTER DESIGN
Natasha Tomchin

PHOTOGRAPHER
Karli Evans

PRODUCER
Natasha Tomchin

Miami

Natasha Tomchin

1.　TK Disco The TK Disco empire was started in 1972 in Miami by South Floridian hitmaker Henry Stone. Heavyweight artists like T-Connection, George McCrae, Timmy Thomas, KC and the Sunshine Band, Jimmy "Bo" Horne, The Jimmy Castor Bunch, Betty Wright, and countless others rose to fame under Stone's umbrella of labels that gained prominence in the days of disco. Although the label went bankrupt in 1981, Stone's influence in shaping musical history with a sound that is distinctly provincial has not been forgotten: As of 2013, October 12 is recognized as TK Records Day in the Miami-Dade city of Hialeah.

2.　2 Live Crew Although the 2 Live Crew originally hail from California, it wasn't until they joined forces with Miami native Luther Campbell (aka Uncle Luke and Luke Skyywalker) that the explosive story of their careers was launched. 2 Live Crew's success took Southern rap and the sound of Miami Bass into the stratosphere with what was arguably the most explosive, infamous, and controversial act of the '90s. Their music was banned from being sold in local South Florida record shops and the band themselves were arrested for performing their signature provocative material. A court found members of the band guilty for violating obscenity laws but the judgment was appealed all the way to the Supreme Court, which eventually ruled in favor of Uncle Luke in what became a monumental battle over race and censorship.

3.　Winter Music Conference For decades, electronic music enthusiasts and DJ's have flocked to Miami during the winter to go bananas. Some call it "Ultra Music Week" or "Miami Music Week," but this internationally recognized tradition began in 1985 with the Winter Music Conference. Every March, music industry panels are held, technology showcases are presented, and many parties take place. With 100,000-plus annual attendees, WMC is a premier scene for electronic dance music and one of Miami's most lucrative tourist attractions.

4.　Murk/Murk Records In 1991, Miami DJ/producers Ralph Falcón and Oscar G formed the house music duo Murk as well as the Murk Records label. Widely acknowledged as pioneers of a futuristic house sound, the duo were visionaries who foresaw the heights to where dance music would eventually elevate. Murk went on to release a wide spectrum of underground cult jams, prime time anthems (under the alias Funky Green Dogs), and remixes for major artists including Madonna, Pet Shop Boys, Donna Summer, Seal, Britney Spears, Jennifer Lopez, Moby, Depeche Mode, and Daft Punk. Always proud to put Miami on the map, Murk immortalized local landmarks and neighborhoods by releasing music under aliases like Coral Way Chiefs and Liberty City. Today, they continue their work independently as DJ's and producers, with Oscar G hosting a weekly residence at Miami's 1-800-Lucky.

5.　Schematic Music Company Founded in 1995 by Miami natives Joshua Kay and Romulo Del Castillo, the record label Schematic Music Company is all about IDM, Miami Breaks, and promoting the farthest regions of experimental electronica with an art-first attitude. Kay and De Castillo are recording artists in their own right with a successful release in 1997 on the prestigious Warp label under the name Phoenecia. They went on to self-release on Schematic as well as to debut an impressive list of U.S. talent including Richard Devine and Otto Von Schirach; they also collaborate with the likes of Autechre, Jamie Lidell, and Miami's own Danny Daze.

6.　Sweat Records A small business of which Miami is proud, Sweat Records has been making an impact on the scene for more than 15 years. In addition to being a mission-driven cultural and social space, Sweat Records is also a world-renowned record shop. (It's a favorite of Miami transplant Iggy Pop, who has filmed several music videos in the store.) A local institution in the neighborhood of Little Haiti, Sweat is now an official music imprint (with a debut LP release from Richie Hell) as well as a community events production machine, with more than 800 dates under its belt.

7.　The Electric Pickle Company The Electric Pickle Company launched in 2009 and hosted a powerful list of dance music's finest (including Little Dragon, DJ Harvey, Soul Clap, Wolf + Lamb, Seth Troxler, Moodymann, Doc Martin, DJ Three, and more) before it closed its doors forever in summer 2019. With its constantly changing interior, intimate and packed dance floor, signature bolero/spaceship disco ball overhead, and supercharged sound system, The Pickle was known around the world and recognized by the music press as among the world's best dance clubs. Although Miami's dance music community suffered a huge loss with the closure of what was Wynwood's longest-running nightclub, owner Will Renuart has since opened a new club with some of the old Pickle charm (and decorations) in Downtown Miami called ATV.

8.　Club Space For more than 20 years, Club Space has been a nightlife cultural phenomenon in Downtown Miami. Known for its marathon-like hours of operation, Space is one of America's only electronic music venues to regularly promote 24-hour parties. On special occasions like national holidays, WMC, and Art Basel, the marathons have stretched even longer—on one occasion, Space hosted a record-breaking 32-hour DJ set from Bronx-born duo The Martinez Brothers. For the brave, there's a tradition known as "breakfast at Space," which means arriving at 6 a.m. to catch the sunrise on the terrace atrium dance floor…and then staying forever.

9.　Gloria Estefan Gloria Estefan is a Cuban-born, Miami-raised, seven-time Grammy Award-winning artist who has maintained a lifelong relationship with her adopted home. Her experimental infusing of Cuban music and rhythms into contemporary pop music propelled her to become the most successful Latin crossover performer in history. In 2015, Estefan was awarded the Presidential Medal of Freedom by President Barack Obama for her contributions to American music. And in 2020, she released a new album called *Brazil305*, which fuses her sound with the music of Brazil, including exciting re-interpretations of her hits like "Rhythm Is Gonna Get You."

10.　The North Beach Bandshell The North Beach Bandshell is located in the heart of the Miami Beach MiMo Historic District and is described as "a futuristic take on a Roman amphitheater." It was designed by Norman Giller (the man who made Miami modern) in 1961 and is one of Miami's most iconic venues. Owned by the city of Miami, the Bandshell was taken over in 2015 by The Rhythm Foundation, a Miami Beach-based nonprofit cultural organization.

1-800-Lucky

I have been DJ-ing for Sven and the team for five years. It's really tough right now because there is the aspect of survival. That means a lot of things to a lot of people. To me survival means let's not get sick, but at the same time there's the survival of money and your living. So there is a struggle there, where people are making decisions based on surviving. Oscar G

Above: Entrance to 1-800-Lucky
Below: interior of 1-800-Lucky

We are fortunate to have an outdoor area where people can still come and eat and still listen to music. We do have DJ's playing here on the weekends. We just really monitor for safety purposes. It's not a stand-up dance party but we still are able to have music. I understand there is the business side of things and then there's the going out and booking entertainment and getting back to the party to a certain extent. I know it's been hard for a lot of us, but speaking for myself, someone who did have COVID, it sucked. It was really really hard and I am personally down to wait. We have been able to figure out a way as a business how to sustain and make it until things open back up and I am really hopeful that some of the other businesses can do the same thing and maintain through this downtime until we are safe to open again. Sven Vogtland

ATV Records

ATV is a liquor-fueled love machine for the dance floor enthusiast.
Will Renuart

I am still learning [to find inspiration] each and every day, but I think if anything, this moment in time is a unique experience to take a step back and reflect and get in touch with yourself and your loved ones and the world around us. Hopefully all this creative energy coming out right now is going to come out on the other side—come to fruition—and there's going to be a lot of interesting music, art, and culture. Definitely something to look back on for the history books. I have been working with Will from ATV and his former club, the Electric Pickle, for a long time. Easily 10-plus years of a wild circus ride of music and nightlife culture in Miami. ATV had a glorious opening and a week of programming ready to go for Miami Music Week. It's really a shame that COVID came and shut everything down because it feels like they didn't really have a chance to get that flow going. Our party—House of EFUNK—was one of the early events to get cancelled and it was heartbreaking.
Charles Levine

Top left: Charles Levine (aka Charlie from Soul Clap aka Lonely C), Artist
Top right: Bolero Ball at ATV Records
Above: Will Renuart, Owner

Churchill's Pub

There are a lot of hardworking people behind the scenes who have to put the pieces together to make those magical moments happen on the stage. If we aren't doing our job behind the scenes, when it's time to open that ticket gate, it doesn't work. You have to have the right people here, organization and sanitation—a lot of stuff that isn't sexy to talk about. But now we are asking our hospitality professionals to become public health professionals as well and make sure sanitation and health guidelines are met. So there's continuing education involved there, tracking, admin, and a lot more stuff that's not really talked about. So we're expecting industry professionals to still carry the workload they have been carrying, deal with their own health and safety, and now they are also going to be monitoring people. So we will see. A lot of unknowns are going to come at us. Franklin Dale

Above: Otto Von Schirach, Artist, in front of the mural outside Churchill's Pub of Otto and Oscar G, Artist (not pictured), by Ahol Sniffs Glue
Right: Franklin Dale, Manager
Below left: Franklin Falestra, Talent Booker
Below right: Interior of Churchill's Pub

I have talked to a lot of musicians during this time and some tell me this is going to be a great reboot, because we have so much time to create powerful music. The angst and the change in America right now—the power of that will hopefully transmit through the frequencies. The music of this time should be phenomenal. And the music industry needs a reboot. Franklin Falestra

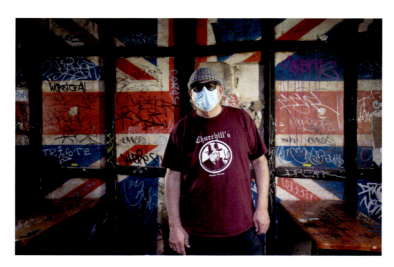

Club Space

Above: Staircase to Club
Space Terrace
Right: Alan Tibaldeo (aka Alan T),
Door Personality at Club Space
Below: Coloma Kaboomsky,
Co-Owner (LinkMiamiRebels)

Before we started our journey with Space, it was a nightclub [that] had been around for 16 years, and it was notorious for many different things. We were faced with many challenges starting out on this journey. So we decided we would partition the space to represent many different styles of music culture in the city. The terrace is the iconic terrace that it is with the 24-hour parties: techno, house, electronic, dance music. In The Ground, with our III Points family, we were really able to bring a lot of live music from all different genres—from gong shows and meditation to jungle, rap, fkj, death metal, jazz. You also have Floyd on the first floor, the smaller 200-person room with more intimate vibes where we can bring in a lot of up-and-coming artists that not a lot of people know. Between the three rooms, we have a really nice time here. We were also very lucky that a lot of ticket buyers chose not to accept their refund and donated their refunds to the club. A lot of the ticket buyers that bought a Miami Music Week pass at Space for the entire week, which is a pretty expensive pass at $300, decided to donate that to the club. When I think about those people, imagine, it definitely gives me a lot of drive. It gives the team a lot of drive. I have been getting DM's about when we are opening, how much they miss us, how much they love us. It's a framework we have created. Have a good time or nothing. If it's not a good time then you weren't here. That's the way I like to say it.
Coloma Kaboomsky

Coyo Taco

Below: Oscar G, Artist, photographed at 1-800-Lucky
Right: Sven Vogtland, Owner/Founder (Coyo Taco and 1-800-Lucky), photographed at 1-800-Lucky

Coyo Taco is a taqueria I opened here in Wynwood about six years ago with my partners, with a little secret speakeasy in the back where we have some great musicians performing. We have had to pivot. With Coyo, we opened to more of a delivery model and opened ghost kitchens or satellite kitchens that aren't brick and mortar, so we are able to deliver to other markets we aren't in right now. It's done very well for us in the past six months. These six months have been really beneficial for time down and spent with friends, family, and loved ones we would not have had during normal business operations. I do feel that bond. There's a lot of people checking in on each other, which maybe we wouldn't have had if we were so caught up in our normal daily grind. Sven Vogtland

The Fillmore Miami Beach

I have been at The Fillmore going on six years, and in the concert business 10 years. People have a connection with music and art in general. It's more than just buying a T-shirt or an inanimate object. Things that happen here leave an imprint on people. This venue is historic, here since 1957 and [operated] under a number of different names. There's not a lot of venues this size that can cater to larger artists, but have an intimate feeling at the same time. This building is very unique because we can handle arena-size production in a 2,700-capacity general admission theater, or 2,400 if we do reserved seating. Giving opportunities to people who are in the city every day making things happen is super important. Greg Johnston

The question always becomes, 'What do you do during the dark time?' So here, the biggest thing is they started a COVID-19 testing facility right behind the building, and the National Guard is helping coordinate the COVID-19 testing at the Convention Center. We have been helping them out with parking spaces and things like that. We partnered with the Community Office at the City. They are using our walk-in refrigerator to provide food and things to the homeless. This has allowed them to expand their footprint with perishable items like milk and cheese. We are here and we can be used if they need us. Trenton Banks

Above: Marquee of The Fillmore Miami Beach
Right top: Greg Johnston, Senior Marketing Manager
Right below: Trenton Banks, General Manager

North Beach Bandshell

We have this opportunity [during COVID] to put some of the best artists in this community on the [online] platform we have been able to create and expose them to the international audience we've cultivated. We aren't looking to wish this away. Instead, we are figuring out ways we can support our local ecosystem and showcase them in these times. Benton Galgay

Above left: Richie Hell, Artist
Above right: Francisca Oyhanarte, Artist
Right: Outside of the North Beach Bandshell
Below left: Benton Galgay, Deputy Director (The Rhythm Foundation)
Below right: James Quinlan, Co-Founder/Director (The Rhythm Foundation)

Sweat Records

One of the things we are really grateful for is that last year we built an online shop. Thankfully, when all this started, we were just getting it launched and it's really been a lifeline for us. It's really cool that most of our regular customers who we used to see in the shop on a weekly- or couple-times-a-month basis have adapted and are now ordering from us. We are really thankful to everyone who has been as adaptable as they can be and are still buying records from us online. Because that really is how we are able to pay our rent, pay our employees—the ones we have been able to bring back—and to keep us going. We'd love to make it 20-25-30 years and be there for all the people and the next generations of kids growing up in Miami and everyone here now who loves music. Lolo Reskin

Top: Lolo Reskin, Owner/Co-Founder
Above: Interior of Sweat Records
Right: Portrait of Iggy Pop at Sweat Records

Minneapolis

POSTER DESIGN
Alexis Politz

PHOTOGRAPHER
Sahra Qaxiye

PRODUCER
Asia Mohamed

envisioning a
new tomorrow

MIN
NEAP
OLIS

1312

black
lives
matter

Minneapolis

Alexis Politz

1. Minneapolis is that sweet spot where stardom meets a hometown classic. A lot of big names come from here without ever making it into a big deal. It's a special place that's had its ass kicked and is working on reforming what it means to be an honest musician who deserves the spotlight.

2. First Avenue is one of the longest-running independently owned venues in the United States. Formerly a bus station-turned-danceteria in the '70s, the nightclub has hosted international acts of all kinds. The First Ave. & 7th St. entry has 531 stars, each with the name of a past performer, painted on the exterior of the building.

3. Sound 80 in downtown Minneapolis is the world's first digital recording studio. It has engineered albums by local legends like Prince, Bob Dylan, The Suburbs, and more.

4. James Samuel "Cornbread" Harris worked on the first Minnesota rock 'n' roll record in 1955 and still plays the blues and jazz at bars in the Twin Cities. His son, Jimmy Jam Harris, a former member of The Time, is a producer and engineer alongside Terry Lewis. The duo has produced more Billboard No. 1's than any other team, including Janet Jackson's album *Control*.

5. Underground DIY music absolutely flourishes here through small venues and basements alike. There's always a show to go to, even in -10 degrees. There's a scene here for just about every genre, from electronic to folk to rap to rock 'n' roll.

6. Minneapolis in the 1980s spawned the Holy Trinity of rock 'n' roll: The Replacements, Soul Asylum, and Hüsker Dü.

7. Eyedea, Nur-D, Psalm One, and Manchita have all made huge names for themselves in the underground hip hop and rap scenes in Minneapolis, while GRRRL PRTY, astralblak, and Blood $moke Body are some of the most innovative, dynamic groups that have ever been formed.

8. Nonprofits like She Rock She Rock and DJ-U are great resources for young femme, trans, and non-binary folks to get into the music and DJ scenes. They operate camps, classes, and other activities to teach kids how to play music and scratch from the ground up.

9. Copycats Media/The ADS Group is the United States' largest CD manufacturer. The company works with everyone from local musicians to the big record labels and international favorites.

10. Mint Condition from Minneapolis is credited as one of the last major funk bands to have multiple albums chart. They were nominated for several Grammy and Soul Train Awards, then entered the Soul Music Hall of Fame in 2012.

First Avenue

Nate Kranz: I grew up coming here. First Avenue is my home team stadium. This is where I grew up and then I got to play for the team. That's everybody's dream, right? And I miss everything about it. I miss my coworkers. The last time I saw Dayna was March 12...

Dayna Frank: Are you *real*? I can't tell!

Nate: I miss my friends, too. We're a family around this place, so it's crazy. I miss the customers and I miss the bands.

Dayna: You think a lot about what First Avenue means, not just as a building, but what it means to have First Avenue in Minneapolis. It almost feels like the two are so symbiotic, you can't have one without the other. It's infinitely important that these stages are used to rise up every voice in our community. It's hard given the economic demands, but we're making sure members of our community know that this stage is for them and that they have access to it. 2020 was set to be a big year, especially for us with our 50th anniversary. We had a whole year of really cool collaborations and underplays and shows that I've been waiting to see my whole effing life booked and ready to go. Hopefully we'll get to have the best 51st anniversary in the history of rock 'n' roll.

Above left: Dayna Frank, Owner and
Nate Kranz, General Manager
Right: Interior of First Avenue

The Garage

Above: Interior of The Garage
Right: Jack Kolb-Williams, Executive Director (Garage)/ Executive Director/ Co-Founder (Twin Cities Catalyst)
Below: Interior of The Garage
Not pictured: Nicole Fallon Breidel, Director of Ops, Twin Cities Catalyst Music

A lot of people are losing their livelihood and their ability to do what they love to do. That's really heartbreaking and really hard to see on a daily basis. But I think what's going to come out of this is that local music is going to be the most important thing we have. Music venues across this country need to recognize that local music and musicians and their live audiences are the first thing that absolutely need to be reconnected. [COVID] has certainly created a lot of camaraderie among folks within our industry who had generally been in competition with one another. We're now seeing the bigger picture of the impact we can have when we do come together, in groups like NIVA, and call for change.
Jack Kolb-Williams

Palace Theatre

Below: Interior of Palace Theatre
Opposite: Mezzanine seating at the
Palace Theatre

I hope to never take it
for granted again. I will
admit when it is your
daily life, you don't
appreciate how special
it really is. There's a big
gaping hole I hope we
can fill again one day.
Dayna Frank, Owner

The Parkway Theater

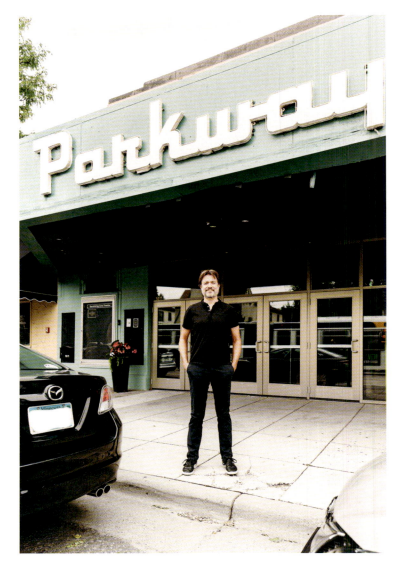

Below: Stage at Parkway
Right: Ward Johnson, Owner

The hope is that when all of this is over, Monday, Tuesday, Wednesday, Thursday, and Sunday will be the new Friday and Saturday. People are going to want to just go out and be around other people and take part in these communal activities and have fun. I try to look forward to that day, that's the big prize. Everything that happens between now and then is going to be really hard, but if we can keep our eyes focused on that big prize at the end, then we can get there. These small, independent venues are how artists are able to grow in popularity. Look at any of the bigger names from Minneapolis: They all got their start at a small independent venue. You don't just start out playing for a Live Nation national conglomerate. This is how you come up through the ranks as an artist, and for a lot of local musicians, this is how they make their living. These local independent venues are really the lifeblood of the independent music scene. Ward Johnson

The Warming House

The Warming House is more than a space: It's a community. We are really looking forward to finding the perfect spot to reopen and make it better than ever and more accessible to more people.
Brianna Lane

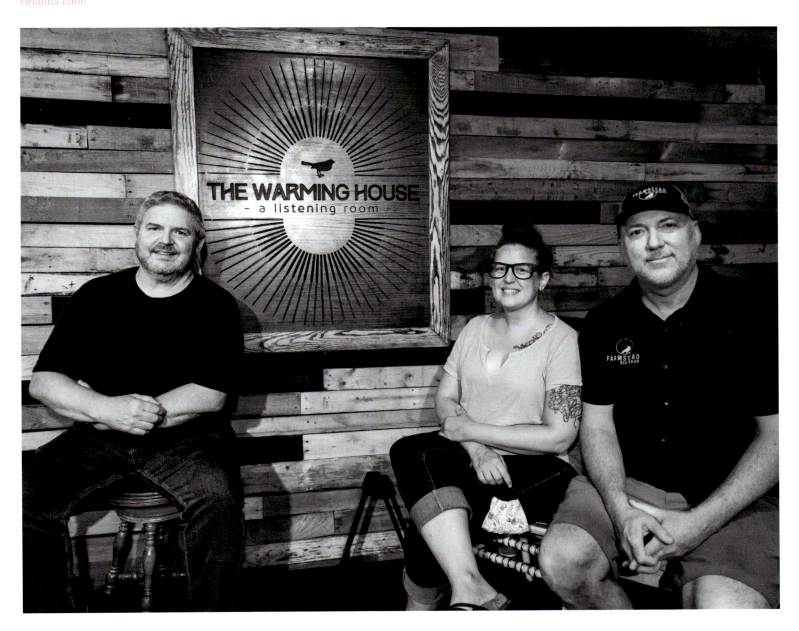

Live music venues are church for so many people and it's not going to disappear. It's going to look different, but it's an essential part of our world and we will find a way to bring it back in some form. I remain hopeful about that. We all need to do what we can to help make sure that happens.
John Louis

Above: John Louis, Founder; Brianna Lane, Founder/Executive Director; Greg Neis, Founder

Part of our mission is to bring new musicians up and give them a place to perform and get used to their stagecraft. When I think about the work we do in this venue in that space, that's getting lost right now. Greg Neis

Nashville

POSTER DESIGN
Josh Shearon

PHOTOGRAPHER
Andrea Behrands

PRODUCER
Amanda Matsui

NASHVILLE

Playlist

This Select EP Playlist Curated by DJ Hesta Prynn

1. The Station Inn *A roots and bluegrass institution* Nestled in a pocket of downtown called The Gulch, The Station Inn is where you go for real authentic bluegrass, and maybe to spot the next big act. The place opened in 1974 but JT Gray's been running the show since 1981, and in 2003 he received the Distinguished Achievement Award from the International Bluegrass Music Association for the venue's contribution to the furtherance of bluegrass music. Bluegrass heavyweights like Bill Monroe and Jimmy Martin used to stroll in after performing at the Grand Ole Opry and sit in with the house band, and it's maintained its reputation as an unassuming hang for well-established and up-and-coming players alike, so long as you've got the chops to keep up.

2. Rudy's Jazz Room *Finest jazz in town* Just 10 minutes down the road from Station Inn is Rudy's. For such a musical city, Nashville was lacking in the classic jazz venue department at the time when it opened in 2017. Stepping into the warm, intimate club designed with assistance from renowned acoustic designer Michael Cronin, you would think you were in New York or New Orleans with the quality of atmosphere and caliber of talent. And if that wasn't enough, co-owner and chef Michael Braden heads the kitchen, serving up fine New Orleans cuisine. This is the place you go for a high-quality, high-end jazz club experience.

3. The Exit/In *Heart of The Rock Block* So named for its unusual side entrance through the exit, the Exit/In has been the epicenter of Nashville's historic "Rock Block" (aka Elliston Place) since its opening in 1971. Locally, independently, and family operated, the intimate listening room-style venue has seen more high-profile action than you can count. Just a cursory glance at their Wall of Fame mural listing past acts—Etta James, John Lee Hooker, Dizzy Gillespie, Muddy Waters, The Ramones, Tom Petty, Linda Ronstadt, Talking Heads, The Verve—helps you begin to understand just how legendary this joint is.

4. DRKMTTR *All ages, all people, all DIY* As is the case with most DIY spaces, the odds are stacked against survival. In an increasingly gentrified Nashville, DRKMTTR has defied those odds, living through several closures and relocations, ultimately finding a third and hopefully final home in a building owned by Donnie Kendall and Mary Mancini, former owners of the late '90s DIY venue Lucy's Record Shop. Co-owners Olivia Scibelli and Kathryn Edwards have stayed true to Drkmttr's DIY ethos as a volunteer-run, all-ages, inclusive and intersectional community-focused space hosting underground music shows, open mic nights, dance parties, and more.

5. Mercy Lounge *Big acts, mid-size, loft-style* Since its opening on the second floor of the historic Cannery Ballroom in 2003, Mercy's gained a stellar reputation for hosting well-established acts and great new talent. Gary Numan, Kacey Musgraves, Kings of Leon, Charli XCX; it's a place to see big names play a relatively small, 500-capacity room. Its state-of-the-art sound system and New York loft-style interior attract all walks of music lovers and socialites. Concertgoers come from all over to see the big acts, and Mercy's free, weekly "8 off 8th" showcases that feature shortened sets by eight local bands are beloved by both locals and visitors.

NASHVILLE

A SIDE

The Station Inn:
The Time Jumpers
On the Outskirts of Town

Rudy's Jazz Room:
Victor Wooten/Wooten Bros.
Funky D

DRKMTTR:
Shell of a Shell
Away Team

Mercy Lounge:
Kacey Musgraves
High Horse

The Exit/In:
Dolly Parton, Linda Ronstadt,
Emmylou Harris
After the Gold Rush

SCAN TO PLAY

Nashville

Amanda Matsui

1. Nashville has one of the highest concentrations of music industry pros in the world. As far back as 2013, there were roughly 60,000 music industry employees in Nashville. Now, especially given the city's recent boom, even more have joined them.

2. Nashville's nickname—"Music City"—has a royal history. The moniker "Music City" was earned by the Fisk Jubilee Singers, a Black gospel singing group comprised of students from Nashville's historically Black Fisk University. During the group's 1873 tour, the singers performed for Queen Victoria, who was so impressed that she said they must be from a "city of music." Over the next 50 years, the nickname took hold, especially as the Grand Ole Opry gained popularity.

3. Nashville is home to the enormously influential Grand Ole Opry radio program, founded in 1925 and the longest-running radio broadcast in U.S. history. Membership in the Opry remains one of country music's crowning achievements, and its members have included icons like George Jones, Dolly Parton, Reba McEntire, Garth Brooks, and Johnny Cash. (Although Cash was kicked out of the Opry in 1965 for busting several stage lights with his microphone stand, he was invited back in 1968 and remained a member for the rest of his life.) The historic radio hour has had many homes throughout its lifetime, among them the Ryman Auditorium, which hosted the show for more than three decades.

4. The Ryman Auditorium, one of the world's most prestigious music venues, was built in 1892 by riverboat captain Thomas Ryman and originally named Union Gospel Tabernacle. Its original purpose was to host large-scale revivals by the Rev. Samuel Porter Jones. By the 1920s, the auditorium had expanded and begun booking various entertainment acts. Even as the Ryman moved further away from being known as a place of worship, its legendary performers continued to refer to the space as "The Mother Church of Country Music," in reference to its gospel roots.

5. Music City is a hotbed and proving ground for countless genres beyond country. Nashville is known the world over for its connections to country music, so it's tempting to overlook the city's other offerings. Countless notable non-country albums have been recorded here, from R.E.M's *Document* in 1987 to Yung Buck's *Straight Outta Cashville* in 2004. Acts who have established careers here include indie rock band Lambchop, the female-fronted punk band Bully, hip hop performers Starlito, Daisha McBride, and Mike Floss, banjo master Béla Fleck, and contemporary jazz artists like The Wooten Brothers, Rod McGaha, and Rahsaan Barber.

6. The Jefferson Street corridor was home to a beloved rock 'n' roll and R&B scene. In the 1940s, '50s, and '60s, Jefferson Street's entertainment venues—including New Era Club, Club Baron, and Club Stealaway—hosted artists including Jimi Hendrix, Etta James, Ray Charles, Little Richard, Otis Redding, and Billy Cox.

7. The New Era Club was also the site of a legendary live soul recording. Etta James recorded her first live album, *Etta James Rocks the House*, at the famous club in 1963. The background banter on the recording opens a window to the once-lively Jefferson Street music scene.

8. Nashville is home to United Record Pressing, the biggest record-pressing operation in the country. Established in 1949, it has pressed vinyl albums for icons including The Beatles, Adele, Stevie Wonder, Dolly Parton, and countless others. According to URP's site, its 143,000-square-foot facility is capable of manufacturing up to 60,000 records in a single day.

9. United Record Pressing's former Chestnut Street location was home to the so-called Motown Suite, an apartment space and R&B landmark where Black musicians and executives would often stay while touring. It was there that artists from labels like Motown and Vee-Jay could find safe quarters in what was then the still-segregated and often hostile South.

10. Nashville is home to Jack White's Third Man Records and its rare live-to-acetate lathe. The independent record label and show space owned by the White Stripes frontman includes a rare 1953 Scully Lathe, a machine used to cut performances straight to acetate (rather than digitally or to tape). Audiences at Third Man's Blue Room can watch through a window near the stage as technicians record live performances direct-to-disc in real time.

The 5 Spot

There was a time when you couldn't even dance in here because it was so packed. *GQ* wrote an article in 2010 called 'Nowville' about East Nashville, and they called it 'the most stylish party in America.' *The New York Times* was even writing about it. We helped make it fun, and people like fun.
Jacob Jones

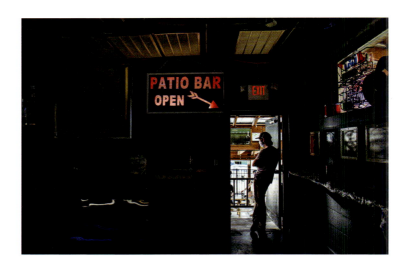

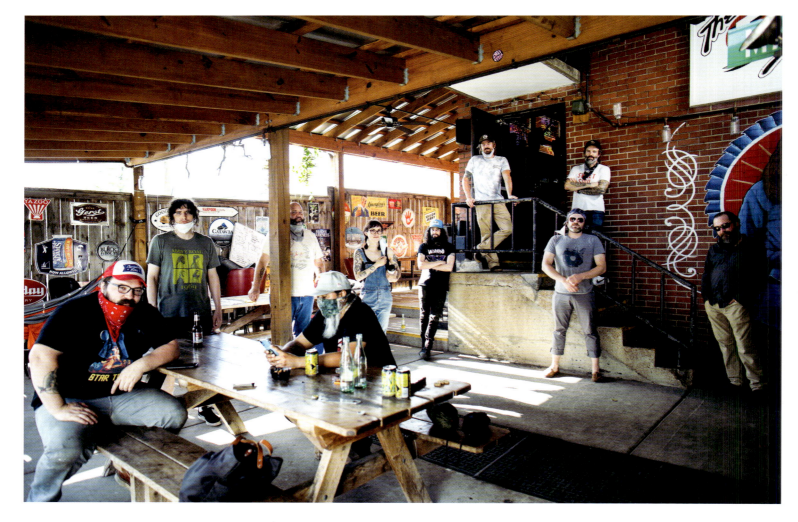

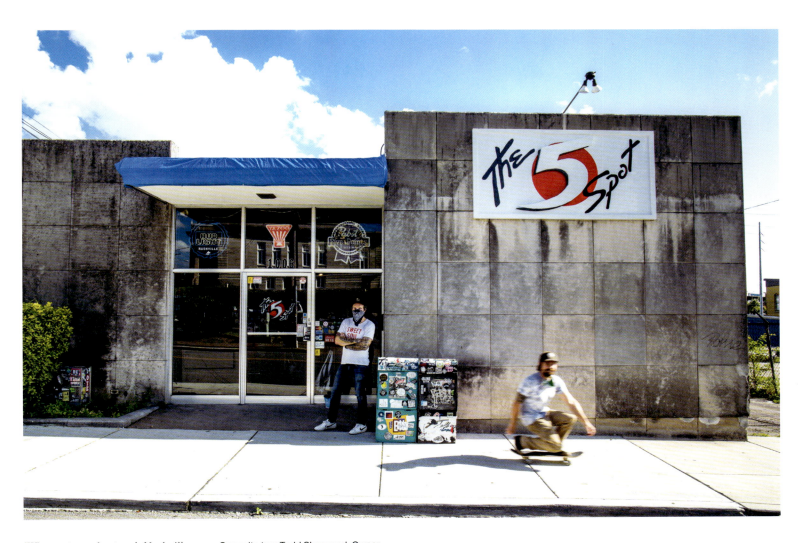

[When a tornado struck Nashville in March 2020], some of the roofing got blown off and our power pole got snapped and was laying in the parking lot. We didn't have power for a week afterward. We were lucky. There were a bunch of people in here and the tornado went right over there [next door]. Twan [a team member] got everyone to move to the middle of the room. The first text I got the next morning said, 'Basement East is gone...5 Spot is OK.' I had no idea what the f**k was going on. The first thing I did was head down to turn the gas off. Todd Sherwood

Opposite top: Todd Sherwood, Owner
Opposite bottom: The 5 Spot family and friends
Above: Jacob Jones, Musician (DJ for Motown Mondays) and Todd Sherwood

The Basement

There's something about a silent room of 10 people or however many people, just a silent room listening to what you have to say that's really empowering for a young artist to feel, and that's what I got here. It was really special. We're in a holding pattern, just trying to survive to fight another day, and hopefully go back to where we left off. Maybe we'll have a room full of sweaty people jumping up and down, cheering on rock 'n' roll. Katie Pruitt

Right: Katie Pruitt, Musician
Below: Dave Brown and
Mike Grimes, Owners
Opposite top: Katie Pruitt
Opposite bottom: Katie Pruitt;
Mike Grimes; Dave Brown

When we took over the space in 2005 the local scene was thriving, so it was really this amazing proving ground for up and coming artists. We made our money from booking local acts and creating a community here that we felt was very important. Mike Grimes

I felt like I'd found my rock 'n' roll home the first time I walked through the doors.
Dave Brown

DRKMTTR

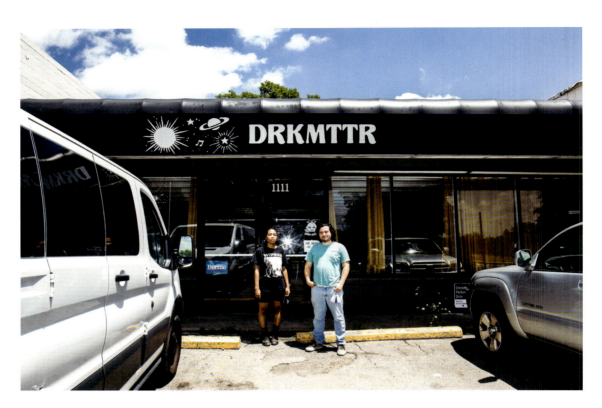

A scene is not going to progress if it's the same people playing all the time. So it was obvious to us that [DRKMTTR] always had to be all ages. The DIY ethos in general— we feel like we have that sort of background. We are concerned about the health of everybody. No one wants to come out because they don't know if it's safe. We don't want to be those people who are jeopardizing other people's health to try to make a buck. It's not worth it in the end.
Kathryn Edwards

Opposite top: Kathryn Edwards and
Chappy Hull, Proprietors
Opposite bottom: Nico, Musician
Above: Kathryn Edwards

We'll see our landlord at shows. We all ran into him when we saw The Jesus Lizard. The first night we had here, I walked up and introduced myself to him. And he was like, 'Oh, yeah, you're Dylan's friend.' My childhood friend and bandmate lived next door to him, and so he saw me growing up. Chappy Hull

The East Room

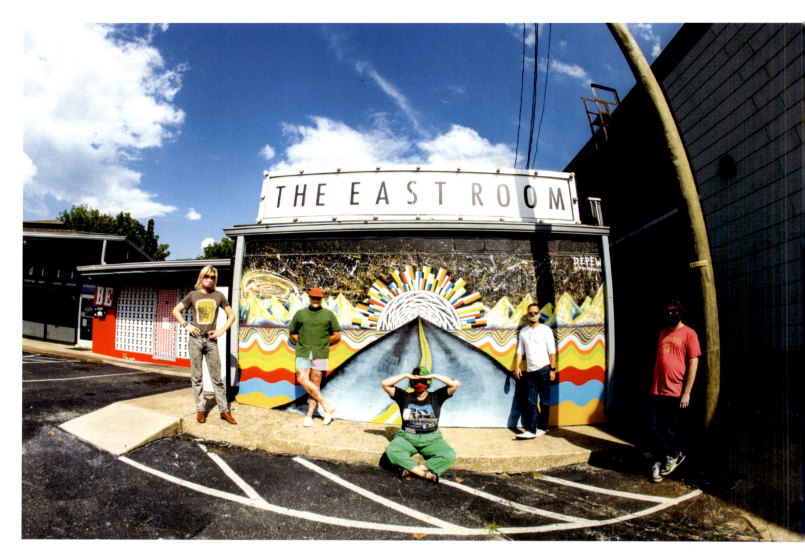

I'd say a big silver lining with all of this is appreciation, missing things, really realizing how important a room like The East Room is...keeping small businesses, local businesses, local venues alive, realizing how important they are to us when you don't have them all the time.
Taylor Jensen

Above: Taylor Cole, Talent Buyer; Tyler Walker, Musician (Meth Dad); Taylor Jensen, Musician (Soft Bodies); Luke Ehrmann, Owner/Bar Manager; Nate Arrington, Owner/Production Manager
Opposite: Taylor Jensen and Tyler Walker

One of the interesting things about this place is that it's quirky but sort of generic...like clay that you can do whatever you want with. A blank canvas.
Nate Arrington

That's the great thing about this industry [music], this business: You never know what's gonna come through here and surprise the hell out of you.
Luke Ehrmann

Exit/In

It's all bad news for live music, for sure. My colleagues and friends who do this for a living, specifically here [in Nashville], we talk a lot, we're all in pretty similar spots. I think we've only seen one closure here in Nashville with Douglas Corner. But there's been a lot more around the country, and there's gonna be more here. It's just inevitable. The effects of this illness on live music is so devastating. Independent venues just were not built to financially weather such a catastrophic economic situation. Chris Cobb

As an owner, you have to weigh personal financial devastation versus keeping this iconic 49-year-old club alive. I want to keep it alive, but I also don't want to lose everything I have doing it. Which is something we're staring in the face. Chris Cobb

Below: Chris Cobb, Owner/NIVA Rep Nashville and Alanna Royale, Musician
Opposite top: Interior of Exit/In
Opposite bottom: Stage of Exit/In

Mercy Lounge

Above: Todd Ohlhauser, Owner
Right: John Bruton, Booker
Below: Alicia Bognanno, Musician
Opposite: Todd Ohlhauser;
John Bruton; Alicia Bognanno
outside of Mercy Lounge

This is a 500-capacity venue. If you had six feet between everybody, 40 people maybe. How do you enforce it? You have to charge a higher ticket just because we have to staff it. Are people willing to pay the labor I have to put into the show?
John Bruton

We are supposed to be touring from September throughout the year, and that's all wiped out. I would never make anybody tour if they're not totally comfortable, especially if there's an illness going around. Part of me feels like everyone will be really excited to get back into the real world, but bands touring and venues opening—that's the last thing that's going to happen. So it's just the future that looks bleak as of now. But I'm hopeful, I guess.
Alicia Bognanno

We had things booked through the end of the year, a stacked calendar. We cancelled roughly 150 shows, between three venues [Cannery, Mercy, High Watt]. There's gonna be more of an appreciation for music: 'I don't want to miss the show, 'cuz you never know'...[if/when you'll ever see this one again].Todd Ohlhauser

Rudy's Jazz Room

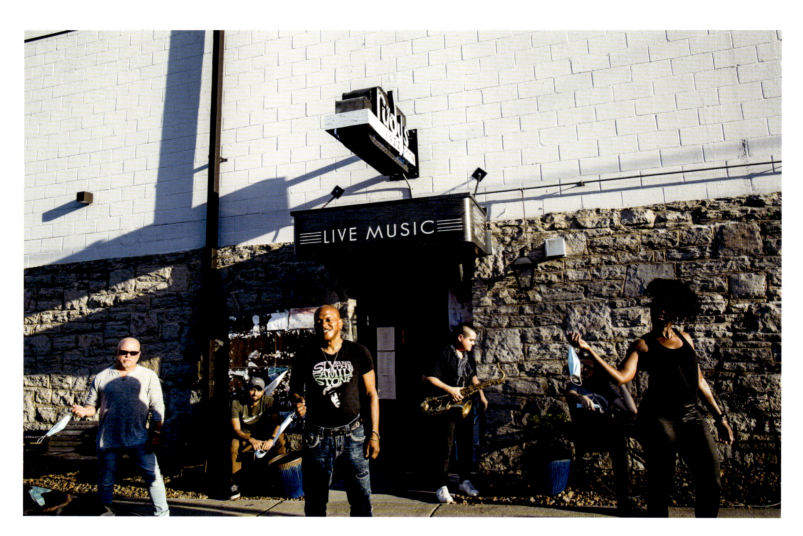

We know the names of a lot of the patrons who come in here. Everybody knows Caroline. That's how it is here. We've got the young hipsters and the kids, and we're trying to carry jazz into the next generation. So, yeah, I love that. [Rudy's] is not quite like any other club to me. Linde Hoefler

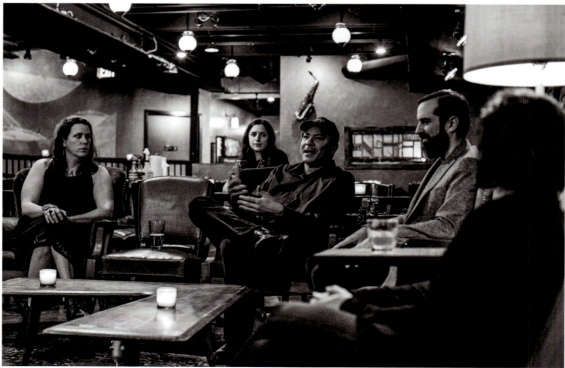

Nashville always had a lot of jazz musicians. A lot of the session players are actually jazz musicians and they're backing country artists and doing records and recording. I got in the scene and realized that wow, there's a ton of jazz musicians here, and they just didn't have a place to play. Adam Charney

Is this business model even sustainable? What if this happens again in two years? We can do months of closure every two years, but you're talking about brick-and-mortar spaces relying on the public. Michael Braden

It's been very hard to try to be creative, even to get out of bed in the morning. It's like you don't even have a purpose, you don't have anything to work toward. It's hit me in a very interesting way. To have your life [music] taken away: What do you do? Stephanie Adlington

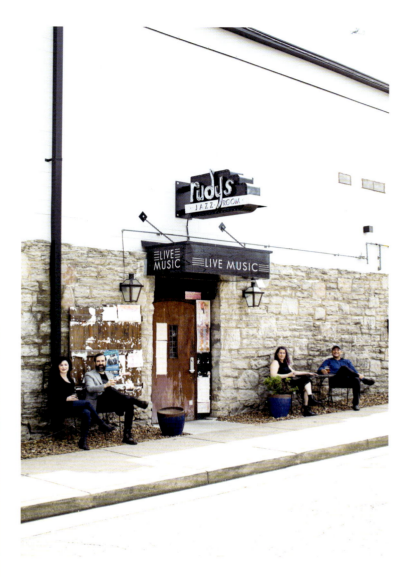

Opposite top: Members of the Joe Wooten band
Opposite bottom: Linde Hoefler, Manager; Caroline Brady, Bartender; Michael Braden, Owner/Chef; Adam Charney, Owner/Booker; Stephanie Adlington, Musician
Above: Stephanie Adlington
Top right: Stephanie Adlington; Adam Charney; Linde Hoefler; Michael Braden
Above right: Adam Charney and a member of the sound team

The Station Inn

The Station Inn [was] started in 1974 by some bluegrass musicians because there was no other place in Nashville at that time for musicians to jam or pick. Lots of musicians who played on the road with bands—it gave 'em a place to play. We started booking Ralph Stanley, Larry Sparks, The Bluegrass Cardinals, The Johnson Mountain Boys, and then of course, the father of bluegrass himself, Bill Monroe and the Bluegrass Boys. They played here several times. JT Gray

Below: Interior of The Station Inn
Opposite: Brad Bulla, Musician; JT Gray, Owner; Jeff Brown, Manager

There was an article going around, talking about the demise of music and art festivals. I read it, but I don't buy it. I know it's difficult, guys, but the music is still alive and people will always want to hear live music. I think it's gonna come back in a big way. Brad Bulla

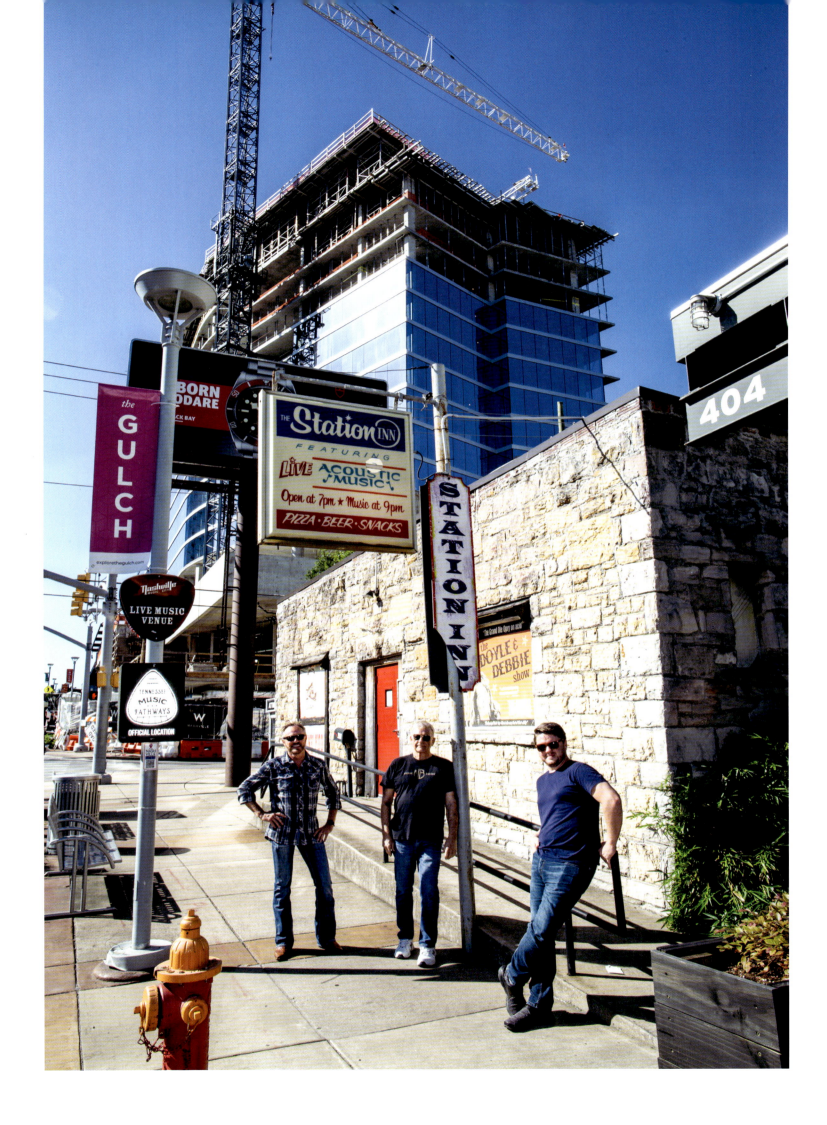

New Orleans

POSTER DESIGN
Jason "Jay" Sayatovic

PHOTOGRAPHER + PRODUCER
Justen Williams

New Orleans

Jay Mazza

1. The flamboyant 1960s rhythm & blues singer Ernie K-Doe was best known for the song "Mother-In-Law." He was also an irrepressible personality who once said, with his characteristic hyperbole, "I'm not sure, but I'm almost positive that all music comes from New Orleans."

2. Many of the first songs considered to be rock 'n' roll—"Tutti Frutti," "Lucille," and "Good Golly Miss Molly" by Little Richard; "Let the Good Times Roll" by Shirley and Lee, "Sea Cruise" by Frankie Ford, and "The Fat Man" by Fats Domino—were recorded in New Orleans in the 1950s at Cosimo Matassa's world-famous studio.

3. Of the many music clubs that have dotted the cultural map of New Orleans for more than 200 years, many stand out. Venues like the Dew Drop Inn and current mainstays the Maple Leaf Bar, Snug Harbor Jazz Bistro, Vaughan's Lounge, the Prime Example, and Bullet's are legendary. But it's been said that Tipitina's is the greatest indoor spot in the world, and countless music fans and musicians, from the famous to the unsung, will attest to that notion.

4. New Orleans is home to generations of musical families, some of which go back to the late 19th century and possibly even earlier. While many music lovers have heard of the Marsalises and the Nevilles, the list also includes the funk pioneers the Batistes; traditional jazz names like Lastie, Brunious, Andrews, and Barbarin; and modern jazz stalwarts the Jordans, that are well known across the city.

5. As bounce music begins to permeate the mainstream pop landscape in the songs of artists like Drake and Beyoncé, it's important to recognize that bounce, like jazz before it, was born in New Orleans. Dancers began twerking in the Crescent City decades before Miley Cyrus had even heard the word.

6. Traditional jazz brass bands have been part of the musical DNA of New Orleans dating back to the mid-19th century. These groups provide music for the city's many social aid and pleasure clubs as well as Mardi Gras parading organizations such as the satirical Krewe du Vieux. They are central to jazz funerals and have evolved over the years to include many forms of popular music, including funk, modern jazz, R&B, and hip hop.

7. Besides the musicians from New Orleans who most people have heard of, like Harry Connick, Jr., Fats Domino, and Wynton Marsalis, the city has produced dozens of artists who are revered in their hometown and loved by the musical cognoscenti across the globe. Though the average person may not have heard of influential performers like Professor Longhair, Allen Toussaint, Dr. John, Mahalia Jackson, Snooks Eaglin, Kermit Ruffins, Germaine Bazzle, Irma Thomas, The Meters, Al Hirt, or numerous others, they are part of the local pantheon.

8. The Tremé neighborhood was put on the world's radar by the HBO series of the same name. The show helped the city recover from the federal levee failures that followed Hurricane Katrina by employing local musicians, crew members, and actors. But the area on the outskirts of the French Quarter is also known as the oldest African American neighborhood in the country and has been a musical epicenter since the early years of the city.

9. Despite being known as the birthplace of jazz and a hotspot of other musical genres including funk, R&B, hip hop, gospel, and the blues, New Orleans had a vibrant punk and new wave scene during the 1970s and 1980s. Bands such as The Normals, The Dick Nixons, and The Cold drew large crowds and influenced generations of indie bands that followed. Fun fact: Vance DeGeneres, the brother of TV and film star Ellen, was a member of The Cold.

10. New Orleans is home to a cultural tradition that is unique in the United States. Known popularly as "Mardi Gras Indians," these groups of African Americans are organized into tribes and craft incredibly beautiful bejeweled and feathered suits. They created a style of music that has influenced much of what has emerged from the city since the early 1900s. Their rhythms and chants have been soaked up by generations of New Orleans musicians, and their sound continues to evolve and influence to this day.

Blue Nile

We pretty much work 365 days a year. I am always working, and when I am not here, I am somewhere else doing security gigs or something. Because I work so much, I usually take August off anyway and stay out of the business. When you look at it from the aspect of the whole world, everyone is going through this. I am a physical worker, [and] not working physically, it's just so weird. I feel like I lost my job, but it's not my fault. It's resetting who you are as a whole person. Gilbert Moses Jefferson

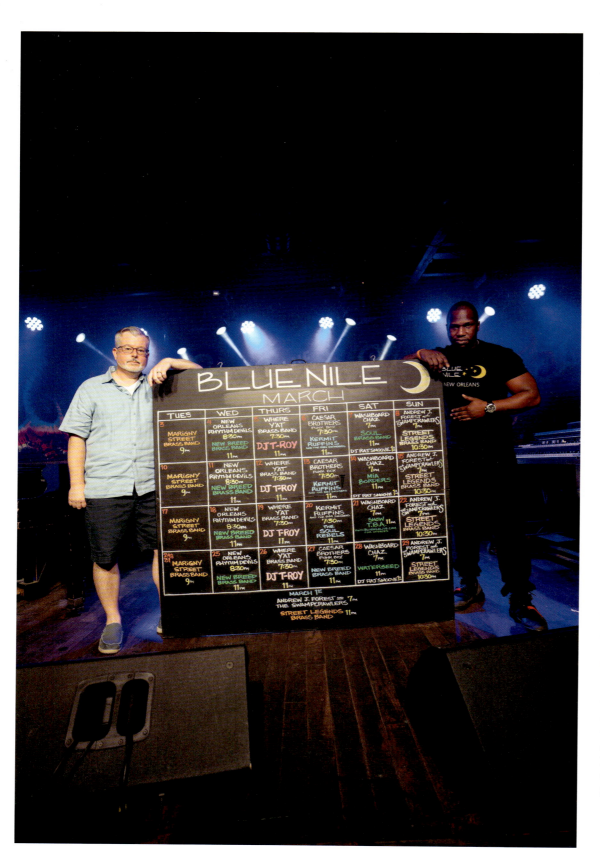

We are housed in a building here in New Orleans on the world-famous Frenchmen Street. [It] was built in 1832. It's been a music club since the '60s, that we can document, and maybe even before. It's been the Blue Nile since 2000. This is where a lot of musicians got their start. We have a lot of famous alumni that started on this stage. Most notable would probably be Trombone Shorty, Jon Batiste, and we also have Kermit Ruffins who played here as a regular every Friday as a residency. The Revivalists. I can go on and on. There's a plethora of musicians who have started on this stage and gone all over the world. In general it's a House of Funk, R&B, Brass Band, New Orleans-style jazz, and a tiny bit of blues on the side. We always have a packed crowd and they come here to dance, to have a good time. Jesse Paige

Above: Jesse Paige, Owner and Gilbert Moses Jefferson, General Manager
Opposite top: Exterior of Blue Nile
Opposite bottom: Stage at Blue Nile

Being socially distant doesn't rhyme with what we do. It's really truly against the nature of our own city. Instead of shaking hands here, we hug. [It] doesn't matter if you know the person or not. We are such a social culture, [and] it's a very foreign thing for us to have to go through. Jesse Paige

Civic Theatre

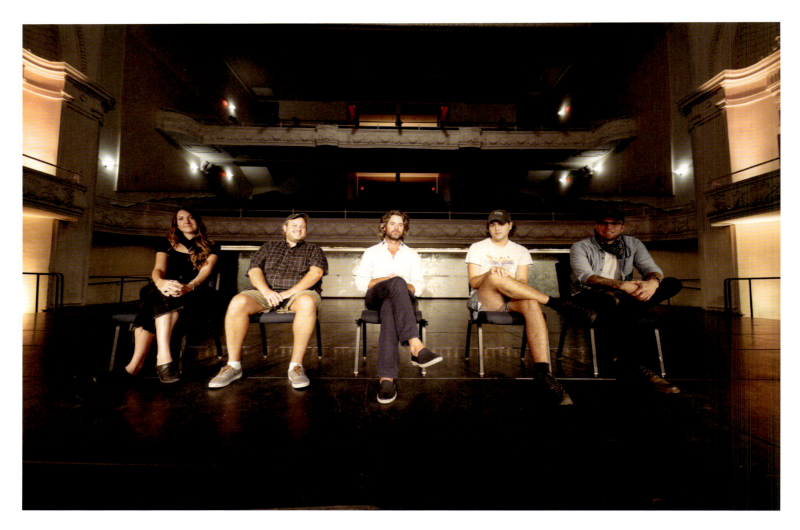

Something I never really thought about before is the amount of human interaction that I have on a day-to-day process on so many different levels with so many different people when we are operating normally. It's crazy, the amount of staff, bands and crews, parties, caterers, delivery people, security people, cleaning crew, outside people, you name it. Now, unfortunately, I come into the venue to work, and [am] pretty much surrounded by one, two, or three people at the most. After a while, it seemed like a little break, but after months, you realize how many people you aren't speaking with on a daily and weekly basis. I don't want to call it isolated, but on so many levels, you start to look back on the interactions we have and the amount of touches you have with different people in a day. It's just flabbergasting. It's been quiet in the sense that I never really realized how much I crave the interaction with other people there. Winter Adler

Above: Cali Gabrielle, Sales Director; Winter Adler, General Manager; Bryan Bailey, Owner; Scott Thompson, Promoter Representative (The Bowery Presents); Michael Twillmann, Production Manager
Right: Stage at the Civic Theatre
Opposite top: Michael Twillmann backstage at the Civic Theatre
Opposite bottom: Cali Gabrielle in the balcony

This theater was built in 1906. It's going to outlive all of us, so let's play the long game. We are stewards of this space and we are here to do our best to facilitate this as a place for community gatherings. Humankind has had this interest to gather, this desire for ceremony, ritual, memorial, theater, art. We have gathered through the history of time, and when we are able, we have no doubt that the Civic will be a place for community gatherings. We have no doubt that people will want to gather again. We have played the long game since 2013, when we opened, and we are going to continue to play the long game. Bryan Bailey

d.b.a.

The original d.b.a. was up in the East Village in New York. My partners and I fell in love with New Orleans and the culture, and really loved Frenchmen Street. We saw it as the East Village of New Orleans and really wanted a venue or a bar on Frenchmen. We bought the property in late '99, and opened in February of 2000. Michael was the first employee I hired. We started just as a bar, and it slowly progressed into a venue. [Because of] Katrina, we were closed for 44 days. We have been closed with COVID about 144 days, with not any idea on when we will reopen. This Jazz Fest would have been our 20-year anniversary. So it's been rough. Tom Thayer

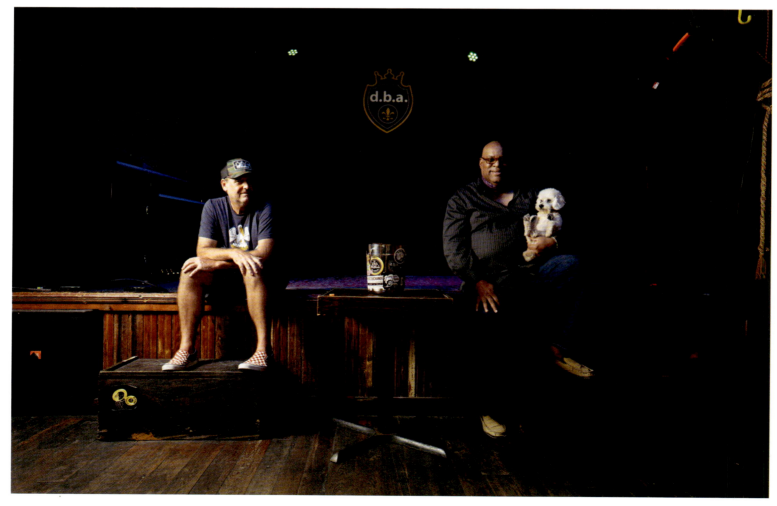

Opposite top: Entrance to d.b.a.
Opposite bottom: Tom Thayer, Owner/
Creative Director and Michael Garran,
Assistant General Manager
Above: Piano on the stage of d.b.a.

It's said often, but it's not a cliche: New Orleans and the state of Louisiana have such a really rich, dense cultural history for different types of music. We have jazz, we have blues, we have zydeco, we have swamp pop, and cajun music. Some of these musicians are the current and final. I shouldn't say final, but the current generation of musical traditions that have been passed down for generations. So not only are they not able to earn a living, but they are not able to spread the music that they grew up listening to that is becoming a dying art. Like Little Freddie King, who is 78 years old, maybe 80. He is one of the last gutbucket blues guys.
Michael Garran

The Howlin' Wolf

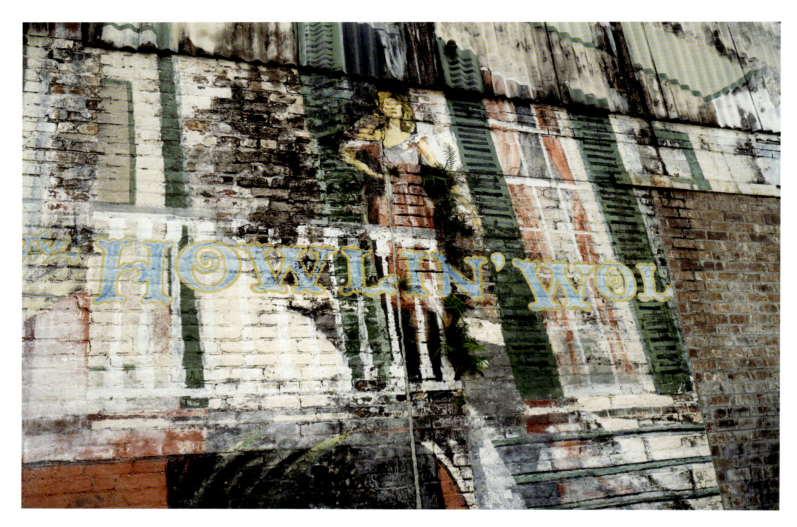

A lot of my friends are in the service industry and are bartenders across the city, and have just not been able to work or have had no outlet or nowhere to go. Being here has been empowering, and has given me the opportunity to reach out to those people and be a light for them and help guide them into opportunities, or tell them about our programs that they might not know about. Even just our very small staff, we keep each other uplifted. Julie Jackson

Above: Mural painted on the facade of The Howlin' Wolf
Opposite: Julie Jackson, Bartender and Howard Kaplan, Owner

In the middle of March, we started a program called Meals for Musicians in conjunction with the New Orleans Musicians' Clinic. As part of that, we give meals every Monday, Wednesday, and Friday to our culture-bearers: the musicians, the Indians, the people who make up the culture of Louisiana. We include our hospitality workers in there. Anybody who serves in New Orleans we consider a culture bearer because that's why people come here. Also, first responders. We have been feeding police districts, fire departments, the whole nine yards. This last week, we went past 20,000 meals as part of that program. Howard Kaplan

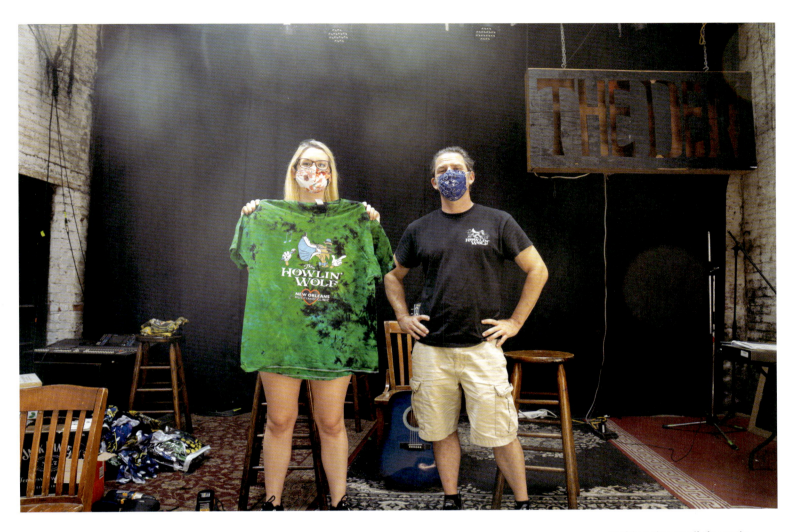

At this point, until the entire country shuts down, other countries have done this really well and they are bringing back culture, [such as] parts of Germany where they have literally shut things down. South Korea, they have shut things down, [and] they've instituted automatic contact tracing, things that can bring music back quicker. We're still arguing about whether or not to wear a mask in public and how we deal with this and lack of resources. Our goal in all this is to make sure that we keep the culture of New Orleans, to make sure the bands survive. If the music doesn't come back and the people don't come back, all I have is a big empty room.
Howard Kaplan

Saenger Theatre

New Orleans is unique. Nobody else has a French Quarter, nobody else has what New Orleans has, but New Orleans has been hit hard by this pandemic. It seems sometimes, people may think New Orleans is snake-bit, but I can tell you New Orleanians are resilient. They are a unique people in New Orleans and I'm glad to call them all my friends. And it's okay. We're going to work our way over it or around it, but we will persevere. Let's face it, there's not another city that wants to party more than New Orleans does. I've joked about it for years: There's a parade on Tuesday, there's a party on Wednesday, there's always something happening in New Orleans. David Skinner, General Manager

Below: Interior of Saenger Theatre
Opposite: Exterior and marquee
of Saenger Theatre

The Saenger Theatre originally opened in 1927. It was the brainchild of the Saenger brothers out of Shreveport, Louisiana. They had built, through the years, about 60 Saenger Theatres throughout North America, Mexico, and South America. Today there are only a handful of those left, the largest of which is the Saenger in New Orleans. The Saenger Theatre for New Orleans is iconic. It's always been the place for any entertainer to go, whether you go back to the days of Liberace, or the days of touring Broadway from Elizabeth Taylor to Richard Burton. It has always been the go-to place in New Orleans for any entertainer of any stature. That's the place they want to perform.
David Skinner

The Spotted Cat Music Club

Initially [what surprised me] was Congress helping out with the stimulus packages. The last one has been a logjam and everyone is waiting for that. The money Congress appropriated for unemployment certainly helped. We don't know where that's going now. It will probably be reduced. More stimulus will probably pass but when is the question. Of course, the smaller businesses like us really are the generators for money for the United States. Small businesses run the country, not the bigger ones. We just need help. A bar or a music venue: When do we reopen? Douglas Emmer

I have learned that people are resilient. Humans have the ability to persevere. Also, there's just a bigger sense of family that helps get through it. To that note, music and especially New Orleans, we are one big music community. Here at Spotted Cat, we are one big family. We are still in contact with all of the musicians, just a sense of that family. We are all going to make it work eventually. The togetherness is the only way it's going to happen. Bradley Clement

Below: Robin Barnes, Musician
(The New Orleans Songbird)
Opposite left: Bradley Clement,
Manager/Bartender
Opposite right: Douglas Emmer,
Managing Partner

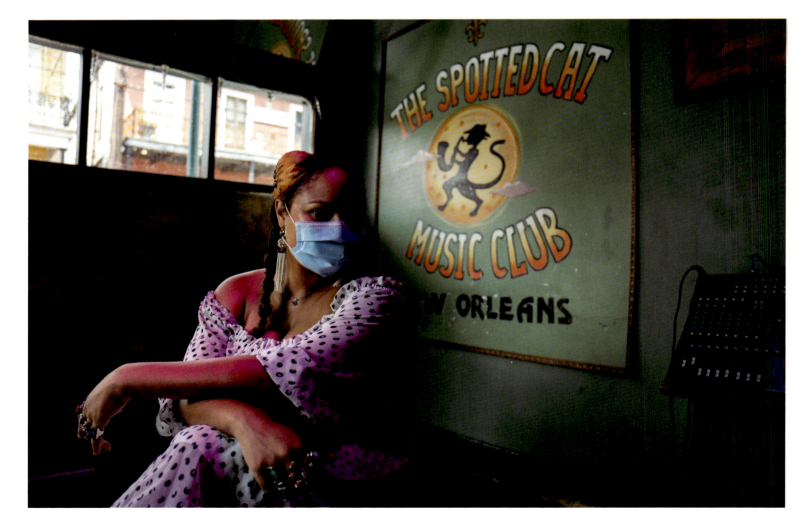

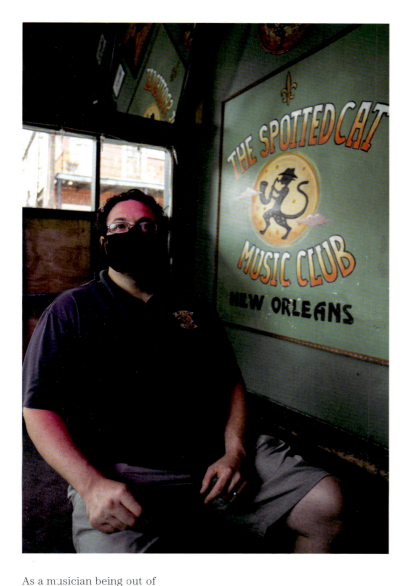

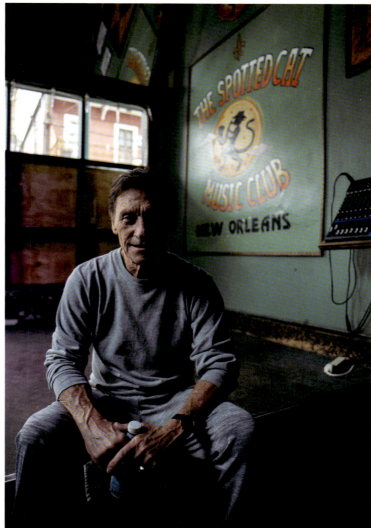

As a musician being out of business, most of us have not been able to do anything for our livelihood and for our income. We have attempted to do live-streaming but as time has passed, there's a lot of donor fatigue. There [are] a lot of people that have really contributed, but aren't able to as well now because of their own circumstances. So we are just trying to survive and hold out. The shock is really how long this has been going on and how long this is just lasting. The beautiful side of it is we already knew how important small business[es] were and how important live music is. Uplifting people. Making people feel happy again. Now the hope is the rest of the world realizing how much this is a lifeline to the U.S. To the rest of the world. Hopefully through Congress, through the people that have been advocating for us, we will be able to continue to be that lifeline the world needs. Robin Barnes

Tipitina's

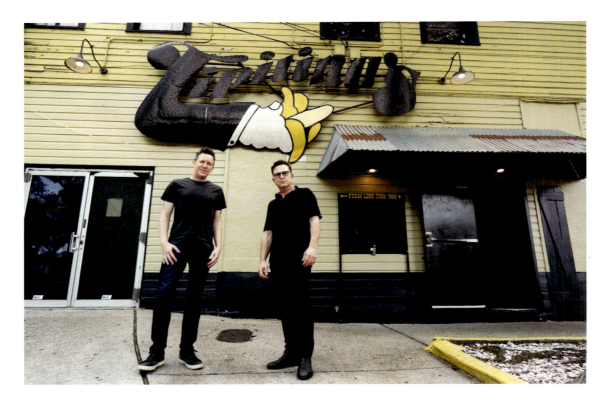

I get a lot of emails from people that want to help. I have never been accused of being an optimist before. Not once in my life. But with however bleak it seems, I feel like there are too many people in the world that love this place too much to ever let it close its doors. I am getting a lot of feedback from people that love Tipitina's. It's the reason why it's not hard for me to get up in the morning and come in: The amount of people that love this place that depend on us to make it to the other side for them. Brian Greenberg

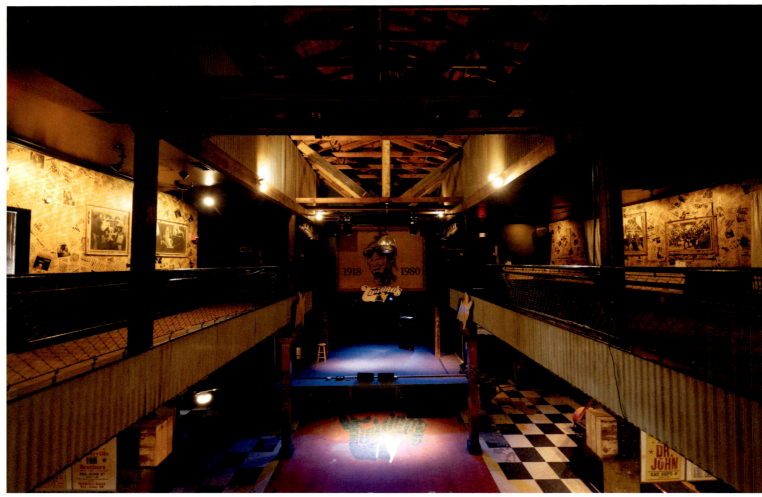

One of the things I have learned through all of this is to not take anything for granted at any point. Ever. There are times when we'd be touring, traveling, and you're just in it and it almost becomes, dare I say, routine. Now, what I have learned coming out of this is how to value every moment and appreciate every moment. Every time you step on the stage. Every time somebody comes up and says that they enjoy what you did. You have to really appreciate and soak that in and realize that you can lose it at any moment. Stanton Moore

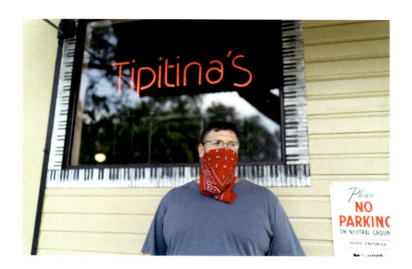

Opposite top: Robert Mercurio, Co-Owner/Bassist (Galactic) and Stanton Moore, Co-Owner/ Drummer (Galactic) outside entrance of Tipitina's with its iconic sign
Opposite bottom: View of the stage from the rear balcony
Above: Brian Greenberg aka Tank, General Manager/Janitor
Below: Robert Mercurio; Brian Greenberg; Stanton Moore

We kept on our salaried employees and management and helped to keep them on through the PPP loan, but that's going to be running out. We have been trying to keep as many employees going, and that's another beautiful thing about Tipitina's TV: [It's] creating and making money for the club, but also making money for the bands, musicians, and the production staff that's behind it all, the staff that's been forgotten about throughout this time as well. There's a large community of people in the production world that don't get the glam and the glory or the attention that the musicians or the clubs get. So it's been nice to be able to feel like we are putting money in people's pockets and keeping people going. Robert Mercurio

New York City

POSTER DESIGN
Jose Berrio

PHOTOGRAPHER
Kevin W. Condon

PRODUCER
Amber Mundinger

Playlist

This Select EP Playlist Curated by DJ Hesta Prynn

1. Blue Note *Then and now* An NYC institution, the Blue Note calls itself "the club where progression and innovation—the foundations of jazz—are encouraged and practiced on a nightly basis." Dizzy Gillespie called it home back in the day. On the modern alignment, Robert Glasper is among a group of musicians who continue to stretch and grow in real-time at this legendary venue.

2. Knitting Factory *Beat Society* Beat Society was a hip hop producer showcase that happened every few months at the original Knitting Factory from 2004 to 2007. Legends like J Dilla and Pete Rock would line up, five on a stage, alongside up-and-comers like !llmind and Kanye West. Mos Def or Bahamadia might show up and freestyle; the audience decided what was dope and what was not. Just about every relevant rapper of a certain era can trace their roots back to this event.

3. Bowery Presents *'00s rock revival* You cannot talk about the NYC rock revival of the '00s without talking about Bowery Ballroom. Post 9/11, an entire generation was given one last look at a cohesive musical movement "derivative" of NYC days gone by, when there was an LES scene, when Manhattan was still cool. When New Yorkers complain about how the city has changed, about the New York that they love and miss, this is the last moment that they are talking about.

4. Bowery Electric *The "New" East Village* Johnny T, Jesse Malin, and Mike Studo—if you were anyone in the East Village in the '00s, you have performed with, danced with, or been drunk with at least one of these three nightlife gurus. In 2008 they came together to open Bowery Electric which, to be honest, was usually empty and decidedly less cool than their other venues. As the East Village became less Cabin Down Below and more NYU playground, Bowery Electric started to take off as a younger, more mainstream crowd found a place to make their own memories—seeing comedy, DJ's, and dancing their faces off to the "throwback" hits of the early 2000s.

5. Terminal 5 *RL Grime Halloween* Despite there being "not a decent view in the house," Terminal 5 is where you go to see an EDM show or a trap show in New York City FULL STOP.

6. Brooklyn Steel *LCD Cuts the ribbon* Brooklyn's "official" band LCD Soundsystem launched the 2017 opening of this East Williamsburg venue with a string of sold-out dates, confirming for anyone still unsure (was anyone unsure?) that Brooklyn was indeed the new Manhattan.

7. Baby's All Right *Blood Orange secret show* In 2015, Dev Hynes aka Blood Orange headlined a career-defining pair of sold-out shows at Harlem's Apollo Theater. Two days before, he announced he'd be playing a secret show *that night* at Brooklyn's Baby's All Right as a warmup—full band, special guests, the whole shebang.

NEW YORK CITY

A SIDE

Blue Note:
Dizzy Gillespie
Caravan

Robert Glasper & Erykah Badu
Afro Blue

Knitting Factory:
Beat Society & Grand Agent
Mingling Goes to Church
(featuring Shitake Monkey)

Bowery Presents:
Yeah Yeah Yeahs
Maps

The Strokes
The Modern Age

The Rapture
House of Jealous Lovers

Bowery Electric:
MGMT
Electric Feel

Terminal 5:
RL Grime
Scylla

Brooklyn Steel:
LCD Soundsystem
Daft Punk Is Playing at My House

Baby's All Right:
Santigold
Can't Get Enough of Myself

SCAN TO PLAY

New York City

Amber Mundinger & Kevin W. Condon

1. In New York City, public performances exist all around you. The street corner is a stage and can be a beautiful and poetic spot to listen to music. Everyone here hustles: from the cellist playing on Bleecker Street to the a cappella group singing through the subway cars (or the breakdancers on the L, 123, or 456 trains, for that matter) to the pianist parked on Broadway in Flatiron with his piano attached to his truck, the city's sonic artists make and sell their art on the streets and are always putting on a show.

2. Most people associate New York jazz with Greenwich Village, but on any given night you can hop across the five boroughs to check out multiple gigs. Start the night at Blue Note, then head to a late show at Smalls, and finish the evening down the street with drinks and pool at Fat Cat on Christopher Street. In the Upper West Side, home of the legendary but recently closed Cleopatra's Needle, you can still check out Smoke as well as Jazz at Lincoln Center.

3. CBGB was the birthplace of New York punk, where golden era artists and bands like Ramones, Blondie, Talking Heads, and Patti Smith performed on the regular, as well as hardcore bands like Youth of Today and Sick of It All. A venue with such a passionate base that it remains infamous even after closing in 2006, its brand today has evolved to include CBGB Radio and a festival. Music fans still come to visit the original location, which has been added to the National Register of Historic Places as part of the Bowery Historic District.

4. A performance at Carnegie Hall always holds reverence. While not exactly an independent music venue, it still waves the flag for the importance of the arts in NYC. Opening in 1891, the legendary performance center has played a central role in elevating the city to become one of the world's great cultural capitals. Its three concert halls continue to sell out shows and serve as the geographical bridge between Broadway and Lincoln Center.

5. An underplay is a secret, sometimes unadvertised and spontaneous concert often held in a venue much smaller than what the performer typically commands. NYC is a place where the best shows can happen in the most unexpected arenas. A classical series can occur in the catacombs of Green-Wood Cemetery; a warehouse-like 99 Scott in the middle of Bushwick can host a pop star's tiny performance; a band can pop up on a boat on the Hudson River, in underground caverns beneath a church, or on the rooftop of a pier…the list goes on and on. New York has always been a great town for secret shows, underplays, and supreme production creativity.

6. Yes, Brooklyn gave us George Gershwin and Aaron Copland, Jay-Z, Biggie, and other hip hop legends, plus the Yeah Yeah Yeahs, TV On The Radio, Grizzly Bear, LCD Soundsystem, and many more indie rock bands, but there is far more to the borough's musical history. Did you know that Brooklyn Jazz was a thing? Freddie Hubbard, Eric Dolphy, and Wes Montgomery lived and created in a communal house on 245 Carlton Avenue in Fort Greene. The area also has one of the country's largest Caribbean populations, which has made huge contributions to reggae in the U.S. From classical and jazz to indie rock, reggae, and hip hop, Brooklyn has fostered many important parts of the music community.

7. Hip hop began in the Bronx with DJ Kool Herc more than 45 years ago. Soon after, the new art form spread across the boroughs, whose resident rappers and DJ's began laying the foundation for what hip hop would become. From Wu-Tang in Staten Island to Nas, LL Cool J, and 50 Cent in Queens, the Beastie Boys in Manhattan, and Jay-Z, Biggie, and Mos Def in Brooklyn, the city's hip hop movement spawned epic rap battles about who was the King of New York and influenced the way New Yorkers—and soon the world—dressed, talked, and lived.

8. Music is an experience and instruments are both tools and objects of art. Wandering the Metropolitan Museum of Art's Musical Instruments Galleries is an education in the history of the musical instrument. More than 5,000 instruments are housed here and you can see 500 or more of them on any day the Met is open.

9. The big guys—Madison Square Garden, Radio City Music Hall, Barclays Center—are all-important milestone stops along the way for touring bands whose reach is growing. Artists all over the world dream to play these iconic venues at some point in their careers.

10. New York seems to have inspired more musical love letters than nearly any other city. From "No Sleep Till Brooklyn," "New York State of Mind," "The Only Living Boy in New York," "Christmas in Hollis," "Autumn in New York," "Empire State of Mind," and so many more, there is no shortage of sung homage to New York City.

Baby's All Right

Looking back at [creating and producing the streaming platform Baby TV during COVID], having a comments section for these shows has been rewarding. My life is centered around these shows right now, so seeing the comments and people I recognize from shows—or normally interact with—and seeing people cultivate and make relationships while watching these shows has been really inspiring. It makes me smile for hours. Seeing that continue to grow has kept me inspired and going in a lot of ways. Greg Rutkin

It's wild, because I feel like so much of this economy in music is relying on things like GoFundMe for healthcare and just supporting their staff. We all live in the richest economy in the world, but where the f**k is that? Arts contributes so much to the world. You can't watch a movie without music. You can't watch a movie at all without the arts. There are other economies that have things for arts funding, things for artists and things for musicians. You can get a check in the mail because you are contributing to society for things people value, but don't think of as work. Music is labor. Running a venue is labor. It is undervalued. Lindsey Gardner

Coming to shows since I was a teenager created a safe space and opened my world. Danny Gomez

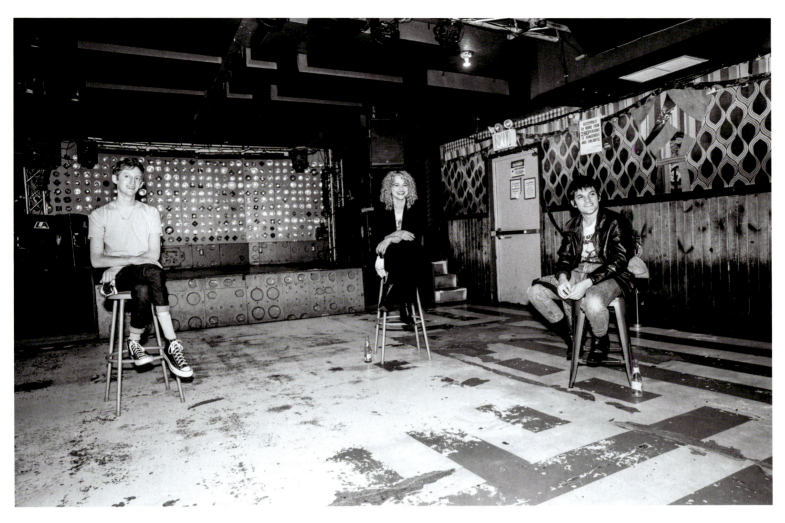

Opposite top: Lindsey Gardner,
Siren Sounds PR
Opposite bottom: Danny Gomez,
Lead Singer/Guitarist (Native Sun)
Above: Greg Rutkin, Production
Manager; Lindsey Gardner;
Danny Gomez
Below: Greg Rutkin

I think one of the most interesting things that has come up, or this has drawn attention to, is that people in the arts—besides independent musicians or everyone that works at venues, that whole community—were a forgotten labor force in the American economy. You are seeing a lot of these problems rise up because of this. I can't tell you how many of my friends are unable to get through to unemployment and a lot of that is people in the arts. People that are a part of this economy and contribute to it. That's not how we view it or why we do it, but I think that this is showing the infrastructure problems we have within this country toward artists.
Danny Gomez

Berlin Under A

Above: Elliot Moss, Artist
and Jesse Malin, Artist/Co-Owner
Opposite: Jesse Malin and Elliot Moss

Every tiny detail of this place has been so carefully considered. You spend three seconds in it and you immediately get that it's a place for bringing people together. I was going to have a residency here until COVID struck. It was going to be a chance to evolve my live show into different avenues and involve all the New York-based people I admire into my show for the first time. This would also have been my first residency. Hopefully, that will still happen. Elliot Moss

I started coming down here from Queens because there were no rock clubs in Queens. I was into things that were a little different and weren't on the radio. So we went to CBGBs when we were in our teens. And from CBGBs we made our way down Avenue A seeing flyers for bands that couldn't afford to be in the Village Voice or whatever. Every show was at places like A7 and 171A, in a neighborhood full of gangs, junkies, and trouble. But you could live really cheap. I moved out of my house when I was 15 and into a storefront and made it a practice space. It was a place where you could be yourself and create art and do it cheaply. There were clubs here that would let you perform and give you an opportunity to make a little bit of money. It was a great place to make a name for yourself, to build what you were doing out of the spotlight and then take it on the road. It was a neighborhood where you could be yourself and not be judged. Jesse Malin

Blue Note Jazz Club

In a lot of ways, Blue Note New York is the mothership for all the clubs around. What was created here is very much a cabaret-seating kind of atmosphere. You come here expecting to meet new people, and to be seated at tables with other people. That aspect of it by its very nature will have to change going into the future, but we hope not too much, because we want that social atmosphere.
Eric Landsman

Below: Jennifer Harrington, Marketing Director
Opposite top: Eric Landsman, General Manager
Opposite bottom: Eric Landsman

The Blue Note is a quirky space because of its compact size. It really lends itself to an all-in-one sort of operation. There are no bad seats in the house. Audience members who prefer to watch the piano player can come in and request to be seated on the side where the pianist is playing. If they want to watch the drummer, they can sit over there. We have had couples come in and the husband wants to sit by the drummer and the wife wants to sit by the pianist. The staff here is extraordinary. My musical tastes range far and wide—but I have always been a Deadhead at heart. For me, a favorite memory is when Bob Weir and Wolf Bros came here to perform. That was easily the one show that touched me very deeply. I have worked for the Grateful Dead in the past, and bringing [that experience] into this space and marrying it all through music, really, is what we did at the Blue Note. We pulled off something no one thought we could pull off—a Grateful Dead show in a tiny club in the West Village. People who were here were so overwhelmed by it, they came up to some of us and thanked us. Eric Landsman

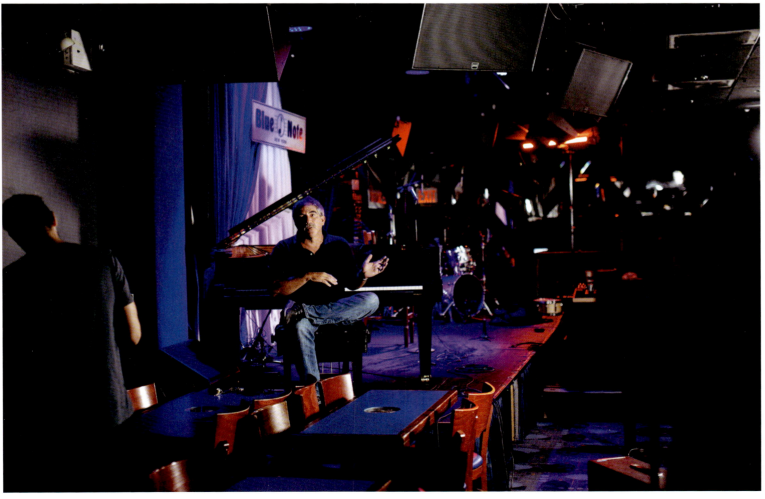

The Bowery Ballroom

The biggest splash was probably Metallica. They played Yankee Stadium the year after or whatever. I lived down the street, and knew they were coming. [I'm] walking down Chrystie Street and there's a fire truck, and I turn the corner and there's fire trucks all along the street by the venue. And I'm like, 'What the f**k happened here, what's going on?' I was always worried about crowds and it turns out I walked in and the firemen were taking turns to come in and listen to the band. It was really pretty cool. That was a huge night for us. Michael Swier

These venues mean everything to us. They are our lives, our children. Michael Swier and Michael Winsch

Top left: Kevin Lalka, Backstage Security
Top right: Kieran Blake, General Manager
Above: Michael Swier, Owner/Partner and Michael Winsch, Owner/Partner
Opposite top: Amanda Haase, Finance/Bartender/Assistant General Manager; Maggie Cannon, Talent Buyer
Opposite middle left: Danielle DePalma, Production Manager
Opposite middle right: Mark Knight, past Production Manager
Opposite bottom: Laura Lee, Bassist (Khruangbin)

The day I got the job here, July 2, nine years ago—that was my fondest memory. But I had so many fond memories before that coming here as a kid, and then years later, I got hired here and I couldn't believe it. It changed my life. It validated so much hustle I did in New York: working at DIY venues, being poor, and working my butt off for years. It was a real validation for me. It changed my life. Kieran Blake

We just signed and renegotiated our lease here. Yesterday I signed it. There were some concessions involved with, etc., but this is a long-term thing. We had to invest. We had to pay money to get this done. It's an investment in the future. We are taking that risk and we feel good about it. We're in it and we are going to stay in it and treat all of our venues the same way, with the same amount of focus. We feel as optimistic as we can. Michael Swier

I played Bowery Ballroom at the end of 2016. It was our first proper U.S. tour and our first show in New York City proper. So it's hugely sentimental to me. Yeah, I'll remember it forever. I learned in the years following how this is a venue setup— with the balcony the way it is—but this was the first one for me. Laura Lee

The Bowery Electric

Seeing Lucinda Williams sing upstairs in the little room, the map room. Seeing Green Day play an acoustic set after just getting off the plane, in that same map room up there. All the films and videos done here. The people who fell asleep here and we found the next day in the closet. This band Wolfmother played here when we first opened, which was pretty cool. There's so many [memories]. I opened this club 12 years ago with three other people, friends of mine, and initially back in the day it was called Bowery Electrical. I probably bought a fuse here or something for an amp when I was a kid. For 50 years, it was an electric supply place here on the Bowery, and it closed at six, so we never saw it at night when we were going to shows. Then it was a place called Remote Lounge, with telephones so you could pick up a telephone and say to someone in the lounge, 'Hey, I like you.' Then texting came out and that whole thing went down the toilet. I had originally looked at it with Joey Ramone and his brother and we were thinking about doing something here. Joey wasn't drinking at the time and he wanted to have a place that had bands and eggs. He wanted to call it something like, 'When Eggs Collide.' But he was very interested in doing it. Joey had a big heart. He loved music. He loved putting on shows and DJ-ing in the New York rock scene. Before we opened here, it was named Joey Ramone Place, right on the corner, Second Street, because he and Dee Dee lived at Arturo Vega's loft before the Ramones made it big. Which is right around the corner from CBGB. We all grew up down here, going to hardcore matinees, drinking 40's on the street. Jesse Malin

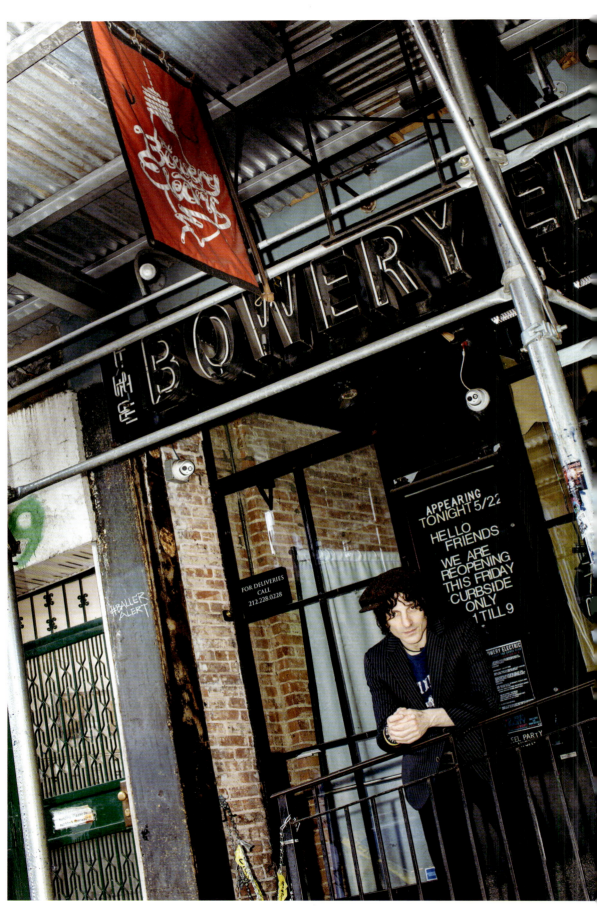

Above: Jesse Malin, Artist/Co-Owner
Opposite: Jonathan Bonilla, Guitarist
(Hollis Brown)

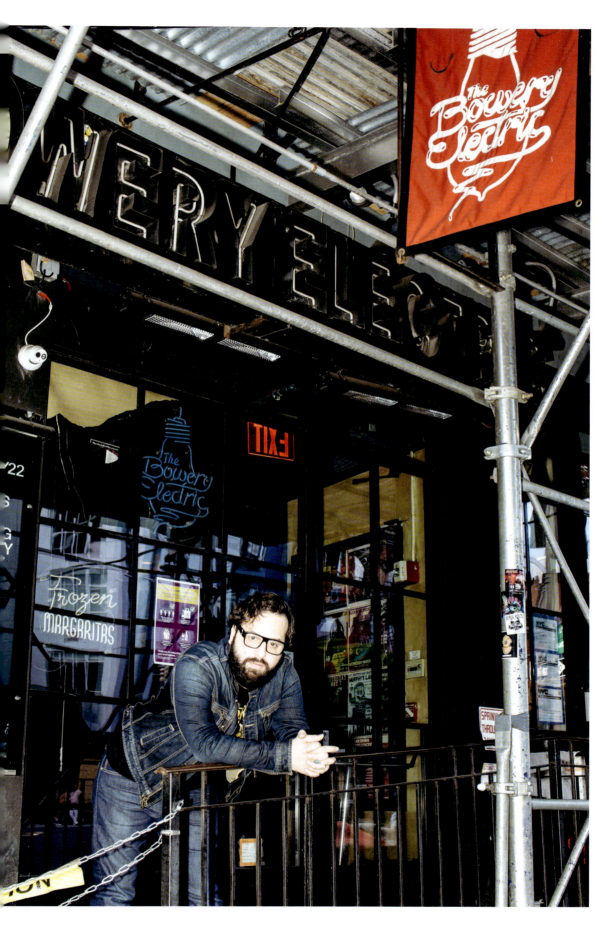

The experience I had with Cyndi Lauper epitomizes Bowery Electric [for me as a performer]. In the middle of "Money Changes Everything," my guitar wasn't tuned and I was standing here onstage [points down at the stage floor]. She came right up to me—she wasn't singing, it was an instrumental part—and she goes, 'Tune your f**king guitar!' Then she just danced away, went right back to the mic and started singing at the top of her lungs. I had never played with someone that famous before, or accomplished. In the moment it was overwhelming and I was nervous, but looking back I'm glad everything happened the way it did. And it happened here. As a fan, my favorite times here have to be the Sally Can't Dance parties—when you can get in, because they get pretty packed and sell out really quick. One particular night, a tribute to the Dead Boys, I remember being a really fun one just because of the energy and atmosphere. You could tell people were into the music and not just here to party. They were here for the music and to party. Those parties have a really good way of bringing out what was going on back in the '70s and '80s—not just re-creating the music, but also the actual atmosphere. Jonathan Bonilla

Brooklyn Bowl

This room is really special because of our owner and designer Charlie Ryan. He has these special hidden things all over the venue. On top of the bar there's a little peephole with a burleseque scene in it. All of the signage in here is inspired by signage from Coney Island. The stage is made from recycled tires, lanes are recycled corks. A lot of this room is recycled products. It's also a wind-powered venue and the bowling pins are on strings to conserve energy. Lots of really quirky nuances to this room make it special, make it Brooklyn Bowl.
Erica Hernandez

Above: Erica Hernandez,
Marketing Director
Right: A Knock Down Punk on a
well-used arcade game
Opposite: Interior of the bowling alley

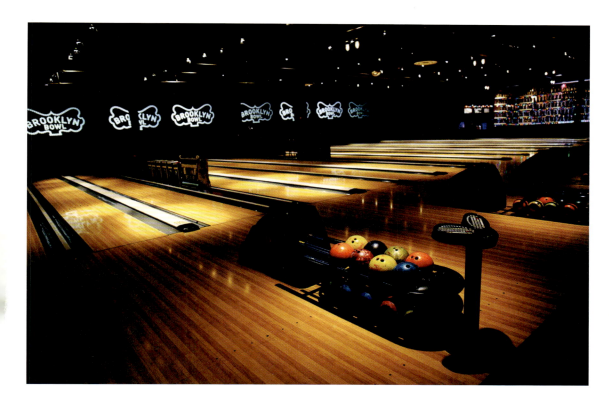

Brooklyn Bowl started with Peter Shapiro and Charlie Ryan. They worked together at the Wetlands in Tribeca. They used to go bowling as a staff outing and when they wanted to start a venue, they wanted to do something different: a bowling alley with [live] music. People didn't think it would work, but it works. Favorite memories? Usher and The Roots playing in June 2016, a rehearsal show for Roots Picnic. Questlove did it as a surprise show. So insanely special. Usher played every hit and just to see him on the stage was beyond epic. Also, two nights of Trey Anastasio. I am a huge Phish fan. Moments like those are so special and surreal, especially when you're fans of these incredible musicians and you get to see them in your second home. It's really amazing.
Erica Hernandez

Brooklyn Steel

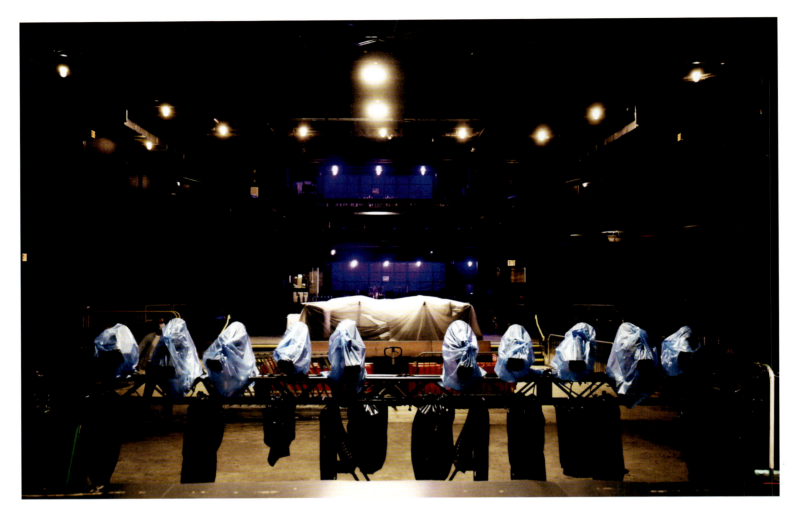

Building a soul of a place like this starts from the ground up. Some rehearsals happened before our first show day [LCD Soundsystem]. No matter what you do and how much you plan, you don't know until show night if it's going to work. When you open the doors and it works— when the lights go down and everyone screams— this is why we do what we do. Julia Chipouras

Above: Stage at Brooklyn Steel
Opposite top: Scott Raved, Construction Manager (The Bowery Presents)
Opposite bottom: Julia Chipouras, Operations (The Bowery Presents)

We had been looking for a spot for years. Long story short, we had spent a fruitless day in Brooklyn looking for venues. We saw about five places and felt pretty dejected. Then our team decided to stop by our landlord's for Music Hall of Williamsburg, since we were in the neighborhood, and came to their office. This was their office. Glancy [Jim, Bowery Presents co-founder] said, 'Wow I can't believe you own this place! Would you rent it to us?' They took a few days and then agreed. It was a steel fabricator [business]

originally. Having a blank canvas with this space was phenomenal. We walked in here and fortunately could envision what we wanted to see. For Bowery the goals and the milestones are really simple: great sight lines, easy to get a drink, easy to go to the bathroom, and for the artists and customers to feel like we cared. It took a while; a year of design, eight months of construction. When I was asked why it was taking so long, because it's just a box with a stage, I noted it's a pretty complicated box with a stage. Scott Raved

New York City

Forest Hills Stadium

[As I was] growing up as a kid, John McEnroe lived two towns over from here. He was my absolute tennis hero, and he's a music fanatic. Robert Plant came and played Forest Hills. I happened to be walking by backstage as John and Robert Plant were talking, and John asked Robert, 'Hey, have you ever played here?' Robert's like, 'You know, I don't think we have,' and it was true. [Led] Zeppelin was one of the major bands that had never played here. Then Robert turned to John and said, 'Hey, have you ever played here?' And that was all McEnroe needed, because he was like, 'I was a ball boy here from when I was 12 to when I was 17. I played in my first US Open here. And the first year I played here....' And John goes on to tell this story we all thought was a joke, but it turns out to be a true, verifiable story. The way we heard it was that someone had gotten shot in the leg in the stadium from somewhere outside, in the neighborhood. [The bullet] bounced off something, then dinged a guy in the shin. And they had to stop the match. It was a story we'd been telling for years, just repeating as if it was true, but no one knew if it was true. Now, I'm standing here listening to John McEnroe tell the story of his time playing in the US Open, and there it was: John McEnroe telling Robert Plant about the time they had to stop his second round match at the US Open right here in the stadium because some poor guy sitting in the stands caught a stray bullet in the leg from a shot fired three blocks away outside the stadium. Only at Forest Hills. Magic! Mike Luba

My real job is to go around the world and find strange places for bands to play. Having grown up on Long Island, I was always peripherally aware of the urban legend of Forest Hills. The backstory is that it was built as the first cathedral to American tennis, after Wimbledon in England. Forest Hills was the second major tennis stadium built anywhere in the world and the home of the US Open from essentially the beginning of the Open era all the way through 1977. By then the Open had just gotten too big for the spot here, so they rebuilt the National Tennis Center about six miles up the road in Flushing Meadows. It broke the heart of the tennis club members who had been here forever. The stadium just stopped being a focus. I don't know if it was too emotional for the club members or what, but for some reason they just left it alone, they basically abandoned the stadium. [Forest Hills] was in the first planned urban neighborhood in America, done by [Frederick Law Olmsted Jr.], the son of the famous guy who designed Central Park and Prospect Park. This was [Olmsted Jr.'s] master project, so when you go into the neighborhood, there are these beautiful houses and everything's interconnected, architecturally. Even now, everything we do anywhere in Forest Hills Gardens has to be run through their architectural board. The best thing about the stadium as a place to see a show is that because it was built to watch people playing tennis, and essentially before electricity, it looks like and feels more like a 7,000-capacity place. And in reality, you can seat 14,000 people and there's not a bad sight line. Mike Luba

Opposite top: Amber Mundinger,
Co-Founder (Bring Music Home)
Opposite bottom: Mike Luba, Partner
(Madison House Presents) sitting
in the stands of Forest Hills
Above: Mike Luba

The Green-Wood Cemetery Catacombs

I have always chosen music that moves me immediately in a profoundly visceral way. I never played classical music growing up, so it was never my first musical language, but when I started to get into it, I found it took me to a far more deeper and transcendental space than other genres of music could reach. So the idea for me is music that has an immediate impact to those who listen to it. It's understandable on an emotional level, but it has themes that tie to the space, that grapple with death, mortality, transcendence, and the themes that unite us. Being in a space like this, we are reminded of the one thing that we share: We will live and we will die. And how to find true meaning in that and that shared visceral, musical experience around music that encourages that. Andrew Ousley

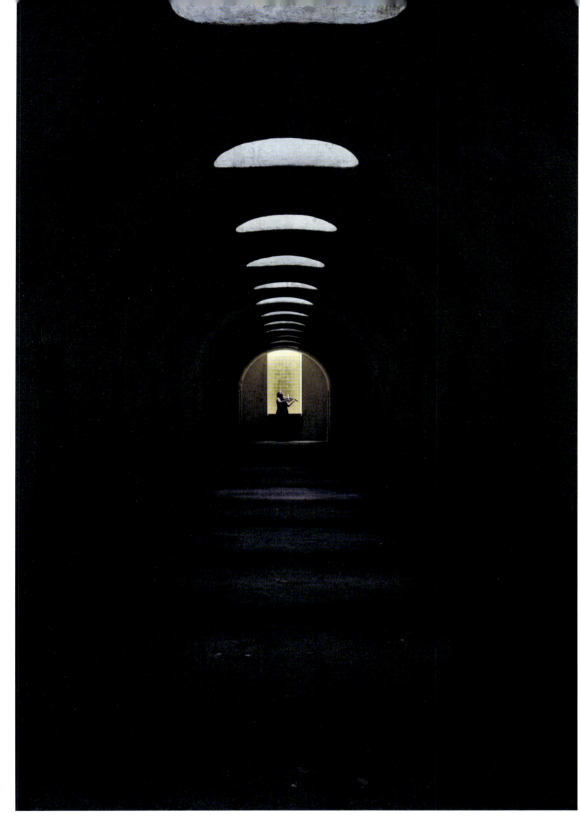

It's really great how the music has the conversation with the space and vice versa. It's never this spectacle of you are in the Catacombs. It's about the sanctity of the space, the beauty of the space. Having music that's having that conversation with people. You don't get that virtually or digital or on the internet. You need to be here in the space with those people around you, even if you don't talk to anyone. As you're walking through the cemetery and you pass the Gothic arch and out those gates, you know you have shared that experience with only 100 other people. I don't think many venues in NYC can do that. The cemetery is a testament to those who have passed. It's a testament to the many lives here—570,000 people are buried here—that this space is here. We call it a forever space, because ostensibly this cemetery will be here forever. Green-Wood wants to welcome visitors in here. We want people to come here not only to experience music, but have a place of solace and discover art history. What's happening with COVID right now is we are seeing people coming in, and they are coming here more for the silence and the respite, and we want to give them that space and that time. There will be music, and there will be music again, and there will be a time for gathering, but right now it's a time for what are we missing in our lives. Death is not just the ultimate death in the end. We have these losses every day in our lives: People lose their jobs, begin to be more anxious, lose their mental health a bit. This is not something easy to go through. So hopefully Green-Wood can help them deal with all those types of losses, not just the ultimate end loss of death. Harry Weil

I have actually gotten much more into the radio during this time. Just listening to the radio, it makes me feel closer with the announcer and everything. I have learned a lot of new pieces from [WQXR] and 88.3, the jazz station, and the Latin stations in New York City. It's impossible to be depressed if you've got salsa music going. I have become a little more eclectic in my listening because I am letting other people choose it. Radio can make you feel more connected. It's probably something I wouldn't have done. Lara St. John

Opposite top: Harry Weil, Director (Green-Wood Cemetery)
Opposite bottom: Andrew Ousley, President (Unison Media)/Founder (Death of Classical)
Above: Lara St. John, Violinist

Kings Theatre

My favorite fun fact is the popcorn machine that's by Bar 2. Before this place was renovated, we found a piece of the original carpet underneath the old popcorn machine. And we found the original carpet company— they are still open—and so this carpet is the exact same carpet as the original print from 1929. Chrystelle Henry

We're in Flatbush, the history of this theater is long, and we are in our 90th year. Actually, our 91st is this year. Kings Theatre opened in 1929, originally as a vaudeville/ movie theater. Vaudeville was not long for this theater unfortunately due to the Great Depression, but the movie theater stayed open from 1929 to 1977. Then the doors were closed and it laid dormant all the way till 2015. We reopened with *the* Diana Ross and haven't looked back! We are usually right around or right below 120 shows a year and that's just our ticketed events. But we also do a lot of community-focused, community-centric programming throughout the year. For a regular show day, we have 15 full-timers and a pool of upward of 200 part-timers, whether they be our bar staff, our cleaning staff, or our security staff. There's a thing you feel when you come in here, and our guest services staff, who are front-facing and the first folks you see when you come into the theater, are the ones who make you feel it— our frontline staff are the ones who make it happen. We're in the shadows, but our part-timers are the ones who keep the wheels turning. Stefanie Tomlin

The theater itself is my moment. Every time I am front-of-house during a show night, I see folks come in and watch their reaction to the space. Because when you walk down Flatbush, clearly you understand there is a theater there, but I don't think folks understand what they are about to embark on when they walk through our doors. So my favorite moment is on show night when folks walk in. It's like walking into a time warp. Like the Titanic— it's just, 'WHOA! I was not expecting *this*!' Ashley Christopher

Opposite: Stefanie Tomlin, the General Manager in front of a portrait of Dorothy Solomon Panzica, the first female General Manager of the Kings Theatre
Top: Ashley Christopher, Production Manager
Middle: Ashley Christopher; Stefanie Tomlin; Chrystelle Henry, Marketing Manager
Below: Chrystelle Henry

Knitting Factory Brooklyn

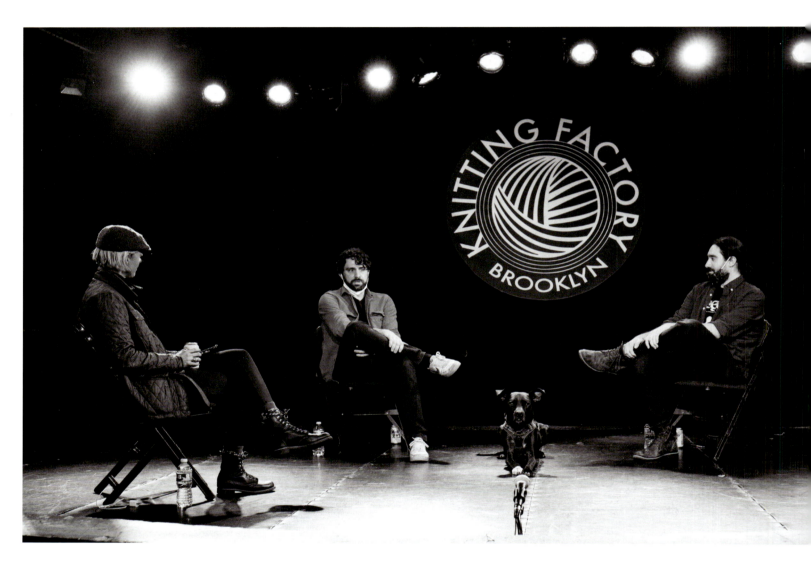

Above: Amber Mundinger, Co-Founder
(*Bring Music Home*); Ryan McGlynn,
Production Manager; Gabe Garskof,
Sound & Tech Engineer
Opposite: Ryan McGlynn

It's hard because there's so much unknown about the situation and how it's going to pan out, so there's a bit of uncertainty. You just find yourself working toward coming back again. I spend a lot of time trying to be better at what I do, studying things like electronic engineering and diving into further knowledge of audio. This is an opportunity for us to better ourselves, so when we do come back, we will be stronger and better and not be discouraged by this time. Ryan McGlynn

I miss the productivity of it. Shows are very fast-paced and you have to troubleshoot things quickly and get everything done to keep it on schedule. Having [those goals] and getting them all done, at the end of the night you feel like you did it. You pulled in a really solid day and you pull[ed] it all off. It's a great and really satisfying feeling. Not being able to run a show every night leaves you wanting for that satisfaction. Ryan McGlynn

Community is what I miss most about a live show. Coming here and seeing Kevin out of nowhere [photographer, friend]. Or a band coming in and going out for drinks and spending the whole night out together. So everything about community for me is the hardest part. Gabe Garskof

Music Hall of Williamsburg

It's crazy how much this neighborhood has changed over the last 10-15-20 years and it's cool because now Music Hall feels like an OG venue in the space. Music Hall has been here for 13 years now, and only a few other venues share kind of the same history—which is weird to think about now, because it's always felt new in a way. Sebastian Freed

Above: Sebastian Freed, Talent Buyer
(The Bowery Presents)
Opposite: Michelle Landry, Talent Buyer
(The Bowery Presents)

Watching how artists are trying to figure out how to connect with their fans in this time is keeping us going in a way. That desire to see them live is just building and building. By the time they're finally going to be able to play, I think it's going to be such a strong reaction.
Michelle Landry

Rough Trade NYC

Top: Matt Siggs, Talent Buyer
(The Bowery Presents)
Above: Matt Siggs and Kayla-CiAnne
Ford, Marketing (The Bowery Presents)
Opposite: Kayla-CiAnne Ford

Working with the artists you love and you grew up listening to, and then suddenly you're part of the experience, is just something completely unmatched.
Kayla-CiAnne Ford

We really get to start bands off here. They sell out Rough Trade and then move on to something like Music Hall. It's super exciting to be able to help grow the bands. It's fun to see some of these bands a couple of years later playing huge shows and we're like, 'We just saw them pack out a tiny Rough Trade show.' A lot of good memories in this space, for sure.
Matt Siggs

Saint Vitus

The caliber of artists we have had in here—everything from Nirvana's Rock 'n' Roll Hall of Fame afterparty to Megadeth, Anthrax—it's pretty nuts. I think the reason bands like that want to play [here] is because we support all of the organic scene in general. Newer, younger bands that now are established—names like Chelsea Wolfe, Blood Incantation, all these awesome bands played here when they were smaller, and now they are playing arenas, selling thousands of tickets. We built [the venue] for the scene and it reinforces itself. So it comes from both angles. David Castillo

Above: George Souleidis,
Co-Owner
Opposite top: David Castillo, Co-Owner
Opposite bottom: Stage at St. Vitus

We launched this Kickstarter campaign with the idea that the product would be the music community, which is very different from what Kickstarter normally does. They had never really done anything like this before. We set a goal of $15,000 and we raised $130,000, which is f**king insane. David Castillo

The rewards were incredible: drum lessons from Billy from Dillinger Escape Plan, drum lessons from Tucker from Thursday. We make a lot of merchandise so we had our special merch. Caroline Harrison, our amazing social media manager, really helped the nuts and bolts of this campaign come together [and] made an incredible design as well. I put it up and it just took off. An hour later, we had made goal, and I was like, 'Holy f**king shit.' David Castillo

When we got the place, it was just a shell. We had to build everything from scratch. Our one partner who [owns] this building, his father ran an industrial plumbing school here. So [there's] a lot of girders and stuff for moving heavy machinery around in here. People always ask if it was just like this, [if we] have been around forever, and no. We have been here for nine years, but it feels a lot longer than that. George Souleidis

Terminal 5

A lot of this industry can be people off in their own corner, but with the pandemic it seems like a lot of those walls have come down and there's a lot more collaboration. We all just want to do shows again. So it's the group collective right now. Hopefully it holds up.
Christopher Burrows

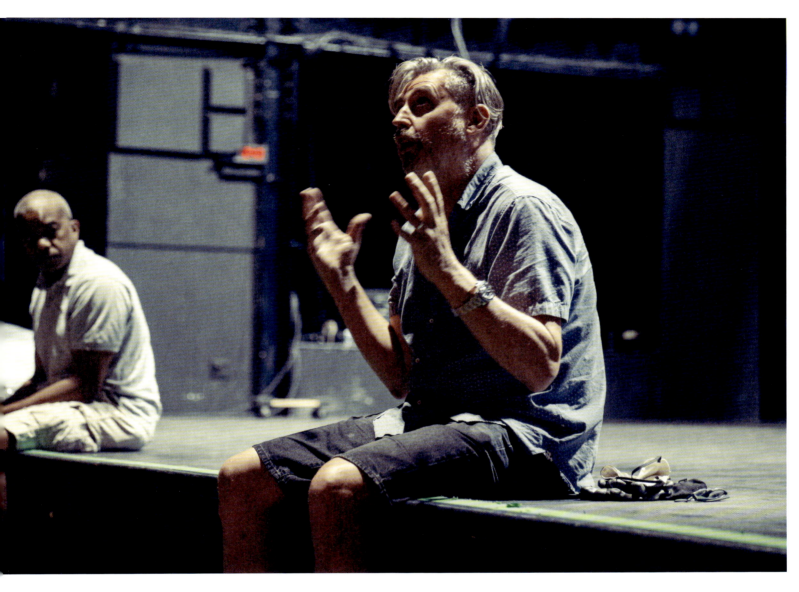

Opposite: Christopher Burrows,
Production Manager
(The Bowery Presents)
Above: Christopher Burrows
and Hal Gould, VP Operations
(The Bowery Presents)

Terminal 5 has been around at least since the '80s. It's been a chain of nightclubs including 4D, Carbon, and Exit, the last venue. I actually bartended here way back in 1986 when it was 4D. Didn't even recognize the building when I got in here. I worked here a couple of years before I realized it was the same place! What has inspired me [during the pandemic] is the connection between the other venues, and not just the ones in New York. Far-reaching venues are getting together because we're all in the same boat. It's been really wonderful. Hal Gould

Union Pool

Last show for Fontaines [before COVID] was Brixton. Biggest show we had ever done. Ended on a high. That was one of the best experiences I've ever had. Usually with big shows they're never as good as you think they're going to be. Everything clicked. A good memory. I feel our bread and butter is playing venues like this [Union Pool]. Second night we played here was my favorite. Felt really welcoming here, like a home. I always compare it to when we first started off in London, this feeling of being the outsiders as the Irish band. It just didn't have that feeling over here. The venue was so great. Conor Curley

Above left: Sacha Lecca, Deputy Photo Director (*Rolling Stone*)
Above right: William Schmiechen, Booker (Union Pool)
Opposite: Conor Curley, Guitarist (Fontaines D.C.)

First bar I came to accidentally in '05-'06. This place means a tremendous amount to me. Been booking shows for 10 years here and the venue has been having shows for 15. It's an old pool supply storage unit. so it's haunted with all sorts of chemicals [laughs]. Built out by the owners. Wood is from Grand Central Station. I've seen a lot of wonderful, meaningful shows here and also seen a lot of really bad ones. Union Pool is a family-owned business. It's the same two families and I've had the same bosses since the beginning. I feel very thankful to work here. A smart, caring community.

We have a food pantry here every Wednesday. We've done a lot for the community and tried to over the years. We know if we don't do that, we're no better than Starbucks.
William Schmiechen

I've loved so many moments here. It's just so comfortable. A few stories? I have a couple. A lot of the work I do at *Rolling Stone* doesn't involve music photography, and I had just closed an issue where we had created a top secret room in the offices that was not connected to any phone lines or any servers because we were working on a top secret feature on El Chapo, the Mexican drug lord, that was written by Sean Penn. So we were working with Sean Penn because he had tracked down how to meet him in person. And what we didn't know was the feds were tracking Sean Penn. So soon after El Chapo was captured, I was here [at Union Pool], in charge of all the photos for the piece, at a show, and I remember my phone was just blowing up from other publications asking for this particular photo of Sean Penn and El Chapo. It was all my worlds colliding.

Also, I loved the first night of Fontaines. [It was] one of those rare things where I didn't know much about you guys [talking to Conor] and was just blown away.

Distanced shows are too expensive. I hope we get to a place where shows can just be safe as they were before. That way, in the middle of a show, someone can just put their arm around you and it's not going to be weird. If we can't have that experience, it's going to be weirder than it is now. Sacha Lecca

Webster Hall

The same thing that I'm missing is what keeps me inspired—it's the people. Mike Venafro

Below: Lindsey Lee Seidman, Marketing (The Bowery Presents) and Mike Venafro, General Manager of Webster Hall (The Bowery Presents)
Opposite top: Stage at Webster Hall
Opposite bottom: Old show posters plastered on the walls backstage

Webster Hall is a New York City landmark and it's not just the facade or the front, it's everything that's happened inside here. I think the quirky things are what make these places so great, and there's so many of those things happening here that the average concertgoer doesn't realize. Maybe they pick up a little here, a little there, but they're like Easter eggs throughout. There's so much going on behind the scenes to create that experience. If you're attending a show, there are people literally below your feet here working, running, carrying something, doing something you're not going to see anyone do at any other job. And they're doing it with passion, not just because they're here at their job. They are doing it because they love this industry, they love concerts. It's what drew me to this industry. Mike Venafro

To this day, one of my favorite weekends ever was Friday night with Sharon Van Etten, and Norah Jones came out and played 'Seventeen' with her, which was so beautiful. We left that show around midnight, went back to our respective homes, and then about nine hours later we came back for a six-hour Vampire Weekend set. It was like we lived here that weekend. They fed us breakfast, lunch, and dinner in the venue. It was like a 48-hour run of music and it was so cool.
Lindsey Lee Seidman

Philadelphia

POSTER DESIGN
Kate Otte

PHOTOGRAPHER + PRODUCER
Colin Kerrigan

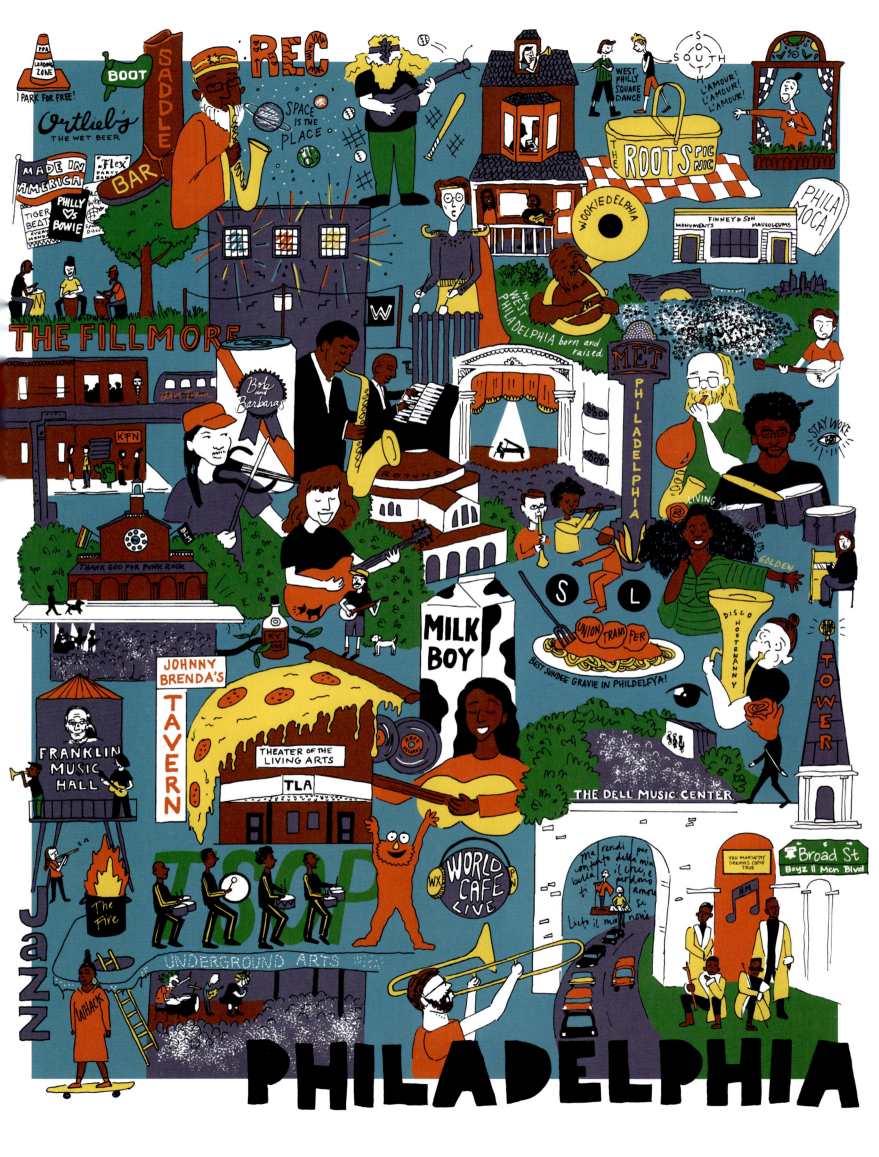

Playlist

This Select EP Playlist Curated by DJ Hesta Prynn

1. **Franklin Music Hall (FKA Electric Factory)** *The Roots*
A Philly mainstay. Before The Fillmore and Union Transfer, Electric Factory and Trocadero were where you went to see everything—Jimi Hendrix, Janis Joplin, Prince, Amy Winehouse, Radiohead, Adele—and it's kept that status. If a band's not playing the big arena, they're playing here. It's a big honor to sell it out.

2. **Johnny Brenda's** *Chip off the old block* A lot has changed in the Fishtown neighborhood in the past 20 years, but still standing at the corner of Frankford and Girard Avenues is that unmistakable triangular brick building and its red-lettered sign for "Johnny Brenda's Tavern." Honoring the bar's old school authenticity, co-owners William Reed and Paul Kimport chose to keep its original name and sign (and pool table) and to support local businesses by serving a wide selection of local beers and great food. Some just come for the food and drink, but they've also got a reputation for booking great shows, too, starting with The War on Drugs, who played the upstairs venue's opening night back in 2006. Since then it's become an oasis for local and touring bands, and its intimate, 250-capacity stage has been the setting for many a memorable night, hosting acts like Kurt Vile, Dirty Projectors, Janelle Monáe, Sufjan Stevens, and the Sun Ra Arkestra.

3. **World Cafe Live** *A musician's venue* Anyone will tell you there's not a bad seat in the house, which is exactly what founders Hal Real and David Dye intended. The renovated Art Deco factory's multiple stages can host several shows in a night and is also home to WXPN's live studios. The attention to acoustics, vibe, lighting, and equipment has made this a place where musicians look forward to performing.

4. **PhilaMOCA (AKA The Philadelphia Mausoleum of Contemporary Arts)** *Dead Man's Party* The historic Finney & Son building was a showroom for mausoleums and tombstones dating back to the 1850s (the original facade is still intact), and it's where PhilaMOCA gets its tongue-in-cheek name. In the mid-2000s Diplo bought the building and used it as a recording studio, but after he left, it shape-shifted yet again to become the multipurpose art, music, and cultural exhibition space that it is today. The DIY ethos is strong in this one, thanks in large part to Manager and Director of Programming Eric Bresler, who's spent the last eight years cultivating PhilaMOCA's reputation as a place for progressive and subversive programming. He keeps busy, hosting 250+ events a year. Lots of indie and punk shows, underground cinema screenings, and contemporary art exhibits. It's a small space, but it's got a good sound system and a lot of character.

5. **Boot & Saddle** *Lone indie foothold* For such a small venue, B&S had a lot of heart. It was cool without trying too hard. With 150-capacity, it was where you went to see acts up close and personal and probably talk with them at the bar after the show. It's where Lizzo and Sam Smith made their Philadelphia debuts, and where bands like Circa Survive, The Menzingers, and The War on Drugs would play secret shows. It was also, at the time, South Philly's only music venue after a near two-decade dry spell. Its iconic neon sign was restored from its dusty former days as a country & western bar, acting as a beacon for music lovers. Sadly, after being shuttered for eight months due to the pandemic, co-owner Sean Agnew finally announced the Boot's permanent closure in November, after seven years and 1,500+ shows, so that its sister venue Union Transfer might live on. For now, the neon sign remains.

PHILADELPHIA

A SIDE

Johnny Brenda's:
Kurt Vile
Pretty Pimpin

World Cafe Live:
Jill Scott
Golden

**Franklin Music Hall
(FKA Electric Factory):**
The Roots
The Seed (2.0)
(featuring Cody Chesnutt)

Boot & Saddle:
The War on Drugs
Under The Pressure

PhilaMOCA:
The Dead Milkmen
Punk Rock Girl

SCAN TO PLAY

Philadelphia

Allie Volpe

1. The Philadelphia Orchestra got the Hollywood treatment with Disney's Fantasia. Yeah, our orchestra is famous. In 1939, the Philadelphia Orchestra began recording the score to Disney's Fantasia at the Academy of Music, led by conductor Leopold Stokowski.

2. The city's jazz scene is unparalleled. Throughout the 20th century, a number of musicians helped define jazz in the city: John Coltrane, Benny Golson, Jimmy Heath, Dizzy Gillespie, and later, Sun Ra. Venues all across the city, like the still-running Clef Club, hosted A-listers like Duke Ellington, Count Basie, and Art Blakey, ingraining jazz culture in the city's musical history.

3. "American Bandstand" brought Philly culture to the masses. From its start in 1952 through 1963, when production moved to Los Angeles, "American Bandstand" was shot in Philly, with hip teens dancing to the country's popular tunes.

4. Gamble and Huff defined the "Philadelphia Sound." Local songwriting and production team Kenny Gamble and Leon Huff founded Philadelphia International Records in 1971 and began exploring a new kind of soul: the Philadelphia Sound. Home to artists like Harold Melvin & the Blue Notes, The O'Jays, and Billy Paul, the label popularized a smoother version of soul that made way for the disco of the '80s.

5. David Bowie and Stevie Wonder came to town to record at Sigma Sound. Speaking of the Philly Sound, many of the cabal of artists under the sub-genre recorded at Sigma Sound Studios at 12th and Race. International stars like David Bowie (who recorded *Young Americans* there in 1974), Stevie Wonder, Gladys Knight, Lou Rawls, and Erykah Badu also paid visits to the legendary studio.

6. Huge music fests got their start here. Roots Picnic? Made in America? Mad Decent Block Party? Yeah, they're all Philly originals. Philly is also home to city-specific events Philadelphia Folk Festival, XPoNential Music Festival, and the Philly Music Fest.

7. You can always find a place to dance. No matter the time, day of the week, or season, there's a dance floor awaiting your presence. From Fishtown's The Barbary to South Philly's Dolphin Tavern (and the many others in between: Warehouse on Watts, Woody's, Silk City, The Trestle Inn, The Saint, Voyeur), the city's best DJ's are always spinning.

8. Our local talent might be the best. Sure, every local says their city has bred the best musicians, but Philly really takes the cake with Billie Holiday, Marian Anderson, Patti LaBelle, Frankie Beverly, Chubby Checker, Mario Lanza, Jill Scott, Meek Mill, Kurt Vile, The Roots, DJ Jazzy Jeff…the list goes on and on.

9. The small rooms are where the magic happens. Arcade Fire in the basement of the First Unitarian Church. Sam Smith at Boot & Saddle. The National at Johnny Brenda's. Eleanor Friedberger and Big Thief at MilkBoy. The lower-cap rooms are where you'll catch the next big thing in music before anyone else.

10. Know the insider show-going secrets. Shows are BYO at the Church, but leave your glass bottles at home. The Fire, appropriately named considering it's located next to a fire station, also feels like an inferno in the summertime. Sneak around the crowd at Union Transfer by slipping up the left or right side of the room. By day, the Pharmacy is a coffee shop, but by night it's an art and performance space and often frequented by the owner's dog. Since Underground Arts is, well, underground, don't expect great phone service (or any service at all, really). The food at Johnny Brenda's is killer, so make a night of it.

Boot & Saddle

This job is my life. Music is my life. Every day I wake up and there's something to do with music: managing this place, booking local bands [here], and playing in my own projects. I've realized that without music, I really have no outlet for expression. Gina Piccari

Below: Stage at Boot & Saddle
Opposite: Gina Piccari,
General Manager

My staff and I have not managed during these times. After two weeks, we all just got really depressed. We don't work in this industry to make money—[but] it's our only form of income. We work in this industry because we love it. The depression kicks in from not having seen live music in months; I haven't even really looked at new bands in months. Part of the cool thing is having a band come through the venue that you've never heard of and watching them and thinking, 'that's really cool.' We do a lot for the city, for South Philly, and for local bands and touring bands, which is cool. It's empowering to remember what we used to do, and hopefully get back to it as soon as possible. Gina Piccari

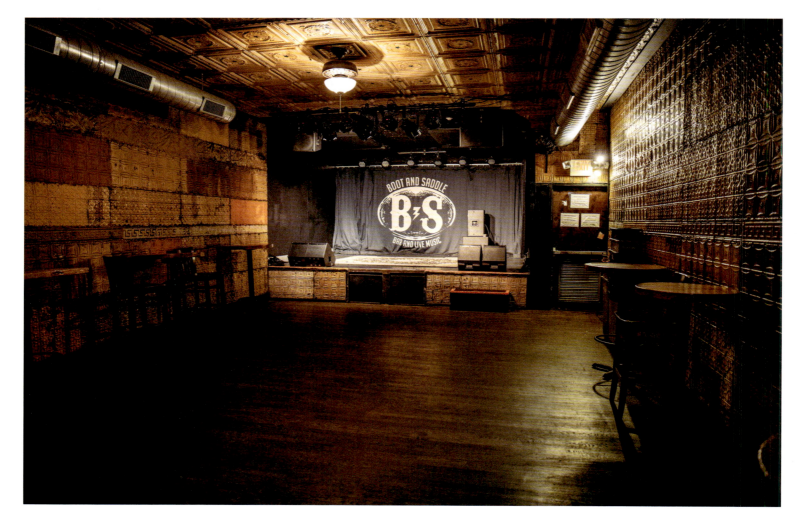

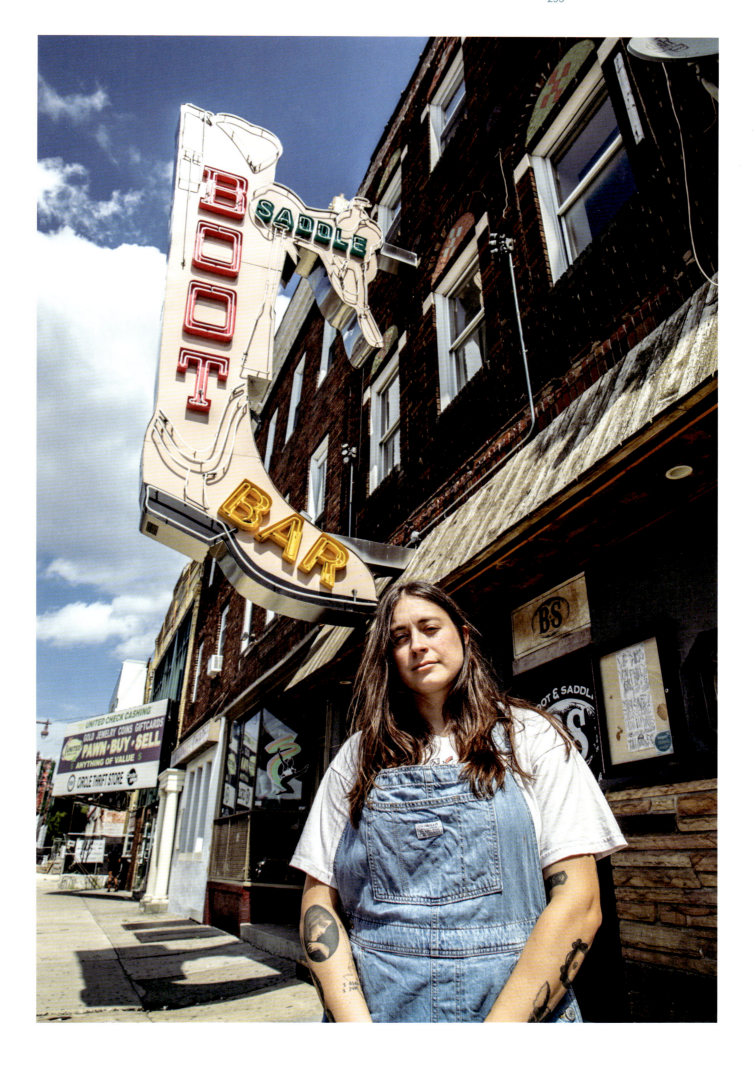

Franklin Music Hall

This place has been here for so long and as far as music goes, and culture and its history, you're inside a place where that all happens and you can't manifest that overnight, you can't manufacture that. What's really crazy about Franklin Music Hall and the Electric Factory now is we're in a time where it's definitely evolved into a whole other thing. When [Franklin Music Hall] was first introduced as a venue, [it] was more of the Goliath in the David and Goliath story. It was the big venue where everybody aspired to go. Now, the terrain is very different for venues. Even though [Franklin Music Hall] was successful, it was bootstrapping through all that and held itself up, and now it's allowed itself to be a tough venue. It's been given the opportunity now to show its teeth, in a sense. It is now a monument to the venues that have come and gone in Philadelphia. It was the No. 1 before and now it's even more important for it to be the No. 1 forever. Jessie Jay

I work at True Hand, and we were hired to do the design and branding for Franklin Music Hall. I've also lived in the city for 15 years and have been an attendant at [Franklin Music Hall] many times. Jessie Jay

I think one of the most
beautiful things to come
out of this shut down
is the support that the
Philadelphia music and
venue community has
shown one another. The
shock of not doing what
we love really brought
people together from
local venues, bands, and
companies, expanding
our community by
frequently connecting
and sharing information
with one another. That
love and concern gives
you great hope for when
we are all able to work
together again.
Toni Bourgeois

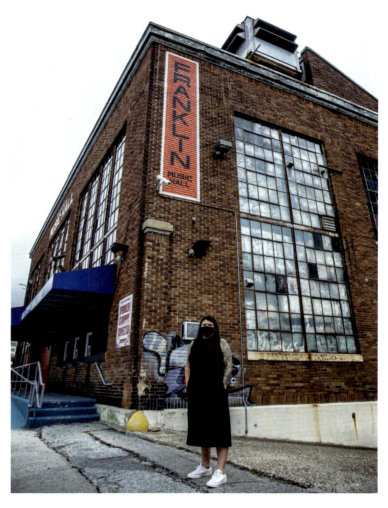

Opposite top: Backstage area
Opposite bottom: Jessie Jay and Mike
Ski, Designers (True Hand)
Above and top: Toni Bourgeois,
General Manager

I also work at True Hand. We
were the designers hired to do
the rebrand for Franklin Music
Hall. I've lived in Philadelphia for
about 14 years and have been a
spectator and hanging around
here in the club for many years.
After spending a decade traveling
and being able to experience
what most major cities are like,
then deciding that Philadelphia
speaks to me and moving here
and making a life here, what
we're getting after is a thing that
is just about Philadelphians: It's
an attitude. [It's] basically, 'F**k
everybody, we don't care,' and
that's a challenge as designers. But
we're also participating in that as
Philadelphians. To the credit of
the people involved [in redesigning
the venue], we appreciate that
as a Philadelphia company and
Philadelphia designers, we were
given the opportunity. We always
complain [when] people come
to Philadelphia and brag about
how they brought this guy from
Brooklyn to paint a mural, and we
f**king hate that shit. So we were
like, 'This is smart.' They know
enough to know Philadelphians
need to be a part of this process,
and we appreciated that. Mike Ski

Johnny Brenda's

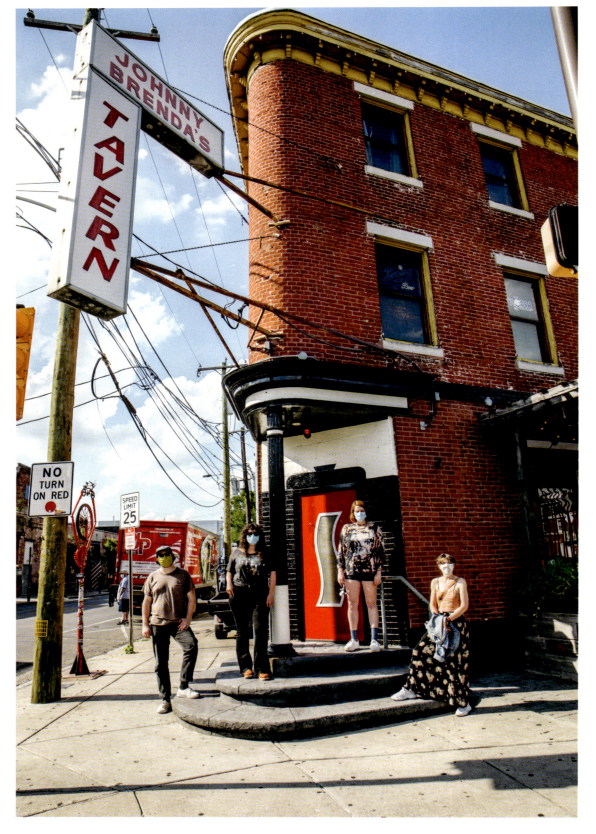

To me, as a scene, Philadelphia is defined by no one doing just one thing. Everyone wears a lot of hats, and that feels very representative of JB's. As the booker, I still make the posters. Everybody's working around and aware of each other's work. It's collaborative. As a standalone, independent venue, we've been able to really focus our programming on stuff we're genuinely excited about, focus on local artists we're excited about, which has really contributed to the reputation of [JB's] in Philly. It really matters to a lot of artists to be able to play here. To sell this place out is a milestone for so many people. To have that community be cut off from this room and this room to be cut off from that community is crushing. The feeling that gathering in these spaces would make people feel sad or scared is so heartbreaking for all of us. These places are built around seeing live music, going to shows, finding new bands, seeing stuff you already love with your friends. These are [also] spaces where people meet. [They] make friends, see people they haven't seen in a while, catch up, talk about politics. This is a place where a lot more than just music happens, not that that's not enough on its own. What these venues do for people all around the world is so much bigger and more spiritual and intrinsic to who you are as a human being. I just can't stop thinking about how many people aren't meeting right now, how many ideas aren't being had, how many hugs aren't being enjoyed. Barrett Lindgren

Above: Barrett Lindgren, Head Talent Buyer; Marley McNamara, Assistant Talent Buyer; Lucy Stone, Musician/ Manager; Frances Quinlan, Lead Singer (Hop Along)/Former Employee
Opposite top: Stage at Johnny Brenda's
Opposite bottom: Lucy Stone; Marley McNamara; Frances Quinlan; Barrett Lindgren

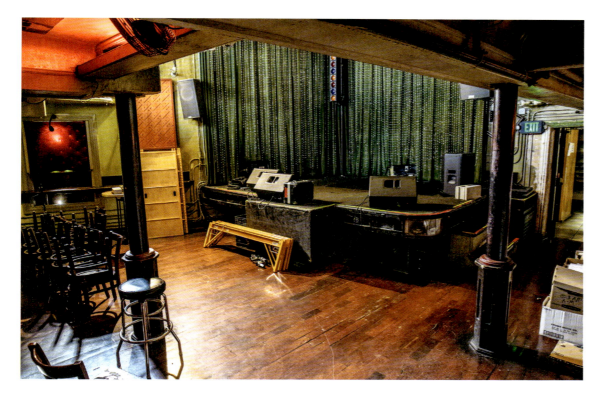

The sense I get is that the people who come in here have an inherent respect for the staff, which is returned by the staff. Everybody just wants it to be a great show, including the servers downstairs and all the bar staff. There really is this throughline that everyone's on the same page: We all want this to be a good experience. Frances Quinlan

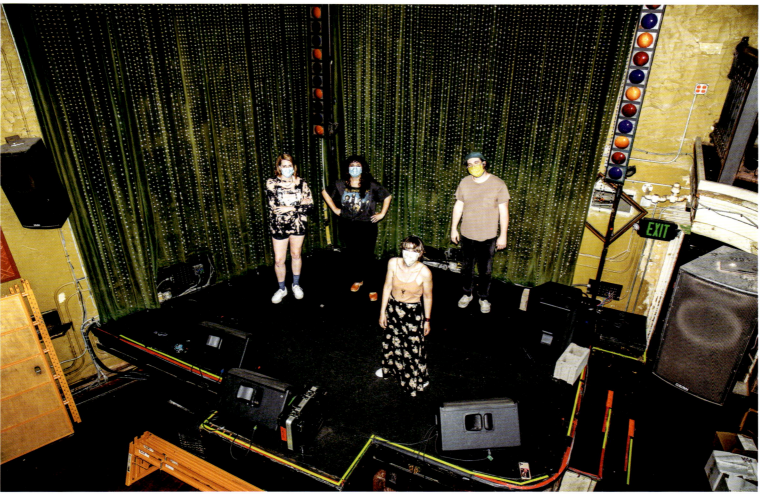

Ortlieb's

The reason people keep coming back is no matter what level you're at, we'll always treat you the same way. The relationship we build with bands is real: If you're good to us, we're good to you.
Kyle Costill

Below: Kyle Kimble, Drummer (Nothing); Kyle Costill, Owner; Patrick Troxell, Booker
Opposite: Stage at Ortlieb's

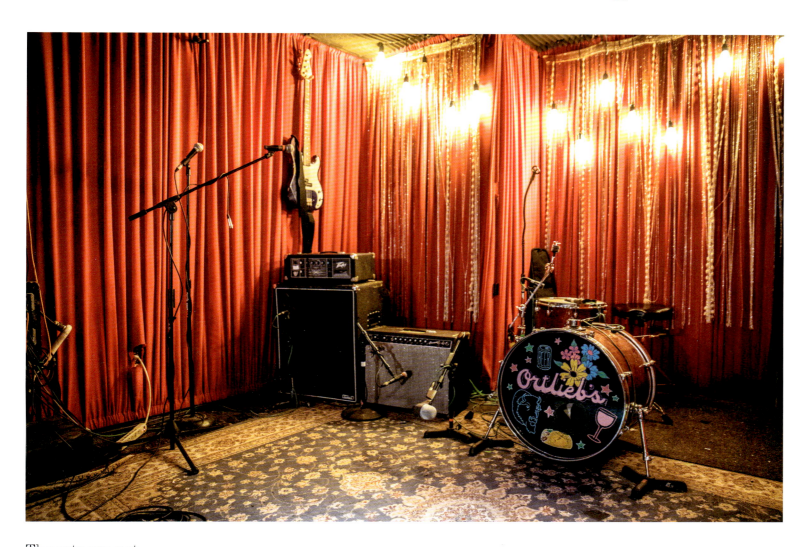

The arts are not funded in general in this country; you don't even hear venues being mentioned in the headlines. We have the National Independent Venue Association that we're part of, but on the national scope of things, I don't think people understand just how many people's jobs and livelihoods and how much money is created by people coming to a show on a Friday night.
Kyle Costill

PhilaMOCA

It's been nine, 10 months and I haven't missed rent. Money came in from all these different sources. [Community support] has been really overwhelming and definitely lessened the stress of each passing month. Eric Bresler

Opposite top: Eric Bresler, Manager/Booker
Opposite bottom: Stage at PhilaMOCA

I did not expect the support our fundraiser received. I was completely shocked. The past eight years I've been here really blend together when you've been as productive as we have. And rarely did anyone come up and say, 'Thank you for doing this, I had a lot of fun.' That lack of compliments and appreciation kind of built up. But I always hoped people enjoyed what they saw here. That became very apparent when people donated money; they really do care about us. That just meant the world. Eric Bresler

REC Philly

We've learned that we're one of the most resilient groups of people we know. If we had it our way, a really excellent way to reopen our space would be to have Tierra Whack and DJ Jazzy Jeff create an experience for 200 people in our space. I'd love to see that, and I think our city would love to see that. Will Toms

Above: Dave Silver, Co-Founder/CEO and Will Toms, Co-Founder/CCO
Opposite top: Sign above the door
Opposite bottom: Stage at REC Philly

No matter how much you try, and the experience you provide, there's nothing that can really replace the interactive experience. We did whatever we could, and everyone understood what was happening. Even when there's a lag, or everyone gets kicked out of Zoom by accident, everyone understands that we're all going to be running into challenges. What was nice about our communities is that we were all on the same page. Dave Silver

As people who really love live music, doing a concert over Zoom just doesn't really scratch the itch. Will Toms

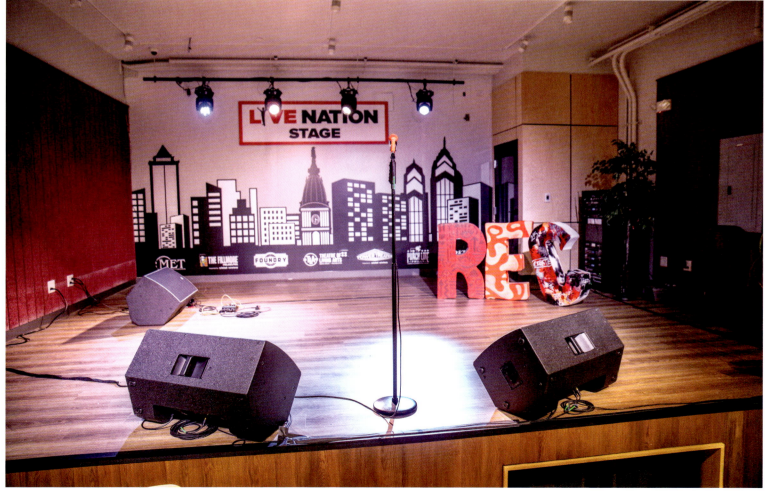

Underground Arts

We did apply for some government assistance and were awarded a fairly substantial amount of money through the PPP program. I made a decision that all that money will go to personnel, not to rent. The whole reason I got involved here to begin with was to help this community. I didn't do it to make a living or to get rich. I just wanted to be an old guy who could be around a lot of young people and have a lot of fun. Gary Reuben

We realized right away that entertainment and places where people gather, especially inside, are going to be the last to reopen. It's probably easy for us to get lost in the mix when we're talking about assistance from the government, so those measures were really important to let our [staff] know we're not going to forget them and when this is all over, they'll have a place to come back to. I applaud the ownership here for, without questioning, just stepping right up to the bat. Rich Stouffer

It's called a pandemic, it's affecting everybody. We're hard-hit but so is everybody else. It's important to be kind to other people during this time and just really focus on other people. [We can't] sit here with our heads in our hands going, 'Woe is me, we can't do shows.' There's important stuff going on beyond music. Rich Stouffer

Above: Gary Reuben, Founder, with some of his favorite show posters from Underground Arts
Opposite top: Stage at Underground Arts
Opposite bottom: Kevin R. Horn, Talent Buyer; Rich Stouffer, General Manager; Gary Reuben

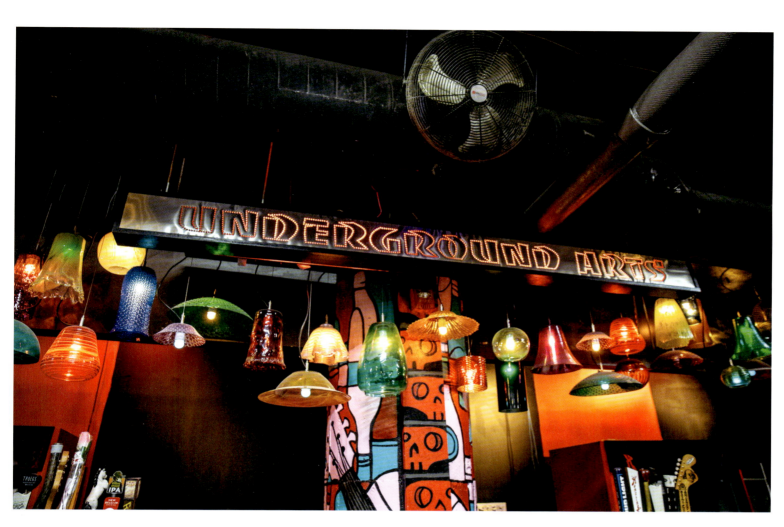

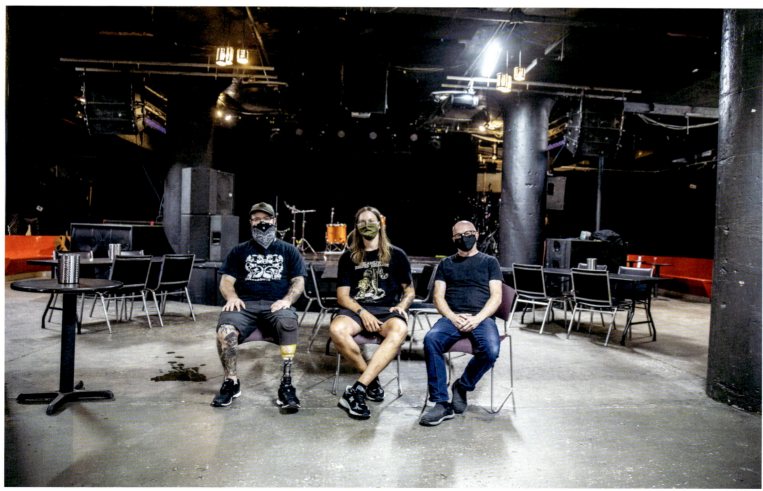

Warehouse on Watts

After the fallout of, 'Shit, this sucks,' we had the drive to see what we had around us and made the best of it. Resilience and our family are both very important to us and I think that became very apparent when all of this happened. Meg Bassett

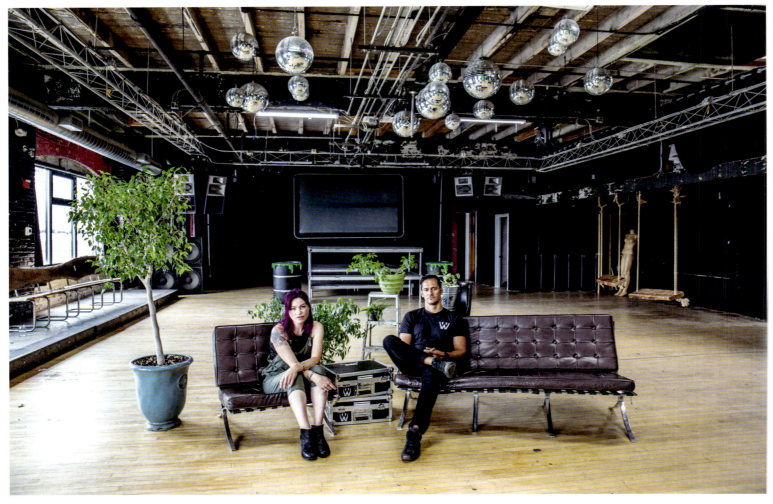

I do rely on these people as a support system, not just as a business, but socially and personally. You're around everyone all day, every day. In most businesses, when you get to a point where the dynamic is altered, it's like, 'Alright, let me know when stuff's up and running again.' But around here everyone just wants to help, wearing all different hats to make it work.
Gavin DiRusso

Opposite top: Meg Bassett, General Manager and Gavin DiRusso, Owner
Opposite bottom: Meg Bassett and Gavin DiRusso
Above: Staircase at Warehouse on Watts
Right: Meg Bassett and Gavin DiRusso

World Cafe Live

Not only are [venue owners] talking to each other nationally, but most cities are also organizing now. We have 30 independent venues in Philly all trying to talk to each other about these things. We may compete on some level, but we have more in common than we do apart. We need a collective voice to say to City Council in Philly, 'For these venues to survive, we need your help.' Hal Real

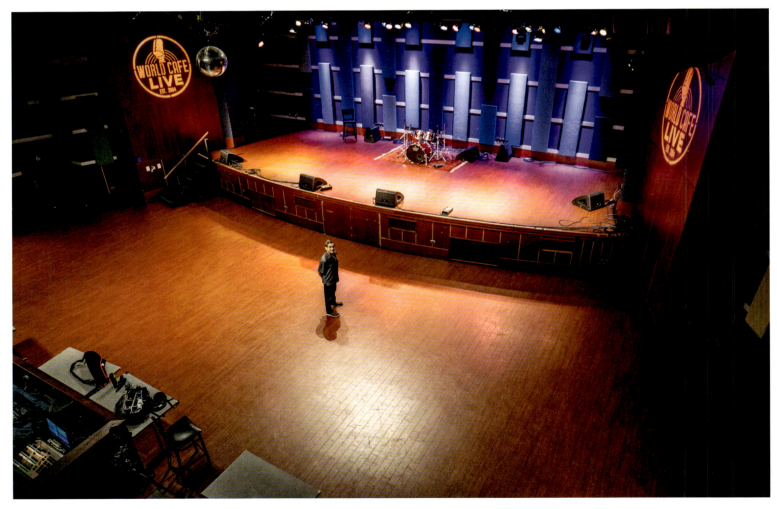

Opposite top: Rob Cottman,
Executive Chef
Opposite bottom: Hal Real,
Founder/President
Right: Exterior of World Cafe Live
Below: Hal Real

Any reopening plans
start and end with the
safety of our staff.
Our staff is our family.
That's very critical to us.
Hal Real

Phoenix

POSTER DESIGN
Quinn Wilson (Hamster Labs)

PHOTOGRAPHER + PRODUCER
Griffin Riley

Phoenix

Stephen Chilton

1. "Those Lowdown Blues" with Bob Corritore For more than 35 years, Rhythm Room owner Bob Corritore has played the blues every Sunday night on local NPR affiliate KJZZ 91.5 FM.

2. Mariachi Pasion You can't talk about the Southwest without talking about traditional Mexican music. Mariachi Pasion is an all-female Mariachi band keeping the traditional sounds alive in Arizona.

3. Rosie's House: A Music Academy for Children We all know the decline of music education in schools is a tragedy. But in Phoenix, we have Rosie's House, one of the largest free after-school music programs nationwide with 400 students from economically disadvantaged backgrounds enrolled annually.

4. Stinkweeds Records Stinkweeds has been a staple of the indie music scene in Phoenix since the '80s. While many other record stores have shuttered, the great community around Stinkweeds keeps it stronger than ever.

5. 8123 Local record label 8123 is home to The Maine as well as several other indie rock and pop bands from Phoenix. Their biennial event 8123 Fest brings fans from all over the world to downtown Phoenix.

6. Flying Blanket Recording Producer and engineer Bob Hoag has recorded some of the best records to come out of Arizona. Local artists like Dear and the Headlights, Spirit Adrift, The Format, The Maine, and The Technicolors have made records with Bob in this studio in Mesa.

7. Alice Cooper's Solid Rock Most people know Alice Cooper for helping invent shock rock, but in Phoenix, he is also known for his nonprofit Solid Rock, a teen center focused on music, arts, self-expression, and creativity. For 19 years, Cooper's Annual Christmas Pudding Fundraiser concert has raised funds for the center.

8. ZIA Records Tower Records stores may have died but ZIA is keeping the record store experience alive with a number of stores in Phoenix, Tucson, Tempe, and Las Vegas.

9. Walter the Bus Walter is a two-to-one-scale replica of a classic VW bus. Since its debut at Burning Man, Walter has grown into the outfit Walter Projects and has become a staple of Arizona events. Bringing a dance party wherever it appears, it has helped make events like Crescent Ballroom's annual NYE Party the largest in the state.

10. Teenage Badass This 2020 coming-of-age comedy film directed by Grant McCord and written by McCord and Matthew Dho tells the story of a fictional indie rock band trying to make it. Set in Phoenix in 2006, the movie was filmed in a number of PHX staples like Rebel Lounge and Gracie's Tax Bar.

Celebrity Theatre

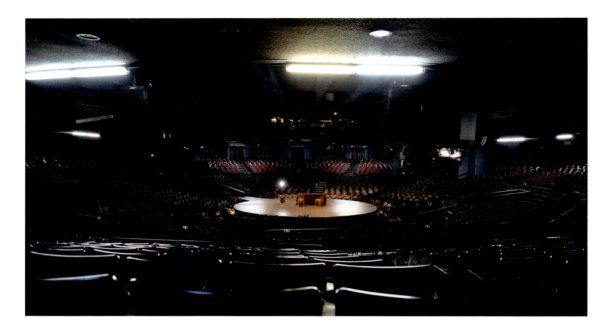

The roar of the crowd and the looks on their faces are going to be priceless. I can't wait.
Heidi Hazelwood

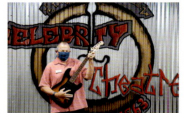

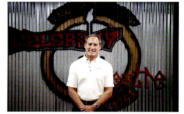

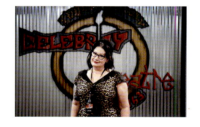

Every rock band worth their salt started in small little theaters or bars or little venues. When we started in Detroit, it would be us and Iggy and the Stooges and MC5 and The Who in a place that was maybe a thousand people, but that's how you learn to be good. A band gets good playing two or three sets a night in a bar. Celebrity Theatre of course, in Phoenix, was a big deal when I was in high school. Here we were, [a] Yardbirds-type of rock band in Phoenix, and Buster Bonoff decided to do a full-on production of *Bye Bye Birdie* with Jan Murray and Sherri Spillane. They wanted us [the band] to play the Birdies, so we played the Birdies. We learned you have to be sincere about legit theater in the round— it was an education for us. And we got bit by the bug that rock 'n' roll has to be theatrical, and that's where a lot of the theatrics came into the Alice Cooper show. It was seeing real theatrics on the stage in the round, realizing we can do this with rock 'n' roll. Why not apply this to rock 'n' roll? Celebrity Theatre played a big part in Alice Cooper and how we developed. Alice Cooper

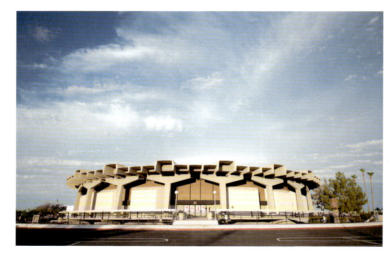

Top left: Stage at the Celebrity Theatre
Middle: Exterior of the Celebrity Theatre
Above: Alice Cooper, Musician
Right (top to bottom): Scott Kroeppler, Guest Services Manager; Andrew Birgensmith, General Manager; Julie Dougherty, Venue Manager; Heidi Hazelwood, President/CEO

We are all about making people happy here and about bringing them back not just a second time, but consistently throughout the year. We want our guests to come back for any performance they are interested in. I just love seeing the looks on their faces when they are here. For a first-time guest to this place, I have seen that look hundreds of times and they are just in awe at the way the stage looks and how close they are to the artists. When they leave, they have something great to say and I know they will be back.
Scott Kroeppler

Crescent Ballroom

One hundred and two years ago, [it was built] as a garage, and after that it was a hunting store and then a dry cleaners. In 2011, it became Crescent Ballroom. Charlie Levy

Personally, my job is a huge part of who I was—and it totally matters. But [I'm] taking a step back and asking myself what standards do I define myself by? That is something I have been deep-diving into the last three months—where to place the value and to find my role in everything. Gwen Massett

I think I am doing what I was born to do. Being in the music industry and behind the scenes doing live music and making shows happen are the only things that have brought purpose to my existence. That may sound crazy to some, but whether I go on to learn other things or do other things outside of this, related to music, this is my life. Music is my life. I am doing what I was born to do and it is going to come back. That's my energy. That's what keeps me going. Grasher Johnson

Above left: Angela Donato, General Manager
Above right: Exterior of Crescent Ballroom
Middle: Charlie Levy, Owner/ General Manager
Bottom: Grasher Johnson, Production/Sound Engineer; Gwen Massett, Box Office Manager; Angela Donato

Marquee Theatre

What have I learned? I'm still a music fan. I can't wait to see a live concert, and I know there's a lot of you out there who feel the same way. For us who have found a career in this business, there's no greater career. When it works, it really works, and when it doesn't work, it's still not that bad. The best thing in terms of the venue and the music is [that] 95% of ticketholders [have] held onto their tickets. We've only had about five, maybe 10% of refunds. The patrons are holding the tickets. Tom LaPenna

Top: Tom LaPenna, Owner
Above: Backstage
at the Marquee Theatre

The Rebel Lounge

This building used to be a venue called the Mason Jar from 1979 to 2005 and was the definitive rock 'n' roll/punk rock bar in Phoenix. Everyone from Black Flag to Metallica to Nirvana all played here. Linkin Park's first show with Chester Bennington was in this building. It was *the* staple rock club for a long time. Then it had been a number of different vibes. When we took it over, we did a massive renovation and opened it as Rebel Lounge in 2015. I was already hearing from other promoters in other cities about shows getting cancelled in Seattle, in New York. Compared to a lot of businesses and other people, we were already seeing the early signs of it. I remember the day SXSW cancelled [March 6, 2020]. I was pretty pessimistic and sat everyone in the office down and was like, 'This could get bad. We need to start thinking this could be bad.' I did not think it would be this dramatic or this bad. I was thinking we could have some cancelled shows, not that we were going to cancel the entire calendar. Steve Chilton

Above: Devan Hash, Administrative Assistant/Promoter Representative
Bottom: Steve Chilton, Co-Owner/Talent Buyer

I am so used to be out and talking with people and meeting new people all the time, and interacting with different tour managers and meeting people at the front door. Going from a lifestyle like that to being in your house all the time really is a dramatic difference in how we live our lives. Devan Hash

Valley Bar

With a lot of us, it's both [managing mentally and economically]. You work so you can eat, but when you are doing what you love and getting paid to do it, you get to see shows and work your dream job. It has a really strong mental effect, too, when you go from having something to do every day for 12 to 14 hours to nothing, overnight. And watching everyone you know around the industry—friends, people you have known over the years—just fall apart. Some people are falling apart, some are managing, and some are just barely managing. Others have found new things to do, hobbies, that they were doing on the side when they weren't working. But [the pandemic] has decimated the music industry as a whole.

Grasher Johnson

Top: Pool table in Valley Bar
Above: Gwen Massett,
Box Office Manager
Right: Grasher Johnson,
Production/Sound Engineer

The Van Buren

The building was built in the late 1920s. It was originally a car dealership and auto showroom, and when our owner now came into the building, it was used by a home developer for all of their equipment and staging materials. A complete renovation happened over 2016 to 2017, and we opened for shows in 2017, with [the] first shows being Cold War Kids. Jessica Hill

Top: Cindy Gavarrete, Box Office Manager
Above: Blair Brejtfus, Talent Buyer
Right: Jessica Hill, General Manager/ Talent Buyer

[If there's a silver lining to the pandemic], I would say, for me, it's how my team stuck together even though they were being furloughed. My entire team decided to support each other and say, 'Hey, if you can't afford food this week we will help you out.' I realized we are a family more than anything. That my team was able to come together and just make sure we were all okay was really amazing to see and to witness. Cindy Gavarrete

Pittsburgh

POSTER DESIGN
Jeff Koch

PHOTOGRAPHER + PRODUCER
Nate Smallwood

PITTSBURGH

Pittsburgh

Jeff Koch & Mya Koch

1. In a darkly lit jazz club in what's known as Pittsburgh's Hill District, the Crawford Grill was known for impacting the national jazz scene. The local composer and Big Band leader Billy Eckstine helped to catapult the careers of jazz greats such as Miles Davis, Dizzy Gillespie, Charlie Parker, and Sarah Vaughan. Duke Ellington's "Take the A Train" was composed by Pittsburgher and longtime collaborator Billy Strayhorn—Ellington often got the credit while Strayhorn did the work. Other jazz notables from here include Art Blakey, Earl "Fatha" Hines, and Maxine Sullivan.

2. Modern jazz guitarist and singer-songwriter George Benson was born and raised in the Hill District, as was prominent jazz trombonist Harold Betters. Jazz pianist Walt Harper, a mainstay at the Crawford Grill, opened his own club, Walt Harper's Attic, in the heart of Downtown and hosted national jazz greats.

3. Beloved children's television show Mister Rogers' Neighborhood benefited from a pair of real-life Pittsburgh neighbors: the jazz guitarist Joe Negri appeared on the show as "Handyman Negri"; and jazz pianist Johnny Costa, as its musical director, arranged and wrote the music for the show.

4. The nation's first radio station, Pittsburgh's KDKA, began broadcasting music and entertainment with a national reach all the way back in 1920.

5. Bret Michaels of Poison and guitar virtuoso Reb Beach of Winger (and later Alice Cooper, Dokken, and Whitesnake) call the region home, while local guitar master Paul Gilbert launched Racer X in 1986 and joined Mr. Big in 1988. Billy Idol hit No. 1 on the charts with "Cradle of Love" in 1990, a song written by Pittsburgher David Werner.

6. In the 2000s, a trio of Pittsburgh bands emerged from the Vans Warped Tour to garner international attention: The Juliana Theory, the progressive punk band Anti-Flag, and Punchline.

7. Pittsburgh has been home to several historic and iconic music venues. The ornate Syria Mosque hosted everyone who was anyone in the music industry but was sadly torn down in 1991 to become a parking lot. The Stanley Theater, now the Benedum Center, hosted Bob Marley's last live performance on Sept. 23, 1980. The Decade, known as a gritty dive bar near the University of Pittsburgh in the city's Oakland section, provided a small stage and intimate experience for the likes of The Police, Pat Benatar, The Pretenders, and even U2.

8. Pop artist Andy Warhol grew up in Pittsburgh. The icon, who worked with and even briefly managed The Velvet Underground, is buried in a local cemetery.

9. Rappers Wiz Khalifa and the late Mac Miller grew up in Pittsburgh. Wiz's smash hit "Black and Yellow" reps Pittsburgh's official colors, while *Blue Slide Park*, Miller's debut studio album, was named after a section of the city's Frick Park. It remains a memorial and active playground.

10. Broadway, television, and red-carpet darling Billy Porter shines Pittsburgh's light on the entertainment world. He not only was born here but also graduated from Carnegie Mellon University.

Carnegie of Homestead Music Hall

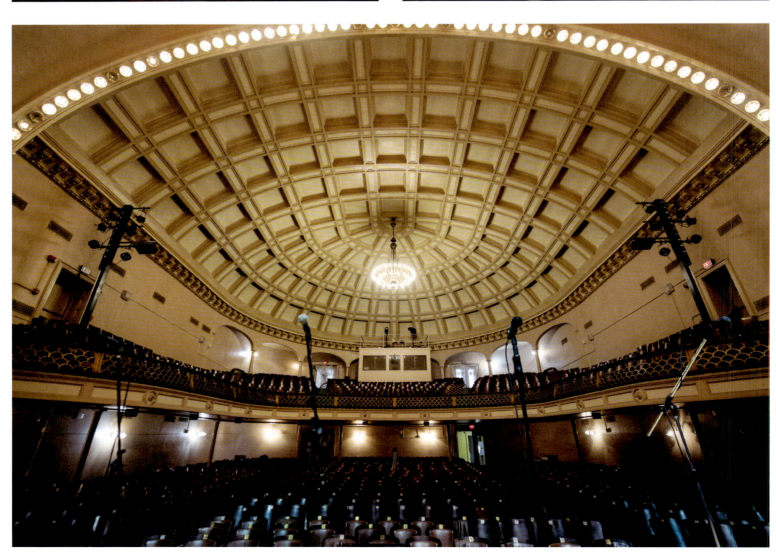

There's a lot of large companies that do this, but the independent venues and promoters are the true backbone of the industry.
Brian Drusky

We're technically in a public library. Andrew Carnegie built 2,000 libraries around the world and this is the third oldest in the country. We've been around since 1898. He built libraries more like community centers 100 years ago. In the center of the building is a public library, the right side is an athletic club, and the left side is this grand concert hall we're in. The music hall makes up 37 percent of our budget. All the money we make at the music hall, we put into programming for the community. Without that income, without that revenue, our community is suffering because we're not able to provide the programming we normally do.
Carol Shrieve

Opposite top left: Brian Drusky, Concert Promoter
Opposite top right: Carol Shrieve, Executive Director
Opposite bottom: View from the stage of Carnegie of Homestead Music Hall
Right: Entrance to Carnegie of Homestead Music Hall
Below: View of the stage of Carnegie of Homestead Music Hall

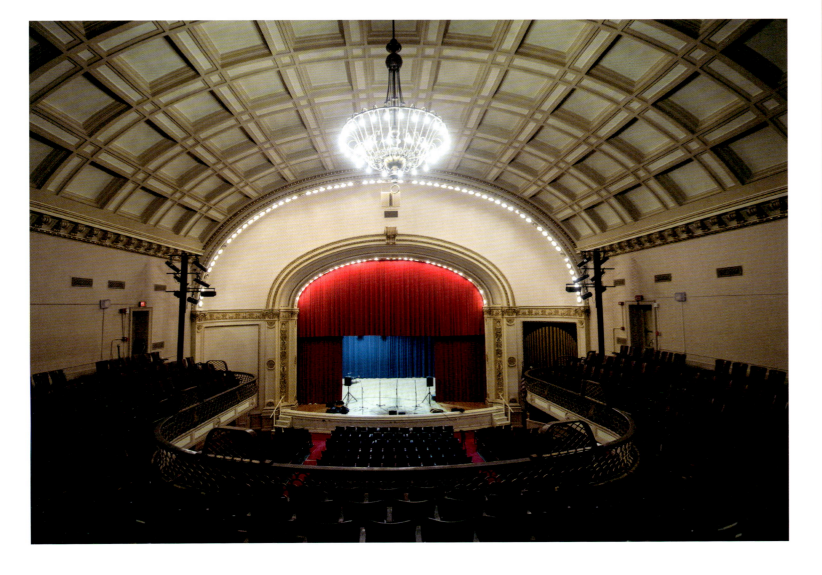

Roxian Theatre

Pittsburgh has a lot of great small, live music venues and everybody has something a little different to offer. It's a pretty diverse music scene and we've all been working together on the NIVA calls; we've all been working to try to get some relief, some funding for live music venues.
John Pergal

Above: John Pergal, Owner
Opposite: Interior of the Roxian, viewed from the stage

Thunderbird Cafe & Music Hall

This took a lifetime to get to where I'm at. I love this place and hopefully I can get it back open. John Pergal

Above: The interior of Thunderbird, viewed from the stage

Portland

POSTER DESIGN
Pilar Zeta

PHOTOGRAPHER
Corey Drayton

PRODUCER
Eric Hillerns

PORTLAND

Portland

Eric Hillerns

1. In 1941, Portland's Bonneville Power Administration hired the anti-fascist Oklahoma songwriter Woody Guthrie to illuminate the promise of public power harnessed by the Columbia River. Having sketched the initial drafts of "This Land is Your Land" the year prior, Guthrie—struggling to feed his growing family and in need of the money—delivered 26 tunes, recording six in Portland. Though he despised the fledgling city, he found the region captivating and his time in "Stumptown" was arguably the most productive songwriting period in his life. Re-inspired by his experience in the West, "This Land is Your Land" was ultimately released in 1945. Guthrie hasn't been the only unlikely musical visitor to reminisce about this place—Dolly Parton, the Grateful Dead, and Steely Dan have penned songs about the region, too.

2. Portland was already an influential center of Black music on the West Coast when tens of thousands of African American men arrived here by rail to work in the Kaiser shipyards during World War II. In 1945, a two-decade-old speakeasy called The Dude Ranch was reimagined as the hottest (and weirdest) "black and tan" supper club west of the Mississippi. Described as a raucous amalgam of The Apollo Theater, The Cotton Club, Las Vegas, and the Wild West, The Dude Ranch welcomed elite jazz musicians from around the world. A single residency billed Roy Eldridge, Coleman Hawkins, and Thelonious Monk.

3. Portland revels in its legacy as an activist center of protest with a vehement distaste for conservative politics. In the '80s, a staffer for George H.W. Bush famously dubbed Portland "Little Beirut"; the nickname remains a badge of honor for residents today. Yet the convergence of protest and music was already in the water. In 1970, in response to a scheduled visit by Richard Nixon, the state of Oregon sponsored "Vortex I: A Biodegradable Festival of Life," a week-long outdoor rock festival. It was designed to corral the anti-war movement by luring hippies, anti-fascists, and counterculture activists outside the city limits by featuring Santana, Jefferson Airplane, and Cream. Those bands never took the stage; neither did Nixon. "Vortex" remains the only state-sponsored rock festival in United States history.

4. Ultra-tolerant perspectives on experimental sex, drugs, and rock 'n' roll defined Portland's furious live music scene in the '70s. Funk powerhouse Pleasure rose to prominence on the national charts, The Kingsmen recorded the seminal anthem "Louie Louie," and a young David Geffen prowled the city for local talent.

5. The '80s ushered in a Northwest blues explosion led by Robert Cray; glam rock and hair metal were teased up with Black 'n Blue (whose guitarist, Tommy Thayer, would later replace Ace Frehley in KISS); and the influential Wipers force-fed a raging regional punk scene. Legendary venues such as Starry Night, Key Largo, Pine Street Theatre, Euphoria, Luis' La Bamba Club, and the West Coast answer to CBGB—Satyricon—elevated every form of performance. Packed with label A&R reps and rabid residents in the know, sleepy Portland had become an unlikely haven for the after-hours set.

6. In 1984, the newly minted mayor and tavern owner Bud Clark, with musician Billy Hults, rolled out the seminal Mayor's Ball, an annual concert celebration of Portland's rich live music culture. *Billboard*, *Rolling Stone*, and scores of national press heralded the ball as a triumph for direct local governmental support of the arts. The eight Mayor's Ball events during Clark's two terms remain the largest gathering of musicians under one roof in the history of Oregon as recognized by Guinness: 88 bands on eight stages in eight hours. Dubbed "The People's Mayor," Clark gained national attention for his "Expose Yourself to Art" poster; Hults would go on to form the Portland Music Association.

7. In 1985, Downtown Portland was introduced to The 24 Hour Church of Elvis, a coin-operated art and music installation. Over the course of its 28-year history and throughout its four locations, the lewd, new media museum and its booze-sex-cash homage to the Catholic confessional were accessible to all artists for display and sale of their work. (A subsequent incarnation offered both legal and "cheap, not legal" weddings for straight and gay unions.) The King himself regularly materialized in the form of a sequined street performer strumming a cardboard guitar.

8. In 1990, Kurt Cobain met Courtney Love at Portland's legendary Satyricon. An homage to Fellini by owner George Touhouliotis, the "dark, narrow barroom on a seedy stretch" was ground zero for local and touring punk and upstart alternative bands such as Soundgarden, Mudhoney, Oasis, Pearl Jam, and GWAR. Portland had long presaged "grundge" (yes, with a "d") and set the table for a beggars' banquet whose main course would later come from Seattle, its larger cousin to the north.

9. Area residents agree: the sketch comedy "Portlandia" is pretty much spot-on in every way. However, most also might point out that Sleater-Kinney remains Carrie Brownstein's best work. And like Brownstein, we too are laughing with Portland, not at Portland. It's home, after all. Alongside Brownstein, noted musicians who call (or once called) the city and its surroundings "home" include The Decemberists, Esperanza Spalding, She & Him, Nancy Wilson, Modest Mouse, Johnny Marr, The Shins, Patterson Hood, k.d. lang, Ray Brown, Peter Buck, Chan Marshall, Willy Vlautin, and the dearly missed Obo Addy and Elliott Smith.

10. While Portland demonstrates a storied history of embracing Black music, the city is anything but diverse and still struggles with a legacy steeped in systemic racism. Not surprisingly, the ill effects of gentrification, targeted police brutality, and COVID have hit Portland's Black and brown communities particularly hard. Notable venues such as The Blue Monk, The Crown Room, Beauty Bar, Harlem, and Someday Lounge have all shuttered. At the time of this writing, not a single venue is Black-owned and operated. Yet the city's hip hop community thrives in protest. Veteran emcees such as Cool Nutz and Vursatyl usher in fresh voices rightfully deserving of national recognition. From Aminé, Dodgr, and Mic Capes to neo-soul's Blossom and femcees Karma Rivera and Fritzwa, Portland's scene is defining a newer, smarter, and more vibrant West Coast Sound.

Alberta Rose Theatre

It's a historic theater, originally a movie house from the 1920s. It had a lot of incarnations over the years. It pretty much showed films up until the late '70s. In the '70s it was owned by Harvey Garnett, who apparently was one of the only Black cinema owners west of the Mississippi. He showed a lot of Blaxploitation films. He's still around. He used to visit us a lot. We see him once in a while. We've done some shows with him. [The building] was condemned or closed down for a long time, and then became a church. So it was kind of out of the public's eye for many years, which made it special when we reopened it. Joe Cawley

The pleasant surprise for me was just the community response overall. First you see it electronically with the donations and the support with our livestream. But then you see how many people are coming out and they're like, 'I'd never heard of some of these bands, but I want to contribute, so I'll do it.' The numbers blew my mind, initially. Then we got into selling merchandise online; I'm the one curating all of that. It's been amazing to have people come to the theater to pick up the goods they bought. And they don't just grab their stuff and go. They really want to stick around and talk about their experiences here. They really want to know how we're doing. They really care. And that's been something that's been really overwhelmingly nice. Christine "Moose" Fuqua

Above: View of the stage
Opposite top: Stage at the
Alberta Rose Theatre
Opposite bottom: Adam East, Talent
Buyer; Joe Cawley, Owner; Christine
"Moose" Fuqua, House Manager

We're a neighborhood theater, we're not downtown. We're a little off the beaten path. There's a bit of a neighborhood vibe in what we do. Sometimes we'll have the opportunity to bring a really great national artist, somebody famous. And we're not just bringing that show to Portland, we're bringing it to our little Alberta Street neighborhood here. There's something really nice about that.
Adam East

Doug Fir Lounge

It's really tough not knowing what it's going to be like tomorrow. My job and responsibilities have shifted a lot over the last few months just depending on what needs to happen. And there's always this thought looming: 'Are we going to make it? Am I going to have a job? Are all of my 68 coworkers who have been laid off going to be able to come back?' It's hard. It was really, really cool to see the support from the community and how fast people were willing to step up. They let us know they want to come back here and want to do anything they can to be part of keeping us around. Rochelle Hunter

This is a place musicians just love to play. We hear it all the time. They're comfortable here and it's been a spot for bigger acts to get small, bands to tune up as they head out on tour or wind down in a more intimate space. The scale is perfect for a show. The sound is incredible. For those who know, it's like our own bunker below a cabin in the future. Sure, it's got its eccentricities. Every great club does, but it's the music that brings this place to life. And we just can't wait to get back to it. Mike Quinn

It's just really unique here. We have such a cozy vibe that it's always a really great surprise to see a loud wall-of-sound band here because it does work really well. You might expect like, 'Oh, it's the cozy Doug Fir, I'm going to go see a folk singer/songwriter,' but it really doesn't have to be that way at all.
Rochelle Hunter

Opposite bottom: Rochelle Hunter, Director of Marketing
Above: Mike Quinn, Owner
Below: Bar at Doug Fir Lounge

Holocene

I was doing internet work in the Bay, and very burnt out and needed to change everything in my life. Scott and I were roommates and went out dancing a lot, three or four nights a week probably. So I really liked weird techno, really liked going out dancing, really hated my job, needed to do something else. So I just thought, 'What the hell? Portland doesn't have anything like this going on.' The thought of people just being able to be together in the space again, and to have this kind of anonymous intimacy, is so amazing. I miss it so much personally, and feel it is so missed. I do picture people back in here together, and it

fills me with intense joy. Learning recently that we're getting some support from the state has been incredibly grounding. It's really a big deal. It lets us say, 'Okay, we're gonna be here, so now how do we make sure we are here, ready to open in the best way, and able to stay in touch with our community, and in small ways take care of people, whether staff, or musicians or other people in the community?' We have to figure out how we can have a purpose now during [the pandemic], rather than thinking about how we're paying rent three months from now. Jarkko Cain

Opposite top: Gina Altamura, Talent Buyer
Opposite bottom: Interior of Holocene
Above: Jarkko Cain, Co-Owner

Something special about the Portland community has always been that sense of cooperation, camaraderie. I don't think there's a real sense of competitiveness. I think it's very much an ecosystem, so I'm not surprised our ecosystem has been able to take care of each other. But I'm also just relieved and overjoyed we actually got that funding. It's such a crucial piece of what makes [Portland] such an incredible place to live. These venues are absolutely our soul as a city. Gina Altamura

Laurelthirst Public House

Michael Hurley would do a monthly series here. I would play with him [for] most of the [shows], and it would just be magical. There'd be a packed room in here, people pin-drop quiet, all on the floor sitting cross-legged and Indian-style. All these 20-something young hipsters were just held in rapt attention by this quirky old folk artist singing these creaky old tunes. He held a spell like that regularly, just the gossamer beauty of that intimacy. There's this sad aspect in that one wants to advocate to save the venues. But at the same time, I'm looking at all the other things going on. It's hard to yell about my little venue being closed when, like, neighbors in my traditionally African American [but] gentrifying neighborhood don't know if they're going to get killed for walking out the door.
Lewi Longmire

Below: Lewi Longmire, Musician/
Co-Owner/Booking Agent
Opposite: Interior of Laurelthirst
Public House

The Laurelthirst opened in 1988. It's been here for 32 years this October [2020] and has morphed over time, but generally it's always been a place for predominantly local and some touring acts. We put on 16 shows a week here. There's a 6 p.m. show and a 9 p.m. show every night and then there were all-ages matinees at noon on the weekends. A lot of the early shows would be a weekly residency band. My other job is that I am a musician myself—playing both my own music and being a support player on guitar, bass, and keyboards for a bunch of other bands, both locally and nationally touring. So I would do about 250 shows a year, mostly at home but quite a few tours as well. Lewi Longmire

Mississippi Studios

I feel an incredible lack of certainty about the future and it just frightens me. Taking a step back from the day to day of it, I realize how fortunate we were to be doing what we did in these spaces. I just hope to God we can come back and do it again, and when we do it, [it] includes more people, more diverse voices. I've been able to see there are some people who have missed out on this, whose voices haven't been heard on the stage or in the ownership entity. We have to fix that. This is vital. It's in my blood, and it's in the blood of every musician and music lover and music employee. Without this, we're all just in little boxes. Society is just in little rooms watching screens. That's how we're going to interact with each other, and that's just not the way life is supposed to be. I'll never take it for granted. Jim Brunberg

We put together the Independent Venue Coalition because we realized places like this were something special. You're so in the race of it that it's not until something like COVID comes along and you have to shut down and take a step back. You realize all of these venues are worth saving; [they're] special to a good group of people: the performers, the employees, the owners, the fans. We realized there were about 150 of these places in Oregon. We knew there were some federal efforts going on, and we teamed up with NIVA on that. We also knew that Oregon, [with] its weird underbelly, was a quirky kind of a place that was probably going to value its institutions. The state of Oregon ended up being the first state in the nation to come through with a relief package for venues and for arts institutions like this where people get together and have in-person experiences. Jim Brunberg

Below: Interior of Mississippi Studios
Opposite top: Jim Brunberg, Owner
Opposite bottom: Soundboard at Mississippi Studios

I was a touring musician for 20 years or so, and I knew that Portland was where I wanted to end up because every time we came through Portland, it was a music town, it was a weird town. My band and I always left with a story to tell. So when I relocated here in the '90s and reconvened with a lot of the friends I had met, one thing I realized is there was a gap: One thing I realized [Portland] was missing a place for: a recording studio that would be accessible to everybody. That's why the name is Mississippi Studios—this was all originally part of a recording studio that was upstairs over there.
Jim Brunberg

San Antonio

POSTER DESIGN
Regina Morales

PHOTOGRAPHER
Oscar Moreno

PRODUCER
Garrett T. Capps

SAN ANTONIO

San Antonio

Oscar Moreno & Garrett T. Capps

1. **"Westside Sound"** SA was home to quite a vibrant Chicano soul scene in the '50s and '60s—kinda like a Tex-Mex Motown. Acts like Sunny & the Sunliners, the Royal Jesters, and the Dell-Kings were vibe masters. Recently, the scene has found its way onto various compilations and re-releases, most notably from the Numero Group (numerogroup.com).

2. **Fiesta is the best damn party** Since 1891, the citywide Fiesta event has taken place each spring to commemorate the Battle of the Alamo and San Jacinto. Think of it as the Tex-Mex Mardi Gras: a great excuse to skip work and get drunk on margaritas for two weeks. Most of the Fiesta events have excellent music of the conjunto or Tejano variety.

3. **Robert Johnson recorded more than half of his catalog here** The legendary bluesman, widely rumored to have sold his soul to the devil at the crossroads and known for his undeniable influence on rock 'n' roll, made his first recordings in Room 414 at the Gunter Hotel in San Antonio in 1936. More than half of his 29 recordings were made during his Alamo City session.

4. **Phil Collins is obsessed with the Alamo** The famous British musician has had a lifelong obsession with Davy Crockett and the Alamo. He owns millions of dollars' worth of original Alamo artifacts (some of which are on display on-site) and has written a 400-page coffee table book about his collection.

5. **Tons of tacos** I don't know how many tacos per capita the city boasts, but it's a lot: puffy tacos, soft, crispy—you name it. Come breakfast, lunch, or dinner, you can find a truly authentic and undeniably delicious Mexican food restaurant open on any street corner in town. SA is the Tex-Mex food capital of the world—pass the enchiladas!

6. **Big city, small-town community** With 1.5 million residents, San Antonio is the seventh-largest city in the U.S., but the community is as tight and supportive as a small town. Anyone with something worth listening to can reach our local radio stations and newspapers to get airtime or a write-up.

7. **A really good—and diverse—music scene** From space country to avant-garde, from black metal to dream pop, San Antonio has an ultra-diverse local music scene. Many musicians in town share a mutual respect for one another despite their different genres.

8. **San Antonio loves DIY** San Antonio has a flourishing DIY scene that dates back to the '70s. This community of self-promoters, backyard-venue owners, and independent label managers is the backbone of the DIY scene. Many up-and-coming bands have made a stop in an old house in San Antonio to play to a packed living room or backyard.

9. **'Heavy Metal Capital of the World'** Back in the early '80s, San Antonio radio stations harnessed thousands of metal fans around the city by playing demos by not-yet iconic bands and throwing massive shows once those acts came to town. The artists would then use the numbers as a selling point when booking larger venues around the U.S., thus earning SA the "Heavy Metal Capital" title. Although the metal scene today is not as present as it used to be, most native San Antonio musicians have some heavy metal in their blood.

10. **Fans will make a drive for a good show** By area, San Antonio is a very large city—in Texas, only Houston is bigger. But you can bet that there are music fans all across SA who don't mind making an hour-long drive to see their favorite bands play on the other side of town. Thankfully, there are plenty of venues scattered around the city that offer convenience for those who live outside Loop 1604.

Brick at Blue Star Art Complex

We were looking at about $150,000 in revenue for March, April, and May.
Michael Julian

I was working at the Artist Foundation of San Antonio. It was in its seventh year and we had created this program called the Moveable Art Party. There were a lot of empty spaces in Blue Star at the time—raw spaces we called them—with a video room, music room at the end of the complex, and this was sort of the main space, the gathering space. Mike and I fell in love with it, and it was just like, 'We have to do something with this!' [That night], I spoke to James Lifshutz, who was our landlord and on the board of the Artist Foundation. He asked what I imagined here, and on Monday morning, I took him my plan and this whole thing began. Elizabeth Ciarfeo

Above: Michael Julian, Tech Director
Below left: Exterior of Brick at Blue Star Art Complex
Below right: Elizabeth Ciarfeo, Co-Owner/General Manager; Mike Looney, Co-Owner; Michael Julian

The city and the county and the SBA have been pretty good to us, but it's like the day that music died. It was epic.
Elizabeth Ciarfeo

Charline McCombs Empire Theatre

'What [the pandemic] has reinforced for me is that we have an amazing team and all of their roles are very important. This is a collaborative industry and a collaborative operation. Nothing will happen here without our team working together, and they remain dedicated and passionate even though they are on standby and furloughed. They're still interested and engaged and ready to come back. We're looking forward to coming together again and bringing the first show back. Emily Smith

Below left: Seat markers
Below right: Garrett T. Capps;
Brittney Garcia, Marketing Director;
Emily Smith, General Manager
Bottom: Interior of the theater

Imagine Books and Records

Before anybody plays at Cafe A Gogo or a large venue like AT&T Center, they start in the tiniest way. Usually they start in their bedrooms, strumming a guitar. The first step onto a public stage is a small venue. Without small venues, you don't have The Beatles, you don't have The Doors, you don't have Joni Mitchell. You name it and go down the artists in history. They don't exist because they never had that small venue to go to. So the small venues are where the real work is done. Venues are vital to our artistic community. Don Hurd

Below: Don Hurd, Owner
Right top: Ezra Hurd, Booking Manager
Right bottom: Irma Hurd, Co-Owner

[Setting up the GoFundMe campaign] was not something we expected, and [we] didn't know who would respond because everyone is going through difficult financial times. A lot of people lost their jobs and yet we have so many supporters—members of our community who came out and supported us. Irma Hurd

The generosity overall has been amazing.
Don Hurd

The Lonesome Rose

During this time, I converted the stage to a recording studio of sorts. I started learning more about home recording and writing a shit-ton in this time I would be playing gigs out of town. It's been funny that this place has been kind of a solo journey for me in the months it's been closed. I have a vision for a post-pandemic pachanga where maybe you don't have to pay a cover, or you get a free drink or something with proof that you have been vaccinated. It's going to be the gnarliest, most radical San Antone-style fiesta I can imagine. I see people wall-to-wall inside, sweating, being terrible and beautiful at the same time, with a solid local lineup of rowdy Tex-Mex, rock 'n' roll, rippin' country-western bands and just making up for all this time. When times are safe and times are cool, cooler than now, please come join us for a cerveza and a shot of tequila and a good time.

Garrett T. Capps

Above: Interior of The Lonesome Rose
Below: Garrett T. Capps, Co-Owner

Majestic Theatre

Below: Emily Smith, General Manager
and Brittney Garcia, Marketing Director
Right: The marquee of the
Majestic Theatre
Opposite: Stage at the Majestic Theatre

One of my favorite shows is definitely Queens of the Stone Age. Seeing a rock band like that in this intimate, opulent setting is just pretty amazing. The music just hits you. That feeling when it just hits you and goes through you is awesome. Emily Smith

While our team is on standby, we've had to cover a lot of roles and take on a lot of duties that were not originally in our job descriptions. The amount of work that goes into just maintaining the venues—from flushing toilets to adding water to the water heater to [checking] the A/C— will shock and surprise you. So the care that has gone into keeping this venue maintained for 90 years is pretty incredible. Brittney Garcia

Paper Tiger

I think in ways it's going to change the way people listen to music, engage with music, and approach live music. I don't know what that looks like exactly, but I know it's going to be different.
Sophie Covo

Free Week [Paper Tiger's biannual summer offering] is great. Going to see a band you love in a venue in your town is always going to be great. But being able to see everyone from your town come together, and be able to see first-hand in person all that talent in your city and see them intermingle, is a really cool experience for me. I really look forward to that every year.
Sophie Covo

Right: Stage at Paper Tiger
Below: Sophie Covo, General Manager and Chad Carey, Founder/Owner

Ventura

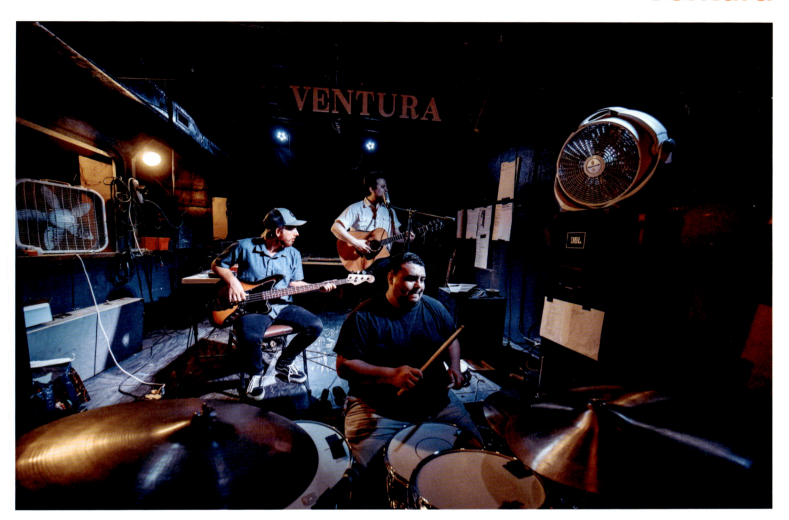

I started working here when I was 18 in 2008 under Jordan Williams, Colin Wells, and Brandon Hicks. I was really young at the time, and there [were] so many different shows. There were a lot of different bands. I was running sound for the Rock Bottom—which was at the corner and is no longer there anymore—when I got walked down the street by one of their friends. Basically they told me that this was going to be the new spot they were going to open up, and I pretty much got introduced to them officially as the sound guy. I did that till 2016, I guess, probably like eight years, so it's been a long time. At this point, any live music will work for me. Michael Carrillo

Top: Lawson Yeager on bass; Michael Carrillo, Owner, on guitar; Kirstian Barboza on drums
Above: Michael Carrillo

San Diego

POSTER DESIGN
Andrew McGranahan

PHOTOGRAPHER + PRODUCER
Jason Juez Steck

SAN DIEGO

ART & DESIGN by ANDREW McGRANAHAN

San Diego

Tim Mays

1. Swami John Reis San Diego National Treasure Number One. The local hero and founder of highly influential bands (Pitchfork, Rocket from the Crypt, Drive Like Jehu, The Night Marchers, Hot Snakes, Sultans, Swami John Reis and the Blind Shake, etc.) also delivers cool DJ sets with his Swami Sound System.

2. South Park This neighborhood is the home of Vinyl Junkies Record Shack and Whistle Stop Bar. In just three years, Vinyl Junkies has established itself as the go-to spot for used and new records in San Diego. The store hosts local DJ battles, spoken word by the likes of Jaz Coleman of Killing Joke, and live shows by local bands (Schizophonics, Thee Sacred Souls, The Loons) as well as national acts (K.Flay, Starcrawler). Whistle Stop is a great neighborhood bar by day and a music venue at night, hosting various local and national bands as well as off-the-hook DJ nights (Booty Bassment, Death by Dancing, Black Friday). South Park also boasts several other must-see places: Warshaw's Provisions, specializing in modern fireplaces, art, mid-century pieces, and CBD products; Trash Lamb Gallery, specializing in local art and cool knick-knacks; and Bad Madge & Co., hawking all things cool and vintage.

3. Redwoods Music This is a loose-knit collective of local musicians who play in multiple bands together and separately. Artists include The Midnight Pine, Birdy Bardot, The Heavy Guilt, Jake Najor and the Moment of Truth, Rebecca Jade and the Cold Fact, Dani Bell and the Tarantist, and more.

4. San Diego's Goth Scene Club Sabbat, founded by Linda Estep 22 years ago and usually found at The Merrow on the second Saturday of every month with Robin Roth as host, is the granddaddy of the local scene. Other clubs like Hemlock and Black Friday pop up at various times as well.

5. San Diego's Independent Music Venues The Casbah is where The White Stripes, The Strokes, The Black Keys, Nirvana, and Arcade Fire all played their first local shows. The Belly Up in North County hosts a wide variety of musical genres and also surprise sets—The Rolling Stones played a small club show there a couple of years ago. Soda Bar features great indie, punk, and alternative bands. Other venues include Black Cat, Tower Bar, Til Two, Music Box, and Brick by Brick.

6. San Diego's Power Couple, Pat and Lety Beers of The Schizophonics Also the founders of the Schizophonics Soul Revue, The Little Richards, and Bobby & The Pins, these DJ's, artists, clothing designers, and roller skaters are supreme at all they do.

7. People Gotta Eat Fathom Bistro on Shelter Island; Salud, Barrio Dog, and Ciccia Osteria in Barrio Logan; Piacere Mio and Buona Forchetta in South Park; La Posta Taco Shop in Hillcrest; Grand Ole BBQ in Flinn Springs; Starlite in Mission Hills; Café La Maze in National City; Cowboy Star downtown; Mama's in University Heights; Pizzeria Luigi in Golden Hill… San Diego is a foodie's paradise.

8. San Diego Renaissance Man Ben Johnson Recently voted "Best Ben in San Diego" in the San Diego Reader's 2020 Annual "Best of" Issue, this musician, author, father, filmmaker, Casbah manager, and raconteur is a powerhouse of talent, integrity, and energy. His first feature-length film, Fan Boy, is self-financed and out now. Ben is also finishing up his third book in the Webworld Trilogy, with previous titles *A Shadow Cast in Dust* and *Blood Silver* available in local bookstores.

9. Bars, Bars, Bars Live Wire, Whistle Stop, False Idol, Bali Hai, Starlite, Cantina Mayahuel, Kindred, Cowboy Star, Pacific Shores, Mister A's…

10. Some Local Musical History Rosie and the Originals hit #1 in 1960 with "Angel Baby"…Frank Zappa and Tom Waits both grew up in San Diego…Iron Butterfly hit No. 1 with "In-A-Gadda-Da-Vida" in 1968…Eddie Vedder grew up working in local music clubs and started his first band, Bad Radio, here…San Diego was hailed as "the next Seattle" in the early '90s with local bands Rocket from the Crypt, Drive Like Jehu, Rust, Inch, blink-182, and Lucy's Fur Coat all getting signed to major labels at the time…Jewel used to sleep in her van on the streets of Pacific Beach before hitting it big… Switchfoot, Slightly Stoopid, and Jason Mraz are nationally known artists…Karl Denson, sax player and founder of avant-jazz band Greyboy Allstars, is now a full-time member of The Rolling Stones…San Diego natives, all!

Belly Up

I've always felt that music is the lifeblood of the body, of the community. It creates all the vibration and flow between everything. It connects everything. It unites people of different political views, it unites people who have different economic situations. It brings people together, creates positivity, and it has for thousands of years. There are very few times in the history of the world where music has just stopped. Not only can we not do it in venues, but also we just can't gather at all. It's like your blood is drying up. That's how it's built for me. It adds to the divisiveness in this country to not have something as communal as music to remind people that there's more to life than just the things that separate us and the things we don't agree on. It's vital, and it's really important that it get back. Chris Goldsmith

I've realized how important music is to people. It's my lifeblood, but I'm a musician. I wake up in the morning, and I grab my guitar and I have a hot cup of something. I play, and that for me is crucial to my life. I need air, water, music, and love. There's a lot of people who don't play music but it's still equally as important to them. Hearing is one thing. Being around it live, being in that energy, is a whole 'nother thing. We need it, people need it. Music is key, but it's also social. Music brings people together in a social environment. So having a venue like this creates that space for people to gather. And without that, I'm worried about a lot of people. It's cool that we're all able to keep in touch virtually. But it's not the same, just as hearing a record is not the same as seeing that band live and up close. That's the other thing about the Belly Up: You're close to the artist, right up in their face. It's as close as you can possibly get. And that's what makes it special. Damian DeRobbio

Above: Damian DeRobbio, Production Manager/Musician
Below: Chris Goldsmith, President

Casbah

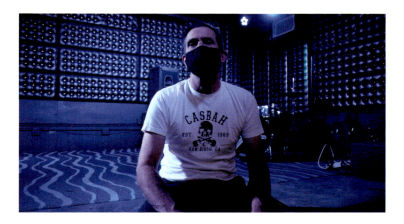

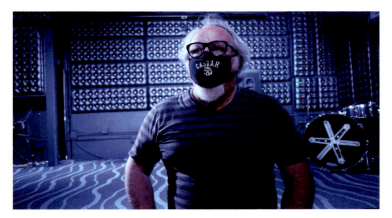

Casbah opened in 1989 at a much smaller location just up the street. Legal capacity was 75 people. We outgrew that after three or four years. Moved into this current location in January 1994. Since then, we've expanded into putting shows and bands not only in here, but also all over town at the various larger venues, once the bands outgrow the current capacity. 'Check yourself before you wreck yourself' at the Casbah. The people who come here, the bands that would play here, and the staff that works here have always been like a family, going back to the very beginning. It's an atmosphere we've created and nurtured, and revel in. We've got a big community of people who all feel like-minded about so many things. That's the family missing now, but we still have, in our hearts, our feelings for all those people who aren't able to get together. We welcome the opportunity get it kick-started, get it back to where it was. And we will. I have confidence that at some point, after this virus has run its course or is under control somehow, this will all turn around and we'll still be here, that we will persevere [and create] a bigger and better future. Tim Mays

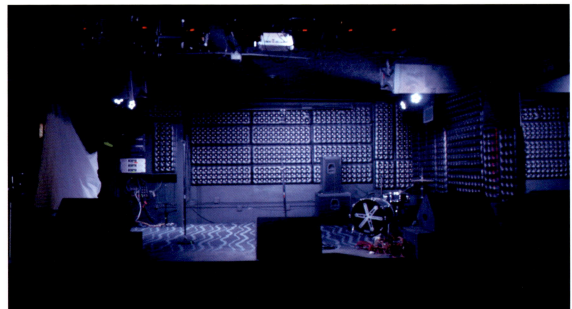

Top left: Pat Beers, Musician (The Schizophonics)
Top right: Ben Johnson, Bar Manager
Middle left: Lety Beers, Musician (The Schizophonics)
Middle right: Tim Mays, Owner
Above: Stage at Casbah

Soda Bar

This time has really shown a lot of powerful, meaningful change and also a lot of heartbreak and selfishness when it comes to pandemic behavior. But I guess I was surprised by all this social activity, all the protests and everything that started during this time; I think that has been a really hopeful thing to come out of something really awful. [We've survived] through selling merchandise, T-shirts, posters. That's the bulk of it. We found ourselves in this funny position of being in the merch business instead of the music business. That's our only real way to bring money in now. People have been amazing and supporting the club and buying stuff. That's really been a lifeline through all of this. Angie Ollman

Below: Stage at Soda Bar
Opposite top: Exterior of Soda Bar
Opposite bottom: Cory Stier, Booking/ Musician (Cults); Jacob Turnbloom, Musician (Mrs. Magician); Angie Ollman, Owner; Ivan Herrera, Bartender

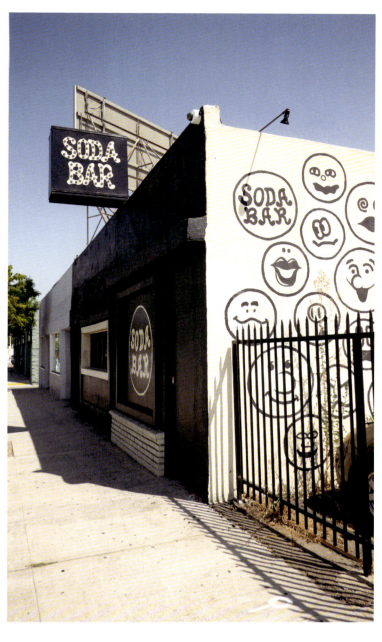

San Francisco

POSTER DESIGN
Gabriel May

PHOTOGRAPHER + PRODUCER
Misha Vladimirskiy

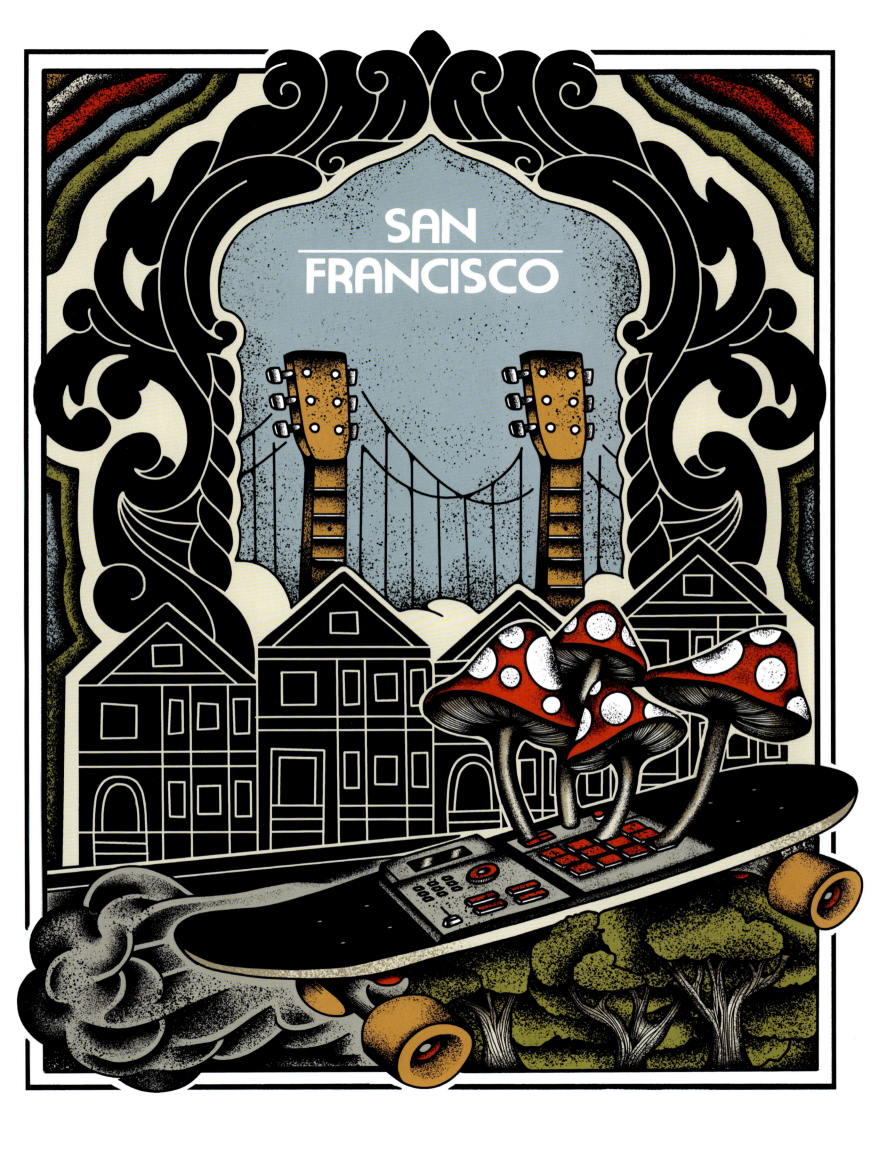

Playlist

This Select EP Playlist Curated by DJ Hesta Prynn

1. The Fillmore *The Graham-daddy of them all* From its early years as a dance hall and roller rink to its super-groovy Bill Graham '60s and '70s glory years, and then to its storied reopening as an alternative music powerhouse in the '90s and into current times, The Fillmore has stood above the rest. This storied music palace on Geary Boulevard has hosted more amazing acts than just about anywhere and is probably best known for its Bill Graham Presents era of psychedelic legends like Hendrix, Floyd, the Dead, Zeppelin, Janis, Santana, and the Airplane…but it's also famous for the free apples it gives out to show-goers each night (as the sign says, have one or two). It's an SF standby in a class by itself.

2. Great American Music Hall *Elegant entertainment in the heart of the 'loin* Built the year after San Francisco's devastating 1906 earthquake, this gorgeous, nearly 500-person capacity venue had operated as a casino, brothel, restaurant, lodge hall, and jazz club before its refurbishing and permanent rebranding as the Great American Music Hall in 1972. Located in the historic and colorful Tenderloin district, the club has been a staple of the West Coast's popular music scene for decades and its elegant atmosphere and interior details (highlighted by ornate wrap-around balconies and tastefully opulent ceiling frescoes) help it stand out even more. Everyone who's anyone has played this hallowed hall, and all self-respecting SF music fans have likely spent myriad evenings bouncing and reveling from the Great American's oak floor. There's a reason it's not called the Pretty Good American Music Hall.

3. Swedish American Hall/Cafe du Nord *Market Street's two-and-more-in-one special* The historic Swedish American Hall and Cafe du Nord share a building on Market Street, with the SAH occupying the upper floors and du Nord on ground level. The former HQ for San Francisco's Swedish Society, the SAH is technically three halls in one, with a balcony overlooking the main room. While larger acts and Noise Pop shows are the focus of SAH, Cafe du Nord built its reputation as a more snug space catering to indie bands and acoustic artists. Over the years, the venues have played host to Iron & Wine, St. Vincent, Spoon, Arthur Lee & Love, and many more. As a bonus, there's plenty of delicious grub on the premises, too, as du Nord maintains its own pub fare and a tapas restaurant operates out of the upstairs SAH space, while the sophisticated, yummy diner Wooden Spoon can be found on ground level. Why would you ever leave?

4. Bottom of the Hill *Started at the bottom, now…* For nearly 30 years, this cozy 350-cap spot located, well, at the bottom of the Potrero Hill neighborhood in SE SF has been doing its thing: offering a wide variety of live music, grub, and charm every single night of the week. It's been described as "scrappy" and even "legendary" (first making waves for a not-so-secret 1996 Beastie Boys show and the resulting tumult) and its colorful *Pee-wee's Playhouse*-meets DEVO interior keeps the mood light and fun. From touring and local indie and hard rock mainstays (Queens of the Stone Age, Andrew Bird, The Stone Foxes) to rockabilly (Reverend Horton Heat) to punk (The (International) Noise Conspiracy, Jello Biafra) to folk (Will Oldham, Joanna Newsom) to pop (Alanis Morissette) and more, BotH delivers only the tip-top.

5. The New Parish *A room of Oakland's own* The New Parish is an Uptown Oakland venue that represents the diverse and energetic spirit of Oakland itself. During any given week you can catch Bay Area underground hip hoppers and international rap legends, freak-folk stars, stacked reggae bills, and some of the East Bay's finest local acts. Since opening in 2010, The New Parish has provided an in-town option for Oakland and other East Bay city residents to get their live music fix without having to BART into the city or drive over the bridge. And with acts this good— from Goodie Mob to Vetiver to Metalachi residencies—plenty of SF dwellers find themselves heading east, too.

SAN FRANCISCO

A SIDE

The Fillmore:
Grateful Dead
Scarlet Begonias

Great American Music Hall:
The Donnas
Take It Off

Swedish American Hall/Cafe Du Nord:
Two Gallants
Halcyon Days

Bottom of the Hill:
Creeper Lagoon
Wrecking Ball

The New Parish:
Hieroglyphics (ft. Goapele)
Make Your Move

SCAN TO PLAY

San Francisco

Misha Vladimirskiy

1. Golden Gate Park Truly one of the most beautiful city parks in the world. From giant festivals like Hardly Strictly Bluegrass and Outside Lands to smaller pop-up shows, getting to hang out in these meadows and open fields while watching killer music and enjoying the fresh air is a joy.

2. Outside Lands Music and Arts Festival Speaking of… Whether you want to discover a new act or see some of the biggest bands in the world, this is the place to do it. The festival also hosts some of the region's best food and wine as well as great comics and amazing mural art by Bay Area natives and artists from around the world.

3. Hardly Strictly Bluegrass Festival Originally called "Strictly Bluegrass" before evolving into its current incarnation, this is one of the world's largest free festivals. People flock from all over the planet to experience amazing acts from the worlds of bluegrass, folk, rock, soul, and many other rootsier genres.

4. Amoeba Music SF's location in the heart of The Haight is the place to go if you're looking to find music you already love or to discover a new artist, to find a rare piece of vinyl or even sell some of your own. There are other Amoeba locations in California but this spot on Haight Street is the best, and one of the best record stores on the West Coast, period.

5. Rock Star Homes While you're in The Haight, be sure to seek out the historic former homes of '60s stars like the Grateful Dead, Jimi Hendrix, and Janis Joplin. Hunt on your own or take a tour—the combination of San Francisco's iconic music and unique architecture make for a worthwhile photo-op.

6. Irish Coffee at The Buena Vista Cafe A legendary drink in a legendary place. If you haven't had an Irish coffee before, this is the place where it was created and is the only place to start. The Buena Vista is located at the end of Fisherman's Wharf, so you get to reward your tourism with an amazing drink.

7. The Fillmore (and each of SF's amazing live music venues) The Bay Area is home to some of the world's best live venues, but the legendary Fillmore just might top the list.

8. World-Class Museums The SF MOMA, the Academy of Sciences, and the de Young display some of the world's best art and science exhibits, and each host amazing music events as well.

9. The Castro The neighborhood center of the LGBTQ world also has great bars and amazing culture. There's always something happening, so if you want to have a good time on a random Tuesday night, just step into the Castro.

10. Murals in the Mission The art scene in the Mission District is top-notch. Highlighted by the murals on the walls of Clarion Alley and Balmy Alley, and helped along the way by the Precita Eyes muralists and art-education group, the Mission is a great place to see the city's art in a more natural habitat.

August Hall

There will be a time when this room is full again. We don't know when that will be, but we're going to work toward that instead of sitting here worrying that it's never going to be full again. It will be full again and we will get back to some form of shows where people are gathering and dancing and screaming and having a great time. The biggest thing I've seen [during the pandemic] is people who might have been competitive somewhere in the back of their minds, being shoulders to lean on. They're friends with a common problem, and really supporting each other. 'How do we handle this? What do we do?' We all have the same questions and we're all looking for answers to those questions, so we're being resources for each other.
Nate Valentine

Above: Josh Lieberman, General Manager and Nate Valentine, Owner
Opposite top: Josh Lieberman and Nate Valentine behind the bar of August Hall
Opposite bottom: Josh Lieberman and Nate Valentine

This building was erected right after the earthquake and fire in 1906. it's a fraternal organization called the Native Sons of the Golden West. The only requirment to be a member is that you were born in California. They are keepers of history.
Nate Valentine

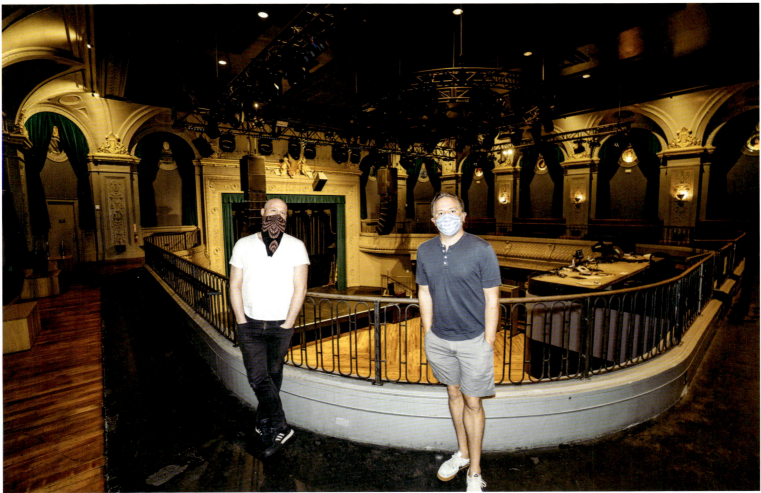

Bottom of the Hill

Twenty-five years ago this December [2020], I started as a cook and was going to stay here for probably a month tops. I fell in love with this place, with Kathleen and Ramona, and all the people I worked with. So I said, 'Oh, can I be a bartender?' And they're like, 'Sure!' Then I'm like, 'Can I be a manager?' and they're like, 'Sure!' Eventually they gave me the huge honor of becoming a partner. This is our family and these are our friends. I think they really feel that. The average length of employment for our employees is, I would say, well over 10 years. This shutdown is so much more to us than just losing our business. Our family is suffering, and we're really afraid for *their* future as well as the business. We're ready to do what it takes to survive. We want to survive. We're going to survive.
Lynn Schwarz

Below: Stage of Bottom of the Hill
Right: Old ad for Schlitz beer
Opposite: Lynn Schwarz, Owner/Head Booker and Kathleen Owen, Owner

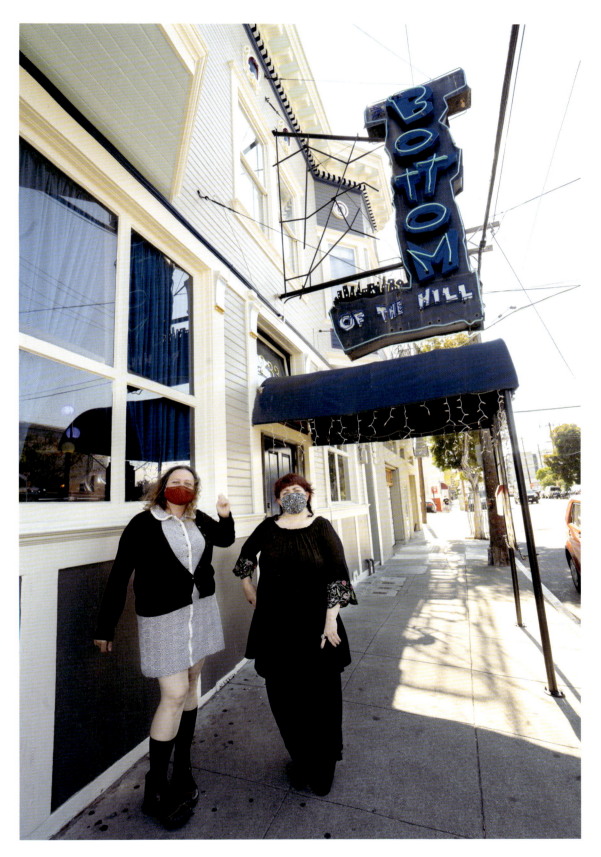

We opened in 1991 and stayed open seven days a week. We served breakfast, lunch, and dinner. It was also an art gallery, [exhibiting] some art shows and stuff. The music was booked maybe four nights a week. It was kind of chaotic then, but the bands that played loved it.
Kathleen Owen

The Fillmore

The venue was built in 1912 as a ballroom, so it was ballroom dancing in here. It later became an R&B club in the '50s. Eventually it was rented to Bill Graham in 1965 who started doing the shows in here that it became famous for—Grateful Dead, Janis Joplin, Jimi Hendrix. He actually only operated here for a few years before he moved to another venue called the Fillmore West. In the mid-'80s it became the entity it is now. Amie Bailey

Above: Staircase at The Fillmore
Right: Amie Bailey, General Manager
Opposite top and bottom: Interior
of The Fillmore

Unfortunately, everyone's been furloughed from this venue but me, so I have to wear a lot of hats keeping things going, building-wise, budget-wise. I'm just very grateful I still have a job and a paycheck, and I don't go a day without feeling like that's a huge blessing. Amie Bailey

Great American Music Hall

We were the first to close and the last to open. Our venue and every venue of our size [cap. 470] and larger are anomalies in this situation because we rely on mass gatherings. We can't socially distance like a restaurant. For a space this size, it takes a lot of money just to be here, for electricity and obviously rent. Our survival is based on having a large number of people in here and there's not really a way to supplement that. Dave Bruno

Below: Interior of the Great American Music Hall
Opposite: Dave Bruno, Assistant General Manager and Christal Davies, Team Player

One day at a time. This whole thing about looking into the future: I can't. I can only deal with what's in front of me. Prior to this, I had the whole year planned. Christal Davies

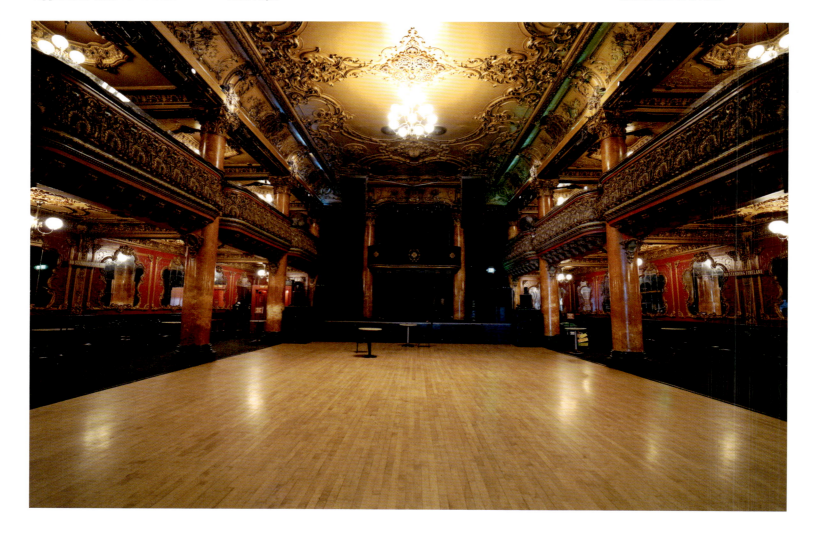

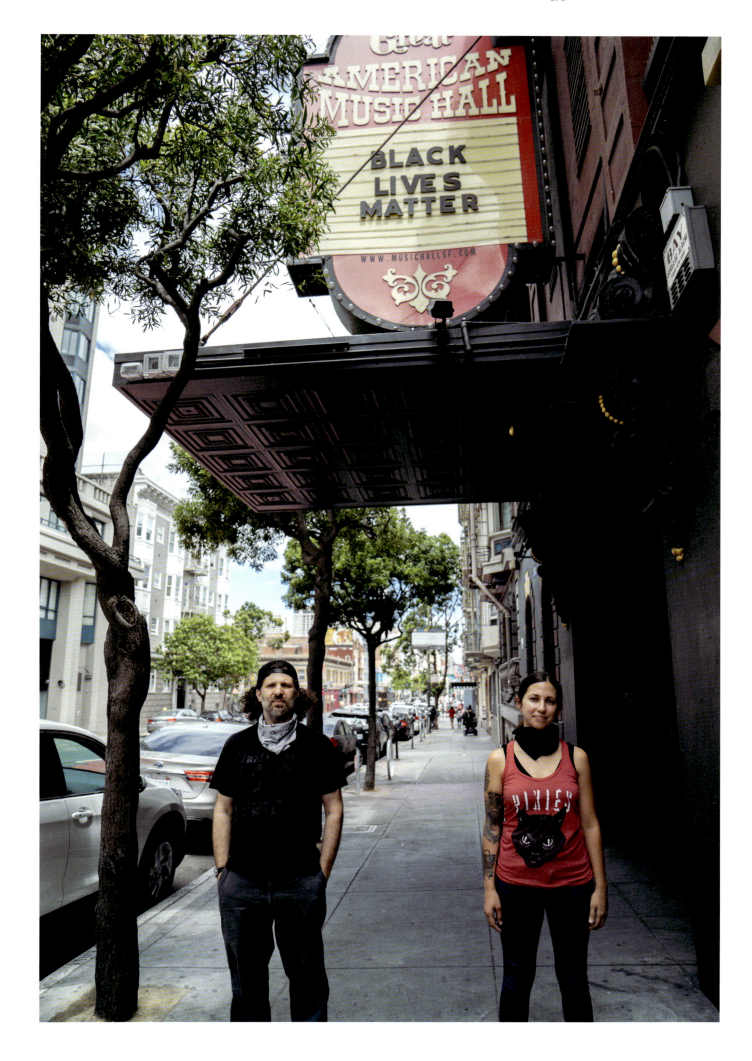

The Great Northern

The Roaring '20s were going to roar back. They did not roar back. Manny Alferez

We were like, '2020 is going to be an amazing year, the year everything falls into place.' Rob Garza

Above: Manny Alferez, Owner/
Booker and Rob Garza, Musician
Opposite top: Manny Alferez
and Rob Garza
Opposite bottom: Stage at
The Great Northern

This place is part of my musical journey. Venues and clubs are part of the fabric of who we are as a city. I feel like we're all in quicksand. There's COVID and then this big realization with the history of our nation and people trying to change that and create this positive force. [The year] 2020 was just filled with all these curveballs, and in a way they're positive because they have the ability to take us somewhere else, just taking it day by day and being creative. Rob Garza

The Independent

It's been a music venue in one form or another for 60+ years. It was originially the Half Note, a jazz club. [During COVID], you're doing all this work but there isn't that tangible reward of, 'Oh, there's this show we put on.' Not having that makes you feel like you're just going through motions. You're getting up every day, working hard—I think we both worked as hard if not harder than we would have if we were in our regular routine of booking shows. But you just keep working, doing what needs to be done, planning as if there's a light at the end of the tunnel, even though there might not be. Jonathan Gunton

Above: Nick Barrie, Talent Buyer
Right: Stickers plastered on a door at The Independent
Opposite top left: Jonathan Gunton, General Manager
Opposite top right: Stage at The Independent
Opposite bottom: View of the venue floor

Get your shit together, America.
Nick Barrie

The New Parish

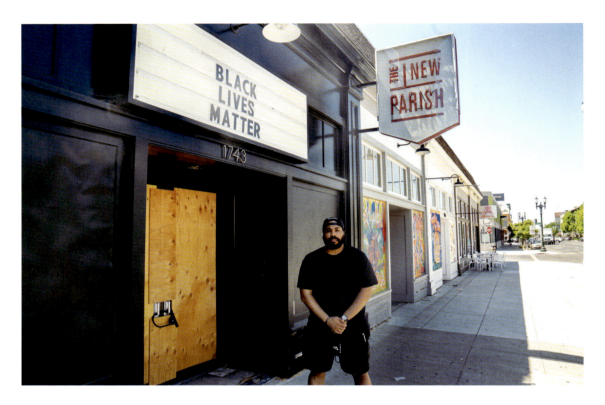

The New Parish has always had a community-oriented element to it, so it's a bummer to be closed when all this stuff is happening here. Oakland is such a hotbed for social protest and we can't really participate in that like we usually would. Michael O'Connor

Above: Jackson Ellis, General Manager
Below: Michael O'Connor, Owner
Opposite: Michael O'Connor and
Jackson Ellis

We're a very powerful industry, a very powerful piece of people's lives that can change, direct, and push things forward. So it strengthens my resolve in that when we do come back, we'll be even better, and hopefully in a better place in the world.
Jackson Ellis

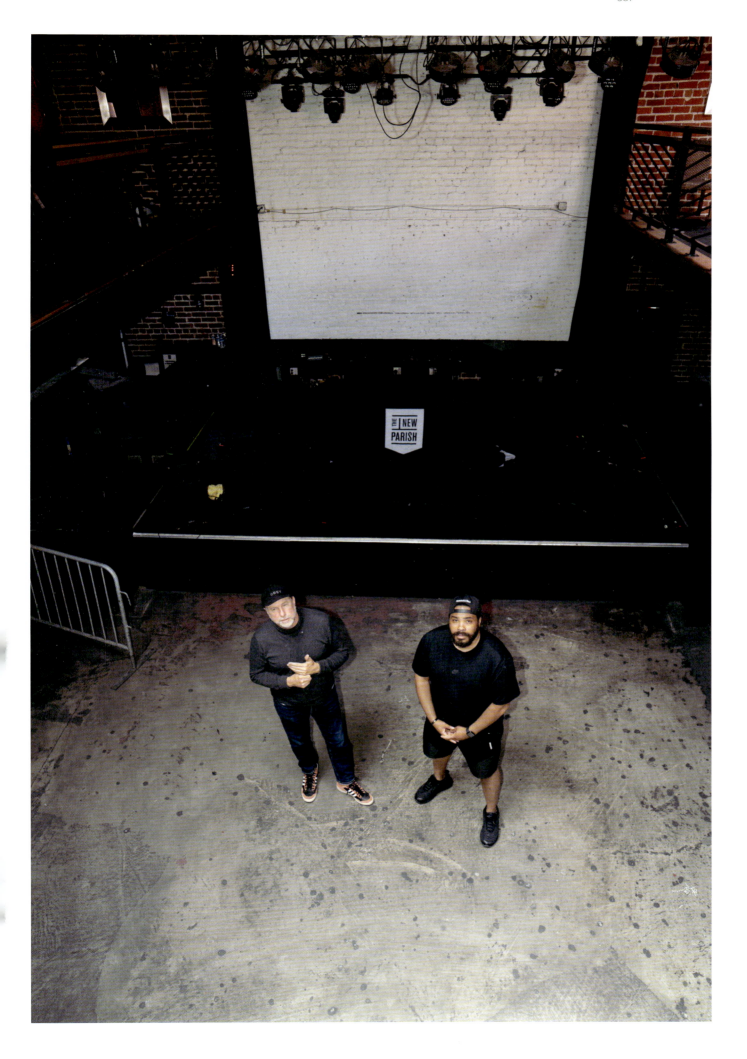

San Francisco

Rickshaw Stop

We are very adaptable.
We are ready and
willing to pull ourselves
up by our bootstraps.
We need to be given the
opportunity to do so.
Christopher White

I feel like my soul was ripped
away from me. Live music for me
is not only a livelihood. I work in
music, but if I wasn't working I
would be attending shows every
night. To lose that experience
of gathering with other humans
and releasing everything in sweat
and dance is something my
mind is having a really hard time
wrapping around. Syd Zee

Opposite: Christopher White, Owner;
Dan Strachota, Talent Buyer/Managing
Partner; Syd Zee, Door
Right: Christopher White; Syd Zee;
Dan Strachota
Below: Dan Strachota; Syd Zee;
Christopher White

Swedish American Hall

The Swedish American Hall was built in 1907 by a very prolific Swedish architect, August Nordin. It was a meeting place for Swedish and Scandinavian cultural events. The building has all of its orginal architecture.
Erin Schaeferle

The full effect to me comes down to the layoffs and the lack of work for everybody who works in our industry. In an industry like ours where events are booked six weeks to six months in advance, we're stuck in a holding pattern not knowing what to tell our clients, not knowing what to tell our agents, not knowing when we can go back to business. Jon Larner

Opposite top: Exterior of the Swedish American Hall
Opposite bottom: Erin Schaeferle, Sales/Operations Manager and Jon Larner, Operating Partner
Above: Stage at the Swedish American Hall
Right: Amp backstage

It's not surprising to me, but it has been heartwarming and impressive to see how the community as a whole and hospitality are just so scrappy. Everybody is finding a way to do something. I think that just speaks to the kind of people who do this work. We're not lazy and don't want to sit around and feel sorry for ourselves. Erin Schaeferle

Seattle

POSTER DESIGNS
Shogo Ota (page 387)
Victor Meléndez (page 388)

PHOTOGRAPHER
Arel Watson

PRODUCER + PHOTOGRAPHER
Austin Wilson

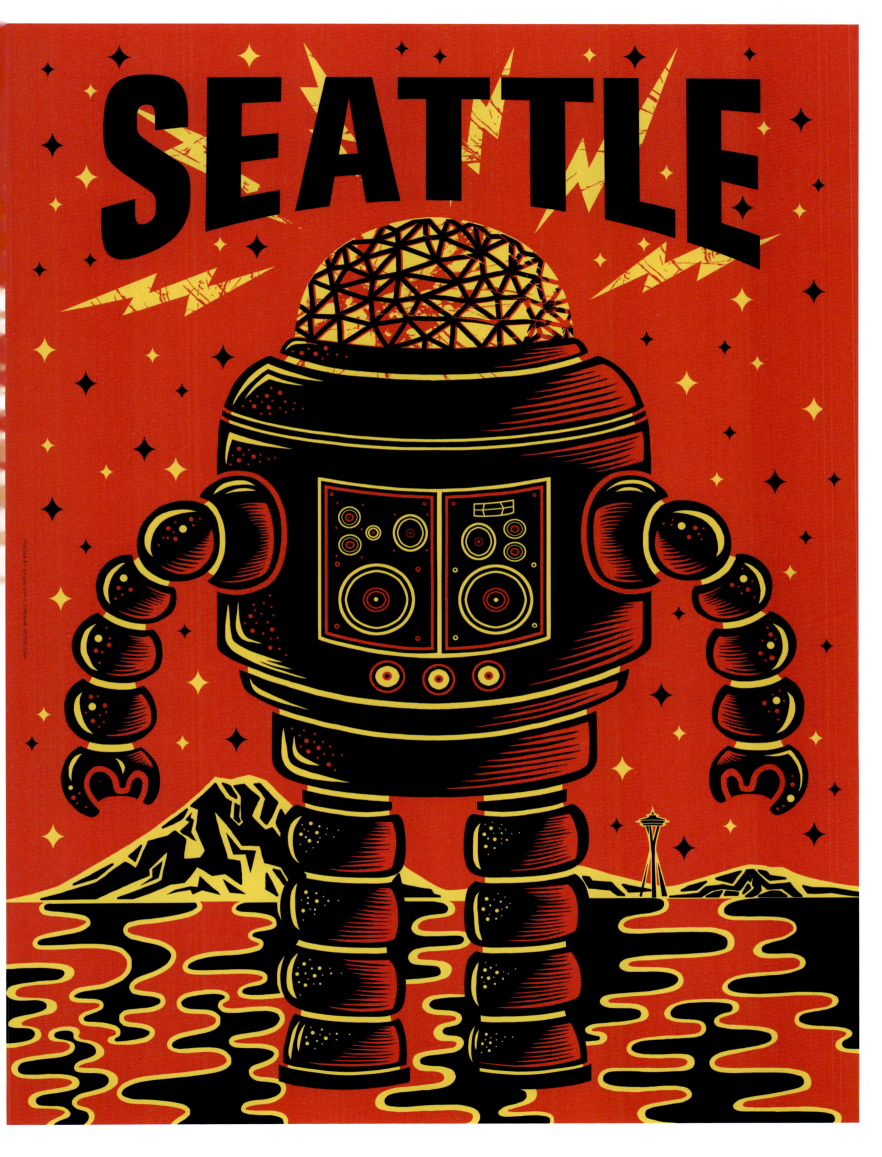

Seattle

Austin Wilson

1. Seattle's Central District has historically been one of the most diverse neighborhoods in the city and where some of the most important moments in American music have occurred. Local artists Quincy Jones and Ray Charles met when they were teenagers at jazz clubs on Jackson Street. Jimi Hendrix grew up there. He bought his first guitar at a pawn shop on 1st Avenue and played his first shows in small venues around town. A generation later, Sir Mix-A-Lot drove his posse through the Central District up to Broadway to talk to girls and get cheeseburgers. The Royal Room and Dimitriou's Jazz Alley feature live jazz in the city today and will hopefully continue the tradition of celebrating these musicians into the future.

2. Capitol Hill is where you'll find a statue of Hendrix as well as the venue Neumos, one of the most beloved independent music halls in Seattle. Until 2020, the Capitol Hill Block Party was an annual outdoor music festival that brought together thousands of people to dance in the streets. The crosswalks in Capitol Hill painted with rainbows celebrating the LGBTQ community and a Black Lives Matter mural painted on Pine Street will serve as a permanent reminder of the summer of 2020.

3. Nirvana's first show was at the Central, the self-proclaimed "oldest saloon" in Seattle. Pearl Jam's first show was at the Off Ramp, now called El Corazon. Before the pandemic, you could still stand in both those rooms and be on the very same hallowed ground as Kurt and Eddie. Then there's the Showbox, located across the street from the Pike Place Market. It's one of the most revered live rooms in the city. Founded in 1939, the venue originally showcased jazz musicians

and comedians. Through the years, it kept pace with the evolving trends of the city. The capacity is only about 1,000 people, but it's the preferred venue for Seattle superstars like Pearl Jam, Brandi Carlile, and Macklemore when they aren't filling city arenas and stadiums. The standing-room-only concert venues often turn into sweaty crowds of fans jumping and shouting along—we all miss that feeling.

4. Sub Pop Records launched the careers of some of the most well-known bands of the twentieth century and put Seattle permanently on the music map. Credited with popularizing grunge, the label became reluctantly famous after signing Nirvana, and went on to discover Soundgarden, Band of Horses and Fleet Foxes, just to name a few. Currently, Tacocat and Shabazz Palaces head their roster of homegrown talent. Fun trivia: if you order from the Sub Pop web store, Mark Arm (lead singer of Mudhoney) might be the one to fill your order; he also runs the shipping warehouse. The Sub Pop headquarters is right around the corner from The Crocodile where all of the above-mentioned artists played some of their earliest shows.

5. Hands down, KEXP is one of the best public radio stations there is. Originally it was the University of Washington's college radio KCMU. With the help of Paul Allen and the support of their listeners, KEXP has evolved into a global tastemaker. If you're driving around Seattle, tune into 90.3 FM, or if you're across the world, you can stream kexp. org and hear current Seattle favorites like Perfume Genius and the Polyrhythmics. The DJ's at KEXP consistently offer a variety of world music but often highlight NW bands from past and present—they might have just a

slight, *slight* bias to Seattle. You can tour KEXP studios at Seattle Center in the shadow of the Space Needle, have a coffee at La Marzocco, buy a record at Light in The Attic Records, and, if you time it right, catch a live performance in the gathering space.

6. For devoted fans, London Bridge Studio is a sacred spot where the most iconic records in Seattle music history were recorded. Pearl Jam's *Ten*, Alice in Chains' *Jar of Flies*, Temple of the Dog, and countless others came to life here. You can book a tour of the studio and stand in the same vocal booth where Eddie Vedder, Layne Staley, Chris Cornell, and so many legendary singers belted verses that defined a generation. BEARAXE recently played a virtual show there to raise funds for the struggling Seattle music community. London Bridge Studio is always seeking ways to give back to the industry that holds its heart and soul.

7. Serious vinyl collectors should plan to spend the day at Easy Street Records and Cafe. *Rolling Stone* magazine listed it as one of the top record stores in the country for its incredible selection of records by every type of artist. The location is more than a place to dig through crates and order a music-themed omelet—it's also secretly a live music venue. Easy Street is particularly fond of local artists and has hosted special in-store performances by The Sonics, Pearl Jam, and Sera Cahoone. It's this symbiotic relationship with Seattle's most beloved local artists that makes Easy Street a place like no other. The shop, in West Seattle, also sells posters and merch from aforementioned Sub Pop and the Ames Bros. Because the exterior walls of Easy Street are covered with ever-changing,

hand-painted murals of the latest album covers, this Seattle treasure is hard to miss.

8. Everyone has heard the name Macklemore, but what most people don't know is that there's a uniquely NW sound of hip hop that's completely different. The current class of Seattle artists like Shabazz Palaces, Blue Scholars and Grieves have ushered in a new wave of more psychedelic and intellectual hip hop that is popping up all over town.

9. A small music festival called Doe Bay Fest has been hosted each summer on Orcas Island since 2010. The magical locale is only accessible by boat or seaplane, so fans and artists camp together for several days against a backdrop of magnificent cliffs along the sea and wooded trails between stages. The island has quickly become the launchpad for success for the best NW songwriters. Festivalgoers are often surprised with secret performances in the middle of the night, under an apple tree or in the yoga studio. The Head and the Heart got their start there singing around the campfire.

10. *The Stranger* is Seattle's alternative newspaper and the best place to find out what's happening around town on any given night. The writers and journalists who contribute have eclectic and often polarizing tastes, but all keep their fingers on the pulse of Seattle music and culture. Back when there were concerts (remember that?), *The Stranger* would strongly push their favorite local bands and you could almost always find a killer band performing any night of the week. It's baffling how they whittled it down. If they recommend a reggae set at Nectar Lounge or a new folk singer at the Tractor, get tickets. They rarely disappoint.

Chop Suey

Chop Suey holds a unique quirkiness to it. I would say it's Seattle's most unique music venue. It has a very personal touch. The owners have all this vintage stuff around. It's always felt like home for that reason. You get to see people in the scene start to grow up and get bigger. It's like the very first stop.
Arel Watson

In the Seattle music scene, community is the biggest, most powerful thing. We all need to stick together and be there for each other. It's the closest thing probably a lot of us have to family, because Seattle has a whole bunch of transplants.
Arel Watson

Opposite top: Arel Watson,
DJ/Photographer
Opposite bottom: Stage at Chop Suey
Right: View of the bar at Chop Suey
Below: Bree McKenna,
Musician (Tacocat)

If you're going to have another job besides being just a musician, it's cool to be surrounded by other musicians and also the chaotic energy of shows, which I love. It's a really bananas thing to do, really fun. Bree McKenna

Clock-Out Lounge

We're all in it together. We're all feeling the same aches and pains and we're trying to push bills through Congress. On a local level, we've done lots of lobbying. That's not something any of us had any experience with. Having that camaraderie, we've all known each other and been friendly to each other but now we're all in the same position and empathetic. We can come together as one. This can only help things once we're out of this mess. Jodi Ecklund

Above: Shaina Shepherd, Musician (BEARAXE)
Right: Interior of Clock-Out Lounge
Opposite top: Exterior of Clock-Out Lounge
Opposite bottom: Jodi Ecklund, Owner/Talent Buyer

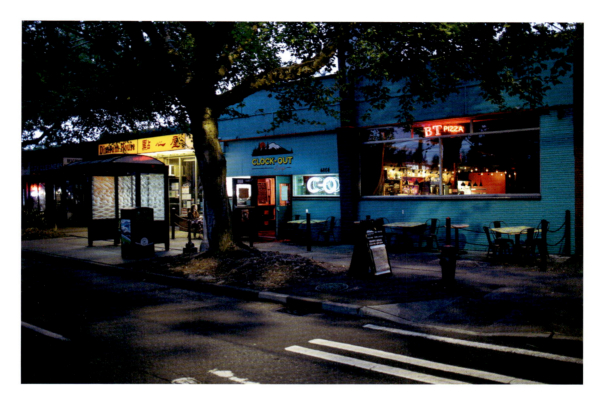

Music is an emotional experience, just like a hug or a physical bond to somebody. It's necessary to remind us that we're together even if we're not touching each other.
Shaina Shepherd

The best part about Seattle is it's learning to be innovative, to embrace new ideas and to get creative, immediately. That's the first instinct in Seattle. I've been trying to do that in my various projects, [learning] how to support other voices, thinking about what people watch in the news. I watch the news and put myself through a lot of pain when it comes to ingesting a lot of the social injustices [I see] happening on TV and in the media, and reacting to that. As an artist, as Nina Simone said, 'You can't help it. An artist's duty, as far as I'm concerned, is to reflect the times,' even if it's uncomfortable and it's not part of the regular artist's experience. I try to live in the moment with everybody and write in the moment of everybody.
Shaina Shepherd

The Crocodile

Seattle's always had a really good music scene. [The Crocodile] became one of the central places in Seattle that was part of the grunge movement. A lot of the local stuff was taking off, and a lot of those bands played here and got their start here. Being an indie venue, we try to give personal attention and treat people like human beings and not just a money machine to sell tickets and beer. We want people to have a good time here and to want to come back to The Crocodile.
Adam Wakeling

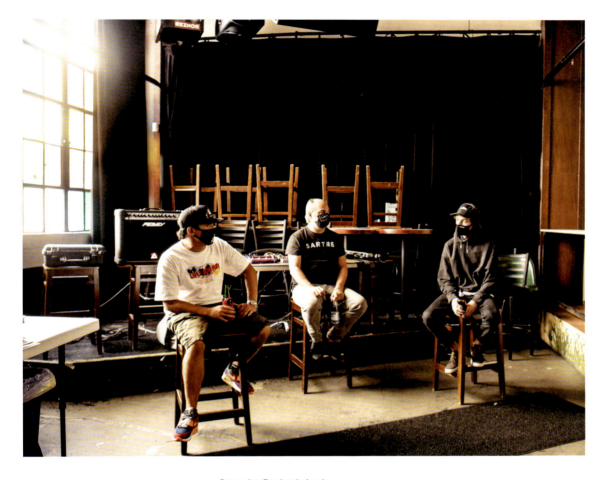

When it first happened. it was scary and ominous. I was on the road when it happened; the first two months were really hard. I've never seen anything like this, and everything I do to make money has been jeopardized. People are, like, 'Well, people are still home listening to music,' but that's not enough. You can go ahead and run up those Spotify numbers up all day, but at my level, that's not going to feed my family or the other people on my payroll who have dedicated everything to this. Benjamin Laub

Opposite: Benjamin Laub,
Musician (Grieves)
Above: Josh Saenger, Marketing/
Ticketing; Adam Wakeling,
General Partner; Benjamin Laub
Below left: Exterior of The Crocodile
Below right: Doors of
The Crocodile chained shut

Nectar Lounge

As soon as we step on stage and play a note, everyone is smiling. The bartenders are smiling, people are happy to buy drinks, everyone is in a symbiotic and positive vibe, at least from our perspective. The smiles are things that are a big difference from other venues in town I've seen.
Ben Bloom

Above: Entrance to Nectar Lounge
Opposite top: Ben Bloom, Musician (Polyrhythmics); Mario Abata, Partner/Talent Buyer; Andy Palmer, Partner/Talent Buyer
Opposite bottom: Mario Abata; Ben Bloom (sitting on stage); Andy Palmer; Austin Wilson, Producer/Photographer (Bring Music Home)

I've spent very little time thinking about pivoting in my career during all of this. It's been all about: 'How do we continue to make this work and come out the other end?' Going virtual was the first step. But we know, artists know, everybody knows, that virtual is not a long-term solution and that eventually we need to be able to get back in the clubs and pouring drinks and seeing those smiles again. Andy Palmer

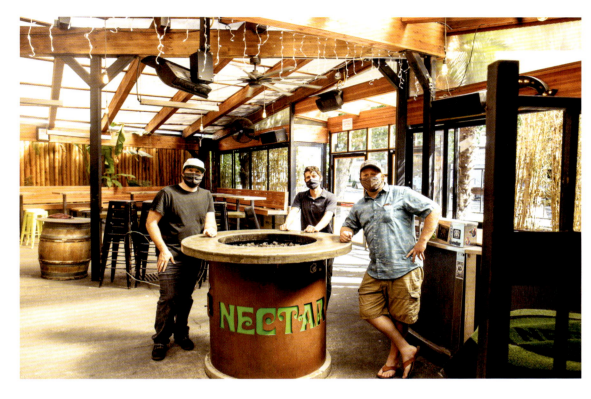

One night you'll come here, and next night the crowd will be completely different. That's really special. We get to engage with a lot of different communities and it's one of the things I love most about Nectar.
Mario Abata

Neumos

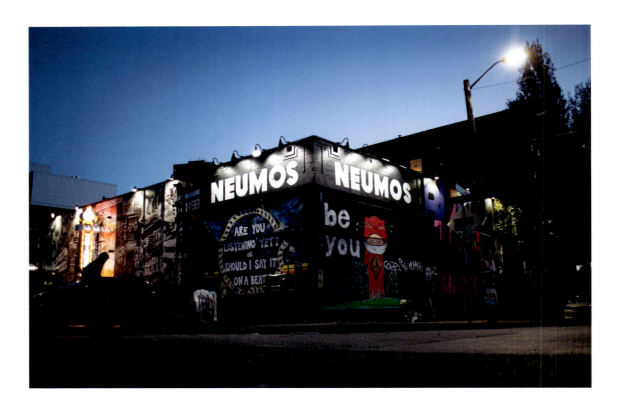

When I think of playing a place like Neumos, it was like a dream. If you grew up in Seattle and played in Seattle, you dream of headlining a venue like Neumos and filling it up. Eva Walker

There's something about Seattle, how people work together to help each other that I don't think they do in other places. We're like the Wild West—we're up here in the corner and people think about us differently, and I think we think about ourselves differently, too. Steven Severin

We were crunching numbers and realized that in 2019, [Neumos] paid 10,000 artists. That's how artists pay their rent and child care and groceries and all that shit. We're not giving them a dime, and they're not getting that money somewhere else. I don't know how we are getting through all of this. It's insane. For any of us to make it, we all have to make it. Steven Severin

Opposite top: Exterior of Neumos
Opposite bottom left:
Steven Severin, Co-Owner
Opposite bottom right: Andy King,
Venue Manager
Above: Cedric Walker and Eva Walker,
Musicians (The Black Tones)

Everyone has to pivot right now, and we all need to pivot together. Andy King

The Royal Room

Because it's a neighborhood place, it's really important that there's not just music I'm interested in, but that it reflects the community. That's huge to me.
Wayne Horvitz

It's been scary knowing what's going on, and that has led to NIVA [National Independent Venue Association]. It's really wonderful connecting with everybody. During this time when everyone feels really alone, it's nice to see what other people are going through. You can't really bury your head in the sand when you find out what's going on. Tia Matthies

You know when you can see something across the horizon for a long time, and then all of a sudden it's in front of you and you're like, 'How did *that* happen? We're locking doors. We're canceling shows. Oh, this is *real*.' That's what it felt like. Brad Rouda

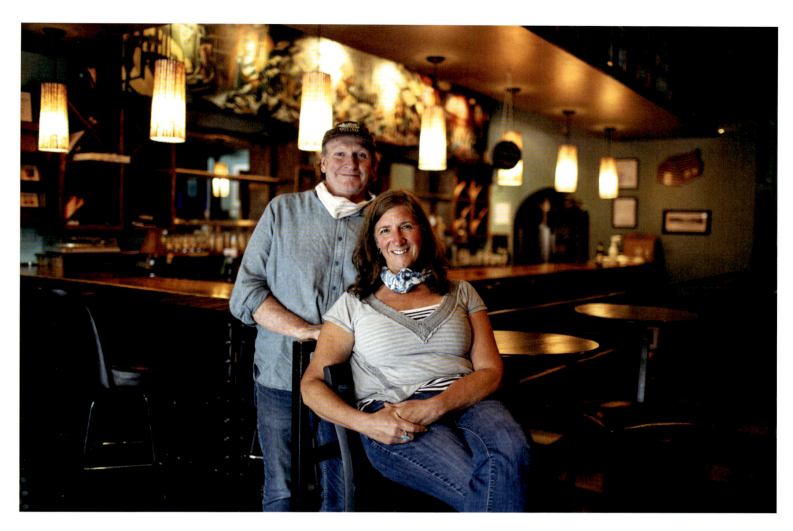

Since I was a kid, the thing I love about playing music the most is being with people, even when no one's watching—just the togetherness of it. I miss that motivation. Sometimes I get worn down and sad that we just don't know when that's going to happen again. It makes me think about my own relationship to music, because I do like that social part so much. Alex Guy

Opposite top: Alex Guy, Musician
Opposite bottom: Steve Freeborn, Owner/Operator and
Brad Rouda, Venue Manager
Above: Tia Matthies, Owner/Operator and Steve Freeborn
Below: Wayne Horvitz, Owner/Operator

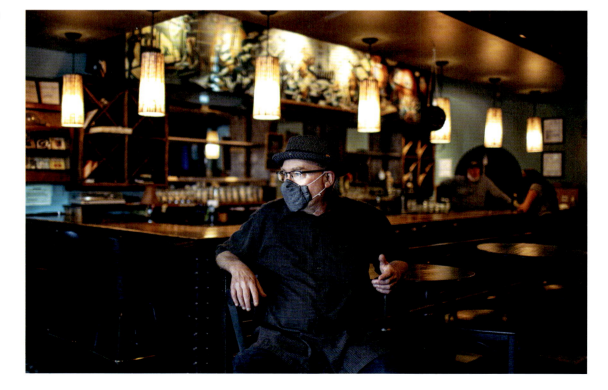

Our whole lives have been around this. There's a whole soul behind live venues. We stream things, they're fun to watch, but it's nothing like being there. I don't know how we'll ever get through until we can open again. Steve Freeborn

The Showbox

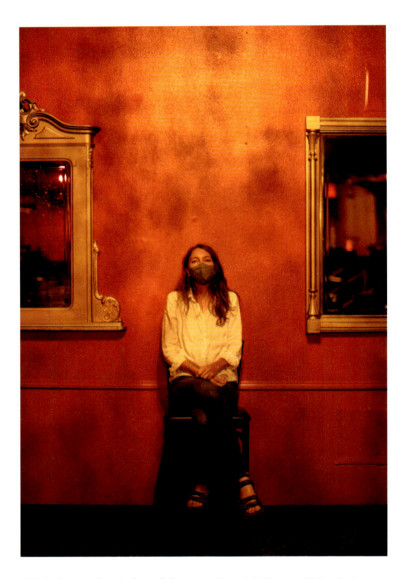

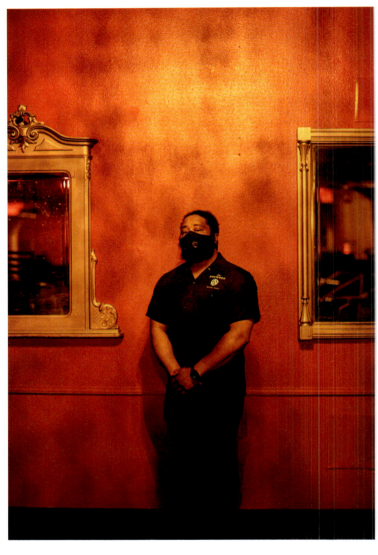

A little-known fact is that all four members of Tacocat used to work here. Me, Bree, and Lelah all did coat check and Eric did security, so it's fun to see some of the same folks. We've been a band for 13 years and that was at the very beginning, so it's cool to still see some friends here. They're like, 'You did it!' Emily Nokes

Above left: Shannon Welles, Assistant General Manager
Above right: Earnie Ashwood, Security/ Box Office/Musician
Opposite top: Emily Nokes, Musician (Tacocat)
Opposite bottom: Marquee at The Showbox

Having a competitive market all working together really supports the idea of what music represents: the ability to connect beyond the things that separate us. We have so many venues with all their own rich history, with their own stake in the claim to artists and to the people coming in. [It's] all about being able to provide an opportunity for artists to connect with the people. The biggest responsiblity all of us [who] have worked in the music scene share is that we have to be able to look past our competitiveness and to see the bigger picture: We have to save music as a whole. This has been one of the most beautiful things that's come out of this really, really scary scenario. Earnie Ashwood

NIVA has sprung up for independent venues all over the country to come together and lobby Congress. I think it's the first time for-profit commercial businesses that would've been competitive before are getting together as a group. They realize we all need each other to survive, we all have a role to play in the ecosystem. If one goes, we're all going. We all need to support each other. We're more powerful as a group.
Shannon Welles

Tractor Tavern

Talking about the things you miss the most, one of the things that came to mind for me was just the check-in we would all do, everybody who worked here, right before the doors would open. All the bartenders had gotten prepared, door people got everything set up, sound person had already done soundcheck, and everything was all ready. We just checked in and had a collective sigh, then opened the door. I'm missing that moment, having taken it for granted so many times. Leigh Bezezekoff

Below: Boots hanging from the ceiling
Right: Dan Cowan, Owner/Talent Buyer
Opposite top left: Leigh Bezezekoff, Marketing/Ticketing
Opposite top right: Jeff Rogness, Booker
Opposite bottom: Sera Cahoone, Musician

The vibe, the people, the space—it brings out the fun in people. Every time I play here, the crowd is always so incredible and I always have the best time. Every single show I've played here is special. Sera Cahoone

I moved to Seattle in 2010 and this was definitely one of the first places I came to see a show. Like a lot of people in Seattle, I've loved this room for so long and was really happy to become a member of the family here. It was a big honor to be behind the scenes and be a part of this historical spot. Jeff Rogness

Wild Buffalo House of Music

We just want to fight. We miss each other, we miss the experience of playing together, of practicing and putting out a show and getting that awesome energy exchange between a crowd and a band. There's just nothing quite like it. Stephanie Walbon

I used to go to bed at 4 a.m. and wake up at noon, and now I'm going to bed around 11:30 and waking up at 7. It's wild. The silver lining is that I'm now connected with so many more people, and I've met so many new friends and people who are in the same boat I'm in—a sinking boat we're all working together to save. Normally, music venue owners don't get along very well. They're constantly competing for shows, even in markets like Seattle and Bellingham. There's always this tension, and now we're all best friends. Craig Jewell

I'm just looking forward to being able to work again. That's the main thing. Most people who choose to do what I do, do it because they love music and making music and tuning up other bands. It's a very social job. I'm looking forward to seeing people in my community play music again, to touring with bands again. My career is on standby at this point. I'm looking forward to being me again.
Rich Canut

Opposite: Stage at Wild Buffalo
Above: Craig Jewell, Owner/Talent Buyer; Rich Canut, Production Manager/Sound Technician; Stephanie Walbon, Musician
Below left: Entrance to the venue
Below right: Coatroom of Wild Buffalo

Tulsa

POSTER DESIGN
Jose Berrio

PHOTOGRAPHER
Melissa Payne

PRODUCER
David Wrangler

Tulsa

Melissa Payne

1. Since 2013, Tulsa has been home to the Woody Guthrie Center, which houses the Woody Guthrie archive. But if Woody Guthrie isn't your thing, hold tight, because the Bob Dylan Center is slated to open in late 2021.

2. Ever heard of the Tulsa Sound? Then you'll want to check out the various murals around town dedicated to the pioneers of the genre like JJ Cale and Leon Russell.

3. Speaking of Leon Russell, The Church Studio, which was the recording studio and home office of Shelter Records, is located in Tulsa. It's currently undergoing extensive renovations but should be open to the public once again soon.

4. The '70s R&B/funk group the Gap Band was from Tulsa. Consisting of brothers Charlie, Ronnie, and Robert Wilson, it got its name from three streets in Tulsa's Greenwood District: Greenwood, Archer, and Pine.

5. Cain's Ballroom, made famous by Bob Wills and his Texas Playboys back in the '30s and '40s, was an important part of the genre known as Western Swing. Cain's is still open to this day and hosts national touring acts as well as local favorites.

6. If you seek a different side of Cain's history, ask the staff about the piece of broken wall still on view in the offices where, at a 1978 Sex Pistols show, Sid Vicious notoriously punched a hole in the green room plaster.

7. The Turnpike Troubadours may no longer be touring together, but the venue made famous in their song "The Mercury" is still alive and kicking. You can visit Mercury Lounge Tulsa, a former gas station-turned-dive bar, on 18th and Boston. Don't forget to grab your $5 shot and beer, admire the collection of taxidermy animals, and remind them of their motto: "This bar sucks!"

8. Rock station KMOD can still be found on the airwaves in Tulsa, but did you know that actress Jeanne Tripplehorn was a DJ there in the '80s?

9. In 2020, a multimedia hip hop project called Fire in Little Africa was recorded in Tulsa. Its purpose is to commemorate the 1921 massacre on Black Wall Street. An album made up of contributions from rappers, poets, and singers will be released in 2021.

10. There is no shortage of music to be found in Tulsa as the city is blessed with multiple venues all catering to different sounds. Local musicians like Paul Benjaman and Pilgrim can be found at venues like The Colony or Cain's Ballroom, and Mercury Lounge welcomes touring bands as well as the locals. The Shrine, The Vanguard, and Blackbird on Pearl are also great places to catch shows. Even the popular restaurant Duet hosts jazz in the basement most nights of the week.

Cain's Ballroom

This whole thing has made me realize how much live music does mean to everyone, even to myself, aside from the business of it. You just can't beat it. Chad Rodgers

It isn't just about a building, the same way a song isn't just about the song on a piece of paper. It's about the performer, the musical expression in it. It's living. It's multidimensional. The caretakers who have given life to a place are such a key part of it; that really is what makes sure all music fans have the kind of places that make memories. Taylor Hanson

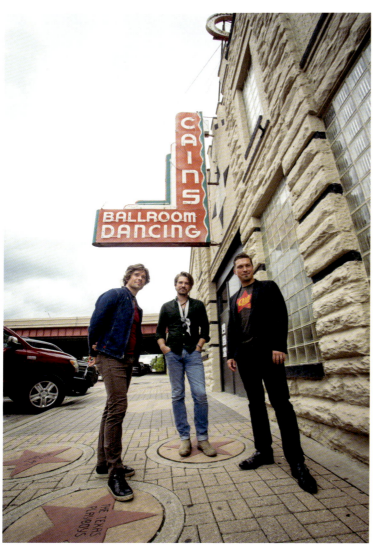

This is not what we do. We're here to work 14-15-hour days to make the public and anybody see a show, a great show. We miss that. It's a horrible feeling not being able to do it. Brad Harris

Left: Brad Harris, Production Manager
Above: Zac Hanson; Taylor Hanson; Isaac Hanson, Musicians (Hanson)
Above right: Chad Rodgers, Owner/ General Manager/Booker
Right: David Wrangler, Creative Director (Vinyl Ranch)

Mercury Lounge

For me, it's always been about the music. [Mercury Lounge has] been a gathering place for Tulsa musicians, for service industry people, seeing people on a Friday afternoon: doctors, lawyers, bikers, mechanics. It's always been a really great, eclectic mix of Tulsa culture. If venues disappear, it will all become big business. There will be a monopoly on art, and I don't want to live in that future. Bobby Dean Orcutt

Above: Stage at Mercury Lounge
Below: Bobby Dean Orcutt, General Manager/Owner; Paddy Ryan, Drummer; Katie Cline, Bartender

This is where bands play on their way to Cain's every time. Being a musician in this industry, all of us, there's never been a safety net or security, so we've all been pretty good at hustling. The hustle out of this bar has been exceptional the past seven months. Paddy Ryan

Washington, D.C.

POSTER DESIGN
Cindy Sun

PHOTOGRAPHER
Kyle Gustafson

PRODUCER
Tracy Hollinshead

Washington, D.C.

Stephanie Williams

1. Punk runs through our veins Fugazi. Bad Brains. Dag Nasty. These are bands that still have an immeasurable impact on music today, and they all hail from the District. D.C.'s punk scene in the '80s has inspired countless documentaries, books, and musical acts that emulate the community's unwavering do-it-yourself spirit. And D.C. punk continues to thrive via projects such as venerable label Dischord Records.

2. ...but go-go is in our hearts, and it drives the beat of the music scene It isn't just the soul of the city; it is by law the official sound of D.C., too. The genre's syncopated beats and funky melodies were born and bred right here in the nation's capital and catapulted to international fame by artists such as the late Chuck Brown, known endearingly as the Godfather of Go-Go. And keeping his legacy going are acts like Backyard Band, Trouble Funk, and Rare Essence, whose high-intensity shows have continued to sell out venues in the region.

3. D.C. is becoming an international player in the world of hip hop Over the years, trailblazing R&B and hip hop acts from the city have broken through into the mainstream lexicon. Ari Lennox, GoldLink, Oddisee, Kali Uchis, and Wale all first cut their teeth in the local music scene before going on to perform at major music festivals around the world and receiving Grammy Award nominations.

4. Our small District is home to a big music festival community D.C. can stand toe-to-toe with other major cities when it comes to festivals. The District offers dozens of festivals including the annual Funk Parade, Kingman Island Bluegrass & Folk Festival, Damaged City Festival, and the All Things Go Fall Classic, which brings in fashionable pop acts from around the globe.

5. Our venues reflect the music scene's diversity D.C.'s eclectic music community is reflected within the city's wide-ranging list of venues. Indie rockers and punks will find refuge at the legendary 9:30 Club and Black Cat, while jazz heads can immerse themselves in Blues Alley or Alice's Jazz and Cultural Society. Bossa and Tropicalia are sanctuaries for world music lovers, and places such as Pearl Street Warehouse cater to bluegrass and Americana music fans alike.

6. 9:30 Club is a staple of the city Over its 40-year history, 9:30 Club has become a pivotal stopping point for the world's biggest bands. Nirvana and Smashing Pumpkins played it before they became household names, and Radiohead played a surprise 9:30 set in 1998. Before that, D.C.'s hardcore and go-go scenes made themselves home at the club and paved the way for its illustrious history.

7. The District was once home to a 'Black Broadway' Throughout the early- and mid-20th century, U Street was an oasis of innovation where Black music thrived, earning it the nickname Black Broadway. Venues such as the Lincoln Theatre (which still stands today) and Bohemian Caverns welcomed the biggest jazz titans to ever walk the earth. Miles Davis, Duke Ellington, Ella Fitzgerald, and John Coltrane are among the exhaustive list of musicians who frequently performed on Black Broadway.

8. Yes, we have Dischord, but there are other record labels based in D.C., too The storied imprint Dischord continues to release music, but there are other small but mighty record labels shepherding the electric sounds of the District to the rest of the world. Babe City Records houses a glimmering rock catalog, while veteran label Carpark Records has played home to established acts like Toro y Moi and Beach House. For otherworldly dance fare, Future Times maintains a consistent output of forward-thinking sounds.

9. The music community is neither exclusive nor cutthroat No, you don't need to know someone or have an "in" with a certain type of venue to immerse yourself in the D.C. music scene. The sheer diversity of the community makes it easy for a fan of nearly any type of music to find a band or group of artists to vibe with. The general atmosphere is supportive, not competitive.

10. The resilience of the music community is like no other Independent venues, labels, and artists still find ways to thrive despite rising rent prices and new development that threatens to undermine their existence. D.C. musicians also have a long history of carving out their own DIY venues around town. The COVID-19 pandemic has only underscored this unwavering resilience as musicians and venues find creative avenues to showcase shows online and through other socially distant gatherings.

9:30 Club

To be perfectly honest, I don't know that I want to necessarily do anything else. I like working in the industry I work in. I don't want to change, so I'm going to try to find ways to stay in [the music business] until the world decides to let us be normal again. Kayla Johnson

Music is a healer, a universal language. It's something that brings people together from all walks of life, [and] something we're missing right now, an element we need for people to come together. We are [going to] do whatever we can to make sure we can come back strong. Being at work is a blessing and therapy in a lot of ways.
Karim Karefa

Opposite top: Kayla Johnson, Bartender
Opposite below: Stage and interior of 9:30 Club filled with supplies. The venue was used to organize and pack for local food drives during COVID.
Above: Karim Karefa, Assistant General Manager
Right: Exterior of 9:30 Club

The Anthem

I couldn't have even fathomed the existential threat. You game it out. You think about, 'How do we, as a business, cover another 2008?' But in 2008, entertainment was an escape for people. They might go to fewer shows, but they'd still go because it was two hours of getting your head in a different place, of community.
Donna Westmoreland

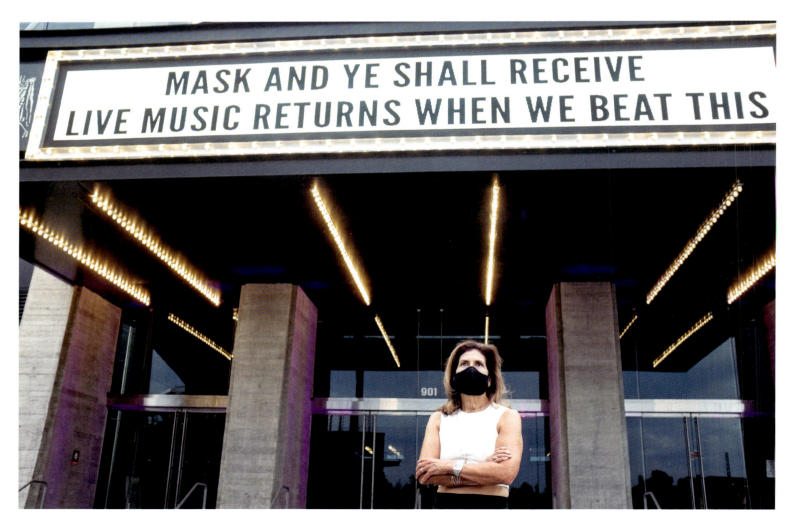

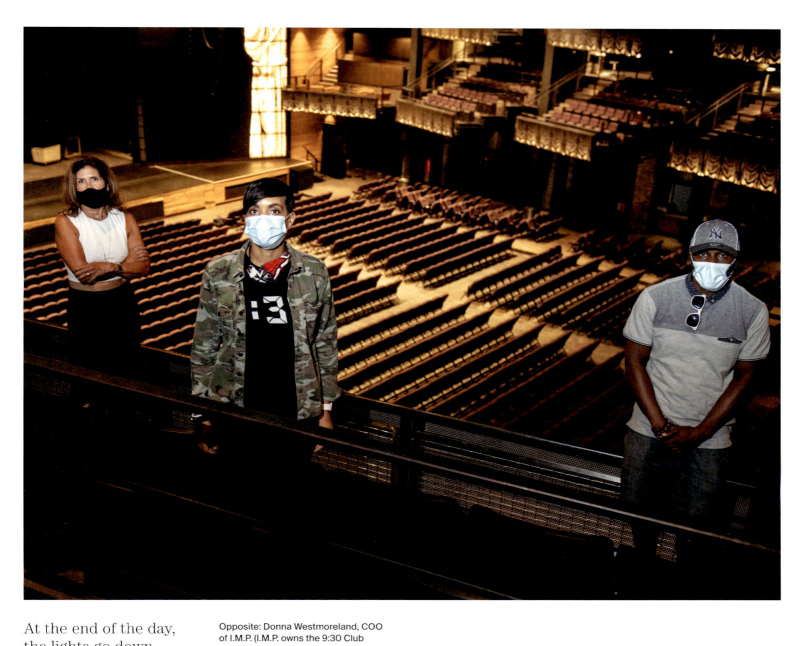

At the end of the day, the lights go down, somebody hits a drum or strikes a chord on a guitar. So yeah, the gathering economy is suffering.

Donna Westmoreland

Opposite: Donna Westmoreland, COO of I.M.P. (I.M.P. owns the 9:30 Club and The Anthem and operates the Lincoln Theatre and Merriweather Post Pavilion.)

Above: Donna Westmoreland, COO of I.M.P.; Kayla Johnson, Bartender of the 9:30 Club; Karim Karefa, Assistant General Manager of the 9:30 Club/ Operations of the Lincoln Theater/ Liaison of U Street Music Hall

Black Cat

It got real, pretty quick. We didn't know what was going to happen with our livelihoods. We've found other things we can do, but it's been out of our comfort zone. We were even doing Uber Eats together. [Ex Hex hasn't] even been able to get together. There have been opportunities to work with people on projects remotely, lots of reaching out, a real sense of real camaraderie.
Laura Harris

Below: Catherine and Dante Ferrando, Founders/Owners
Opposite top: Laura Harris, Musician (Ex Hex)/Bartender
Opposite bottom: Al Budd, Musician (The Shirks)/Bartender

A pleasant surprise was how many regulars and friends tipped us virtually when they heard we were out of work. It was just a real outpouring of support and help when the future looked pretty grim. Al Budd

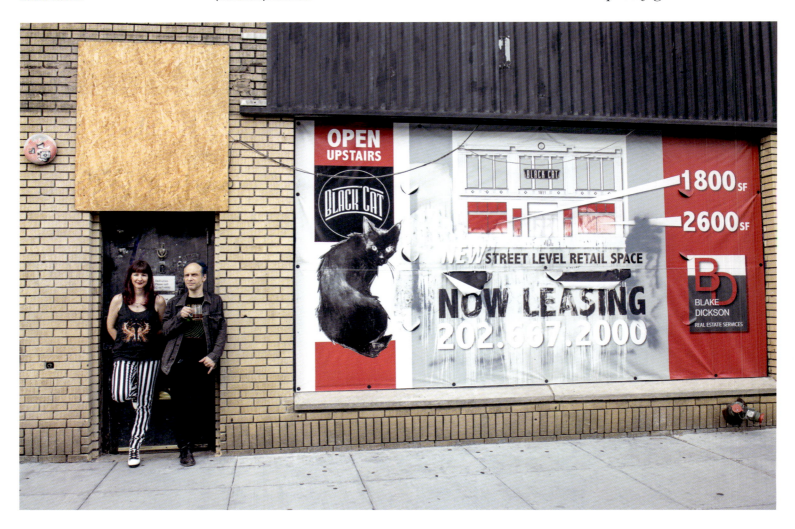

Lincoln Theatre

That's one thing about working in this business: The time that goes by doesn't seem real. You take it one show at a time, one band at a time. It just doesn't seem real. Karim Karefa, Assistant General Manager

Below: The lobby of the Lincoln Theatre filled with stacks of supplies. The theater was used as a staging area for local food drives during COVID. Opposite: Bust of Abraham Lincoln in the window of the theatre.

It never gets old to see people cross each other in the street who may not speak, but put them in the same room with the same band that they love, and everything changes. To me, that's magic.
Karim Karefa

Merriweather Post Pavilion

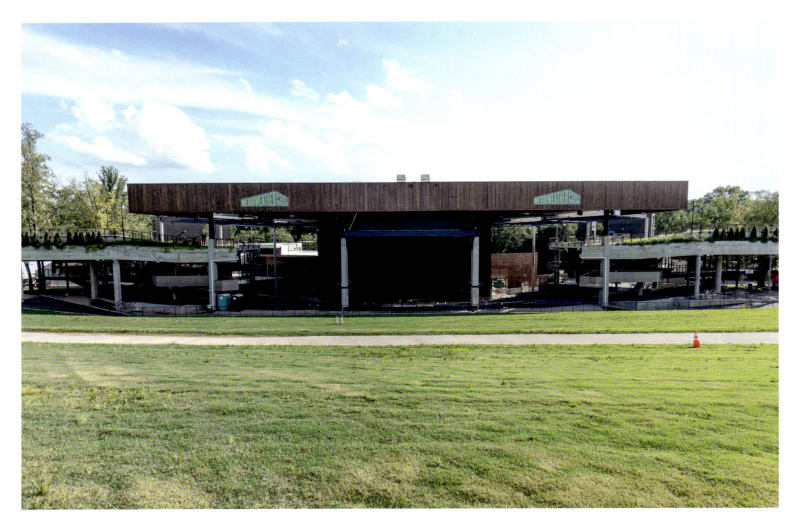

The gathering economy is suffering. With this many venues and this much staff, our burn rate is not insignificant. We don't have a parking lot for a drive-in concert, and virtual shows have been driven by the artist. We started a 501(c)(3) fund to benefit our employees. Donna Westmoreland, COO of I.M.P.

Above: View of the Merriweather Post Pavilion from the lawn
Opposite: The stage at the Merriweather Post Pavilion

[COVID is] terrifying,
and it's this bizarre
combination
of exhaustion and
boredom and ennui
and frustration
and lots of busywork
and keeping things
going, but nothing has
any joy of it.
Donna Westmoreland

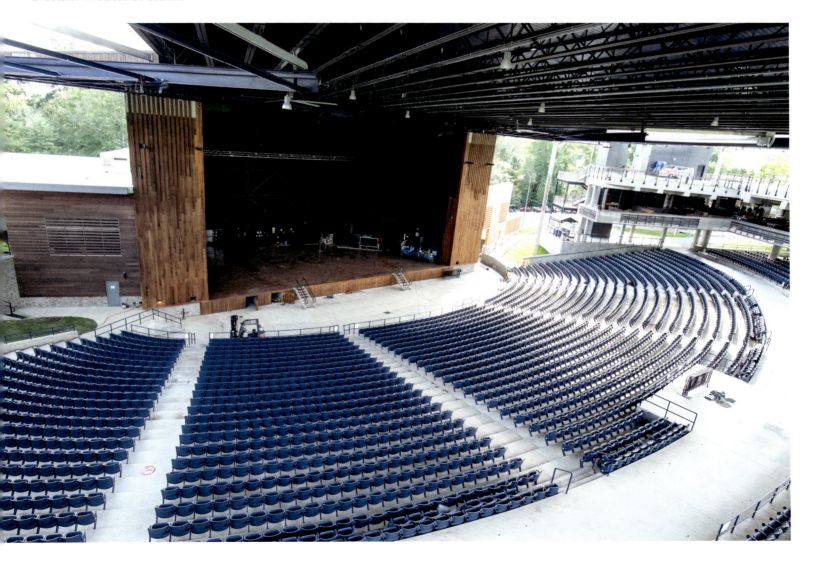

Songbyrd

Tonight we have a live-streamed show we're doing downstairs for Twitch, and then we're [going to] project it outside. We decided to just reach out to all the artists who played here, or the people who were supposed to play here and see if they'd be interested in going live from our networks. So it's like they promote themselves, they promote the venue, so [Songbyrd doesn't] disappear like everything else.
Chadwick Alexander

Below: Joe Lapan, Co-Owner/ Marketing Director
Right: Alisha Edmonson, Co-Owner
Opposite top: Zeeshan Shad, Talent Buyer and Johnny O'Connor, Head Talent Buyer
Opposite bottom: Chadwick Alexander, General Manager/Marketing Assistant

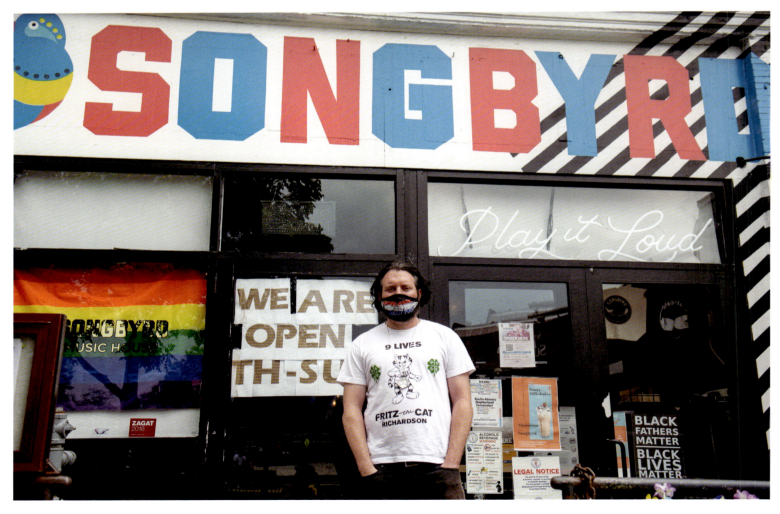

A silver lining to all of this is that out of the ashes of everything that crumbled, could we see a rise in more independent businesses, agencies, management companies, instead of just playing by this one set of rules? Johnny O'Connor

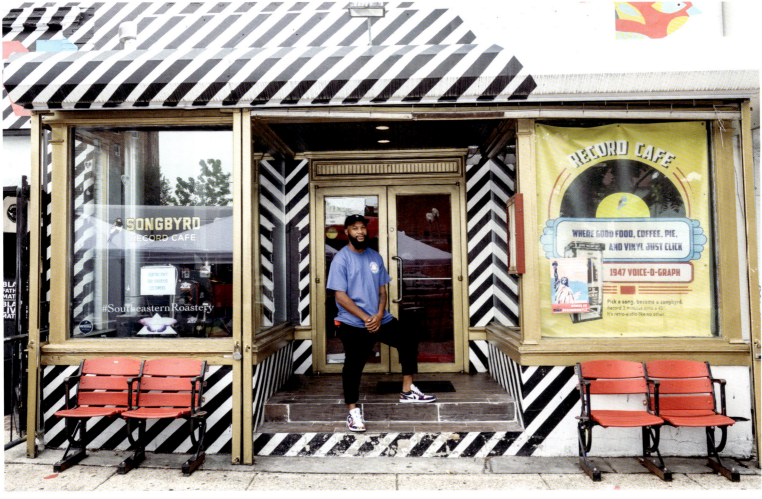

U Street Music Hall

Immediately, what I'm looking forward to the most is having more local artists come here and perform and have a platform. That's very, very important, especially for us as a small independent venue, to add fuel to the fire for musicians [who] don't have a platform.
Ameer Dyson

Congress is playing political theater, and it's upsetting to a lot of us. It's upsetting to me because we were closed due to no fault of our own, and we stayed closed as a responsible measure. For the betterment of society, we haven't surreptitiously or maliciously brought people in. We've practiced safe social distancing, we've done everything we possibly could through merchandise sales and live-streaming, and it's still less than four percent of the revenue we were bringing in before. So if this society wants to help us get through this, they're going to have to help us out. Will Eastman

Opposite top: Ken Brobeck,
General Manager
Opposite bottom: Will Eastman, Owner
Above: Ameer Dyson, Assistant
General Manager/Musician

Union Stage

Below: Daniel Brindley, Owner
Opposite: Bakri Mohamed-Nur,
Bar Manager

It's an adrenaline rush for real, coming in and knowing it's a sold-out show, and just not really ever being prepared for whatever the night is going to bring, because everything is going to be different [from the previous booking]. It's like gearing up and just having to push through and rise to the occasion and rock. That's definitely something the staff has cultivated here, always being able to step up and go that extra mile regardless of situation, regardless of show. Bakri Mohamed-Nur

The outlook is no concerts until at least 2021. Clubs are in an incredibly dire situation, basically flipping into recording studios and video studios at this point. We've had to furlough tons of staff. I think that's what's coming up: thinking about new things and how to monetize it. The reference point is not 'the way it was' anymore. The reference point is something totally new, that's not even defined. Daniel Brindley

Other Cities

POSTER DESIGN
Franky Aguilar

BOULDER, CO (PAGE 438, 444)
PHOTOGRAPHER
Lisa Siciliano

PORT CHESTER, NY (PAGE 440)
PHOTOGRAPHER
Kevin W. Condon
PRODUCER
Amber Mundinger

LAS VEGAS, NV (PAGE 442)
Damon Burton

CLARKSDALE, MS (PAGE 446)
PHOTOGRAPHER
Lawrence Matthews

PIONEERTOWN, CA (PAGE 448)
PHOTOGRAPHER
Jason Juez Steck

ASBURY PARK (PAGE 450, 454, 456)
PHOTOGRAPHER
Danny Clinch

SAYREVILLE, NEW JERSEY (PAGE 452)
PHOTOGRAPHER
Kevin W. Condon
PRODUCER
Amber Mundinger

Las Vegas

Rikka Logan

1. **The Rat Pack** This little desert town wouldn't be where it is today without the entertainment provided by our earliest performers. The iconic sounds of Las Vegas that still echo through the city today were created by this notorious group. Vegas-themed songs such as "Luck Be a Lady" by Rat Pack member Frank Sinatra can still be heard during the spectacular Bellagio Fountain Show.

2. **Life Is Beautiful** An integral part of Downtown Las Vegas's transformation into a cultural hub, this three-day music, art, and food festival brings in top musicians (Arctic Monkeys, Billie Eilish, Stevie Wonder) each year along with tens of thousands of festivalgoers excited to see them perform. While the economic and cultural impact of this event can't be ignored, the biggest takeaway is the yearly reminder that, undoubtedly, life is beautiful.

3. **The Killers** Formed in Las Vegas, this rock band is the musical crown jewel of the city. On the corner of Fremont and Main Street (mentioned in their song "Read My Mind"), you can find the Plaza Hotel & Casino, which happens to be the set of their music video for "The Man." Despite multiple platinum records and international fame, it's clear that this small-town band remembers where they come from.

4. **Concert Residencies** Las Vegas is where the stars come to die, but that's when stars shine the brightest, isn't it? Beginning with Liberace in 1944, we've hosted everyone from Britney to Elton John in residence. None, however, have been more successful than Celine Dion. Grossing $681 million over the span of 12 years, she is the highest-grossing resident performer of all time.

5. **11th Street Records** Located on iconic Fremont Street, this record store keeps that Old Vegas charm alive with its eclectic selection of vinyl records. More than just a record store, 11th Street is home to a music studio where many local musicians (including The Killers) have recorded.

6. **EDC** Also known as the Electric Daisy Carnival, this magical wonderland offers three nights of music, art, and love under the Electric Sky. A raver's paradise, EDC boasts awe-inspiring stages equipped with incredible sound systems, lights, performers, and pyrotechnics. Every sense of your being comes to life as you dance the night away.

7. **The Chelsea at The Cosmopolitan of Las Vegas** This intimate concert venue has a capacity of only 2,500. With its "vintage meets urban-industrial" decor, including details of reclaimed wood and theatrical rope adorning the walls, it has a cozy feel. The best part of this venue is its spring-loaded floor, which allows it to move with the crowd to create a unique concert experience.

8. **Fergusons Downtown** So much more than a simple retail plaza, Fergusons is a community that is all about supporting its creatives. Located in the heart of downtown, it's a magnet for locals from across the valley who come together to collaborate and share ideas here. Set with a stage in the center of the yard, local musicians can often be found performing, adding that extra bit of magic to the space.

9. **Nightclubs** When people come to Las Vegas, they come to party. What better way to do so than to dance all night long to the top DJ's in the world? Opulent and sensual, this crucial element of the Entertainment Capital of the World offers the perfect escape from reality to tourists and locals alike.

10. **Elvis** Nobody said it better than the King: Viva Las Vegas! It's no surprise that Elvis Presley shared this sentiment, considering Las Vegas was where he made his glorious return to the stage in 1968 after a seven-year hiatus from live performances. It was also the setting for one of his most popular films, aptly named *Viva Las Vegas*.

Boulder Theater

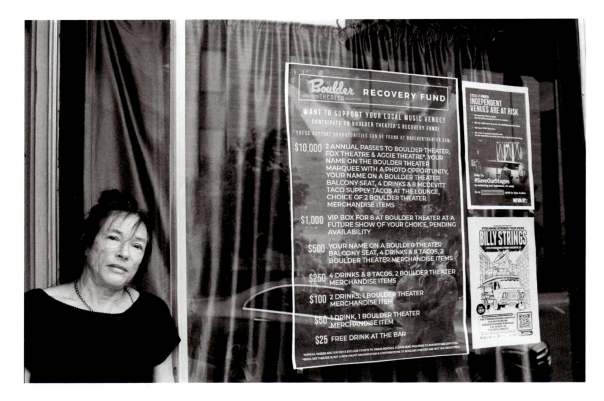

Technically, almost every music venue in America, maybe even the world, is bankrupt. It was never a business where everybody's getting rich overnight and has fat margins. It's always been about hard work, love, and you could earn a good living if you do a good job. We're all committed to the future. We're all committed to being here and we're all committed to helping each other through this process.

Doug Greene

Above: Cheryl Liguori, Co-Owner of Fox Theater/Partner (Z2 Entertainment)
Right: Doug Greene, Owner
Opposite: Doug Greene and Cheryl Liguori

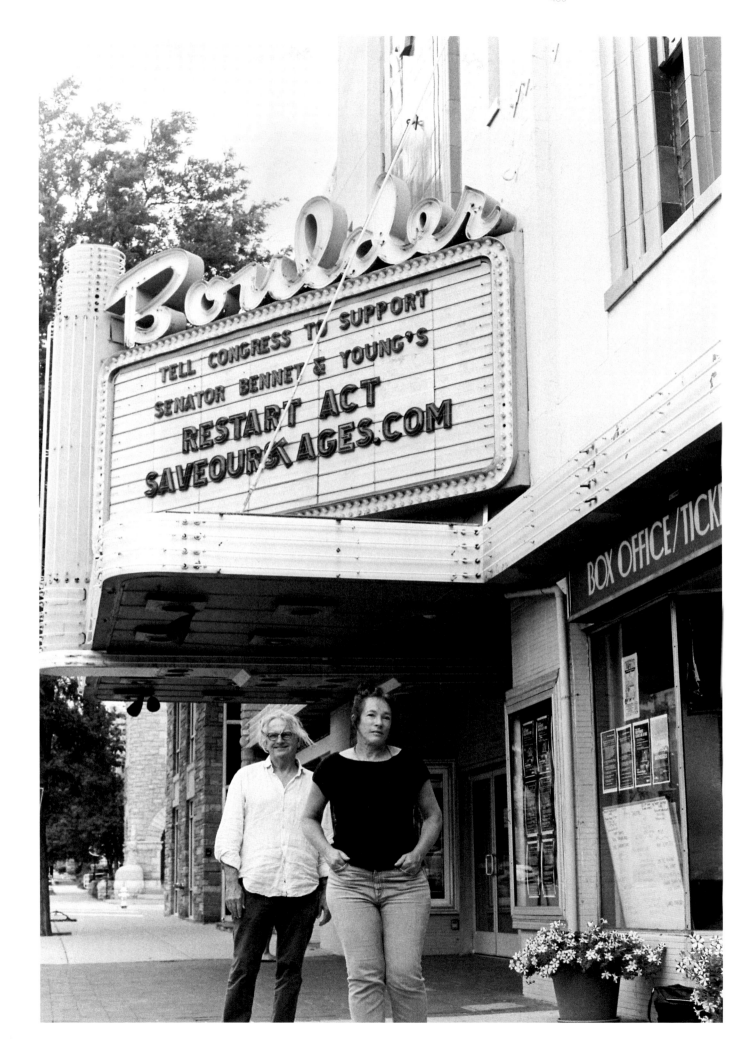

The Capitol Theatre

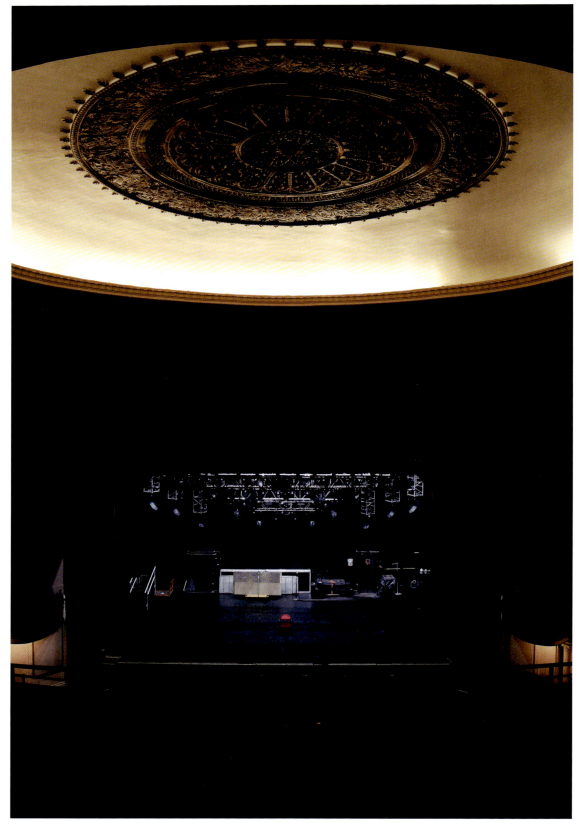

The venue was built in 1926 by Thomas Lamb. [It] originally held vaudeville performances, and in the '30s and '40s held silent films. An article published when the theater opened called it the first refrigerated theater in Westchester, and a lavish and dignified playhouse. We really like to brag about the '70s. [We] had every major rock 'n' roll band come through: Pink Floyd, Jefferson Airplane, Janis Joplin, Frank Zappa, Fleetwood Mac; Grateful Dead played 18 shows here in one year. There's a famous story that [Joplin] played "Mercedes Benz" for the first time on this stage, and she wrote it down on a napkin down the street at a bar. People tell me that The Cap saved their life. It's amazing. This is a place where it doesn't matter what is playing. The same people are here because this is their escape and where they found their family and friends. The fans at The Cap are not your normal fans. This is their home, where they feel comfortable, loved, [they] dance like they're crazy, [they] laugh, cry, and hug each other. People will sit out at 7 a.m. just so they can be with the their family and friends. We have the best, unique fans.
Stefanie May

Above: Stage at The Capitol Theatre
Opposite top: Stefanie May,
Marketing Director
Opposite bottom: Stefanie May inside
of The Capitol Theatre

The Dive Bar

We're a high-paced bar with a lot of people, and a big family of regulars on top of a lot of tourists. We're just hoping to get back to normal so we can have all of our favorite people back again.
Shay Teague

Above left: Stickers on the
wall of The Dive Bar
Above right: Angie Randazzo, Owner
Opposite top left:
Shay Teague, Bartender
Opposite top right: Toni Luca
Opposite bottom: Stage
at The Dive Bar

EVERYONE MUST
WEAR A MASK OR
FACE COVERING!
ONCE INSIDE STAY
STAY SEATED, A
SERVER WILL COME
TO YOU!

Fox Theatre

The great thing about Z2 [is that] it's more like a family than a corporate structure. All of us are working together. That's really the heart of the music business and what we're all about. We've all just been working together, and creatively trying to survive and trying to support as many people as we can. Don Strasburg

Above: Don Strasburg, Co-Owner/
Partner (Z2 Entertainment)
Opposite top: Cheryl Liguori,
Co-Owner/Partner (Z2
Entertainment) and Don Strasburg
Opposite bottom: Don Strasburg

Better priorities are going to make the business much healthier in the long run.
Cheryl Liguori

Ground Zero Blues Club

This has really been ground zero for blues music right here in the Mississippi Delta. That alluvial land that is the northwest quadrant of the state of Mississippi—cotton fields and cypress trees and the swamps and all of that really just gave birth to this music. It has informed this city from Day One. I remember, as a 10-year-old, crossing this railroad track right here with my father on a Saturday night. On Saturday nights, it was jumping, let me just put it that way. There were bobbing heads wall to wall out in the street and music coming from every corner. It's ingrained in our lives here.
Bill Luckett

Right: Anthony "Big A" Sherrod, Security Work/Artist
Below: Anthony "Big A" Sherrod and Tameal Edwards, Booking Manager
Opposite top and bottom: Bill Luckett, Owner

I always tell everyone, 'Y'all, welcome home, come on in. Welcome to your home away from home.'
Anthony "Big A" Sherrod

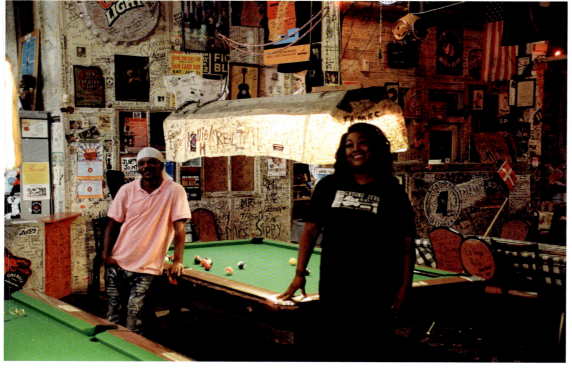

Ground Zero, we see all kinds of people, all kind of experiences. You have some of the greatest conversations ever from life to love to how people meet. It just always has a vibe. With as much that's going on in this world, it's good to have a place where everybody feels comfortable.
Tameal Edwards

Pappy & Harriet's

The beauty of Pappy & Harriet's is that we're in the desert; we have so much open space. So we've been business as usual, just without the live shows. The people who work for me who wanted to come back, they didn't stop. We did take-out immediately. Just had to keep this name alive and have to keep the people working. For us, too. I just couldn't imagine shutting these doors. Why I bought Pappy and Harriet's is going to seem a little far-fetched and not possible: I bought this place because I love Lucinda Williams. I was obsessed with her record *Car Wheels* *on a Gravel Road*. My partner Linda, who owns this place with me, knew about Pappy's. We'd come out here sometimes from New York; we're both from New York City. One night, I drunkenly booked [Lucinda Williams] online. I put an offer in and it was accepted by Frank Riley at [her touring agency]. So I had no choice, and we had to buy Pappy's. Anybody else would probably be like, 'Yeah, just kidding,' but I had to do the show. When we bought Pappy's there were tax liens on it. [It] was a total disaster, but we did it anyway. Robyn Celia

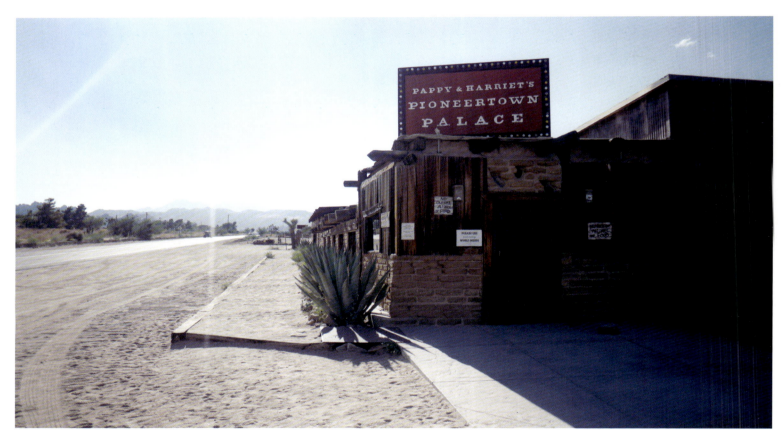

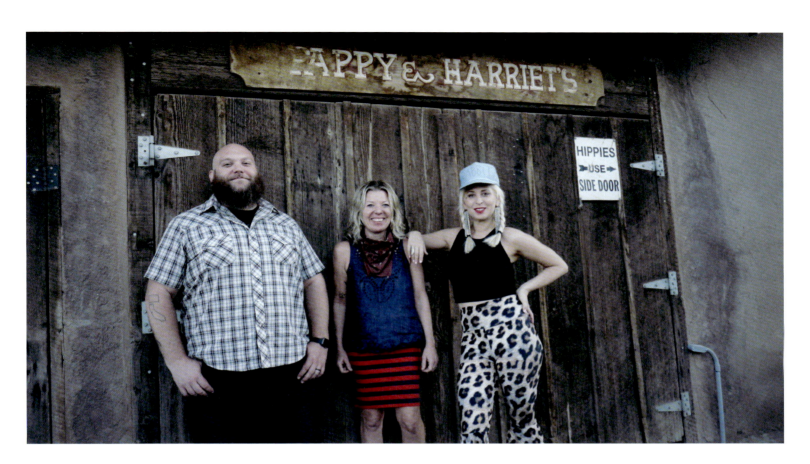

Opposite: Exterior of Pappy
& Harriet's
Top: Jon Ballard, Production
Manager/Sound Engineer; Robyn
Celia, Owner/Booking; Jesika Von
Rabbit, Musician
Above: Stage at Pappy & Harriet's

The Saint

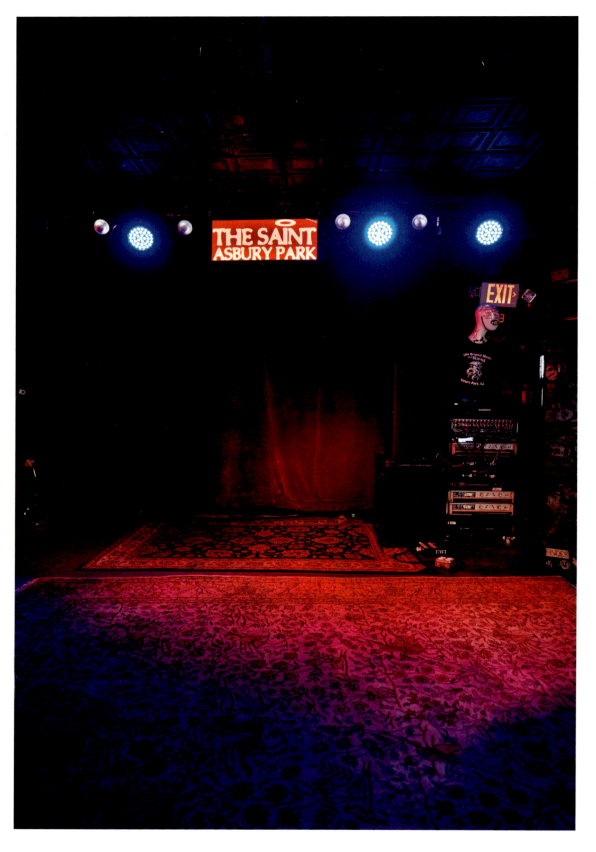

Our motto is 'Home of Live Original Music in Asbury Park, Since 1994.' The Saint is a small live music venue, an incubator for emerging talent and home to the local music and arts scene, road bands, and music lovers. The Saint is where Bruce Springsteen recorded *A Secret History* in 1998. Scott Stamper and Meg Donoghue Kelly, Co-Owners

[A favorite memory is] the night Joey Ramone and the Dream hosted a show [at The Saint]. Joey was on the radio in the early part of the evening at FM 106.3 "Modern Rock at The Jersey Shore" WHTG-FM, hosted by DJ Michele Amabile [who's now a writer at *Variety*]. Oh, and Dee Dee Ramone also played…D Generation was on before Joey. An amazing show. Scott Stamper and Meg Donoghue Kelly

Above: Stage at The Saint
Above right: Bathrooms at The Saint, covered in stickers
Opposite top: Entrance to The Saint
Opposite bottom: Scott Stamper, Owner/Talent Buyer

In hard times our teacher, isolation, can be healing and transformative. The general public, friends, family, and fans have shown up, demonstrating to us great love and compassion. They came through full force and showed their support and allegiance to The Saint and live original music in Asbury Park. The happiness we receive from live music is essential to life. Scott Stamper and Meg Donoghue Kelly

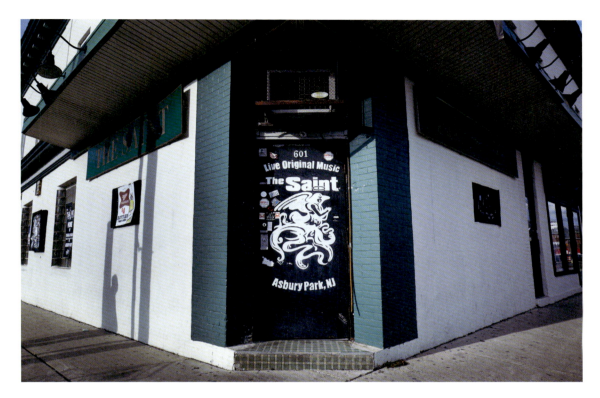

Starland Ballroom

Below: Maria Shields, Marketing
Manager (The Bowery Presents,
New Jersey)
Opposite top: Interior of the
Starland Ballroom
Opposite bottom: Maria Shields

Many people don't know this, but we became a music venue in December 2003. Before, it was called Hunka Bunka. It was a New Jersey staple, a nightclub with teen nights that I have attended. When people find out that's what we were, they are in shock because most people recognize the name of that club. We are on our 17th year now. Coming here, you would never know it's a music venue. It's not something you need to come into a major city for. It's not something you need to rely on mass transportation for. It's a very homey type of place. Everybody here tends to know everyone who comes. We've seen people tweeting that they have met their best friends here, their spouses here. There's always a memory to be made at Starland Ballroom. There's not a bad place to stand in the house. Anywhere in here, you will feel like you are right in the front. [Community support has] been incredible and I know we have always had such a solid fanbase. It's kind of weird to say, because I handle all of our social media, that people are a fan of a venue. We try to have a personality behind our brand. To see the amount of support and number of people rallying behind us during this time makes us feel more connected than ever. Maria Shields

The Stone Pony

The Stone Pony, the most famous part of the city of Asbury Park, opened its doors on Feb. 8, 1974. The club's most famous association is with Bruce Springsteen, who would often jump onstage with other artists, and who brought the E Street Band in for a pre-tour warmup before embarking on the massive *Born in the USA* tour.
Caroline O'Toole

I have learned that rediscovering who you used to be is an essential part of who you are and how you can be better. I took every experience I was thrown and learned whatever I could from it. I am looking forward to welcoming back our customers and to be part of many more history-making moments at a legendary venue.
Caroline O'Toole

Above: Stage at The Stone Pony
Opposite: Caroline O'Toole,
General Manager

Wonder Bar

Vincent Pastore brings great players in from New York to host three benefits a year for our animal rescue, Asbury Boardwalk Rescue. Debbie DeLisa and Lance Larson

We have hosted many amazing local musicians as well as very famous ones: Leon Russell, Dick Dale, James McCartney, Bruce Springsteen, soul, classic rock, doo-wop, country...you name it, we have offered it. Debbie DeLisa and Lance Larson

The Wonder Bar is not only a place of employment for [us] but [our] passion in life. [We] took it from an abandoned building and gave it a heart and soul that is loved by people who visit from all over the world. This pandemic brought so many of us down to our knees, but just like Asbury Park rose again from the ashes of despair and destruction, I truly believe we will rise again bigger and better than ever. We need music to keep everybody's hopes alive. Debbie DeLisa and Lance Larson

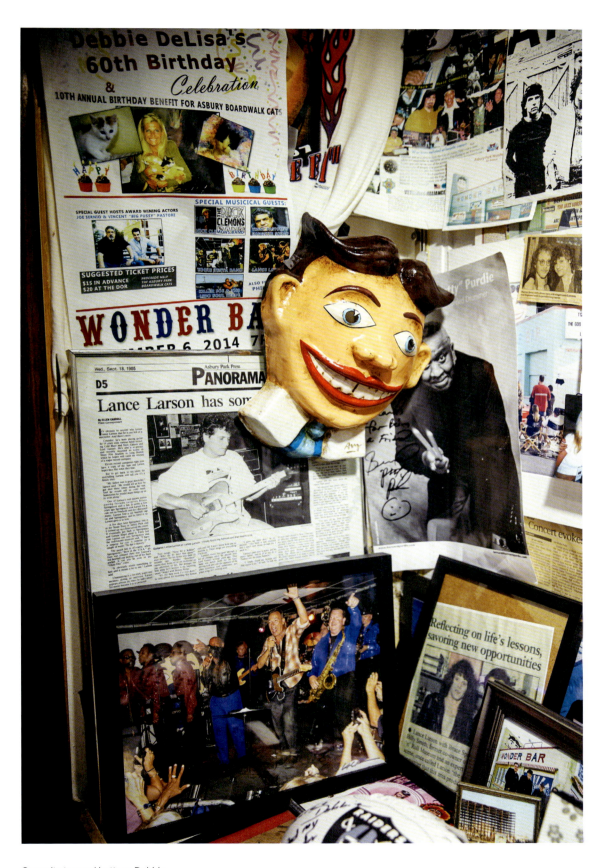

Opposite top and bottom: Debbie DeLisa and Lance Larson, Co-Owners
Above: Interior of Wonder Bar

1

3

2

4

5

Founders + Partners

AMBER MUNDINGER (1) Amber Mundinger is Chief Operating Officer and Head of Strategic Partnerships for Artists Den Entertainment, based at the company's New York headquarters, and is passionate about creative pursuits in the music and entertainment space. Amber has spent more than a decade working across sports, fashion, and music. Prior to her role with The Artists Den, she spent five years at Penske Media Corporation (PMC), where she served as SVP, Live Media & Strategic Partnerships for *Rolling Stone*. Previous to that she served as Vice President, New Ventures and General Manager, Summits & Events for Fairchild Live/WWD. Amber was also the producer for the New York City portion of Bring Music Home.

KEVIN W. CONDON (2) Kevin W. Condon is a Brooklyn-based photographer. He is self-taught and music driven. His photos have been seen in *Rolling Stone*, *The New York Times*, *The Wall Street Journal*, *NME*, and *Billboard*, along with many others. While photography is his focus, Kevin is also an accomplished director who has written/directed nearly a dozen music videos to date. Kevin was the Bring Music Home photographer for New York City. Find his work at weirdhours.com.

TAMARA DEIKE (3) Tamara Deike has been a fixture in the entertainment space for more than a decade, cutting her teeth at Om Records, overseeing 200+ releases. A former *Vice* contributor, booking agent, artist manager, promoter, and DJ, her career has taken her from managing Rose McGowan during the #MeToo movement, overseeing her No. 1 New York Times bestseller; to creating her own agency, ACES HIGH, where she develops brand experiences for clients like Spotify, Facebook, and for artists like Beck, Sheryl Crow, and Cage The Elephant. Today, she resides in Austin, where she continues to write and is currently producing a book about iconic Eagles album cover artist Boyd Elder. Tamara was the Bring Music Home producer for Austin.

MISHA VLADIMIRSKIY (4) Misha Vladimirskiy is a photographer and filmmaker from San Francisco. He is also the founder of Filterless and managing partner of International and Brand Development at Bring Music Home. Misha has worked with Coachella, Levi's, Airbnb, StubHub, New Era, and GoPro. He has been featured in leading publications such as *Rolling Stone*, *Billboard*, and *The New York Times*. Misha specializes in making creative content, partnerships, and brand strategy for companies all over the world. His personal work is a reflection of his own interest in music and art, and the people pushing the boundaries of the creative world. Misha photographed San Francisco for Bring Music Home.

JULIE POTASH SLAVIN (DJ HESTA PRYNN) (5) Julie Potash Slavin, aka "Hesta Prynn," is the go-to DJ, talent curator, and event programmer for a blue-chip client list with an emphasis on all things tech and female-focused. Her work with brands like Spotify, Google, Twitter, AT&T, Medialink, Amazon, and Morgan Stanley has made her a regular presence at global leadership summits. She is a frequent guest on SiriusXM Radio, and has been featured in numerous fashion campaigns and television commercials, including the Twitter ad that ran during the Oscars, which AdAge called "a nod to #TimesUp and #MeToo." Julie now acts as musical director for a number of companies and retail spaces and produces live events and television programs. She is known for her encyclopedic knowledge of musical genres and her career of "firsts," breaking down barriers and operating in spaces traditionally reserved for men. Julie oversaw all music direction for the book.

Creative Collaborators

1

2

3

4

5

6

7

8

9

10

11

12

MATT ALLEN (CHICAGO) (1) Matt Allen is an editorial and conceptual photographer, musician, and designer currently working in Chicago. Matt currently is pursuing his narrative as an artist curating work that revolves around metamodernism, human connection, and urbanism. He's worked with various brands and agencies such as Mercedes-Benz, Pitchfork, Airbnb, Facebook, and Condé Nast.

JULIAN BAJSEL (HOUSTON) (2) Julian Bajsel is based in Houston and has been shooting music for nine years. Until recently, he worked regularly as a staff photographer for major festivals like Coachella and boutique experiences such as FORM Arcosanti. He usually spends lots of time out on the road working with artists such as Odesza and Zedd, but now he just hangs out with his cats.

ANDREA BEHRENDS (NASHVILLE) (3) Andrea Behrends wants to hear your story and will probably try to take your portrait. She is considered direct when she's in her native Midwest and rude by some in the South, where she is currently based in Nashville. But no matter what anyone says: Andrea wants you to know she gives a shit and she won't let you down.

DAMON BURTON (LAS VEGAS) (4) Damon (Duh-mon) Burton, recognized as @psimtheshooter_ has been generating buzz and a following for himself with his drive and consistency of work. At 26 years of age, he hails from the east side of Las Vegas. He's a father, and his kids drive his intense passion and provide a fierce motivation. Damon has continued exploring his creative passions as a freelance photographer. He began shooting during his high school years; his interest stemmed from sports photography for his high school yearbook. Damon has now branded himself as @psimtheshooter_ and continues his freelance journey in portraits and editorial work.

CORY CAMERON (DALLAS) (5) Cory Cameron is a photographer living in Dallas. He uses photography as a means to document the world around him. He takes photos that show a city's urban landscape and viewpoints that make up its visual character. This exploration of cities helps him find the best parts of an area to view. His goal is to capture photographs that immerse viewers in that moment in time—allowing them to visualize themselves in that place. He loves city skylines and different architecture. Growing up, his family took many road trips around the Eastern Seaboard to visit relatives. He remembers eagerly waiting to arrive in a new city to view the skyline and buildings from the car window. Now, his photographs capture those views.

Cory's work also includes experience with real estate companies, clothing apparel, portraiture, and weddings. He is inspired by a number of photographers who explore cities as he does, igniting his passion to shoot when traveling. "My photos will always be a reflection of memories from traveling and hope to capture more in the future," he said.

GARRETT T. CAPPS (SAN ANTONIO) (6) Garrett T. Capps is a Tex-Mex rock 'n' roll/NASA country musician who resides in San Antone, Texas. He is also the talent buyer and part-owner of lauded SA honky-tonk The Lonesome Rose. He is always doing his best to enliven the local music scene and keep the South Tejas spirit alive on an international level. Viva.

DANNY CLINCH (ASBURY PARK) (7) Danny loves music. He listens to it, plays it, photographs it, and films it. Danny has established himself as one of the premier photographers and filmmakers of the popular music scene. He has photographed and filmed a wide range of artists, from Johnny Cash to Tupac Shakur, from Bjork to Bruce Springsteen.

His photographs have appeared on hundreds of magazine and album covers. As a director, Danny has received 3 Grammy Award nominations for short films.

As a local, Danny and Maria Barba-Clinch started the Transparent Clinch Gallery (also a live music venue) along with Tina Kerekes, and he is a partner in the Sea Hear Now Music, Surf, and Art Festival, both in Asbury Park, NJ. Most importantly, these projects include giving back to the community and respecting art, the ocean, and Mother Earth.

Danny plays harmonica in The Tangiers Blues Band, and, being a musician, can truly understand the importance of playing, hearing, living, and loving music.

MAGGIE DERTHICK (DETROIT) (8) Maggie Derthick began her love affair with music long before she ever hit the floor of a venue. Her love of music then led her to booking bands and eventually a promotions company, a u x e t i c , in Detroit, focused on underground electronic music for more than a decade. Maggie is also the founder of the long needed Girls Gone Vinyl project (started in 2006) bringing attention to women in underground electronic music across the globe. She is missing these dance floors and rooms as much as we all are and is thrilled to help bring attention to some storied venues in Detroit.

COREY DRAYTON (PORTLAND) (9) Corey Drayton is a cinematographer, photographer, and writer returning to creative work after a two-year battle with advanced cancer. Hailing from the U.K., but based in the beautiful Pacific Northwest, Corey has worked in feature films, television, and commercials with brands such as Intel, Nike, Adidas, and Nissan. The son of a photojournalist, his passion lies in documentary where he has worked on Academy Award-winning features such as *The Cove*, and contributed to prolific outlets such as *Vice* and *Rolling Stone*.

CYDNI ELLEDGE (DETROIT) (10) Cydni Elledge is a photographer from Detroit whose love for art and natural talent transformed a hobby into a profession. Her work has been published in more than five publications including the *Detroit News*, *Metro Times*, and most recently *MFON: Women Photographers of the African Diaspora* by Laylah Barrayn and Adama Delphine Fawundu. Cydni's photographs are featured on "Grand on River" in Detroit, and were also featured at Photoville in Brooklyn, New York in September 2017. For the past six years, she has assisted international photojournalist Monica Morgan. Cydni also holds a Bachelor of Fine Arts in Photography from the College for Creative Studies. Her commitment to the community and love for her hometown speaks through her work, as much of it captures the essence of Detroit and focuses on the unfiltered everyday lives of its residents.

KARLI EVANS (MIAMI) (11) Karli Evans is a photographer, filmmaker, and creative director based in the jungle of Miami. Energized by urban spaces and local subculture, Karli uses creative storytelling to capture people in their environment, document experiences, and explore identity expression. Karli's work borders the documentary and the collaboration, offering vibrant glimpses into Miami's underground art, music, and queer scenes. Recently, she's been commissioned to lead projects for Stella Artois, Greater Miami, and the Borscht Corporation. Her images have been featured by *Red Bull Music*, *GQ*, *Paper Magazine*, *Soho House*, *New York Magazine*, and *Miami New Times*.

RYAN FILCHAK (CHICAGO) (12) Ryan Filchak is a Chicago-based arts and culture writer. Originally from Lexington, Kentucky, Filchak studied English at Transylvania University and later earned his master's degree in

(*Ryan Filchak continued*) Art History and Visual Studies at the University of Kentucky. A regular contributor to *THE SEEN* and *Newcity Art*, his work has also appeared in *Vice*, *Burnaway*, *The Smudge*, and *Amadeus Magazine*.

POONEH GHANA (LOS ANGELES) (13) Pooneh Ghana is a Texas-born-and-bred music photographer currently based in Los Angeles (or somewhere on the road shooting when she's not home). Her clients have ranged from *Rolling Stone* to Apple, and she's toured with bands such as Cage The Elephant, Idles, King Gizzard, Foals, Glass Animals, and more.

KYLE GUSTAFSON (WASHINGTON, D.C.) (14) Kyle Gustafson is a freelance photographer based in Washington, D.C. He's been shooting concerts and entertainment assignments for *The Washington Post* for more than a decade. His work has also appeared in *The New York Times*, *Vanity Fair*, *The Wall Street Journal*, *GQ*, *Rolling Stone*, *Pitchfork*, *Billboard*, *NPR*, *MOJO Magazine*, and many others. He owns too many camera bags.

ERIC HILLERNS (PORTLAND) (15) Eric Hillerns is a culture advocate in whatever form. He founded Design Week Portland, realized through an annual festival infrastructure of 500 events over seven days at venues across the city. He created and hosts Designspeaks, about bringing people together to confer on creativity at Ace Hotel properties around the country. As a strategist, his advocacy includes consulting global consumer brands ranging from Airbnb and Nike to climate-based nonprofits and NGOs the world over. Eric is platform-agnostic. Words are his baseline. Music, his throughline.

CRAIG HLAVATY (HOUSTON) (16) Craig Hlavaty is a native Texan and longtime Houston resident who has been involved in nearly all facets of Houston media for the past two decades. He has written for the *Houston Press*, *Houstonia*, and the *Houston Chronicle*, along with being a constant mainstay on local TV and radio. He is currently the social media manager and in-house reporter for the Houston Museum of Natural Science. He volunteers for YMCA Houston and the Houston Humane Society.

TRACY HOLLINSHEAD (WASHINGTON, D.C.) (17) Tracy Hollinshead has worked in the telecommunications industry for more than 15 years. He's been the producer and DJ of the mixed-genre radio show *Area 22 Radio* for 11 years on public access platform Radio Fairfax. He's a lifelong collector of vinyl and an avid concert attendee.

COLIN KERRIGAN (PHILADELPHIA) (18) Colin Kerrigan is a photographer and filmmaker from Philadelphia. He has spent the last decade documenting the Philly music scene and beyond. Colin's first concert was Rod Stewart with his mother when he was 8. She also took him to see David Bowie, Prince, Bruce Springsteen, and more, so it all makes sense why he's dedicated a large amount of his life documenting musicians. Aside from that, Colin loves to travel, snowboard, and watch his favorite sports teams (Go Birds!).

NICK KOVA (NEW YORK CITY) (19) Nick Kova is a New York City-based principal photographer working in both still and motion. Growing up in California, Nick watched the movie *Point Break* weekly. In 2018, he came in 2nd place for the selection of character Johnny Utah in *Point Break Live NYC*. In 2014, Nick saw the lead singer of Smash Mouth in an airport, though it could have been Guy Fieri. Nick's weaknesses are caring too much, being too organized, and working too hard. He works as a commercial photographer, focusing on product, lifestyle, and documentary visuals. He hopes to one day ride motorcycles with Keanu Reeves.

JOYCE LEE (SOUTH KOREA) (20) Joyce Lee is a New York-based Korean-American entrepreneur and founder of the creative consultancy Talk to Her. She is also a newly appointed Editor at Large for *Cosmopolitan Korea*. Joyce uses her expertise in beauty and fashion to identify business opportunities and creative partnerships for clients, including the Council of Fashion Designers of America, Makeup Museum, Sephora, Allure, L'Oreal, Opening Ceremony, Samsung, Shinsegae International, Olive Young, and others. Prior to Talk to Her, Joyce spent more than eight years at innovative retailer Opening Ceremony, where she helped with the e-commerce launch and developed key partnerships for collaborations and activations. Learn more about Joyce Lee and her work at talktoher.nyc.

MATT LIEF ANDERSON (AUSTIN) (21) Matt Lief Anderson is an award-winning photographer and filmmaker born in 1983. After college he spent four years living, traveling, and photographing Asia and Europe, but now resides in Austin, Texas. Matt is a multidisciplinary photographer working in music, fashion, travel, and landscape photography, as well as coordinating and photo editing at *Pitchfork* for various events, festivals, installations, and partnerships.

JOY MARTINS (ATLANTA) (22) Los Angeles native Joy Martins is a visionary architect passionate about taking her clients' businesses to the next level. While attending Clark Atlanta University, Joy majored in biology, but through her past experiences when working at the radio station Power 106 and with artists such as YG, she realized her strong passion for the entertainment industry and decided to pursue a dual degree in biology and public relations. Since then, Joy has been providing her marketing and business development skills in the entertainment industry, working with businesses such as BET, Monster, Red Bull, Afro Punk, the NBA, and the MLB. She's also taken advantage of opportunities to work with artists such as Jay-Z, Young Thug, Megan Thee Stallion, Lil Uzi Vert, Burna Boy, and many others. As a visionary architect, Joy's talents range from branding, marketing, project managing, and brand identity to image crisis consulting, event production, and booking. Joy's versatility and experiences have given her the skill set to elevate businesses to the next level. Presently, Joy continues to use her passion to cultivate brands through her ever-growing professional experiences and personal networks.

AMANDA MATSUI (NASHVILLE) (23) Amanda Matsui is a Nashville-based jane-of-all-trades. She has filled the role of art director, production designer, event producer, and fabricator for Carrie Underwood, Madisen Ward and the Mama Bear, Spotify, CMT, and the hit TV show *Nashville*, to name a few. Her fabrication projects can be seen at music festivals across the Midwest, including Forecastle, Bonnaroo, Highwater, Homecoming festival, and Electric Forest. She is currently cutting her teeth with Yuyo Botanics, a beauty brand that can be found in magazines such as *Vogue*, *Shape*, and *Elle*.

LAWRENCE MATTHEWS (MEMPHIS, CLARKSDALE) (24) Lawrence Matthews is an artist from Memphis, Tennessee working in music, photography, painting, and filmmaking. Lawrence received his Bachelor of Fine Arts degree from the University of Memphis in 2014. Since being awarded the Arts Accelerator grant in 2016, he has had many group and solo exhibitions spanning galleries and museums across the mid-South, as well as the residency program at Crosstown Arts. Lawrence's exploration of photography has focused on areas and moments within Black communities in Memphis that have been greatly affected by gentrification, systematic disenfranchisement, and city planning. Recently

13

16

19

22

14

17

20

23

15

18

21

24

25

26

27

28

29

30

31

32

33

34

(*Lawrence Matthews continued*) acquired by international artist Derek Fordjour and the Elliot & Kimberly Perry Collection, Lawrence's archive of photo work captures moments of openness and the haunting reminders of things that once were, highlighting the conflict between remenance of the past and the modern-day city-imposed infrastructural decay.

MALLORY MILLER (DALLAS) (25) Mallory Miller is a brand strategist, content creator, and marketing expert who helps clients build an authentic presence and meaningful connections with consumers, media, and stakeholders. After nearly a decade in New York City with stints at Hearst and Condé Nast overseeing integrated marketing partnerships for *Harper's BAZAAR*, *Allure*, and *Teen Vogue*, Mallory returned home to Texas, where her agency and in-house experience working with hospitality, entertainment, tech, CPG, and wellness brands positioned her to launch her own consulting company. Based in Austin, Mirell Collective is a marketing and communications consultancy where Miller brings together talented females from her network across various disciplines to create personalized teams based on individual client needs.

ASIA MOHAMED (MINNEAPOLIS) (26) Asia Mohamed (Aceyaa) is a Minneapolis-based podcaster. Her podcast, *The Ceyaa Show*, was influenced by her solo travels around the world and her realization that there needed to be more safe spaces geared toward motivating women to live life fully and pursue their dreams and aspirations. Aceyaa is also the cofounder of Helping Hands Financial, a financial company that empowers people to achieve financial literacy. Aceyaa is a mental health advocate and involved in many local organizations around the Twin Cities.

OSCAR MORENO (SAN ANTONIO) (27) Oscar Moreno is a music and festival photographer from Monterrey, Mexico, and has lived the majority of his life in San Antonio, Texas. He has dedicated most of his photographic career to capturing local music around the city, and spreading awareness of the local art and music scene to anyone willing to listen. Most recently, he has been a tour photographer traveling internationally and capturing the essence of the international music community. His work has been seen in several publications and artist profiles around the world.

DANIEL OAKLEY (LOS ANGELES) (28) Daniel Oakley, a native of Nashville, has worked at the crux of music and technology since dropping out of pre-med studies in 2005 to pursue a degree in the music business. After graduating from Middle Tennessee State University, Daniel moved to New York City to learn under the Sony Music umbrella, leveraging new technologies and social media to connect artists with fans. In 2012, Daniel was tapped by Jimmy Iovine and Trent Reznor and moved to Los Angeles to lead partnership efforts for the stealth startup that would become Beats Music. After the $3 billion Beats Music acquisition by Apple, Daniel would ascend to oversee Global Lifestyle Marketing for Apple Music. He led the content partnership strategy and marketing rollout for the simultaneous release of Apple Music and Beats 1 Radio in more than 100 countries. Contrasted by managing Rose McGowan at the height of the #MeToo crisis, and producing experiences for Bonnaroo that even *Rolling Stone* has heralded iconic, Daniel now works at Spotify in Experiential Marketing, producing industry and creator experiences. He enjoys good coffee, mustaches, and spending time with his wife and 2-year-old, Kit.

EZEKIEL ORNELAS (CHICAGO) (29) A graduate of Columbia College Chicago (B.A. 2011 - Film and Video), Joey Ornelas is interested predominantly in the documentary realm. In the past few years, he has been working with the fine folks at Grass Fed Cinema on a handful of social issue documentaries highlighting eccentric folks in the Midwest. Additionally, he's had the pleasure to work for a number of national and local brands and agencies, including Shure, Samsung, The Players' Tribune, and more.

MELISSA PAYNE (TULSA) (30) Melissa Payne is a Tulsa-based photographer who is late to the game of live music. Her love affair with live music and the Americana genre began after seeing The Black Lillies in 2014. Since then, she's contributed to various publications as a writer and photojournalist and has now taken over as managing editor of *The Amp*. All this means she's been lucky enough to see everyone from Margo Price to Lost Dog Street Band in concert, and lived to tell about it. There's nothing Melissa enjoys more than documenting artists, shows, and venues, as she feels even in pre-pandemic times that this was an important stage of music history. When she's not at a concert or living life as a mom of two, Melissa is the business manager of both the Woody Guthrie Center and the Bob Dylan Center (set to open in 2021). Quite the 180 for someone who didn't grow up going to shows or being involved in music.

SAHRA QAXIYE (MINNEAPOLIS) (31) Sahra Qaxiye is a published portrait and wedding photographer in Minneapolis. Her portraiture and fashion work can be found in publications such as *PUMP Magazine* and *The Growler*. Her photography journey started with her love for people and storytelling. "Through my images, I want people to feel like they are truly getting to know the subject; as if they've spent an entire evening exchanging stories," she said.

GRIFFIN RILEY (PHOENIX) (32) Griffin Riley is a self-taught photographer who's been in the game since 2012. A first-generation college graduate, 22-year-old Griffin has a background in journalism and political science that taught him the nuances of storytelling and the way the world molds each of us. When he approaches a shoot, Griffin strives to find the human condition within every frame. In addition to his wide array of freelance work, Griffin was the senior photographer for his university newspaper, *The Daily Wildcat*, a photography apprentice at the *Arizona Daily Star* in Tucson, and was the Media Director for ZonaZoo, the university's student section for athletic events.

LISA SICILIANO (DENVER/BOULDER) (33) Lisa Siciliano is a full-time, self-taught professional photographer living in Boulder, Colorado. Over the last 24 years, she has made art working as a house photographer for Red Rocks, The Boulder Theater, The Colorado Sound, Chautauqua Music Hall, Bellco Theatre, and *Marquee Magazine*. Her black-and-white fine art photos are taken on 35mm film, hand processed and printed the old-fashioned way. Lisa has photographed several album covers, captured numerous promotional band photos, and has her work displayed backstage at Red Rocks, the Fillmore Auditorium, The Boulder Theater, Bellco Theatre, and in numerous homes around the world. She has worked with music producers, record companies, and band publicists nationwide. Most recently, she launched her passion project called Lumin Project, which aims to bring light onto the hard stuff in life, including death, pain, poverty, forgotten culture, and the unseen. She seeks to create images that will help us see and understand each other more compassionately.

JOSH SISK (BALTIMORE) (34) Josh Sisk is a Baltimore-based culture photographer who has spent more than 15 years documenting the city's dynamic music and art scene. Josh is a contributing photographer for *The Washington Post* and *Decibel Magazine*, and his photos have appeared in *Rolling Stone*, *VICE*, *SPIN*, *The Atlantic*, *Revolver*, *Guitar World*, and *NME*, among many other publications. His work has been featured in the

35

38

41

44

45

36

39

42

37

40

43

(John Sisk continued) books *9:30: A Time and a Place* and *Choosing Death: The Improbable History of Death Metal & Grindcore*, among others. His clients include Merge Records, Thrill Jockey, Domino, Bandcamp, Relapse, and more. Find out more at joshsisk.com.

NATE SMALLWOOD (PITTSBURGH) (35) Nate Smallwood is a photojournalist and documentary filmmaker based in Pittsburgh. Born in Columbus, Ohio in 1994, Nate earned a degree from Ohio University's School of Visual Communication. Nate's work has ranged from focusing on race relations and social justice issues in various regions of the United States, to the ongoing war in Eastern Ukraine.

When not working for a local newspaper, the *Pittsburgh Tribune-Review*, Nate freelances upon request.

JUSTIN SMITH (CHARLOTTE) (36) Justin Smith is a photographer and cinematographer born and raised in Charlotte, North Carolina. While he was cutting his teeth shooting for local newspapers and periodicals, his work was also quickly earning recognition by the local advertising industry. Countless global campaigns and national commercials later, you can still find him wandering the streets of Charlotte with his rangefinder.

OMARI SPEARS (BOSTON) (37) Omari Spears is a photographer in the Boston area whose work centers around Boston's music scene. Pre-pandemic, you could normally find Omari shooting at both venue and house shows multiple nights a week, with a focus on local artists.

JASON JUEZ STECK (SAN DIEGO) (38) Jason Juez Steck is a director, cinematographer, film professor, and multi-instrumentalist producer based in Southern California. Jason has directed and lensed such artists as Snoop Dogg, Nicki Minaj, Nipsey Hussle, The Game, Wiz Khalifa, Lupe Fiasco, Freddie Gibbs, Alanis Morissette, Fiona Apple, Pete Yorn, Ben Harper, TV on the Radio, Promise of the Real, and Cage The Elephant, as well as many soulless multinational conglomerates such as LG, Samsung, Pepsi, Louis Vuitton, BBC, HGTV, A&E, Mattel, Disney, McDonald's, and Walmart. Jason likes to believe there is such a thing as karma, and so has helped contribute to nonprofit campaigns such as Amazon Watch, Wounded Warriors, California State Parks, The Hi, How Are You Project, and NIVA. He has high hopes his humble contribution to the Bring Music Home project will, in some small way, help alleviate the ailing live music industry, one he and many of his close friends are dependent upon for their livelihood.

NATASHA TOMCHIN (MIAMI) (39) Natasha Tomchin is a multidisciplinary artist, designer, and coder whose practice is driven by her fascination with natural phenomena. Born in Belarus and raised in Nebraska, she's called Miami home for the last 10 years. Inspired by the clouds and lush flora, her art draws directly from her surroundings in an effort to connect more deeply with nature. These feelings translate across code art, painted furniture, sculpture, video, and projection installations. Always exploring new creative forms of expression, she uses unconventional methods to cross visual boundaries. Natasha's "Digital Dreamscapes" are surreal manipulations of the natural world that encourage the audience to appreciate the ephemeral and awe-inspiring beauty surrounding them. She encourages us to put our phones down and "Don't forget to look up!"

KAIYANNA T. WASHINGTON (ATLANTA) (40) KaiYanna T. Washington aka "Kai Tsehay" is a creative entrepreneur and freelance photographer. She is Spelman alumna with a bachelor's degree in psychology, originally from Washington, D.C., and currently working in both Atlanta and New York City. Since her start in 2016, Kai Tsehay has captured the Atlanta University Center's student life, concerts, festivals, and visual projects across the Atlanta metro area, Washington D.C., London, and New York. She's worked as the lead photographer on Morehouse College's student newspaper *The Maroon Tiger*, as well as a marketing intern for T.I.'s Grand Hustle Entertainment, and a studio representative for Atlanta's famed Cam Kirk Studios. Her portfolio includes work of Killer Mike, Trouble, 2 Chainz, Mike Will Made It, Michelle Williams, Amiyah Scott, Dinah Jane, and more. She has also produced work for Chan Zuckerberg Initiative, Rolling Out, Elliot Wilson for Tidal, The People's Station V-103, Xfinity Black Film and TV, and I Love My HBCU. She also photographed the cover for Westside Gunn's *Flygod Is An Awesome God 2* album, and is a featured photographer in the Trap Music Museum.

AREL WATSON (SEATTLE) (41) Arel Watson is a DJ, graphic designer, photographer, and event curator based in Seattle. He's known for his work in both the music and skateboarding community, from capturing unique moments to creating events that bring people together of all genders and nationalities. Arel is a true self-taught jack-of-all-trades, and is constantly evolving with art, sound, and more. He can be found via reigningcloud.com.

GAVIN WATTS (AUSTIN) (42) Gavin Watts is a musician, audio engineer/producer, and visual artist. He works in art-rock, conceptual, and experimental music composition and installation. Some of his recent bands/collaborations include The Answers, Cougar Island, The Reformers, and Gavin Watts (solo). His studio is located in Austin, Texas. Find his work at thewattshappening.com.

JUSTEN WILLIAMS (NEW ORLEANS) (43) Justen Williams is a New Orleans-based commercial, editorial, advertising, and portrait photographer/photojournalist. With work spanning several different genres of photography, Justen prides himself on his ability to deal with people, a skill he believes is even more important than his complementary camera techniques. His "Be better people than the work that you do" concept forms the foundation of his company and his work. Justen has had opportunities to collaborate on projects with Spotify, Redbull, Adidas, New Orleans Pelicans, AT&T, New Orleans Tourism, 360i, Allergan, and Bumble.

AUSTIN WILSON (SEATTLE) (44) Austin Wilson loves being on the road. Whether it's filming on location or touring with a band, that's where he likes to work. He grew up in Georgia, attended film school at the University of Southern California, and now lives in Seattle. It's probably his Southern background, but he spends extra time with the people he works with. It gets the performances he's after—honest, even heartfelt. He's most excited about his music projects with Band of Horses and Iron & Wine because he's such a fan. Austin's music videos and documentaries have screened at SXSW, SIFF, and others. He has 10+ years of experience in advertising, working on national campaigns for Intel, Nissan, and Amazon. As a commercial director, he captures real people in their day-to-day life in a cinematic way, raw and beautifully so.

DAVE WRANGLER (TULSA) (45)
Dave "Disko Cowboy" Wrangler is a critically acclaimed DJ and producer, and the creative director/founder of Vinyl Ranch. Since 2007, the Texas-based lifestyle brand has redefined urban cowboy culture by remixing classic country with disco nightlife themes. Together, Vinyl Ranch and Disko Cowboy bring boutique music events to NYC, Nashville, Texas, and beyond. The *Houston Chronicle* called Dave "one of the most notorious, entertaining, and fascinating Houstonians of 2019," alongside Lizzo, Joel Osteen, and Russell Westbrook.

Poster Artists

FRANKY AGUILAR (LAS VEGAS) (1) Franky Aguilar, also known as frankynines, is an American multidisciplinary artist and mobile developer based in Las Vegas. His creative works incorporate technical design, digital illustration, interaction development, hand-painted works of art, and more. He studied Web Development and Multimedia Design at the Art Institute of California – San Francisco and has been developing instantly successful mobile applications since 2008. He has worked with gaming giants such as Zynga as early as 2011, and began developing mobile applications earning millions of downloads. Aguilar founded YoShirt Inc. in 2016, a venture capital-backed venture fusing digital-to-physical clothing distribution, manufacturing, and consumer e-commerce into one single platform. These viral hits sparked collaborations with clients including Snoop Dogg, Steve Aoki, Major Lazer, Fox Digital Ent. Group, Grumpy Cat, and many others. While Franky began painting trains and graffiti as a teenager, he now plays at the intersection of art and technology. He focuses on interactive design that encourages people to create their own art, design their own merchandise, and embrace their individual artistic style. He began translating his skills to the emerging blockchain space in 2018 by partnering with CryptoKitties developer Dapper Labs. Franky extends his design expertise to the conceptual and technical art development, user interface design, and product design fields. He continues his relationship with digital, technical, and fine arts to this day, spending much of his time maintaining his art gallery and educating other artists.

JOSE BERRIO (NEW YORK CITY + TULSA) (2) Jose Berrio is a graphic designer from Bogota now based in Brooklyn. After working in the advertising industry for almost seven years, in 2015 he decided to become a freelancer and moved to New York, aiming to focus more on independent and music-related projects. Some of the clients and bands he has worked with include HarperCollins, *The Wall Street Journal*, DoSomething.org, APE (Another Planet Entertainment), Crumb, Combo Chimbita, Tall Juan, Gustaf, Fat Possum Records, and Public Practice, among others. In addition to his work as a designer, Jose also plays drums and has been an active member of the New York music community over the past few years, playing with different bands.

JULIA FLETCHER (BALTIMORE) (3) Julia Fletcher is a self-taught music-based designer and photographer from Baltimore, based in Manhattan. Inspired by the colors and artwork of '70s and '80s new wave/post-punk album artwork, she brings a fun, colorful, and nostalgic feeling to musicians' identities through a contemporary lens, usually through merchandise, poster design, and album artwork.

REBECCA GOLDBERG (DETROIT) (4) Rebecca Goldberg (@rebecca__goldberg) is a working artist based in Detroit. She is immersed in the creative culture of her city as the creative director of her own freelance company (@designsby_rg), having designed flyers, posters, album art, logos, and brands for the last decade. For Rebecca, art and music go hand in hand. She is also an electronic music producer and DJ/live performer (@313acidqueen). She is inspired by pop art, collage, and type design, and is known for her bold color work.

MIKE GRAVES (DENVER) (5) Mike Graves is a multidisciplinary artist from Denver who creates with a wide range of mediums, including paintings, illustrations, murals, and art figures. The ability to create and share art with people makes him truly happy. Mike's goal is to paint whimsical, bright character-based work that brings people joy and helps them feel like a child again. His art has been seen in Hawaii, Las Vegas, San Francisco, Phoenix, Miami, Chicago, Denver, Houston, L.A., New York, Canada, Australia, and the U.K.

DAVE HAIRE (CHARLOTTE) (6) Half designer/half musician, Dave Haire is a creative from Charlotte, North Carolina with a career of almost 20 years. As a designer, Dave has worked on projects for Sony Records, Blue Note Records, OM Records, and the NBA, to name a few. He currently designs for Stand Strong CLT, a local social justice initiative which he founded in 2016. As a musician, Dave has had his music featured in worldwide ad campaigns ranging from Nintendo, NBA, VELUX Skylights, and the 2014 FIFA World Cup. Dave's music can be found on every major streaming platform under the moniker "Dirty Drummer" and also the experimental fusion of sounds under the moniker "up/dn."

CARLOS HERNANDEZ (HOUSTON) (7) The work of Houston-based serigraphy artist Carlos Hernandez has been featured in the 2011 Communication Arts Typography annual, the 2011 and 2012 Communication Arts Illustration annual, and was also recently published in the 2012 book *Mexican Graphics* by London-based Korero Press. He has designed and printed gig posters for artists such as Beck, U2, The Kills, Arcade Fire, Santana, and more. Most recently, he was selected as the official poster artist to design the commemorative poster for the Austin City Limits Music Festival. Carlos is a founding partner of Burning Bones Press, a full-service printmaking studio located in the Houston Heights, and has served as an instructor of Screen Printing at Rice University, Department of Visual and Dramatic Arts. Corporate work has included Apple, Levi's, American Express, Miller Brewing Company, Google, Lincoln Motor Company, Live Nation, New West Records, C3 Presents, Hohner USA, and more. One of his career highlights has been his work with childhood idol and hot-rod legend Ed "Big Daddy" Roth. Carlos has received awards from the American Institute of Graphic Artists, American Advertising Federation, "Judges Favorite" from the Art Directors Club of Houston, and "Best in Show" from the American Marketing Association. Carlos was a featured speaker during the "Design Now – Houston" series at the Contemporary Arts Museum Houston, and has served as an instructor at Frogman's Print Workshops. He is a member of the legendary Outlaw Printmakers and is a graduate of the Texas Tech Graphic Design program. The Smithsonian Institute recently collected his prints as part of a national tour.

JEFF KOCH (PITTSBURGH) (8) Jeff Koch is an independent graphic artist and part-time musician from Pittsburgh. He is currently the graphic designer for Pittsburgh-based Drusky Entertainment and live events graphic designer for Bethel Woods Center for the Arts in Bethel, N.Y. Jeff has contracted with Live Nation in the Pittsburgh market and a handful of other Live Nation Midwest markets, as well as independent venues in New Jersey, Florida, Ohio, and West Virginia. While the bulk of his work is with live event posters, flyers, and advertising, he occasionally designs merch for Hard Rock Cafe Pittsburgh and local bands. Jeff's work also includes concert site plans, illustrative maps, and vinyl vehicle graphics. "Art and design was always a side gig for me in between stints as a FOH and recording engineer, musician, and even a run as an editorial cartoonist," Jeff said. "But I turned that around in the mid-'90s when the demand for my work increased and I haven't looked back."

HUNTER MOEHRING (DALLAS) (9) Hunter Moehring is a Dallas-based illustrator and musician whose work focuses on album covers, tour posters, and apparel design for musicians. His talent also extends to many venues, bars, skate shops, and clothing brands around the city. Following in his father's footsteps, he became obsessed with music and design at a young age, and found a passion for screen printing posters. He draws inspiration from vintage sci-fi, old Westerns, Bronze Age comic books, skateboards, and punk rock. You can usually find him at Three Links in Deep Elm.

1

2

3

4

5

6

8

9

7

10

13

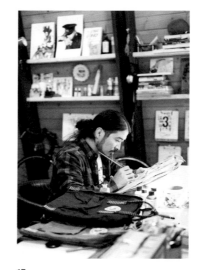

15

18

14

19

11

16

17

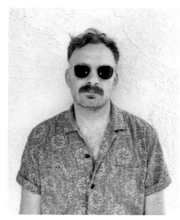

12

JOEY MARS (BOSTON) (10) For more than 30 years, Joey Mars has been creating a unique world of characters and far-out planetary environments on rock posters, T-shirts, merch, murals, cars, boats, and paintings. His art has reached most of the corners of the globe through distribution deals with Liquid Blue, Polygram, Giant, Not Fade Away, Net Sales, and Orion Distributors. Black light posters, patches, stickers, ceramics, rolling papers, clocks, incense, and energy drinks are also some of the items he has licensed his art for through the years. His public work started to appear in Boston in the 1980s while attending art school, where he met musicians and filmmakers looking for poster art. A great time for underground rock, by the late 1980s into early '90s, the Boston scene was dynamic, thriving, and rich with alternative touring acts, local grunge and punk all stars, and a strong alt-newspaper scene. Joey cooked pizza at Captain Nemo's in Kenmore Square next to the infamous rock club The Rathskeller, and airbrushed T-shirts at a local marina. His portfolio started to land some national distribution deals as well as merchandise art projects for Aerosmith and the Grateful Dead. Other clients include Tea Party Concerts, *The Boston Globe*, *The Boston Phoenix*, The David Bieber Archives, Shop Therapy, The Martinez Brothers, and his newest project with @FABCANS, where he has been illustrating craft beer labels for an enthusiastic and thirsty market. Searching instagram for #joeymars reveals a thriving vintage market on his '90s T-shirts and merchandise. He exhibits his work in galleries as well as on his website at joeymars.com, where visitors can view an extensive archived collection of his work. Instagram @joeymarsartwebsite and Instagram @fabcans.

GABRIEL MAY (SAN FRANCISCO) (11) Native to the Bay Area, Gabriel May is an American tattoo artist and illustrator now based in San Francisco. Inspired by classic and timeless design, he has demonstrated his aesthetic primarily via skin art, digital design, and traditional stationery. He currently works at UNDRGRND Tattoo and is represented by Filterless Co.

ANDREW MCGRANAHAN (SAN DIEGO) (12) Andrew McGranahan is a freelance graphic designer in San Diego. Much of his work is for the music industry—gig posters, album art, merch designs, and more—and he is also the senior designer for Desert Daze. While his style is influenced by the poster artists of San Francisco in the 1960s, Andrew said, "I feel like I'd be doing myself and my clients a disservice by just copying that style, so finding my own brand of psychedelia, so to speak, seemed like the natural thing to do." Other influences on his work include ancient history and mythology, sci-fi book covers and films, vintage Swiss design, Dada (he's particularly fond of Max Ernst), the Polish School of Posters, the animation and film work of Terry Gilliam, and so on.

VICTOR MELENDEZ (SEATTLE) (13) Victor Melendez is an art director, graphic designer, and illustrator in Seattle. He has created award-winning work for a wide variety of clients that include REI, T-Mobile, Starbucks, Crayola, Sub Pop, USPS, Red Hook Brewery, Hallmark, Sasquatch! Music Festival, and many more. Melendez's multicultural upbringing gives him a unique approach to craft and style. This distinctive quality has given him the opportunity to not only produce captivating illustrative work, but also explore different techniques such as printmaking, silkscreening, engraving, and mural painting. His work has been featured in *Communications Arts*, *HOW*, *Print*, and more.

REGINA MORALES (SAN ANTONIO) (14) Regina Morales is a Chicana artist inspired by comic books and her culture. She enjoys drawing monsters, sci-fi, and horror. Growing up Tejana, her family had a small Tex-Mex restaurant from 1966 to about 2010. She was surrounded by music from her dad's old Tejano records, listening to KXTN 107.5 Tejano radio in the kitchen with her mom, to playing trumpet for over seven years in school and with a local mariachi group. Over time, Regina has spent her art years making flyers for local venues, album covers, and shirt designs for musicians and bands. Her 9-to-5 is spent at a print shop where she designs all things print-related for small businesses. When not working, she enjoys spending time with her family and playing competitive pinball (pre-COVID) in a women's league, Belles and Chimes, San Antonio. You can find Regina's art on her Instagram @helloreg.

SHOGO OTA (SEATTLE) (15) Shogo Ota hails from Japan. He has called the Pacific Northwest home for more than a decade. He enjoys working on everything from murals to branding, and has been referred to as a "stylistic chameleon," savoring the challenge of evading a signature style.

KATE OTTE (PHILADELPHIA) (16) Kate Otte is a designer and illustrator whose work spans a variety of disciplines, including branding, hand lettering, environmental graphics, interpretive signage, and wayfinding strategy. She is best known for *Drawn Jawn*, a Philadelphia-themed coloring book that celebrates and pokes fun at the city's landmarks, culture, and quirks. She has designed posters for bands, films, music festivals, and community organizations across the city. Some of her other noteworthy projects include an 80-foot laser-cut history wall at Philadelphia's Rail Park, a dog- and cat-shaped typographic mural, and illustrations of "green" tools like rain gardens, stormwater planters, and tree trenches for the Philadelphia Water Department. Kate is currently developing a board game inspired by rock climbing, @FirstAscentGame.

VANYA PADMANABHAN (ATLANTA) (17) An Atlanta-based visual designer, illustrator, and friend, Vanya Padmanabhan creates stories, identities, websites, campaigns, installations, photo journals, and jewelry. Her work explores new ways to do old things.

ALEXIS POLITZ (MINNEAPOLIS) (18) Alexis Politz (she/her) is a queer illustrator and designer who has been working with bands, organizations, and small businesses for more than six years in Minneapolis. Her goal is to visually represent other individuals and creatives alike through digital and traditional media. For someone who got their career started in DIY environments, she hopes to continue to be an accessible resource for those beginning to pursue their passions, as well as a professional asset for established companies. Since graduating from the Minneapolis College of Art and Design in 2017, she has formed a good ol' belt of knowledge in print, graphic design, printmaking, and book arts. Alexis is now a full-time designer at Copycats Media, working on various products and packaging for the music industry and beyond. On the side, she helps run a local record label called Brace Cove Records, plays bass, loves her cats, learns a lot, and indulges in lots of ice cream.

JUSTIN PRINCE (AUSTIN) (19) Justin Prince is an artist from Austin, Texas. Predominantly painting murals and signs since the early 2000s, he has traveled all over the United States with a clear focus in mind to create. A decade ago, he returned to his home in Austin and has enjoyed a more structured career as a printmaker, designing and printing apparel and posters. Still, he is constantly on the lookout for new avenues, media, and opportunities to push his art and compete with himself to do things that are bigger, better, and more exciting.

QUINN MURPHY (PHOENIX) (20) Quinn Murphy is a Phoenix-based designer, illustrator, and printmaker. He is also co-founder and owner of Hamster Labs, a full-service design and print shop focused on the arts and entertainment industry. Since 2015, his work has consisted of album covers, gig posters, merch design, branding, and illustrations. His partnerships with promotional companies Live Nation, Stateside Presents, Psyko Steve Presents, and venues including The Van Buren, Crescent Ballroom, The Rebel Lounge, Valley Bar, and Last Exit Live have given rise to his branding of music festivals as well as countless gig posters and merchandise. His portfolio includes work for national acts like Bishop Briggs, Rufus Wainwright, Murder by Death, The Get Up Kids, and The Sword. Not to be omitted is his dedication to the local scene. This includes work with local radio stations KUPD and KWSS, Zia Records, and art for local musicians decker, Miniature Tigers, Paper Foxes, Wyves, and Banana Gun, to name a few.

MIA SAINE (MEMPHIS) (21) Mia Saine is a Memphis-based illustrator and designer whose creations combine bold illustrations and designs with affirming messages to celebrate minorities. Mia uses her work to normalize Black self-love, vulnerability, empowerment, and hope. Since she graduated from Memphis College of Art in 2017, she has collaborated with a collection of individuals, organizations, and companies to establish creative solutions and awareness.

JASON "JAY" SAYATOVIC (NEW ORLEANS) (22) In the mid-to-late 2000s, while working as a graphic designer and video editor for a B2B industrial organization, it struck Jason "Jay" Sayatovic that he had gotten pretty far away from what drew him to his career in the first place: drawing. Luckily, Jay loves music and a lot of his friends are musicians. "I knew what their promotional items and merchandise looked like and thought, 'I can do better,'" he said. He then put pencil to paper, or rather, hand to mouse, and started drawing posters he would want to purchase at a gig. Once again, he was lucky. After they saw his illustrations, his musician friends and their merch-consuming fans wanted to buy them. Jay's nights and weekends became poster/T-shirt/logo design time, taking him back to drawing. "I'm able to take the inspiration I get from hearing music, design it, work in the artist's name and venue and date, and create promo items that, hopefully, help my friends get more people in the door," he said. "Plus, it gets my work seen by a larger audience than my wife and dog."

JOSH SHEARON (NASHVILLE) (23) Josh Shearon is a graphic designer and art director from Nashville. He is also co-founder of Risology Club, an independent publisher of limited-edition artist prints and zines. For the last decade, Josh has worked with brands like the Country Music Hall of Fame and Museum, Salesforce, CMT, Walmart, CVS, Griffin Technology, and Big Machine Records, and is presently an associate creative director at Smile Direct Club. His collaborative spirit has elevated artists, musicians, events, and digital content since the early 2000s when he first began developing his approach to design thinking. Josh specializes in holistic branding, experiential marketing, strategy, and creative direction for companies and products internationally. His personal work has been featured at the Chicago Design Museum, and is deeply rooted in culture and truth.

CINDY SUN (WASHINGTON D.C.) (24) Cindy Sun is a self-taught freelance designer and illustrator specializing in album art and gig posters, although her past work expands far beyond those boundaries. Over the last few years, Cindy has developed a distinct style combining abstract imagery with surrealist environments and retro-inspired color palettes. Her clients include Republic/Lava Records, Alamo Records, Awful Records, Kate Bollinger, Modern Nomad, and more. Additionally, Cindy will graduate with a bachelor's degree in Studio Art as a Printmaking Concentration in spring 2021.

NATASHA TOMCHIN (MIAMI) (25) Natasha Tomchin is a multidisciplinary artist, designer, and coder whose practice is driven by her fascination with natural phenomena. Born in Belarus and raised in Nebraska, she's called Miami home for the last 10 years. Inspired by the clouds and lush flora, her art draws directly from her surroundings in an effort to connect more deeply with nature. These feelings translate across code art, painted furniture, sculpture, video, and projection installations. Always exploring new creative forms of expression, she uses unconventional methods to cross visual boundaries. Natasha's "Digital Dreamscapes" are surreal manipulations of the natural world that encourage the audience to appreciate the ephemeral and awe-inspiring beauty surrounding them. She encourages us to put our phones down and "Don't forget to look up!"

ELIZA WEBER (CHICAGO) (26) Eliza Weber is a musician and graphic designer living in Chicago. As a designer, she is self-taught, and mostly makes fliers, shirts, and album art for bands.

YOUNG & SICK (LOS ANGELES) (27) Nick van Hofwegen, professionally known as Young & Sick, is a Dutch-born, U.S.-based multifaceted artist. As an illustrator and designer, he is behind the art for Foster the People, Maroon 5 (*Overexposed*), and the Machine Gun Kelly/Young Thug "Hotel Diablo Tour," along with many festivals, comedy podcasts, and dozens of other events. As a musician, he has released music across a slew of major and independent labels under the same moniker. He currently resides in a ghost town called Cerro Gordo, where he is one of three residents.

PILAR ZETA (PORTLAND) (28) Argentinian artist and creative director Pilar Zeta has manifested her aesthethic in numerous mediums such as music videos, album artwork, set design, and live performances. She has collaborated with artists such as Coldplay, Miguel, and Katy Perry, among others. Visually, Zeta's colors are bold, her shapes are deconstructed, and her compositions surreal and minimal. Fueled by a lifelong love of the paranormal, Zeta's metaphysical iconography and art exist in futuristic, surreal, and elegant spaces. Her visual work functions as a form of practical magic in a machine-centric world, connecting different mediums through a singular, transcendent vision.

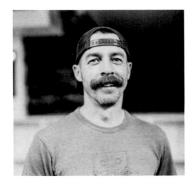

20

23

26

21

24

27

22

25

28

Team

NICOLE ANDREWS (1) Nicole Andrews grew up in a house full of music. Literally, her bedroom walls were lined with a collection of 7,000 LPs. Born and raised in Los Angeles, she has been attending concerts since she was a toddler, thanks to two parents who were very involved in live music as performers and music journalists. Her voracity for music has only grown in her adulthood, as she hits about 150 live performances a year. After graduating with a degree in Ethnomusicology from UCLA, she immediately started work as a music consultant and programmer for an international company, and since then has also worked as a DJ, radio show host, performer, producer, and consultant and assistant in music supervision at Picture Music Company (*Stranger Things*, *The OA*, *White Famous*, *Ray Donovan*, *Better Things*). She currently contributes to a weekly music column in the *Santa Monica Daily Press*, and still works as an international music consultant and programmer.

KATHERINE BARNA-GLOVER (2) Katherine Barna is a communications and brand executive in New York. She's held roles in communications strategy for a number of startups ranging from Hello Alfred, a leading proptech company, to Awesomeness, a Gen-Z multi-platform media company which was acquired by Viacom in 2018. She spent several years as Head of Communications and Public Policy for Tumblr both before and after its acquisition by Yahoo. She joined the company in 2011 as the 25th employee overall, and oversaw all aspects of the company's communications efforts as well as initiated the company's first major social impact campaign centering around mental health awareness. Previous roles include communications for Hearst, *Newsweek* magazine, and XM Radio, and started her career as a publicist for classical musicians at a boutique PR agency. She is a graduate of Fordham University at Lincoln Center where she studied Theatre Performance and Anthropology.

LIZ BARNA (3) Liz Barna is a seasoned sales professional based in Brooklyn. She has been in software as a service enterprise sales rep focusing on start-up community, building relationships and value for B2B partners in the technology industry, with a passion for facilitating communications and collaborations across teams to drive success.

LUCAS BLEEG (4) Lucas Bleeg grew up in the Bay Area and discovered his love of music during the thriving underground rave scene of the late '90s and early '00s. He moved to Germany in 2005 and began working at various record labels and enjoying the electronic music scene in the old East German suburbs of Berlin. Those experiences were pivotal and pushed Lucas to New York to pursue a law degree and employment in the arts. After spending time in Los Angeles and getting acquainted with the independent music scene and entertainment industry, Lucas is now in Sydney, continuing to expand his knowledge and give back to the music community.

CAITLIN BURLA (5) Caitlin Burla is a public relations professional with a background in entertainment, working at networks, production companies, and streaming platforms. Most recently, she was a lead at Quibi, where she oversaw a slate of more than 20 shows and helped launch the company in 2020. Prior to that, she held roles at Viacom-owned Awesomeness, Participant Media, E! Entertainment, and A&E Network. When she's not pitching reporters, she can be found singing country music, at a concert, or trying new recipes. She lives in Los Angeles with her fiancé and their dog, Tennessee.

ISAAC "IZ" BURNS (6) Isaac "IZ" Burns started his professional career at age 17 as a music producer, performer, and music director. Now 22, he's based in Chicago and New York, and his work spans the range of anything strategy-oriented and creative. Born and raised in Chicago, he began at an early age to focus on the arts, and hasn't wavered. As a musician, he has produced music for artists like Clairo, Omar Apollo, G Herbo, and his own group Burns Twins, as well as creating unpublished work with Chance the Rapper and Mac Miller. As a performer, Iz has played notable Chicago festivals like Lollapalooza and North Coast, and notable Chicago venues like the Metro, Lincoln Hall, Subterranean, and Schuba's. After focusing full time on music, at 21 he needed a change, and decided to return to higher education. He is now studying neural sciences at New York University's Gallatin School of Individualized Study, but his freelance strategic consulting work started the moment he arrived in New York. Producing and curating events for Danny Cole, consulting individuals on their work in the music industry, and working as a consultant for small brands and artists, Iz has broadened from strictly music to anything and everything creative.

CRISENE "CASPER" (7) Crisene "Casper" is an integral member of Austin's live music scene and economy. With a career that spans 20 years in operations, production, talent booking, and stage management, she lives and breathes the language of artist hospitality and creative negotiations. Working across events like Lollapalooza, SXSW, and Willie's 4th of July Picnic, she is an intrinsic team member at C3 Presents as production manager for The Scoot Inn, and navigates her time between podcast and live-stream production while supporting the Bring Music Home team on a variety of creative endeavors.

MEGAN COOK (8) Megan Cook was an administrative assistant at The Rocks Management after completing an internship with the company (before COVID). Born and raised in New Jersey, she is an avid music fan and no stranger to the DIY music scene. When Megan entered the music industry, she worked with DIY scenes in South Jersey and Philadelphia, and eventually Asbury Park, fulfilling roles such as street promoter, venue security, merch seller, and social media marketing. Not long after, Megan expanded her skills when she interned as a publicist at a boutique PR firm and worked as security at Firefly Music Festival. Her favorite project was when she handled artist relations, booking, and digital marketing for a DIY music festival in Brooklyn, in summer 2019. Megan's background in fulfilling several roles in the music industry helped her realize her true calling: artist management.

NIKKI CRAIG (9) Nikki Craig is a jack-of-all-trades music industry gigger out of Austin, Texas. She attended the Savannah College of Art and Design for Photography and Advertising Design, but started her music industry career with a degree in Music Business and Performance Technology at Austin Community College. While acquiring her degree, she moved into an internship at C3 Presents doing artist relations and festival marketing, in tandem with an internship with Triple 8 Management doing merchandise and tour marketing. Before graduating, she signed multiple local Austin artists under her business of Live Presence Management. She handled all day-to-day operations, from booking, accounting, branding, marketing and promotion, and legal to general cat-herding. Before COVID wiped out the music industry, she was nestled with C3 Presents as a full-time contractual worker doing anything and everything in between: festival ticketing and fulfillment, box office, VIP services, merchandise, office coordinator, assistant production manager, and artist hospitality, for venues and festivals such as Scoot Inn, Stubb's, Emo's, ACL Fest, VooDoo Fest, and SXSW.

ERIC GANG (10) Eric Gang has been helping companies and brands navigate and succeed through their start-up modes for more than 14 years. An expert in lean and bootstrap-minded growth, he uses his passion and skills in technology and brand experience to elevate new organizations and bring clarity to complex endeavors. Whether aligning a company's technologies and user experience, or charting rocket ship-sized growth with focus and determination, Eric helps make a company's ideas better.

1

4

7

10

2

5

8

3

6

9

11

14

17

20

12

15

18

21

13

16

19

22

MEGHANA GOLI (11) Meghana Goli is a college student and intern at Aces High Creative. As an Austin native, she grew up witnessing the power music has to build communities. She loves everything music-related, from live shows to music history, and is always making a new playlist. Understanding the influence music has on shaping cultural ideas and thoughts is one of her greatest interests. You can catch her going on a music history deep-dive or (virtually) running around behind the scenes.

RACHEL GOODMAN (12) New York City-based documentary filmmaker Rachel Goodman by day crafts content as an associate producer at NBC Sports and Olympics, shining a light on the powerful characters and incredible communities that make professional sports about so much more than just the games on the field of play. By night, you're likely to find her sprinting off a subway trying not to miss the opening act at a show. Raised in Dallas and educated at the University of Texas at Austin's School of Journalism, Rachel as a youth was enveloped in the sounds emanating from historic intimate venues across Texas. Her approach to storytelling is deeply rooted in those experiences—a passion that lays at the intersection of pushing the creative envelope and delving deeply to find the kernels of truth that often make a stripped-down moment in time extraordinary.

CRYSTAL KALISH (13) Crystal Kalish is well-versed in live music. After almost a decade in New York City, she has seen a show in almost every venue the city has to offer, and is passionate about the experience and camaraderie of a live performance. She has spent the past eight years in the event industry developing relationships with clients who produce music festivals, fashion shows, sporting events, and everything in between.

EMMA MALIBORSKI (14) A Midwesterner by birth and New Yorker by choice, Emma Maliborski spent the last four years studying communications, English, and history at Fordham University in the Bronx. After a digital media internship at her hometown's Cincinnati Magazine and a stint at a public relations agency in New York, she was introduced to the music industry in her role at Artists Den Entertainment. As a coordinator, she has a hand in everything from fan engagement to talent research to strategic partnerships. Passionate about storytelling and the power of great writing, Emma is also a staff writer for an independent Chicago-based music blog, and strives to create compelling messages wherever she works.

PAT MCGUIRE (15) A music and culture writer and editor based in Los Angeles, Pat McGuire has spent the better part of the past two decades interviewing a diverse group of luminaries including Tom Waits, Neil Young, Leonard Cohen, Kendrick Lamar, Mel Brooks, Karen O, Nas, Nick Cave, Conan O'Brien, Merle Haggard, Wes Anderson, and Janelle Monae. The editor-in-chief of *Filter* from 2006 until the magazine's closing in 2014, he reported on culture from six continents and helmed more than 100 issues across the publisher's print and digital platforms. Moving on to a founding editor-in-chief role with *Flood* in 2015, he now enjoys a freelance career writing artist profiles and bios, doing corporate creative work, and conducting documentary-style interviews.

APRIL MILEK (16) April Milek knows music. Hailing from Austin, Texas—the Live Music Capital of the World—April drew upon her lifelong passion for supporting artists into a successful career in the music industry. After graduating from Emerson College in Boston, she went on to hold positions at major record labels in New York and Los Angeles, including Rhino Entertainment, Warner Strategic Marketing, and EMI Records. She was also a founding member of the U.S. division of Universal Music Mobile. While holding these positions, April was able to help artists license their music and successfully navigate innovative opportunities in the digital space. She enjoys managing complex projects from conception to completion, event planning, and business development. Said April: "The finish line is close. I know you can see it. Keep going!"

PAM RICKLIN (17) Pam Ricklin is based in the NYC area and got her start in the music industry as programming director and DJ at her college radio station WFNP. Then, what began as a summer internship in 2013 grew into a full-time role, and now she's acting as Assistant Artist Manager at The Rocks Management. She runs the social media accounts for the 1960s British Invasion band The Zombies, and was part of the marketing campaign team to induct the band into the Rock 'n' Roll Hall of Fame in 2019. She's even toured with the band numerous times as their merchandise seller and coordinator. Her No. 1 passion is attending concerts, whether that's seeing a big rock act at The Garden or a singer-songwriter at The Bitter End.

BENJAMIN SARGENT (18) Benjamin Sargent is a certified public accountant based in New York who realized in his 20s that his talent lay somewhere other than holding a guitar. He now supports creators, photographers, and musicians by helping them navigate their often unpredictable financial lives. Growing up in a house where the first thing you did when you got home was put on a record before even taking off your shoes and coat, music, no matter the style, has always felt like home. You can find him on the North Fork of Long Island with his wife and kids, belting out "Yellow Submarine" off-key in the backyard.

COREY STEWART (19) Corey Stewart has lived in New Orleans, Amsterdam, Marfa, and Austin, and rambled around to places in between. He's traveled across the underbelly of our country on Greyhound buses, flown first-class to Europe with a pocket full of blackjack winnings, spent nights on the streets in concrete jungles, and camped in the African jungle. His passion for writing means he can't stop telling stories: two books, a novella, and a screenplay, so far. "Words fall out of me, I do my best to put them on paper," Corey said. The randomness of his career has taken him from bodyguard work for celebrities like Queen Latifah and Matthew McConaughey to a li'l bit of acting/modeling, and from managing a yoga retreat in Upstate New York to project-managing live events for clients like Netflix and HBO: "Guess you could say I like to keep it interesting."

BROOKE URIS (20) With more than 15 years' experience, Brooke Uris is a seasoned veteran of New York City's live events and marketing industries. Brooke specializes in working with her clients to creatively conceive and produce one-of-a-kind experiences. She focuses on both the corporate and nonprofit sectors, with a client roster including *The 60th Annual Grammys*, ABC's *American Idol*, Spotify, Little Kids Rock, The T.J. Martell Foundation, and many more. To know Brooke is to know her love and passion for music, her career, and helping others.

SYDNEY VAN NESS (21) Sydney Van Ness is a born-and-raised Clevelander who has had a passion for music for as long as she can remember. She got her career started as an intern at the Rock 'n' Roll Hall of Fame where she would go on to become the artist and VIP relations assistant for the organization. During her career, Sydney has had the opportunity to work with countless local-to-internationally-known artists. She is an Ohio University alumni with a background in journalism and marketing. She loves connecting with others, helping them achieve their goals, and telling their stories.

LAURA YOUNGKIN (22) Laura Youngkin is a creative producer and writer specializing in immersive experiences. Past notable projects include the Museum of Ice Cream, Hulu's '*Castle Rock*' *Experience* based on the works of Stephen King, and *Pandora: The World of Avatar* at Disney's Animal Kingdom. A former Disney Imagineer, Laura is passionate about storytelling and placemaking, which is why Bring Music Home is important to her. She is currently a contributor at Forbes and based in Los Angeles.

2.10	~+	GRIFF w/ Royal & The Serpent
2.11	~+	Hollow Coves w/ Harrison Storm
2.11	~+	CIG40 w/ Guests
2.12	~+	Women That Rock Galentine's Day Show
2.13	~+	MFM Presents: MANNYWELZ
2.13	~+	Max Pain & The Groovies
2.14	~+	Beatle's Valentine's Dance Party
2.14	~+	Uptown: A Prince Party
2.15	~+	Bedstudy w/ Firstworld, Di Ivories
2.16		PAZZI PROM II
		This Is Lorelei, Julia Julian, EBPO, Blankat
	~+	Tom Tom Mag ft. Stud1nt +
2.19	~+	Closebye w/ Margaux, Cutouts
2.19	~+	Oak & Ash
2.21	~+	Popshop NYC: Jax Anderson
21	~+	the BFF Party
22	~+	Meyru
	~+	·◇· HOT HONEY ·◇· LGBTQ Womxn Party
	~+	Kojey Radical w/ KAMAUU
2.24	~+	ALY & AJ
2.25	~+	Afro Dominicano & The Saturators
2.26	~+	Maya Hawke
2.27	~+	Khai Dreams w/ Love-Sadkid
2.27	~+	Stonefield
2.28	~+	PNTHN
2.29	~+	Broke Royals
2.29	~+	Back To Life

Above: Danny Gomez, Lead Singer/
Guitarist (Native Sun) pointing
to the lineup posted at Baby's All Right,
Brooklyn, NY
Photograph by Kevin W. Condon
Page 484: Marquee of the Palace
Theatre, Minneapolis, MN.
Photograph by Sahra Qaxiye

Book Credits

BRING MUSIC HOME CONCEPT:
Amber Mundinger
Kevin W. Condon
Tamara Deike

IN PARTNERSHIP WITH:
YETI
Tito's Handmade Vodka

WRITTEN BY:
Amber Mundinger + Tamara Deike

ART DIRECTION:
Kevin W. Condon

DESIGN + LAYOUT:
Bonnie Briant

COVER DESIGN + CONCEPT:
Jose Berrio

BRING MUSIC HOME LOGO:
Misha Vladimirskiy

BOOK PRODUCTION TEAM:
Brooke Uris
Crystal Kalish

TRANSCRIPTION + CONTENT MANAGER:
Rachel Goodman

TRANSCRIPTION + CONTENT PRODUCTION TEAM:
Megan Cook
Corey Stewart
Sydney Van Ness
Emma Maliborski
Crisene "Casper"
Isaac "IZ" Burns
April Milek
Nikki Craig

MUSIC DIRECTOR + MUSIC PLAYLIST CURATION:
DJ Hesta Prynn

MUSIC PLAYLIST RESEARCH + ADDITIONAL STORIES:
Pat McGuire
Nicole Andrews

ADDITIONAL EDITING:
Pat McGuire

SOCIAL MEDIA MANAGEMENT:
Pam Ricklin

PR + MEDIA MANAGEMENT:
Katherine Barna Glover
Caitlin Burla
Laura Youngkin

PR + MEDIA SUPPORT:
Megan Cook
Liz Barna
Sydney Van Ness
Meghana Goli

LEGAL COUNSEL:
Lucas Bleeg

ACCOUNTING:
Benjamin Sargent

MARKETING MANAGEMENT:
Amber Mundinger
Tamara Deike
Misha Vladimirskiy

PROOFREADING + ADDITIONAL EDITING:
Stephen K. Peeples
Rory Aronsky

WEBSITE DEVELOPMENT:
Amber Mundinger
Eric Gang
Misha Vladimirskiy

ADDITIONAL PHOTO + VIDEO ASSISTANCE ON LOCATION:
Chris Clip (Atlanta)
Jake Flint (Tulsa)
Preston Roper (Tulsa)
Maren Celest (Chicago)
Nick Kova (New York)

PRINTING + MANUFACTURING:
Editoriale Bortolazzi Stei S.r.l.
(EBS), Verona, Italy

DISTRIBUTION:
Fine Southern Gentlemen

A long, long time ago
I can still remember how that music
used to make me smile
And I knew if I had my chance
That I could make those
people dance
And maybe they'd be happy
for a while…
—Don McLean, "American Pie"

Thank you for stopping by…
We hope to see you across the
room at a live show soon.

xo,
The Bring Music Home
Team

P.S.
Continue the story here:

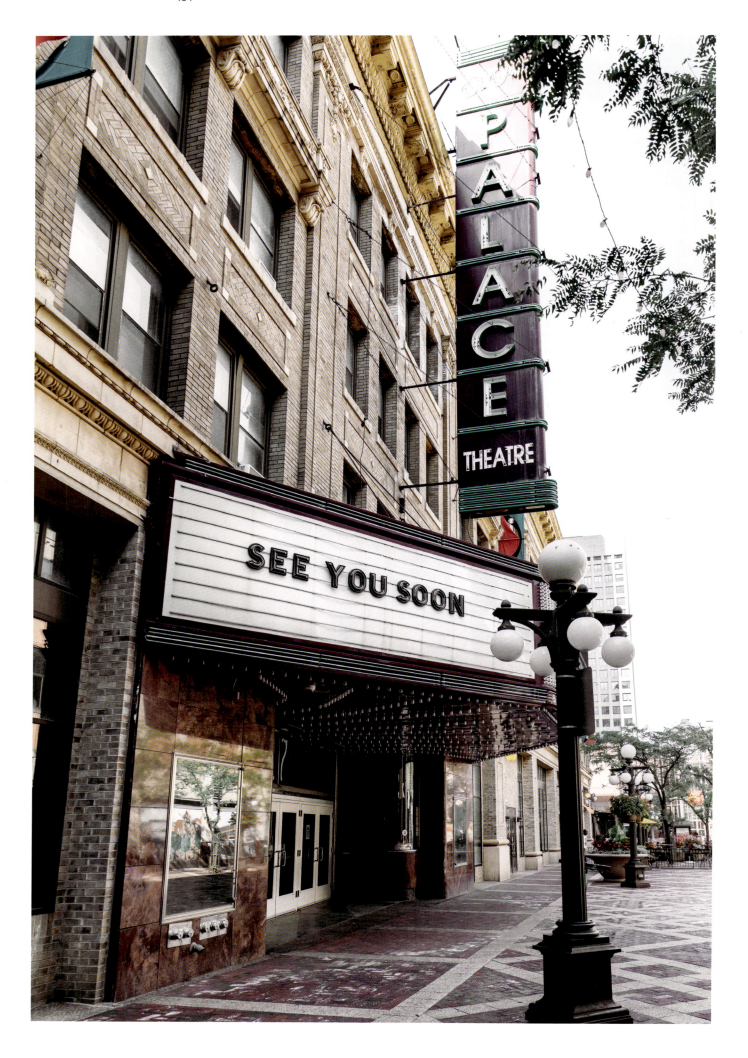